DESIGNS
ON FILM

ALSO BY CATHY WHITLOCK

Re-de-sign: New Directions for Your Interior Design Career

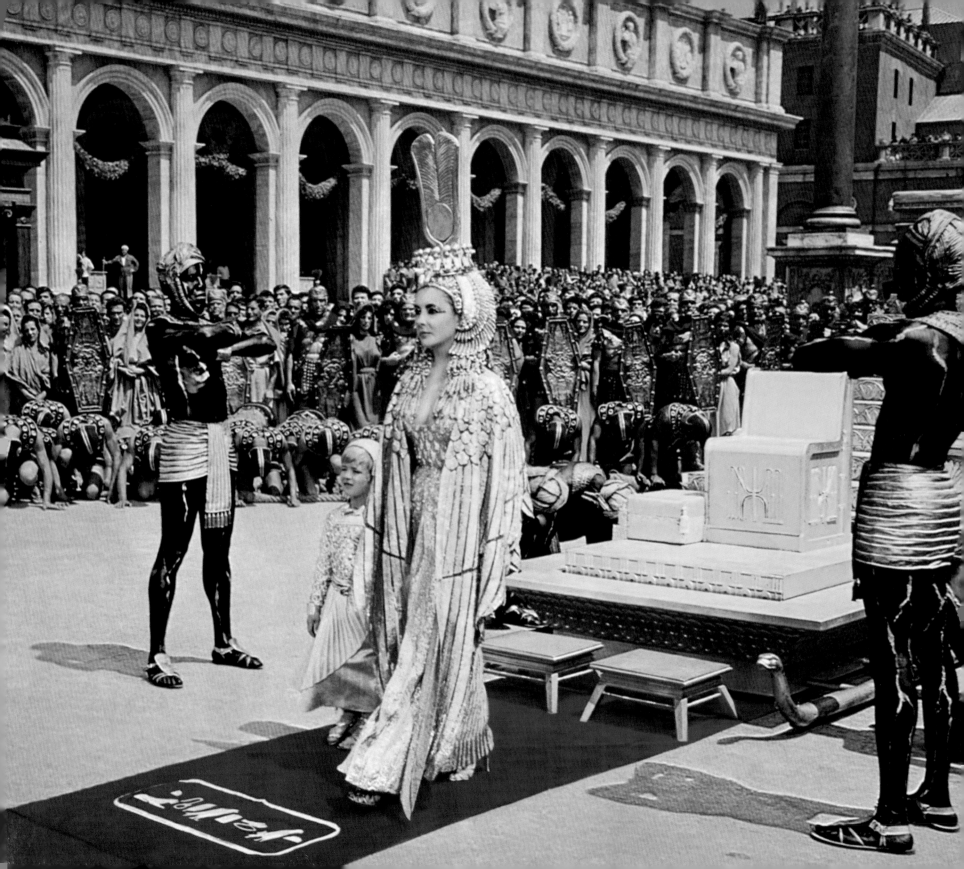

DESIGNS

A CENTURY OF HOLLYWOOD ART DIRECTION

ON FILM

CATHY WHITLOCK

AND THE ART DIRECTORS GUILD

itbooks

AN IMPRINT OF HARPERCOLLINS PUBLISHERS

HarperCollins books may be purchased for educational, business, or sales promotional use. For information please write:

Special Markets Department, HarperCollins Publishers, 10 East 53rd Street, New York, NY 10022.

FIRST EDITION

DESIGNED BY RENATO STANISIC

Library of Congress Cataloging-in-Publication Data has been applied for.

ISBN 978-0-06-088122-1

11 12 13 14 ID3/AP 10 9 8 7 6 5 4 3 2

PAY NO ATTENTION TO THE MAN BEHIND THE CURTAIN.
—*THE WIZARD OF OZ*

THIS BOOK IS DEDICATED TO THE MANY
UNSUNG HEROES AND HEROINES WHOSE DESIGN TALENTS AND
CONTRIBUTIONS HAVE PROVIDED WONDERMENT
IN THE DARK FOR MILLIONS OF
MOVIEGOERS AROUND THE WORLD.

PART 1

THE DESIGNERS:
ARCHITECTS OF DREAMS

PART 2

A CENTURY OF DESIGN

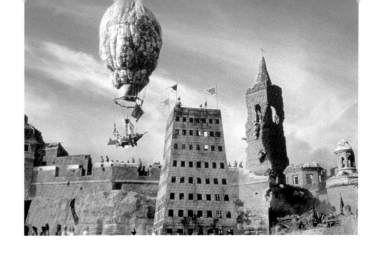

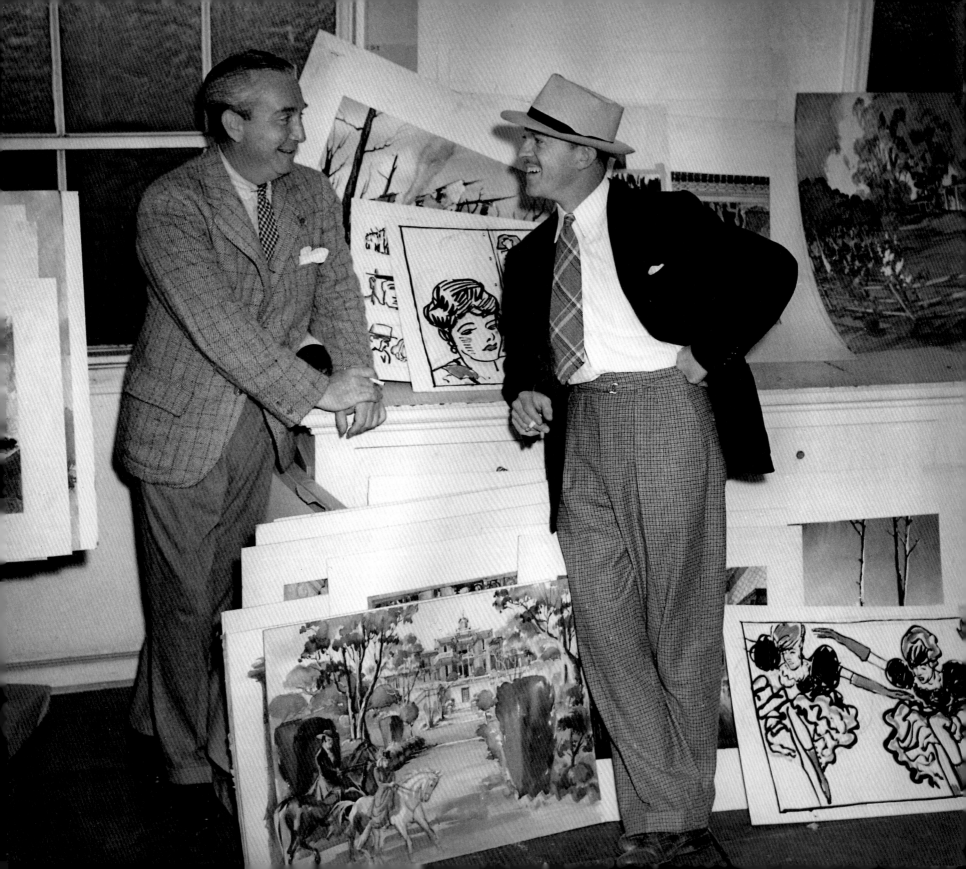

FOREWORD

Thomas A. Walsh

PRESIDENT, ART DIRECTORS GUILD

To be a narrative designer or "an architect of dreams" is to be a purveyor of wonderment. The production designer must have the heart of a child—one that is insatiably curious and excited by new discoveries—as well as be the designated adult who is an informed and impassioned advocate that nurtures, advises, and guides a uniquely collaborative process.

Art direction for film is a distinctively original profession led by the production designer. The production designer is a corner of the central triangle that unites the director, the cinematographer, and the designer in a creative and interdependent partnership. This connection is fundamental to a successful production, as this partnership spans the entire arc of the moviemaking journey, from a film's inception to conclusion. But, as you'll see, this partnership is one of *many* the production designer must negotiate, as there are many complementary professions in filmmaking that the production designer depends upon and coordinates.

As an art form, art direction has evolved to meet the needs of an industry that has grown and changed drastically over a century. Yet, at its core, some of the most fundamental tools and traditions of art direction extend

OPPOSITE PAGE: Production designer William Cameron Menzies and art director Lyle Wheeler in the art department of *Gone with the Wind* (1939). The pair supervised the creation of 1,500 watercolor paintings prepared by a staff of seven artists.

back to the very beginning of recorded time. The art of designing for narrative performance began with man's first attempt to organize the act of storytelling. Whether it was a cave drawing on a wall that complemented an oral and ritual reenactment of a hunt, or a royal court pageant that catered to all of the senses, designs were a continuum of evolving experiences, carefully conceived to take one on a journey through the complete arc of a narrative story.

In America, art direction for film began as a trade and craft, one that was created to service the most basic needs of the story and location requirements. It evolved very quickly into an art form of its own and continues to evolve and adapt as innovative technologies provide new solutions to meet the challenges of filmmakers. Many of Hollywood's art direction pioneers came to southern California from all over the world. Stage designers from Broadway, architects from Chicago, and a vast diaspora of artists of varying descriptions from all over Europe all converged at what was then an isolated desert community on the edge of the Pacific Ocean. However, these originators of art direction were not exclusively from the theatrical or architectural professions, as painters, sculptors, commercial artists, contractors and builders, decorators, and more than a few disillusioned thespians contributed to the creation of this profession. For most, the Hollywood motion picture studio was both a trade school and a college; one where on-the-job experiences and close community provided a significant crucible in which our many traditions, standards, and practices were originated.

After some false starts in nomenclature, the title of art director was determined to be best suited to represent the design leader of this new profession, known from its inception as art direction. The rank of supervising art director was first used by legendary designers, such as Cedric Gibbons at MGM and Hans Dreier at Paramount, and was created to distinguish these principal figures within the studio's management hierarchy. Entrusted with the overall supervision of the studio's art departments, they also oversaw the work of set design, decoration, hand props, construction, painting, special effects, locations, set budgeting, and the logistics of production.

In the early 1950s, the Golden Age of the Hollywood studio was ending, and a new form of independent production slowly replaced the studio system. Limited partnerships were formed to make one production at a time. Sadly, almost as if Rome had been pillaged and burned, many of the studios' vast collections of furniture, set pieces, artworks, and accessories were stolen, sold at auction, or discarded into landfills. The many artisans who built the great studios and so effectively realized Hollywood stories became independent freelancers. Many of the finest practitioners took their knowledge and professional experiences with them to the grave, often before their knowledge could be documented for future generations. Fortunately, we can still study and learn from their work. We can marvel at their ingenuity, much like at a Greek temple's marble frieze or a Flemish genre painting of a domestic scene, and deconstruct it so that we might better appreciate their challenges and achievements.

Among the many changes that occurred during the transition from the studio system to that of the independent production was the use of the title of production designer instead of art director, to distinguish the head of the art department from the head of the creative team. This title was first conceived for, and used by, designer and director William Cameron Menzies, as a way of honoring his many contributions to the making of *Gone with the Wind*. It signifies that the designer has provided extensive and significant creative influence and leadership to the entire project,

from the forming of a film's first visual concepts, through its full realization and completion. The term "art director" is still in use today, but now signifies a supporting role to that of the production designer.

Today the principal role of the production designer is still the same as it always was. They are there to advise and assist the director in the decision-making process. The production designer is the first to visualize the story and discover its cinematic potential. Central to this process is the seeking of answers to fundamental questions: What's the story about? What are the most compelling characteristics of the story? For the production designer, "character" can be a person, a place, a thing, an emotion, a texture, or a nuance. All of these elements combined provide gravity and reality to the story and are the source of some of the most arresting images in the cinema, images we hold today in the highest of regard.

It is our hope that as you read the pages of this book and study its many images, you will understand and appreciate more fully those many pioneers, innovators, and visual artists who have contributed so much to the creation and advancement of the art of design for the moving image.

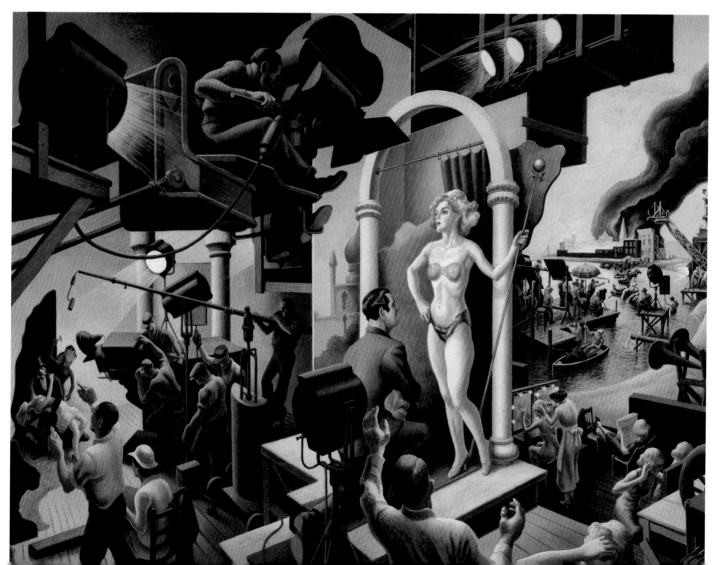

LEFT: Thomas Hart Benton, American (1889–1975). *Hollywood,* 1937–1938, tempera with oil on canvas mounted on panel. Benton described the design as "the combination of a machine and sex that Hollywood is."

DESIGNS
ON FILM

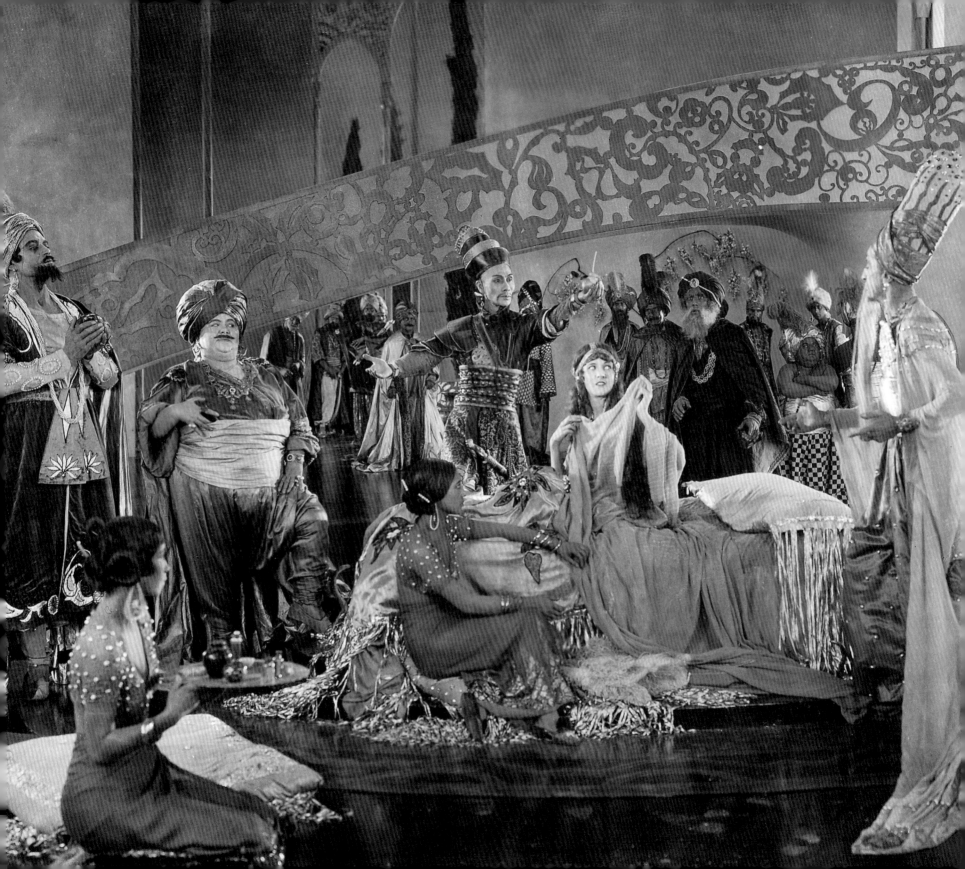

INTRODUCTION

Who can forget the richly detailed drawing rooms of *The Age of Innocence*? The Moorish architecture and opulent grandeur of *The Thief of Bagdad*? The Fallingwater-style house, inspired by Frank Lloyd Wright, in *North by Northwest*? The sleekly stylized high-gloss sets synonymous with the musicals of Fred and Ginger?

From the Tara plantation in *Gone with the Wind,* Norma Desmond's house in *Sunset Boulevard, Rebecca's* Manderley, and *Citizen Kane's* Xanadu, to the dusty and desolate streets of *High Noon's* Hadleyville, Dracula's Gothic cobweb-filled castle, and the Burnhams' *American Beauty* suburbia, the cinema is home to some of the world's most memorable places and images.

It is through these images that movies have the magical ability to transport us from our day-to-day reality to a new, distinctive, self-contained world. As the ultimate escape, the cinema has the power to entertain, enlighten, and envelop us in the surroundings it brings to life. While this suspension of disbelief can often be credited to a compelling script, the performance of the actors, or the subtle yet exacting direction, a film's design and art direction are its very core—the powerful center from which movie magic is created.

Film design, known in the industry as production design and art direction, establishes the overall visual look and feel of a film. The settings, spaces, and images that designers create serve as a film's backdrop, help develop a film's narrative, and support the characters' identities and motivations. While even the most

infrequent moviegoer can recall the name of a famous director, actor, and perhaps cinematographer, if hard-pressed, few know who the production designer is, or what he or she does.

FILMMAKING IS A collaboration between actors, the director, the screenwriter, the cinematographer, and a host of other skilled craftspeople. Hundreds of people and moving parts come together to create even a single scene within a production. While generally unknown and uncelebrated, the cinema's true unsung heroes are production designers and their talented teams of art directors and set

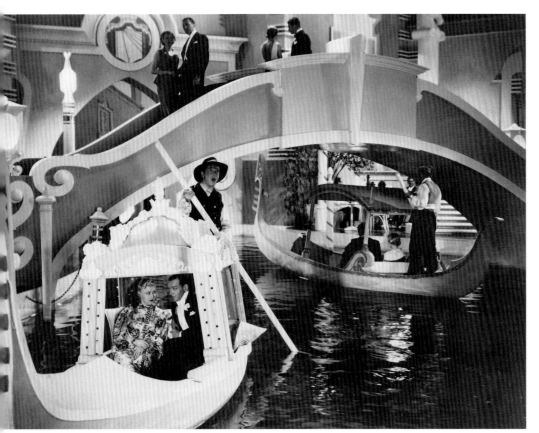

decorators. They are the architects of illusion; they are tasked with taking a blank soundstage or location and producing a visually convincing, functional, and appealing setting for the screen. In short, they are visionaries designing cinematic dreams.

For me, film has always inspired and challenged my design aesthetic. I have spent many afternoons in a darkened theater, transported to new experiences and stunning surroundings, for only the price of admission. I have been lost in the opulent grandeur of an eighteenth-century opera house in *Amadeus*. I've traveled back in time to a mysterious, smoke-filled Moroccan bar in *Casablanca*. I found a haven in Karen Blixen's portico overlooking the Nairobi landscape in *Out of Africa* (and Robert Redford certainly added to the atmosphere as well). Watching *Weekend at the Waldorf, Pillow Talk,* and *A Perfect Murder,* I lusted after the ubiquitous Manhattan penthouse with the perfect terrace and the seemingly spectacular view.

I became intrigued with the subject of film design when I was approached by an interior-design client back in the late 1980s. She asked me to design her living room to resemble the sophisticated white-on-white interiors of the Tom Berenger–Mimi Rogers film *Someone to Watch Over Me*. I didn't have to rent the video (the tape du jour of the period!); I immediately could see what she wanted. Production designer Jim Bissell's luxurious sets came to mind in an instant, becoming my muse for the design of the client's interiors. The elegant furnishings, the use of tone-on-tone colors, and the atmospheric mood of the lighting were all reinterpreted to her satisfaction.

Since that time, I have viewed and analyzed films through an entirely different lens, appreciating the important role production design and art direction play in the filmmaking process. As a design journalist, I study the work of the interior-design profession's Hollywood counterpart—the

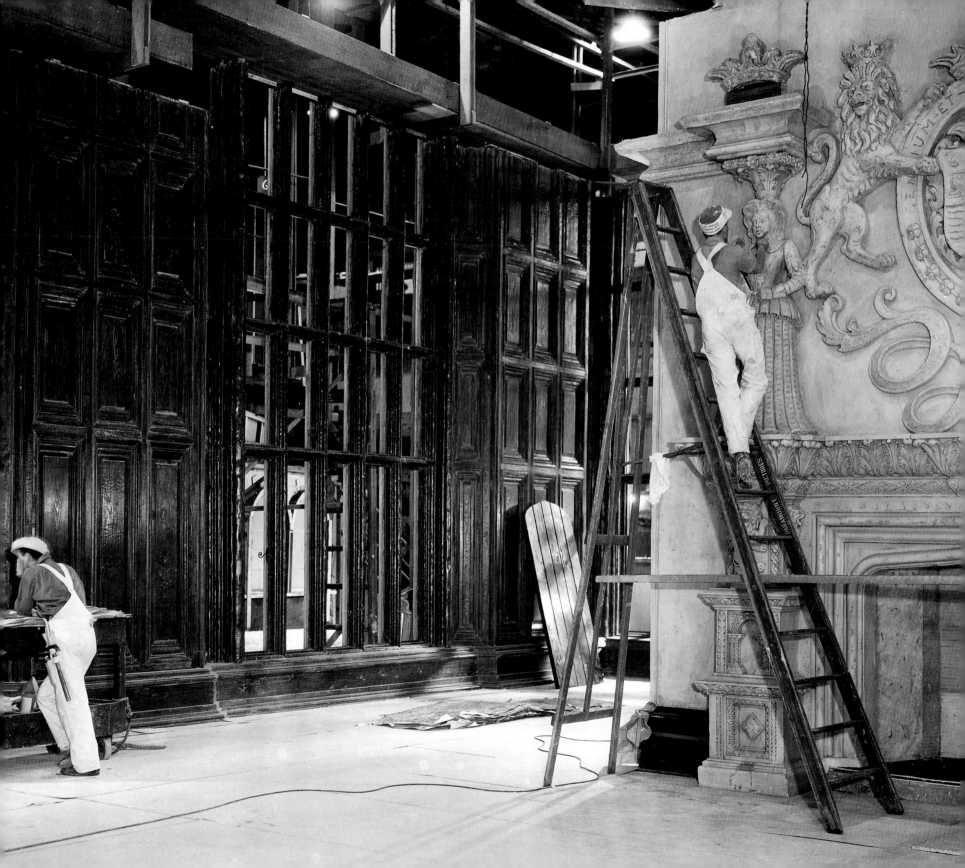

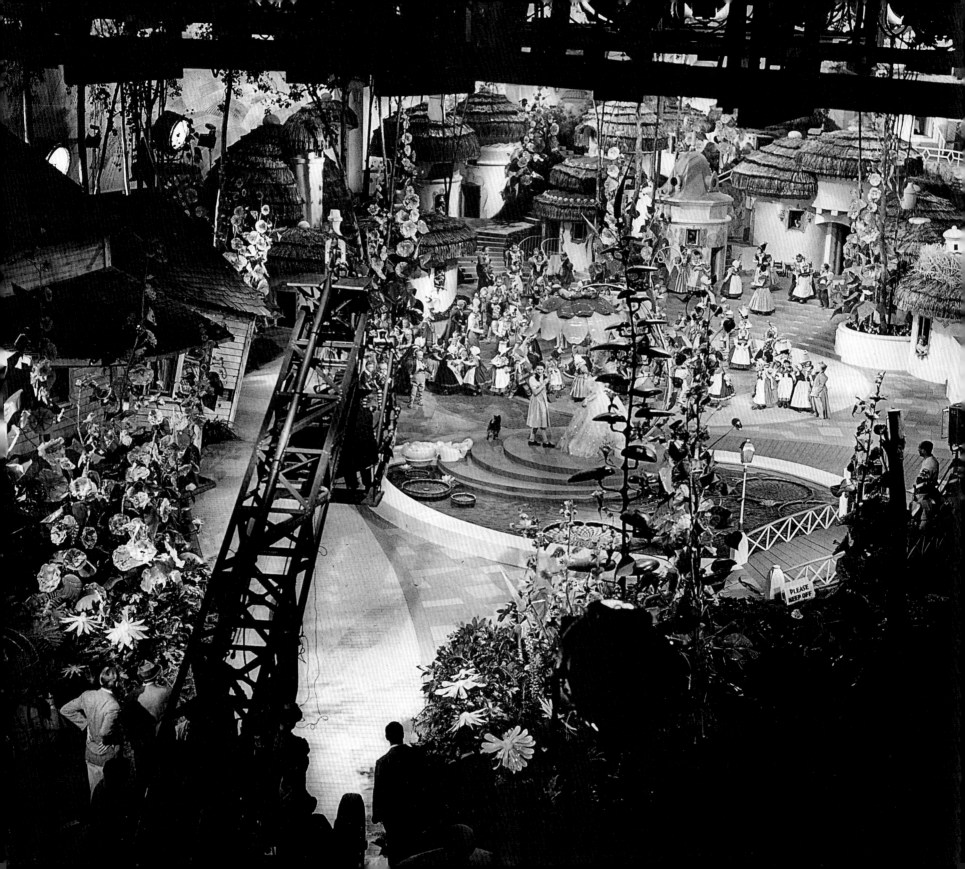

set decorator. Along with many modern moviegoers, I have an unquenchable desire to see behind the scenes and learn from the sets of the cinema's most glamorous films. And since I am a former film publicist, movies have always been in my blood. *Designs on Film* is the marriage of my two passions of design and film.

A book of this nature is a daunting one, and the task of selecting films to highlight proved to be even harder. Tom Walsh, my cohort and the president of the Art Directors Guild, and I spent countless hours examining and culling lists of this century's best films. The final selection represents a vast array of film styles: historical period pieces (often known as costume dramas), the epics, science fiction and fantasy, westerns, comedies and drama, and other stylized genres such as film noir and its cousin, neo-noir.

Selection of these films was initially based on several criteria: Were the images compelling? Were they memorable? Did they support the film's story? And could they go in a time capsule of the century's finest production design?

While the majority of films are considered timeless classics and box-office successes, many are simply reflections of the social consciousness and trends of the decade. As production designer Joe Alves (*Jaws, Close Encounters of the Third Kind*) reflected, "It is often some of the worst films that have the best sets. When we are working our hearts out on a film, we often don't know if it will be good or bad." Regardless of the story, the actors, or the box-office receipts, good design is good design, and I've tried to showcase that very feat from films throughout the century.

Our central mission was to highlight the work of the brilliant professionals in the field—first the pioneers of the silent era, who were basically carpenters and artists; then the forefathers of Hollywood's Golden Age (then known as art directors), who rose through the ranks of the classic studio system; and finally the modern designers, who continue to innovate and expand the role of film design. Not only adept at traditional production design, today's visionaries add dealing with the challenges of special effects and computer-graphic imaging to their résumés.

I also wanted to pay special tribute to another unappreciated group—set decorators. My work as an interior designer is similar, but where I design a home or single room, my cinema colleagues are responsible for selecting the total furnishings and accessories for the film sets—every detail of every room in every scene. Set decorating is a true art. Each room shown needs to represent a character's lifestyle, habits, personal history—it must instantly achieve a look that is lived-in and, most important, believable. Whether it's placing period antiques in a stately English castle for *Pride and Prejudice,* or outfitting a dusty old saloon with authentic barware in *Unforgiven,* or creating an entire imaginary landscape inhabited by Munchkins in *The Wizard of Oz,* the responsibility remains the same.

All of these films share one common denominator: they start as a fantasy in the mind of the designer and end up on the screen as a cinematic vision. It is my true hope that the next time you go to the movies and are taken away . . . you will remember the unsung heroes who took you there.

OPPOSITE PAGE:
The "Munchkinland" set on *The Wizard of Oz* (1939) • William Horning, Jack Martin Smith, and Malcolm Brown, art directors; Cedric Gibbons, supervising art director

PART ONE

THE DESIGNERS: ARCHITECTS OF DREAMS

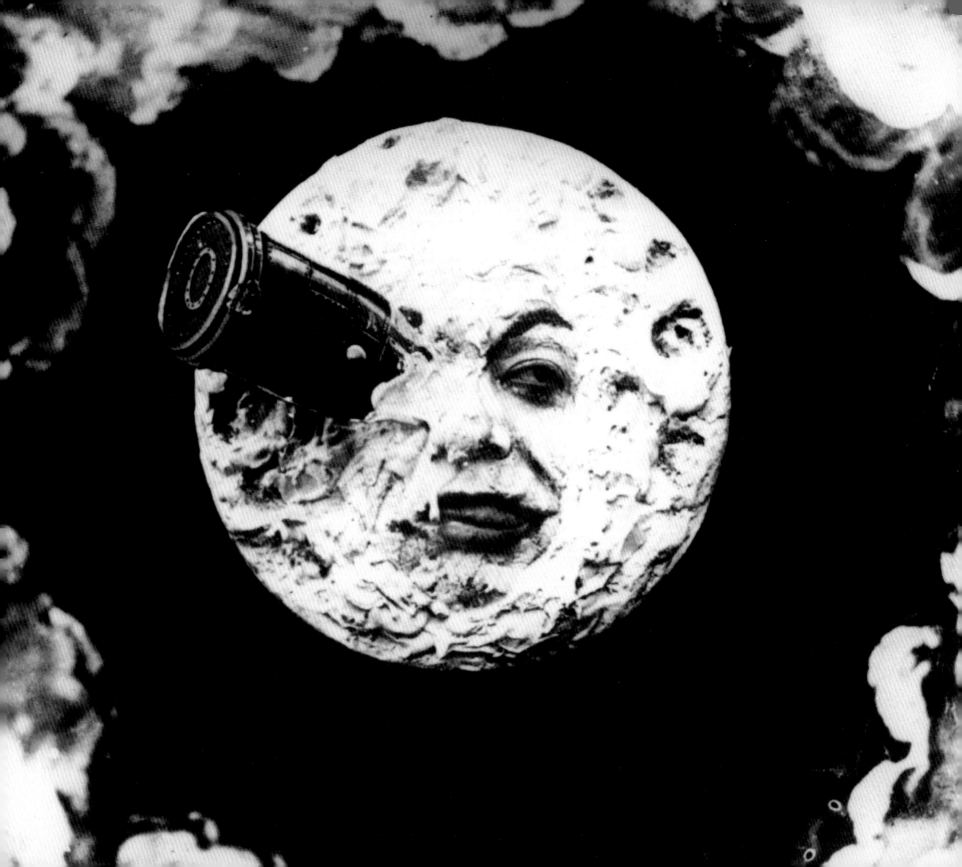

THE ART DIRECTOR

He must have knowledge of architecture of all periods and nationalities. He must be able to visualize and make interesting a tenement or a prison. He must be a cartoonist, a costumier, a marine painter, a designer of ships, an interior decorator, a landscape painter, a dramatist, an inventor, a historical and, now, an acoustical expert.

—William Cameron Menzies, the first credited production designer

THE BIRTH OF ART DIRECTION: WILFRED BUCKLAND

With little more than a hand-painted trompe l'oeil scene on a flat panel constructed by a carpenter, the practice of film design was born.

While historians may differ as to the first film to employ actual set design, one of the earliest designed productions can be traced back to 1902. The film, *Le voyage dans la lune (A Trip to the Moon),* was a science fiction fantasy produced by the French magician and filmmaker Georges Méliès. Famous for its "fool-the-eye trickery," special effects, and intricately painted backdrops, the twelve-minute silent film was considered a masterpiece.

The development of film and the natural emergence of subsequent sets evolved hand in hand. It was the time of film before sound, and art direction was a mere shell of itself. It borrowed heavily from its predecessor, the theater, and often involved the practice of designing boxed stages with walls or a painted backdrop.

Wilfred Buckland (1866–1946), originally a theater set designer, is considered by many film historians to be the first art director to use the title on record. Buckland was brought to Hollywood by filmmaker Cecil B. DeMille

OPPOSITE PAGE:
Le voyage dans la lune (1902)
• Georges Méliès, art director

to design and light architectural settings for films like *The Cheat, Carmen,* and *Male and Female.* DeMille, like Buckland, had also trained on Broadway under the famed producer David Belasco.

Buckland headed up a staff of artists and draftsmen who comprised the film distribution company Famous Players–Lasky. Working at an exhausting pace, Buckland literally broadened the scope of design by "thinking out of the box" of the ready-made theater set. Buckland's first film sets were built in the very first "studio"—an old barn on the corner of Vine and Selma avenues in Hollywood. Buckland's innovations included the use of the Klieg light for interior and exterior shots, and application of chiaroscuro effects (the use of light and shade to exaggerate images). This controlled studio lighting ushered in a new era of artistry in filmmaking. Before Buckland's arrival in Hollywood, films were shot in the harsh California daylight. Even interior shots were set up in the open air, with gauze or silk reflectors to diffuse the sunlight on the actors. Wind blowing through a backdrop was not an uncommon sight.

Early art direction grew out of a simple need—a basic backdrop that could help tell a story. Art direction was not necessarily realistic, emotive, or stylistic until Buckland's paradigm-shifting lighting techniques. And in 1922, as supervising art director alongside William Cameron Menzies and Anton Grot, Buckland provided filmgoers with a view into a completely new world of his creation—the majestic castle and its unforgettable accompanying sets in Douglas Fairbanks's *Robin Hood.*

Introducing audiences to the term *swashbuckler,* Fairbanks is dwarfed by the film's enormous castle. At ninety feet high, it was considered the tallest tower built for film at that time. The film's massive scale and detailed set design became a blueprint for future adventure epics.

Buckland and his actress wife, Veda, were members of Hollywood society, and like many of their peers, the couple was eventually left penniless by the Great Depression. Buckland's contributions changed the industry, yet the role of art director would not become prestigious for another decade. As Cecil B. DeMille wrote in his 1959 autobiography, "If anyone is ever inclined to catalogue contributions I have made to motion pictures, I hope that my bringing Wilfred Buckland to Hollywood will be put near the head of the list." And DeMille should know about achievements: he is credited with everything from innovations in lighting, photography, and elaborate set designs to what we know today as the epic Hollywood blockbuster.

ART DIRECTORS OF THE HOLLYWOOD STUDIO SYSTEM

The period from 1910 to the early 1960s was known in the film world as the "Hollywood studio system," a time where a few major studios began to rule the film industry. Also known as the "Golden Age of Hollywood," during this period the classic studio system became a tightly controlled environment. Studios produced films with the efficiency of a well-run factory. From the first draft of a script to the final reel, all-powerful studio heads called the shots in true dictatorial style. Controlling the entire creative package, the studios locked in their top stars personally and professionally with long-term contracts, gave directors limited power, and monitored the pitch delivered by the publicity departments.

ART DIRECTION IN the Golden Age of Hollywood was also tightly controlled by the all-seeing studio heads. As a result, the singular style of the top art director usually

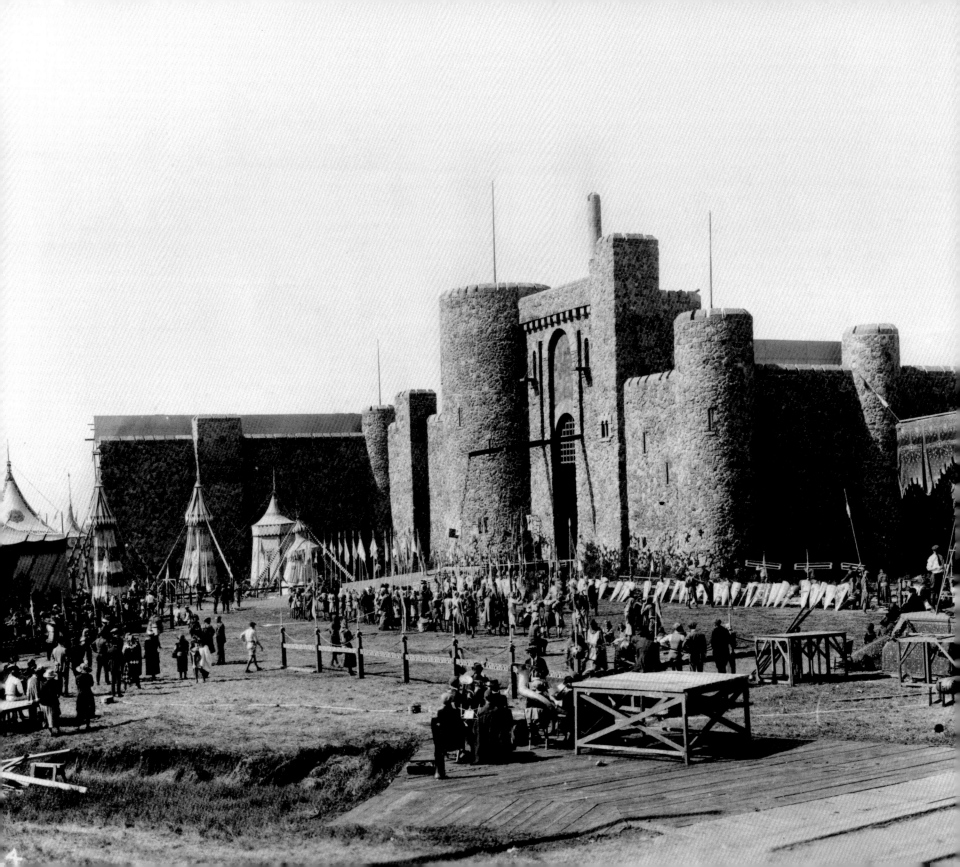

defined that of an entire studio, resulting in a "trademark look" that was assigned to the majority of their films.

The modern definition of an art director was given the title of supervising art director during this period, a job that carried the duties of an executive as well as a designer. The supervising art director was responsible for the entire art department and oversaw the work of several hundred unit art directors, draftsmen, and painters, in addition to the prop, construction, and special-effects departments. It was a male-dominated division, where an influx of European and American artisans would come to work daily in their suits, roll up their white shirtsleeves, and spend the day drafting. Below the supervising art director, the unit art director was traditionally appointed to a single film and became its true acting designer. Unit art directors worked with the director and cinematographer, and supervised the production of sketches, sets, and miniature models for the film.

Like any successful factory, the art department worked at breakneck speed, and often required its members to keep a hectic, six-days-a-week schedule. Illustrators sketched sets while draftsmen turned artistic renderings into architectural drawings or models. Artists poured over beautifully designed presentations in order to sell the film's designs to budget-conscious studio heads. Often illustrated in charcoal or painted in watercolor, they were truly works of art.

The decline of the studio system was a sign of the times and marked an end of an era. The invention, and subsequent popularity, of television created a shift in moviegoing habits, and, in addition, a 1948 Supreme Court ruling stated that the studios must divest themselves of interest in movie theaters. As a result, their feudal power over the overall filmmaking process and distribution diminished. The Golden Age of Hollywood was over.

WILLIAM CAMERON MENZIES

Two years after Buckland's revolutionary sets for *Robin Hood*, an upcoming art director was cutting his teeth on a similar epic, *The Thief of Bagdad*. An arts and architecture graduate of Yale and the Art Students League of New York, William Cameron Menzies (1896–1957) started his career as a children's-book illustrator. Following the path of his colleague Wilfred Buckland, Menzies joined Famous Players–Lasky in 1918 as a set designer for silent films. His first project was *Witness for the Defense,* in 1919.

Menzies teamed up with director Ernst Lubitsch and actress Mary Pickford on the 1923 film *Rosita.* While he had worked (uncredited) as an assistant art director on *Robin Hood,* it was his eye-popping designs for *The Thief of Bagdad* that put his career on the map. Also starring Douglas Fairbanks, the Arabian adventure tale was the ultimate fantasy. Its architecture drew from Moorish origins, and the ethereal interiors were perfectly staged for Fairbanks's thief to swing in and out of the sets, swashbuckler-style. Considered a prodigy by those who worked with him, Menzies designed the remarkable fantasy film before the age of thirty. Art director Ted Haworth knew him as "a man with a million movies in his head."

Armed with the talent of an artist and skills of a draftsman, Menzies sported style as varied as the subjects of the films themselves. He designed romantic, Spanish-inspired interiors for Rudolph Valentino's *Cobra* and created a fantasy ship for another Fairbanks vehicle, *Reaching for the Moon.* Menzies even tried his hand (to bad reviews) in directing the sci-fi film *Things to Come.* He also has the distinction of winning the first Academy Award for Art Direction, in 1929, for his films *The Dove* and *The Tempest,* and was nominated for *The Awakening* and *Bulldog Drummond,* in 1928 and 1929, respectively.

Menzies wasn't confined to a single studio and essentially

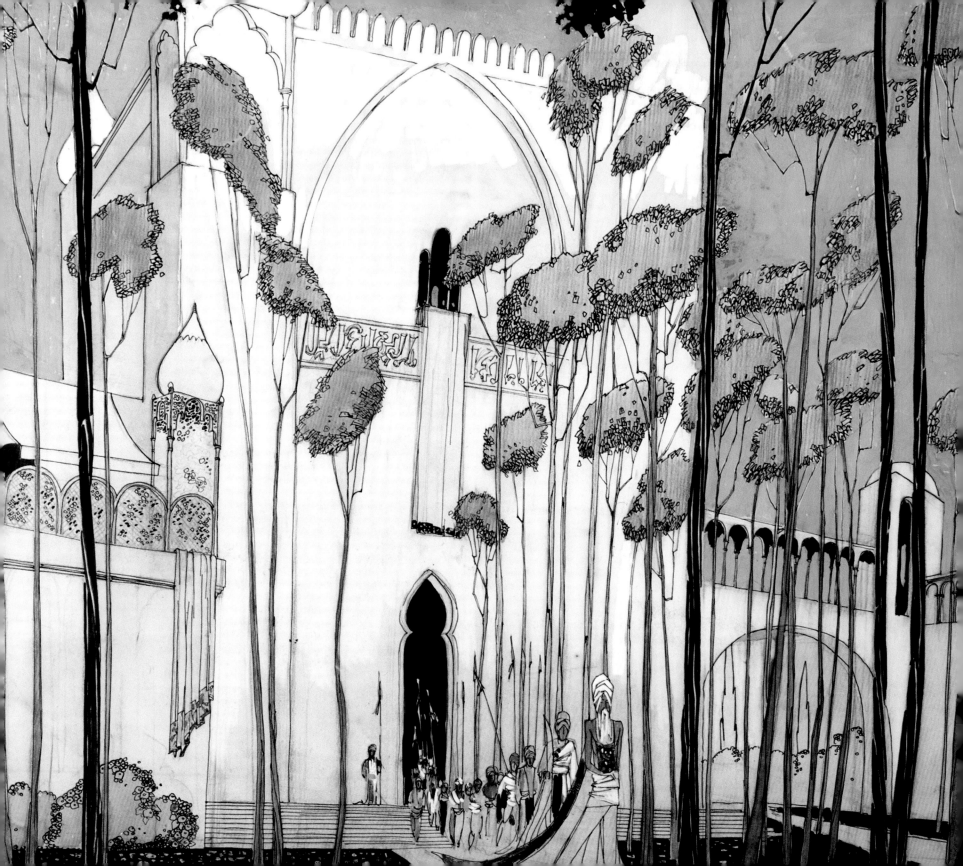

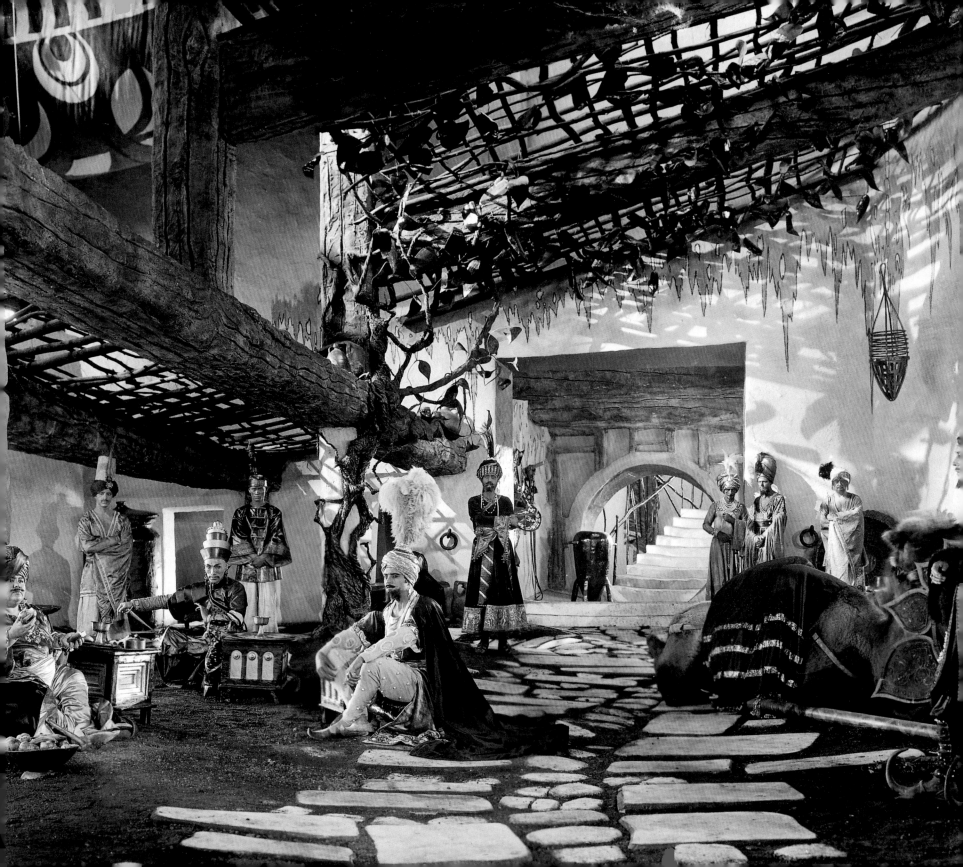

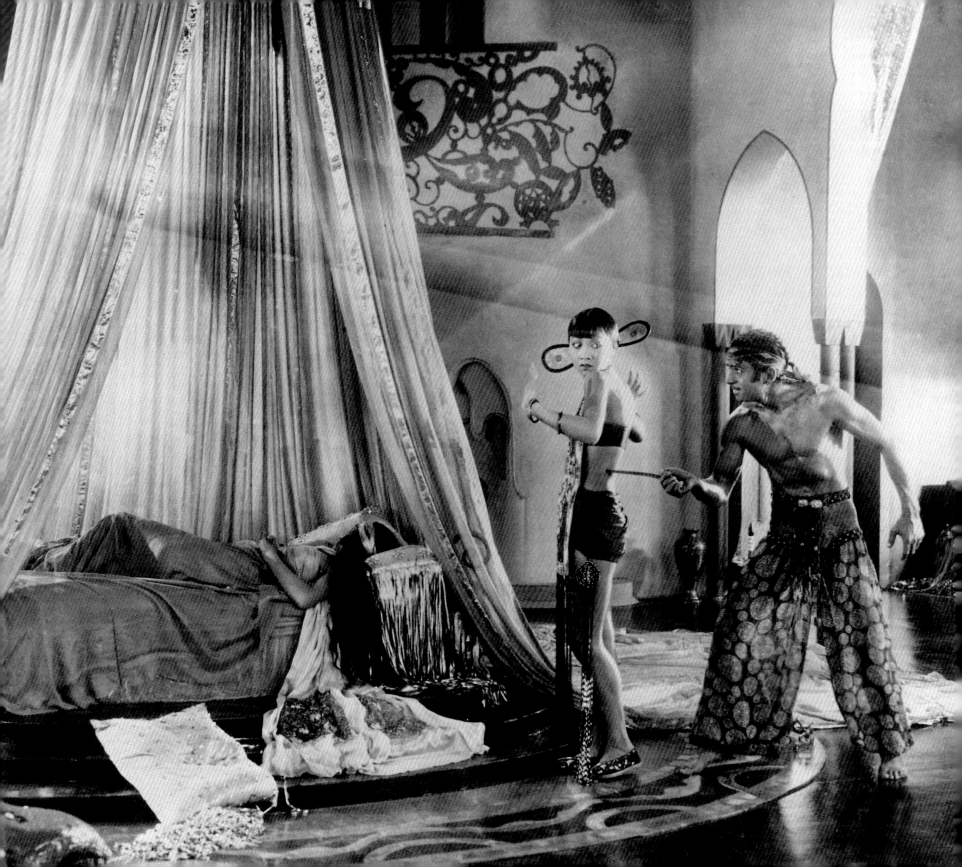

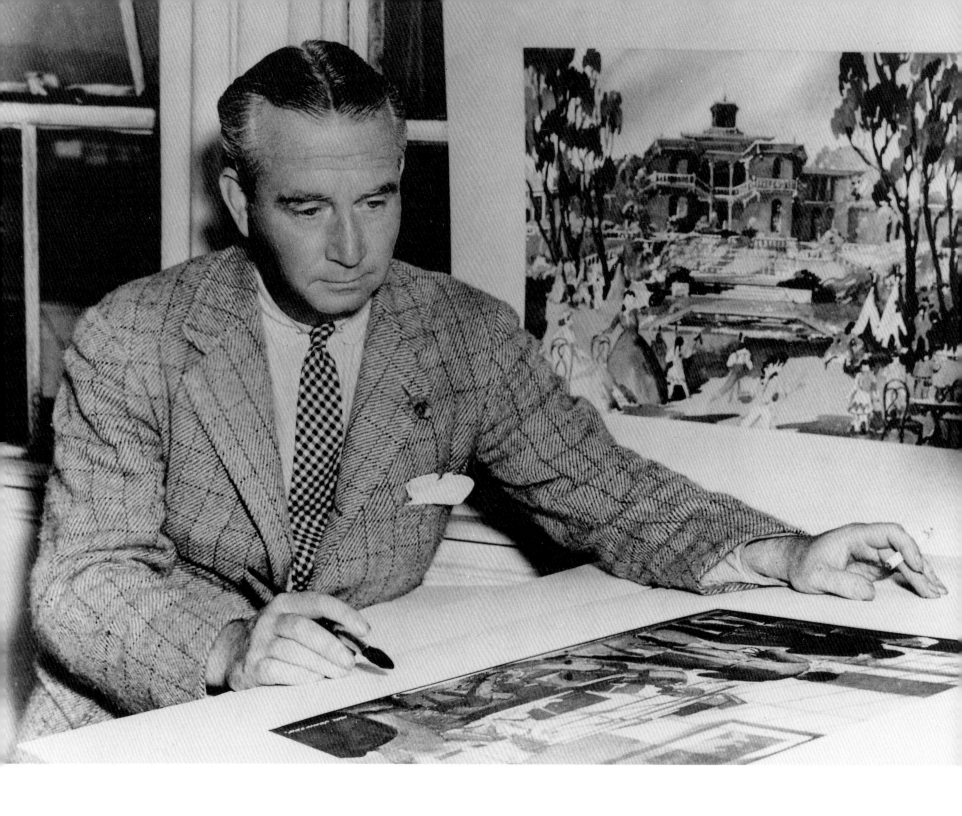

worked as a freelance designer—a role that mirrors to-day's production designer. He made films with a number of Hollywood luminaries, including D. W. Griffith, Samuel Goldwyn, Lionel Barrymore, Alexander Korda, and Alfred Hitchcock, but none would top his legendary work with David O. Selznick on *Gone with the Wind*.

Menzies mapped out a movie through complex storyboards. The beautiful and richly detailed watercolor sketches for the Selznick production numbered over two thousand. As the shoot became plagued with a revolving door of directors and the occasional turmoil, these detailed visual designs greatly contributed to the success of the much-celebrated film. Beyond his contributions as art director, historians note that he also contributed to the film

by choreographing and directing several pivotal scenes— Scarlett in the Atlanta hospital, her return to Tara—and is even credited with adding the ending of her famed exclamation to part one: "As God is my witness, I will never go hungry again!"

As a result of his efforts, Menzies won an Honorary Award at the 1940 Academy Awards for "outstanding achievement in the use of color for the enhancement of dramatic mood in the production of *Gone with the Wind*." Selznick bestowed on him another honor, the first credit to ever be held by an art director: "This Production Designed by . . ." The title of production designer stuck, elevating these talented artists within the increasingly stratified Hollywood hierarchy.

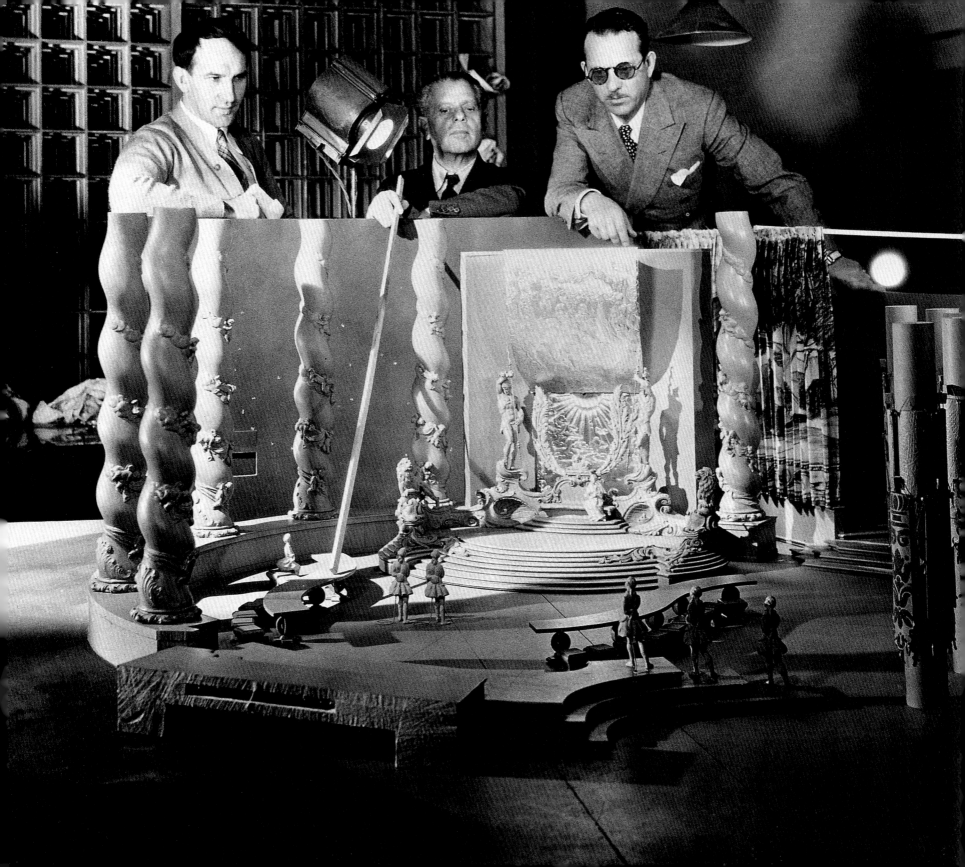

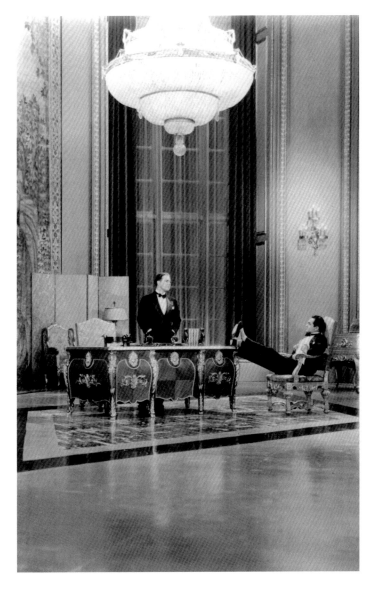

uncredited), but he made his mark in the 1930s. Grot's work on the Edward G. Robinson classic *Little Caesar* defined a new genre—the gangster film. In using contrasting shadows, Grot created the gritty realism of the underworld and set the prototype for future generations of gangster films. He also set the tone for many of the Warner Bros. films during his reign, using heavy architectural settings, low arches, somber colors, and angular shadows to create a mood. Grot excelled at perspective drawings, and made charcoal sketches in the correct perspective for filming. It is said that he gave Warner Bros. its distinctive atmospheric style that presaged film noir.

Born in Poland, Grot studied art, interior design, and illustration in Germany before emigrating to America. His lucky break came when producer Sigmund Lubin spotted Grot's oil paintings in the window of a Philadelphia department store and hired him to do set design. He eventually moved to the West Coast and designed films for Cecil B. De-Mille and Mary Pickford, before joining Warner Bros.

Grot worked with prominent directors, such as Michael Curtiz and Mervyn LeRoy, and his work ethic was said to be a dream; his knack for visualizing every scene helped to speed up shooting and thus save the studios money. His visual formula took film noir to another level, especially with his work on *Mildred Pierce*. Grot's use of deep, dark shadows at a Malibu beach house and during the ominous opening scene of Mildred at the ocean pier were pulled directly from his original 11" × 14" charcoal drawings.

Grot was nominated for an Academy Award for several films: *Svengali* (1930), *The Life of Emile Zola* (1937), and *The Sea Hawk* (1940), and won a special Academy Award in 1940 for his invention of a ripple-and-wave illusion machine, which created weather effects on water.

ANTON GROT AND WARNER BROS.

Menzies's fellow colleague and former collaborator on *The Thief of Bagdad*, Anton Grot (1884–1974), made a name for himself within the studio system at Warner Bros. His career began in the silent-film era (he also worked on *Robin Hood*

OPPOSITE PAGE: *A Midsummer Night's Dream* (1935) • Art director Anton Grot *(right)* with directors Max Reinhardt *(center)* and William Dieterle *(left)*

LEFT: *Little Caesar* (1931) • Anton Grot, art director

CEDRIC GIBBONS AND THE MGM STYLE

Cedric Gibbons (1893–1960), one of the most influential art directors in history, reigned at MGM as the supervising art director for a record thirty-two years, from 1924 to 1956. His trademark look and tone are as synonymous with MGM as its golden lion emblem.

Gibbons's dictatorial reign at the studio was legendary—he even had the foresight to insert a clause in his contract that his name should be listed as art director on every MGM film made in the United States. Cedric Gibbons was thereby credited with everything related to art direction at MGM—more than fifteen hundred films in his thirty-two years, most of which he did not design but they were made under his supervision in the art department. In spite of his stature, he did not care for the title "art director," as he thought of his staff as the "architectural and engineering department."

Born in Brooklyn, Gibbons was greatly influenced by his father, an Irish architect. He learned to draw and design at the Art Students League of New York and eventually landed an apprenticeship with Hugo Ballin, one of the industry's first art directors. By the age of twenty-five, he headed up the art department of Goldwyn Studios, which merged with Metro to form the powerhouse Metro-Goldwyn-Mayer, or MGM.

From 1924 until his retirement in 1956, Gibbons oversaw an art department of nearly two hundred people—the art

RIGHT: Art director Cedric Gibbons favored all-white décor, as seen in *The Night Is Young* (1936)

OPPOSITE PAGE: Cedric Gibbons at home with his wife, actress Dolores Del Rio. The Gibbons home was designed much like his highly stylized sets

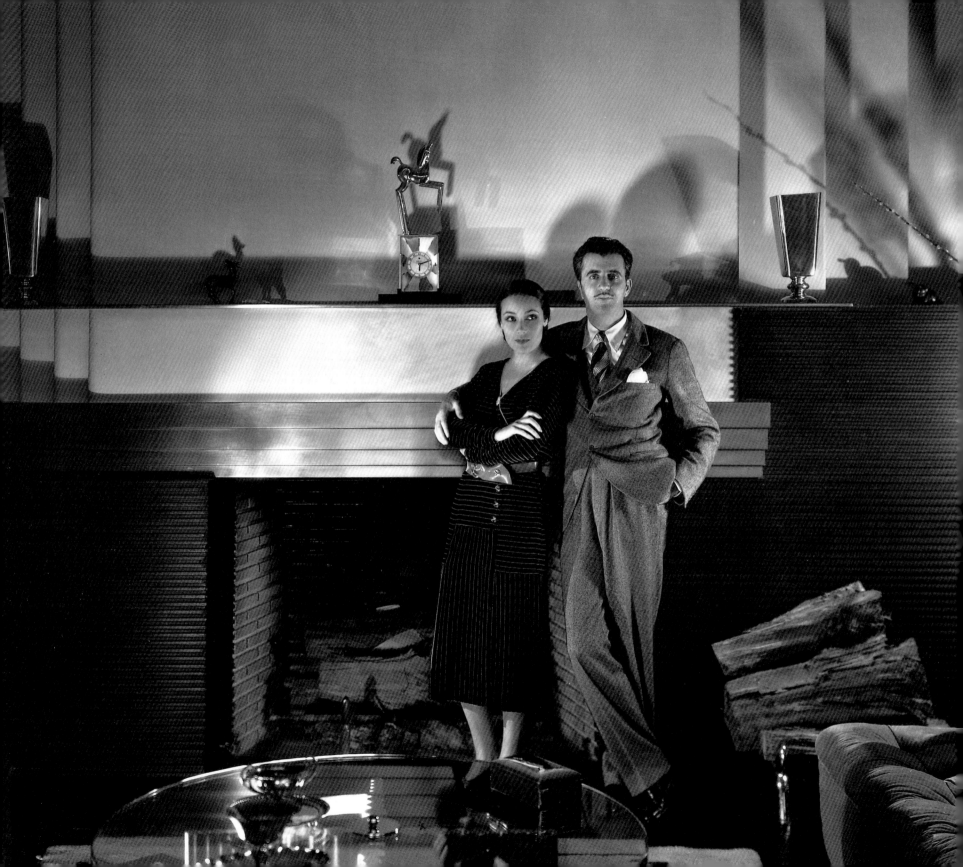

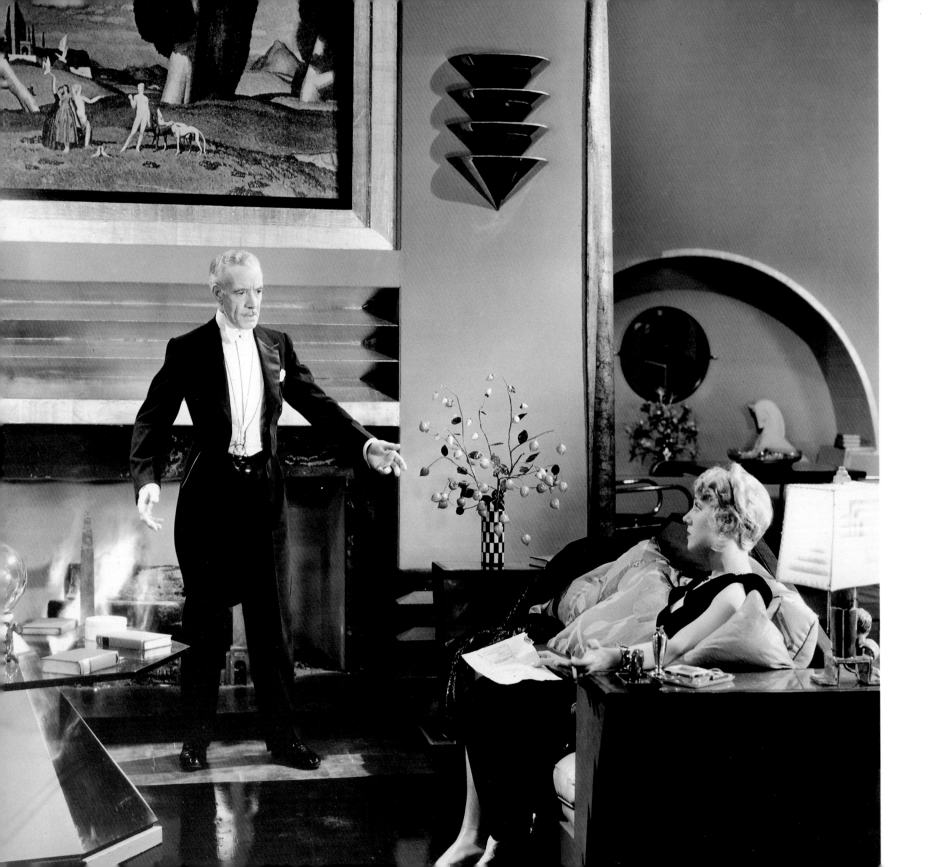

directors, draftsmen, and illustrators who did all the design work, as well as a multitude of set dressers and the entire special-effects department. With the luxury of complete autonomy, he was one of the most important executives on the studio lot, and his penchant for sleek and elegant interiors was the hallmark of almost every MGM film.

Gibbons was drawn to Art Deco and Modernism after visiting the 1925 Exposition Internationale des Arts Décoratifs et Industriels Modernes in Paris. He brought the styles back to Hollywood—the clean-ordered lines, the use of arches and moldings, the sleek furnishings—and these aesthetic trademarks set the scene for the classic MGM films that would define the era.

A suave, movie star–like character, Gibbons was married to the actress Dolores Del Rio. The pair was considered one of the Hollywood glamour couples of the Golden Age. Gibbons and MGM architect Douglas Honnold designed the couple's Santa Monica home, which was regarded as one of the ultimate Hollywood residences. Reminiscent of his movie sets, the house was designed with Streamline Moderne period décor, complete with all the latest technology. Influenced by architect Frank Lloyd Wright's use of open-floor planning, he employed indirect lighting to highlight the luxurious interiors.

Even Gibbons's white Duesenberg reflected his elite status, rivaling that of the biggest movie stars of the period. He and Del Rio lived and loved the Hollywood life and parties, and their social outings were chronicled in the press. Gibbons habitually dressed the part, arriving every day to work in a gray homburg with matching gray gloves.

The lasting influences of a "Gibbons set" are numerous. Designs for *Born to Dance* and *Rosalie* were said, by the critic Alistair Cooke, to have inspired motion picture theater architecture in the late thirties through the fifties. Gibbons succeeded the Russian-born designer Erté (best known for his Art Deco stage designs) and ushered MGM into a new era of modern architectural décor. His penchant for geometric shapes, high gloss, and refined settings can be seen in such films as *Our Dancing Daughters, The Kiss, The Wonder of Women,* and *Our Blushing Brides.*

Perhaps his most lasting accomplishment was the design of the Oscar statue. As a board member of the Academy Awards of Motion Picture Arts and Sciences, in 1929 he was tapped to create an elegant symbol for the newly launched awards program. Ironically, he was nominated thirty-nine times for the statue, winning eleven (which, no doubt, figured prominently on his streamlined fireplace mantel), including three for such classics as *The Wizard of Oz, An American in Paris,* and *Julius Caesar* (1953).

VAN NEST POLGLASE AND THE RKO STYLE

At the heart of every Fred Astaire and Ginger Rogers musical lies the handiwork of Van Nest Polglase (1898–1968), supervising art director at RKO. From *Top Hat*'s Venice Canal to *Swing Time*'s Silver Sandal, the larger-than-life sets with their massive space, elegant white furnishings, and the interplay of black and white became known as the "Big White Set." Together, Polglase and Cedric Gibbons made the "Big White Set" a hallmark of the era.

Born in Brooklyn, Van Nest Polglase studied architecture and interior design in New York before embarking on a career in film design at Famous Players–Lasky and at Paramount's film studio in Queens. In the late 1920s, he traveled west to Hollywood and spent several years under the Gibbons regime at MGM before Selznick brought him over to RKO in 1932. Together with art director Carroll Clark, Polglase helped RKO's bottom line, a task especially difficult as the major studios were struggling to stay afloat.

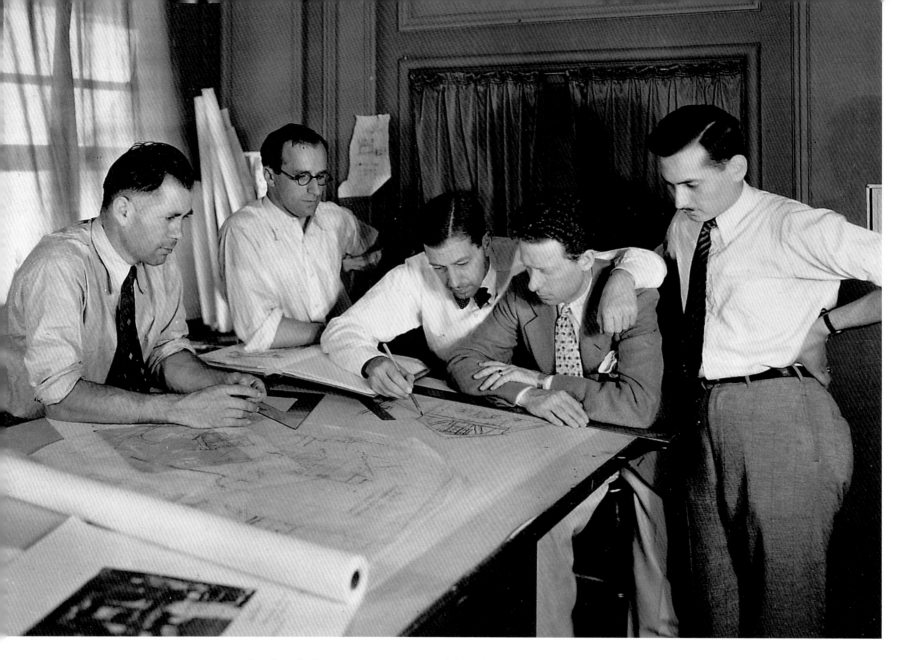

ABOVE: Van Nest Polglase with his team of art directors at RKO

OPPOSITE PAGE: *Top Hat* (1935) • Carroll Clark, art director; Van Nest Polglase, supervising art director

During his decade-long tenure at RKO, Polglase brought glamour to the beauty-starved audiences of the Depression. His work was legendary for its mixture of designs, including Art Deco, Neoclassical, and Streamline Moderne. His escapist vision can be seen in such varied films as *The Hunchback of Notre Dame* (1939), *Gunga Din,* and *My Favorite Wife.*

While his name quite controversially appeared in *Citizen Kane* credits (in a supervisory capacity), *Citizen Kane* was principally designed by RKO associate art director Perry Ferguson. The film was a departure from RKO's larger-than-life musicals, as Kane's Xanadu marks the beginning of film noir and sets designed for deep-focus photography.

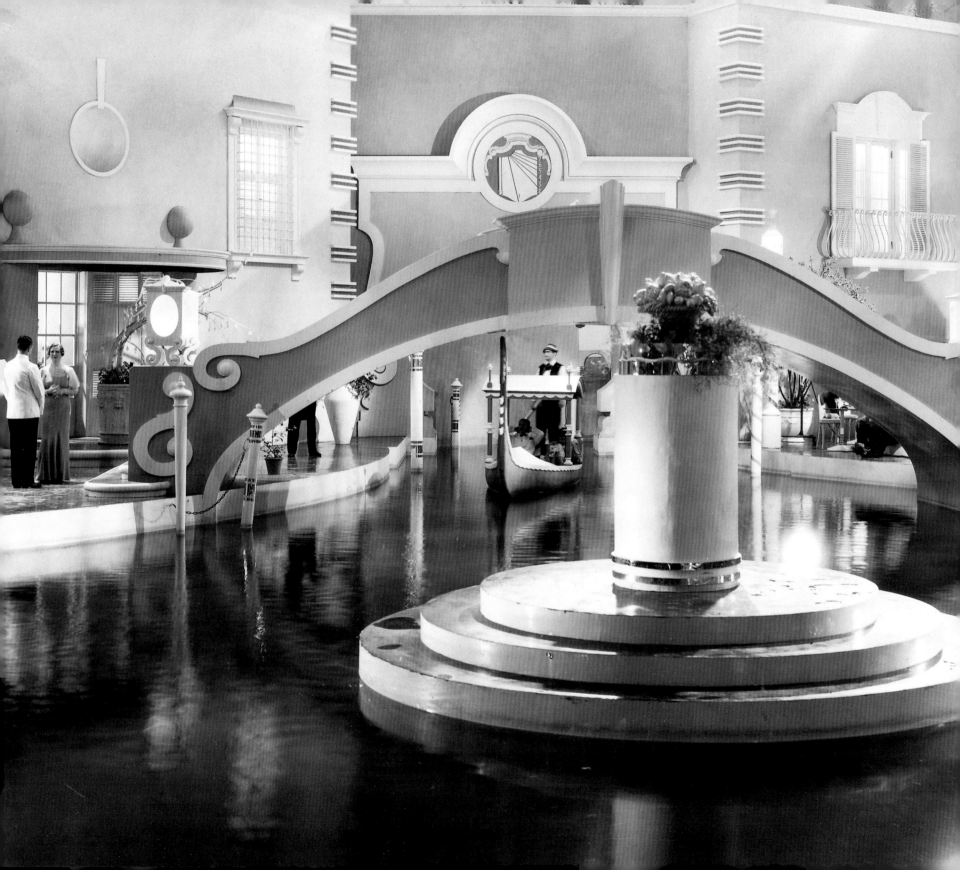

HANS DREIER AND THE PARAMOUNT GLOW

In his book *Hollywood in the Thirties*, film historian John Baxter summed it up best: "If MGM films had polish, Paramount films had a glow." The man responsible was German-born Hans Dreier (1885–1966), supervising art director at Paramount for twenty-seven years.

Dreier studied architecture in Munich and was eventually lured to films by fellow German film director Ernst Lubitsch as part of the first wave of German artists who fled to Hollywood in the twenties. Dreier joined Paramount in 1923 and remained there until his retirement in 1950. Known for his subtle designs and evocative atmosphere, the affable designer was responsible for hiring and nurturing an entire generation of future production designers and

art directors. Known as "Hans Dreier College," his art department launched the careers of such designers as Henry Bumstead, Robert Clatworthy, Richard Day, Boris Leven, and Robert Boyle. Dreier mentored young designers, teaching them the importance of the script and its connection to design. "Hans used to say, a good set is like Swiss cheese," said Boyle. "It's full of holes. A good set indicates a world behind it is not a closed area and allows sight or sound and what goes [on] inside or outside."

Dreier was considered the master of chiaroscuro—the use of contrasting shadows to create a mood—and his career was one of extremes. His work ranged from heavily shadowed films like *The Scarlet Empress* to the shiny, opulent *Design for Living*. Two of Dreier's later films would prove to be his most important—*Sunset Boulevard* and *A Place in the Sun*. Norma Desmond's mansion of yesteryear won Dreier and John Meehan the Academy Award for Art Direction. Dreier's remarkable career garnered him seventeen Academy Award nominations.

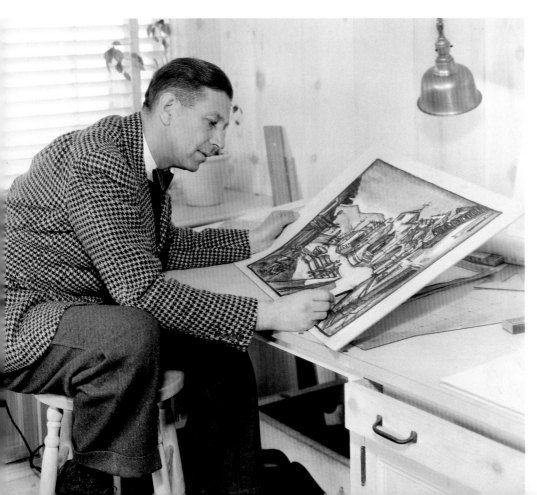

BELOW: Hans Dreier, at work on a sketch for *The Devil Is a Woman* (1935)

OPPOSITE PAGE: *Modern Times* (1936) • Charles D. Hall, art director

CHARLES D. HALL AND UNIVERSAL GOTHIC

Born in England, Charles "Danny" Hall (1888–1970) began his career in the theater as a stage designer. Danny and his brother Archer headed to Hollywood to embark on careers in film design. Finding a home at Universal, Archer became head of construction while Danny was named principal art director. Danny Hall's tenure marked a pivotal moment for Universal, his groundbreaking work breathed life into a new genre in filmmaking—horror. Dr. Frankenstein's laboratory in *Frankenstein* (1931), the English village in *The Invisible Man* (1933), the Art Deco interiors of *The Black Cat*, and Transylvania in *Dracula* (1931) all grew out of Hall's imagination. His films, arguably the best of

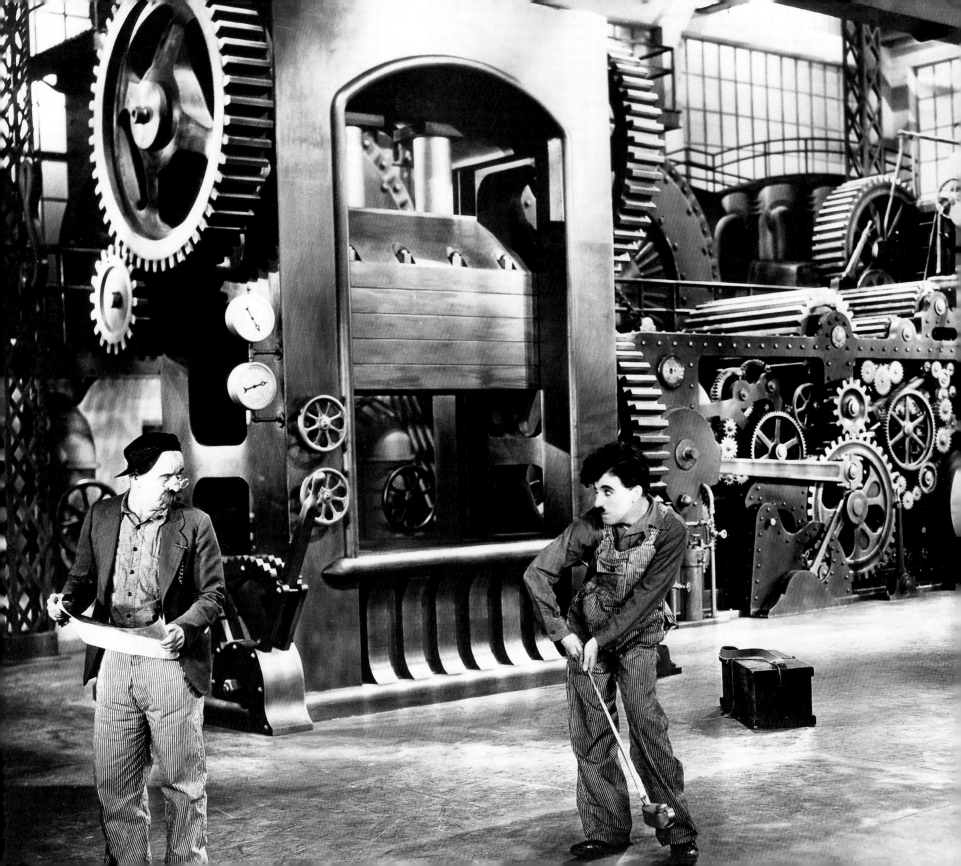

the budding genre, would influence filmmakers and haunt moviegoers for decades to come.

Hall's memorable designs are also associated with the beloved film icon Charlie Chaplin. His teetering cabin in the Klondike for *The Gold Rush*, the modern city in *City Lights*, and the factory life in *Modern Times* are all unforgettable moments of Hall's design. Hall went on to design the Academy Award–winning film *All Quiet on the Western Front*. In a departure from low-budget Gothic sets, Hall created an entire German town—complete with four blocks of houses, a cathedral, and a town hall, as well as trenches that played host to the dramatic battle scenes. Hall, notably, also worked on the elaborate twenty-five-foot-high cathedral and accompanying sets for Lon Chaney's *The Hunchback of Notre Dame* (1923).

As the Hollywood landscape changed, Hall moved to Hal Roach Studios and designed the Laurel and Hardy comedies along with *One Million B.C.* (1940). He continued to design Broadway shows and even found the time to manage—and sometimes play for—the English-style soccer team he founded.

Hall was considered the backbone of Hollywood studio design. Patrick Downing and John Hambley note in their book *The Art of Hollywood* that, unlike many of his ambitious colleagues, Hall "had no pretensions to power or glory, but simply turned in a thoughtful and professional performance for an enormously wide range of film and directors over thirty years."

LYLE R. WHEELER AT TWENTIETH CENTURY FOX

University of Southern California graduate Lyle R. Wheeler (1905–1990) began his career as an industrial designer and magazine illustrator before entering the film industry. His big break came when David O. Selznick hired him to work as a set designer. Wheeler became known as the man who could create stunning interiors on a budget.

Wheeler's ability to stick to a tight bottom line came in handy as he embarked on the biggest film of his career—Selznick's *Gone with the Wind*. From the burning of Atlanta to the building of Tara, his collaboration with Menzies earned him his first Academy Award. Wheeler remained with Selznick until the early forties, when he succeeded Richard Day as the supervising art director of Twentieth Century Fox.

His distinctive designs for Fox included *Gentlemen's Agreement*, *All About Eve*, and *An Affair to Remember*, all of which were known for their superbly elegant city interiors. He also won Academy Awards for *Anna and the King of Siam*, *The Robe*, and *The Diary of Anne Frank*. His impressive career spanned forty years, three hundred and fifty films, and twenty-nine Academy Award nominations (including five wins).

THESE TALENTED MEN of the Golden Age studio system were the true pioneers of art direction and formed the foundation for future generations of production designers who are profiled in the upcoming chapters. As the hierarchy-based studio system gave way to a new age of independent directors and production companies, the role of supervising art director was replaced by the independent production designer. No longer tied to the confines of a single studio art department, film designers from the sixties to the present worked, and continue to work, in a freelance fashion, often collaborating with a favorite director and/or specializing in a particular genre.

While life in Hollywood is certainly different from the Golden Age, today's designers owe yesterday's pioneering art directors a huge debt of gratitude.

THE PRODUCTION DESIGNER

Designing a movie is a little like painting a landscape in a hurricane.

—*Masters of Production: The Hidden Art of Hollywood*

While much has changed in the industry since the early title of art director—the person acting as head design chief—gave way to the more modern term *production designer,* the responsibilities are largely the same. Where yesterday's art director led the charge, today's production designer oversees a staff of talented designers and decorators whose cumulative responsibility is to assist and realize the overall look of the film.

Under the new hierarchy, the art director reports to the production designer. The art director oversees the basic functions of the art department—which can include everything from the preparation of blueprints, models, and storyboards to scheduling and managing the busy department. Also reporting to the production designer are set decorators, the people who oversee set dressers and support personnel (upholsterers, drapery workrooms, etc.); set designers, whose duties can include design and preparation of architectural drawings and elevations; as well as the various support departments of construction, property, location manager, and scenic artists.

While tasked with the same overall goal—coordinating a cohesive design—yesterday's art director might not recognize the tasks of today's production designer.

Today, technological advances and special effects have fundamentally changed the way that films are made,

OPPOSITE PAGE: An elaborate banquet hall design for *The Scarlet Empress* (1934) • Hans Dreier, art director

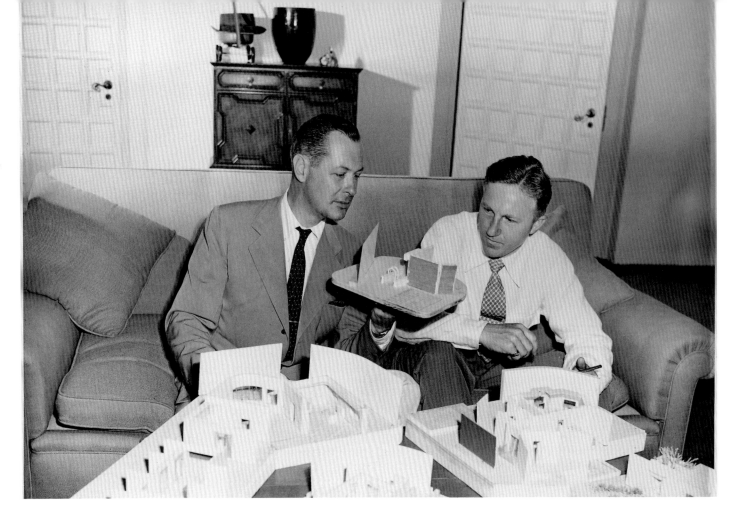

and the scenic painter and his backdrop have been upstaged by the computer and an army of technologically savvy designers. While contemporary designers face more challenges than their predecessors, their task of creating the complete overall look of a film remains the same.

The role of the modern production designer is one made up of many layers. As one of the most important contributors to a film, a production designer must be able to interpret and visualize the script—as all great filmmaking begins with the story. He or she looks for metaphors, themes, settings that exist on the page, or between the lines, and they must internalize the important details that help to establish each unique character. By considering such aspects as color,

texture, scale, decoration, and architecture, the production designer can build a visual narrative to support the story.

Quite often these techniques are invisible, but their combined effect is to create a believable visual space for the audience. "We create that world of impossibility," says production designer Rick Carter, who is best known for his groundbreaking work on *Jurassic Park, Forrest Gump,* and *Avatar.* "We create everything that audiences don't think about when they watch a movie. Our job is to create the spirit of the place."

Along with the director and cinematographer, the production designer forms what is known in the film industry as "the trinity." A film cannot successfully come to be with

one corner of the trinity missing. These three key personnel meet during the crucial preproduction phase and together establish the director's vision, map out a plan for the filming, and decide upon the overarching style for the film. As the cinematographer and production designer take their initial cues from the director, their ability to visually translate the director's ideas, filmmaking philosophy, and general style is crucial. A production designer's collaboration with the cinematographer will determine the film's general tone and atmosphere through the use of color schemes and lighting. Together they will also scout various settings to determine whether a film should be shot on a soundstage and/or on location. From there, design plans are made, budgets determined, and an art department assembled.

A successful production designer must be able to act diplomatically as a liaison between the director, producer, and the supporting design crew. The production designer serves as an executive of sorts, overseeing an art department that consists of art directors, draftspersons, illustrators, set decorators, prop departments, and many other skilled craftspersons. As computer-generated imagery has become an industry standard, the production designer now has the added job of once again overseeing the visual effects department as well.

Beyond effectively managing a team and working with a director and cinematographer, fundamentally, a production designer must be both inquisitive and resourceful. He or she must draw from a huge working knowledge of interior design, architecture, art, history, theater, and other creative endeavors. "Designing a movie is like putting together a collage," explains production designer Wynn Thomas, who lists *A Beautiful Mind, Jungle Fever,* and *Cinderella Man* among his many credits. "One is taking bits and pieces from many different sources and influences and trying to make it work as one cohesive whole."

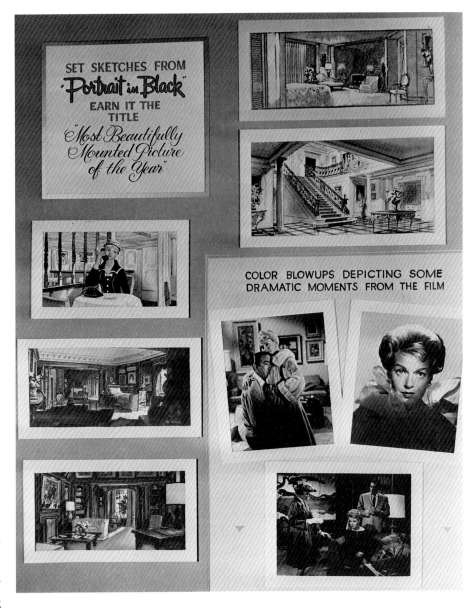

Most important, the production designer must have the innate ability to dream, as the process of creating illusion and reality is truly an art form like no other. Or, to quote production designer Peter Wooley, "A production designer looks at nothing and sees everything."

ABOVE: Set sketches from *Portrait in Black* (1960) • Richard H. Riedel, art director

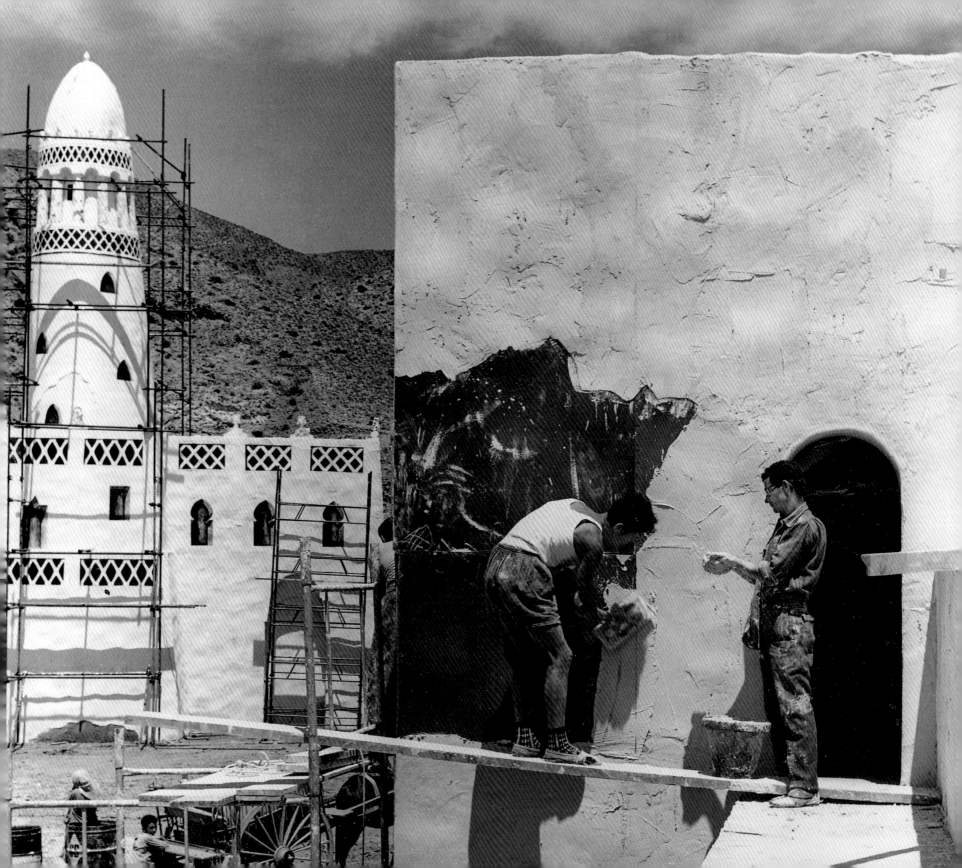

THE SET DECORATOR

I am sure you've seen barren sets on empty soundstages come to life under the set decorator's touch. Compare it to the architect who has completed a house, but it is the interior decorator who breathes life into the rooms.

—Henry Grace, longtime set decorator at MGM

Often overlooked by film historians and overshadowed by the design supervisors, the set decorator is an essential part of the production design of a film. The physical objects of a set create characters, scenes, and storylines, just as fundamentally as do actors, costumes, and spoken lines. As far back as 1916, the in-house studio magazine *Paramount Progress* noted: "Not so long ago in the history of photodrama, a rich man's parlor was changed into a millionaire's drawing room merely by the addition of a few more vases, another rug, or an extra large oil painting. In fact, when a director called for a rich man's home, all the bric-a-brac, rugs and painting and junk in the property room would be brought forth and placed in that particular set. The more that could be crowded into the set, the wealthier the man."

While today's set decorators are more discriminating in their choices, they are tasked with the job of establishing a character's personality through the use of interior decoration. The job is more than just the act of choosing and placing objects in an empty room: they provide a true narrative backstory by bringing environments to life through detail and decoration. A sparse, contemporary interior devoid of color and accessories can

OPPOSITE PAGE: Set construction on *Lawrence of Arabia* (1962) • John Box, production designer

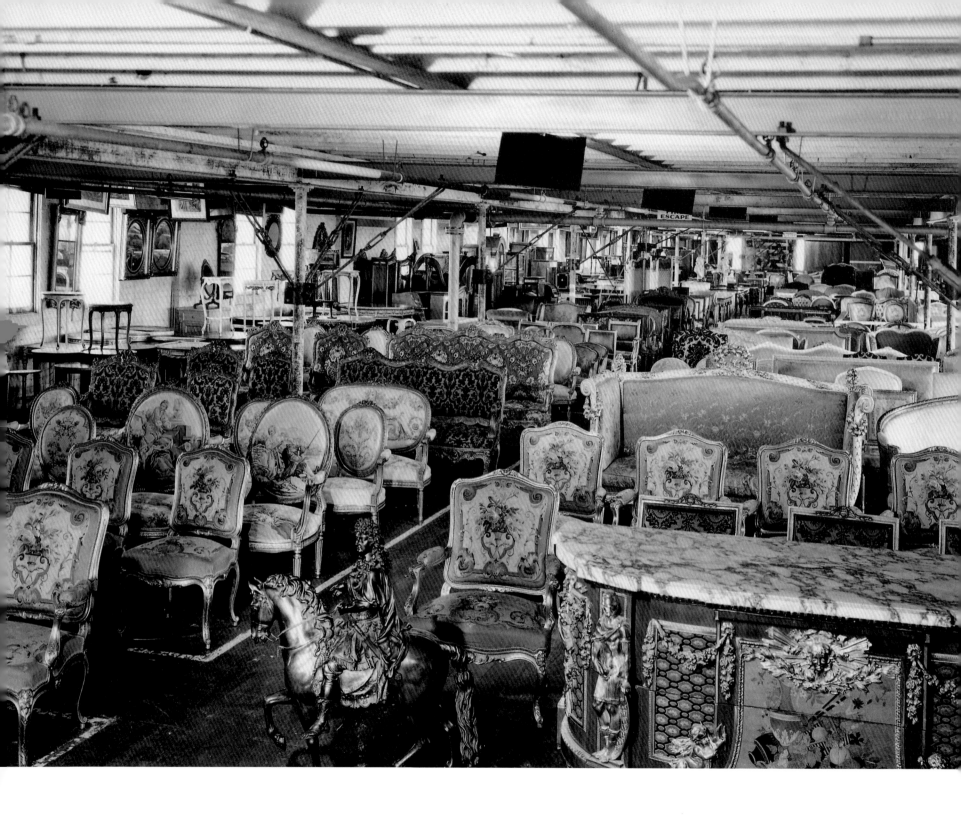

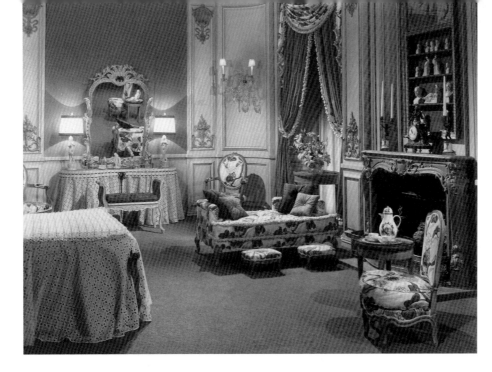

express the cold persona of the owner, while a cozy, well-lived-in room of accumulated objects can project a feeling of warmth, family, and tradition. "Like the production designer, we must be storytellers and come from a place of passion about the character," explains Rosemary Brandenburg, an acclaimed decorator on *Cast Away, What Women Want,* and the 2001 remake of the classic *Planet of the Apes.* "It's a skill not taught in design schools . . . this comes out of the tradition of the theater. We need to understand the entire mind-set of the period and the surroundings [we are decorating]. . . . If you want to become a set decorator, you really have to want to dress a police station, as so few sets are about gorgeous, fabulous interiors."

Set decorators, in close collaboration with the production designer, are responsible for acquiring every detail of decoration, and for every object that appears on set—the furniture, accessories, drapery, and lighting. They shop rental prop houses, flea markets, and stores, and work with a variety of specialists—from furniture and drapery-makers to upholsterers—all on a tightly controlled budget.

The pressures are great and the work is fast-paced, as it is typical to work simultaneously on a number of sets that have to be prepped, shot, and dismantled very quickly.

One of the earliest set decorators was Edwin B. Willis (1893–1963). A longtime set designer and decorator at MGM, he dressed an astonishing 640 productions. His varied body of work ranges from the 1925 version of *Ben-Hur* to *Adam's Rib, Philadelphia Story,* and *Brigadoon.* He was nominated for thirty-two Academy Awards, and won on eight occasions.

Set decorators Thomas Little, Paul S. Fox, and Walter M. Scott also greatly influenced a variety of genres. Little helped give *Top Hat* its shine and opulence, and lent his hand to such films as *The Day the Earth Stood Still* (1951) and *All About Eve.* Production designer John DeCuir teamed up with Paul S. Fox on *South Pacific* and *The King and I,* while Walter M. Scott assisted DeCuir on the incredibly labor-intensive sets for *Cleopatra.* As with any successful collaboration, the sum is the total of its parts and the set decorator plays a vital role.

PART
TWO

A CENTURY OF DESIGN

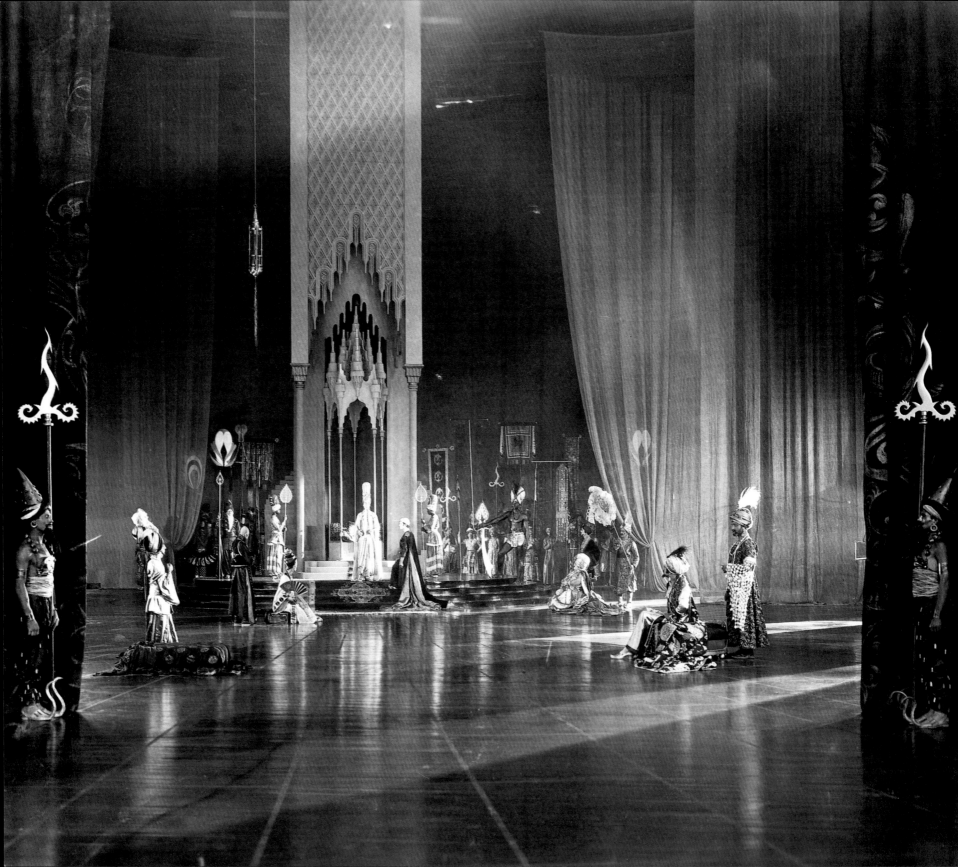

THE SILENT ERA
AND THE TWENTIES

The Birth of the Epic

The twenties marked a true growing period in film. Not only did the industry progress in style and filming technique, it grew as a business. Silent films dominated the early decade, yet eventually gave way to the "talkies" and extravaganza adventures, pantomime comedies, horror, and gangster and western films. The twenties also marked the birth of the studio system as an "entertainment factory"—films were literally manufactured as products on an assembly line—and that was the decade in which the five major studios (RKO, Warner Bros., Fox, Famous Players–Lasky, and Metro-Goldwyn-Mayer) came into being. The twenties also ushered in "picture houses," mammoth and elaborate movie palaces that often competed with the films themselves for attention.

While today's audiences are dazzled by CGI effects, 3D, IMAX, and remarkably realistic acting performances, some of the most important films of the twentieth century were its first—the sweeping historical Hollywood epics of the silent era. With its roots in vaudeville and the coin-operated "peep shows" of the 1910s and 1920s, the American film has evolved a great deal in a very short period of time.

OPPOSITE PAGE:
The Thief of Bagdad (1924) • William Cameron Menzies, art director

D. W. GRIFFITH

Director D. W. Griffith's innovative 1915 film *The Birth of a Nation* forever changed the landscape of the American film. The film chronicled two American families during the Civil War and the Reconstruction, and included vivid scenes of Lincoln's assassination at the Ford Theatre and the birth and rise of the Ku Klux Klan. This now-classic film used brand-new techniques and refinements, such as the use of chiaroscuro, mise-en-scène, and montages to weave its story. *The Birth of a Nation* utilized natural outdoor landscapes—the Ford Theatre was shot without a ceiling in the California sunlight—as well as color tinting, and the practice of artistically turning hundreds of extras into thousands for the film's battle scenes—an economical process that would appear in hundreds of future films.

Griffith followed his initial success with a 1916 sequel: *Intolerance: Love's Struggle Throughout the Ages*. The film had all the makings of an epic—lavish, over-the-top sets placed up against panoramic backdrops, prolific period costumes, and a cast of thousands. Covering a span of 2,500 years, the theme of man's intolerance is explored through the scenes of the fall of Babylon, the crucifixion of Christ, and the St. Bartholomew's Day Massacre in 1572.

Towering over Sunset Boulevard, the mammoth sets of "Babylon" and its inner court were the film's centerpiece. At 150 feet long and 90 feet high, the "Towers of Babylon" were often seen swaying in the Californian winds. Designed by English theatrical designer Walter L. Hall, the sets were said to be influenced by the 1914 Italian film *Cabiria*, as they mimicked the large scale, imposing columns, and the film's magnificent elephant procession.

RIGHT AND OPPOSITE PAGE:
The Birth of a Nation (1915) • Frank Wortman, art director

FOLLOWING PAGES LEFT AND RIGHT:
Intolerance: Love's Struggle Throughout the Ages (1916) • D. W. Griffith, director and production designer; Walter L. Hall, art director

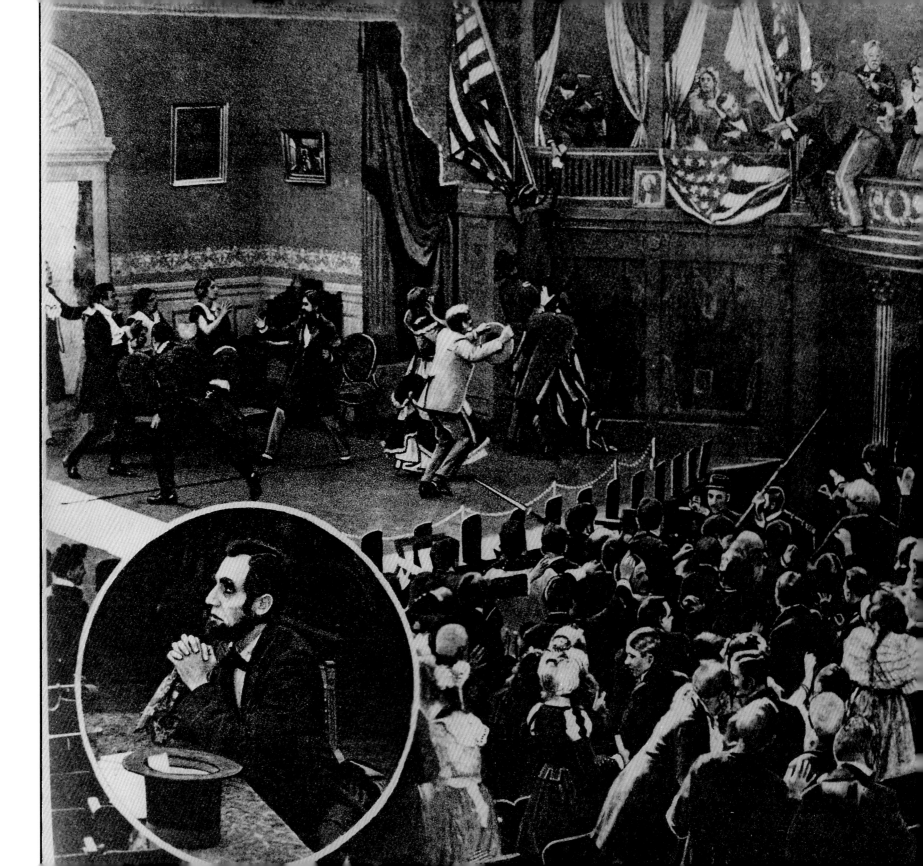

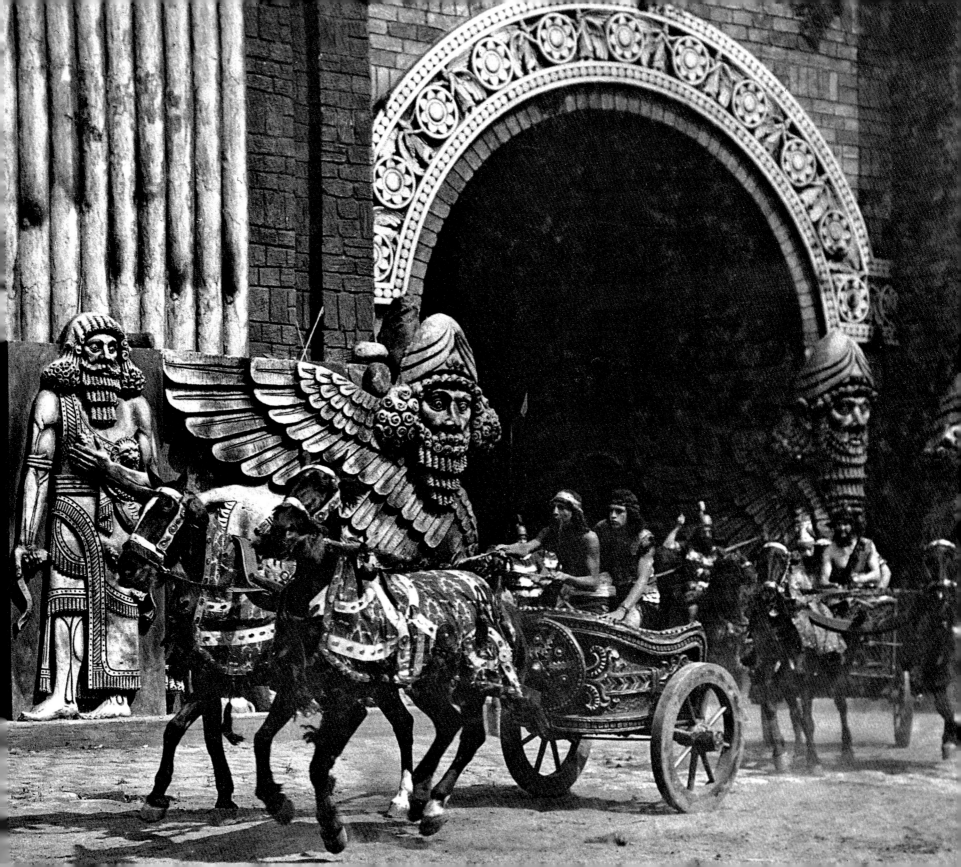

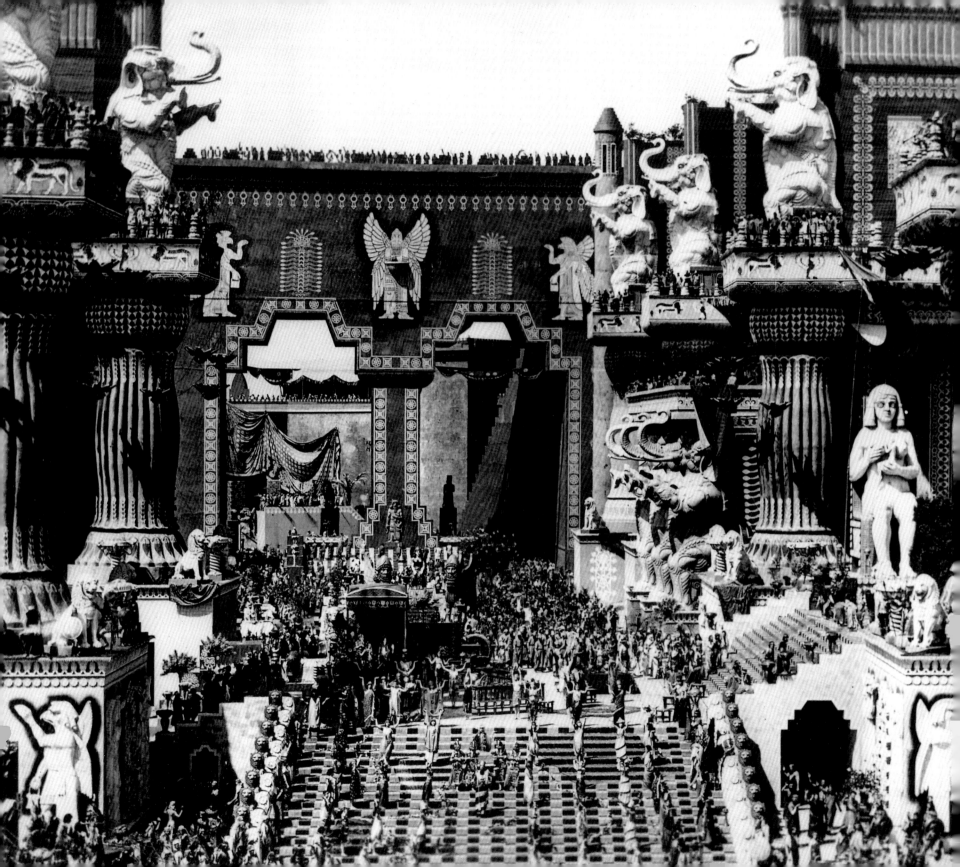

THE EARLY EPICS

The Thief of Bagdad

Despite the grandeur of the Babylonian sets of *Intolerance,* William Cameron Menzies's designs for *The Thief of Bagdad* (Douglas Fairbanks Productions/United Artists, 1924) mark the pinnacle of the silent-era epic. The story is a mélange of travel, fantasy, spectacle, and entertainment, and Douglas Fairbanks starred in the title role.

Fairbanks spent a massive sum on the production—$2 million—and the majority of the budget was used for the film's design. Built on six acres on North Formosa Street, the imposing city of "Bagdad" was massive in scale and size and involved designing a world completely steeped in fantasy. The sets were constructed with highly polished floors painted black, and specialized lighting techniques—including the use of gauze as a light diffuser—gave the film an ethereal quality. The buildings were also lit from below to give the look of a city floating in the clouds.

Menzies ultimately combined Moorish architecture with Art Deco and Art Nouveau when designing his dazzling

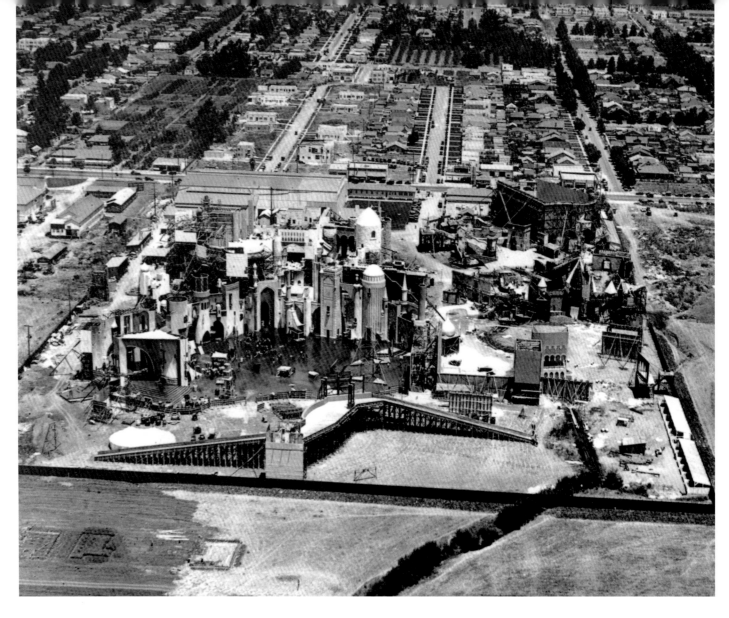

kingdom of fantasy. The use of decorative scroll ironwork (which would also appear in the contemporary surroundings of his later films *Rosita*, in 1923, and *Cobra*, in 1925), as well as the appearance of arches, beams, and stucco walls added to the Moorish feel.

Many of the innovative special effects that appeared in *The Thief of Bagdad* were groundbreaking for the period. The magic carpet was actually a three-quarter-inch-thick piece of steel rigged by sixteen piano wires and anchored to the top of a crane. The physically fit Fairbanks performed stunts with no doubles, while hanging suspended over three thousand extras. To complete the set for the undersea world of the "Realm of Glass," a family of artisans spent three months hand-blowing the required glass pieces. Other special effects of interest involved winged horses, giant spiders, and an invisibility cloak.

Ben-Hur

While Italian and Moorish influences were deeply ingrained in *Intolerance* and *The Thief of Bagdad,* the making of another 1920s epic proved the old adage that Rome was not built in a day. *Ben-Hur: A Tale of the Christ* (MGM, 1925) depicted a Rome of unbelievable scale and detail—complete with breathtaking chariot races in the colossal Circus Maximus, visually stunning battles at sea, and throngs of marching soldiers. Based on General Lew Wallace's novel, *Ben-Hur* told the beloved tale of the changing fortunes of a Jewish prince, Judah Ben-Hur, and his childhood friend and nemesis, Messala.

The film cost $4 million, an amazing twenty times the average budget of a typical MGM release. The soaring budget was no doubt the result of the spectacular chariot race—a scene that would go on to make motion picture history and set the stage for a host of future "gladiator-style" films. On the corner of Culver City's Venice and La Cienega boulevards, filmmakers built an arena that would dwarf anything seen in Rome. Forty cameras filmed the Saturday afternoon event, as such Hollywood royalty as Harold Lloyd, Mary Pickford, and Douglas Fairbanks joined hundreds of extras to watch the thrilling races.

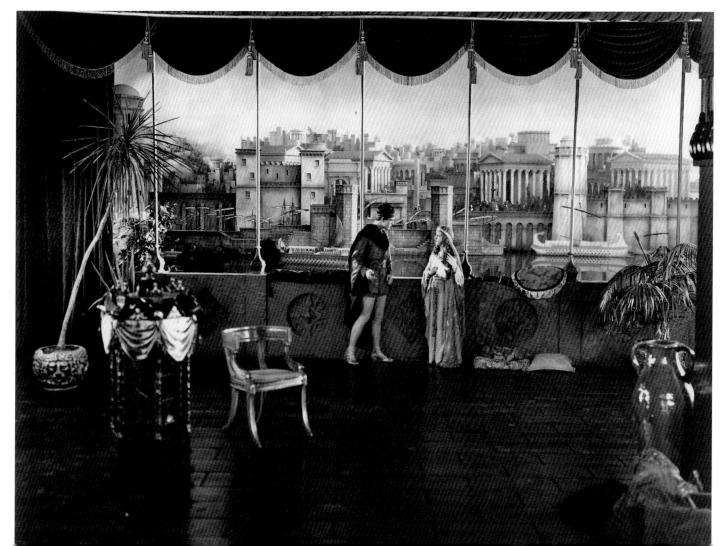

LEFT AND FOLLOWING PAGES: *Ben-Hur: A Tale of the Christ* (1925) • Cedric Gibbons, art director

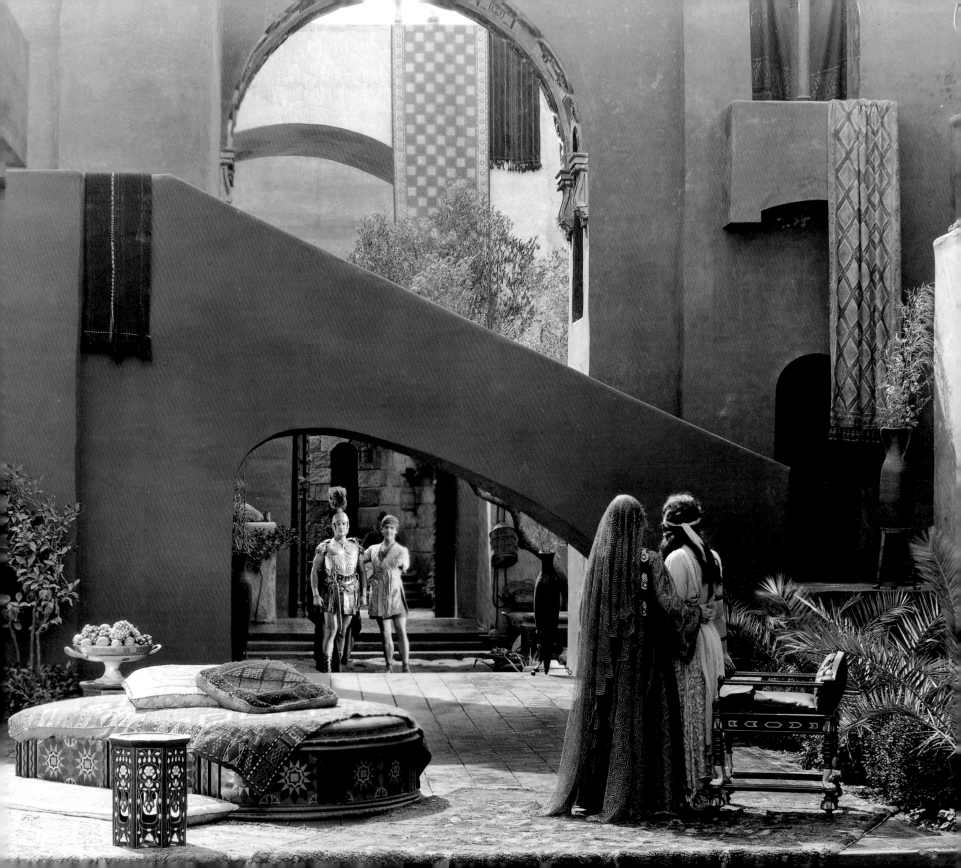

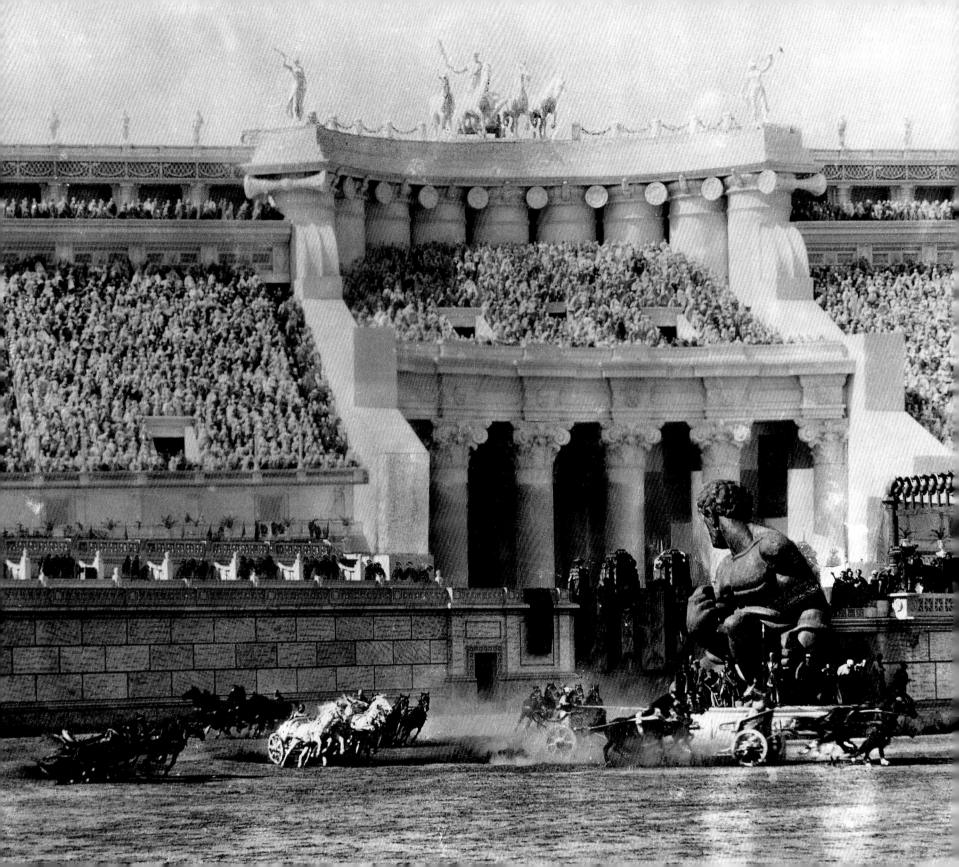

DESIGNING THE SILENT COMEDY

Two of the most important comedians of the century emerged during the twenties in the form of the Great Stone Face and the Little Tramp.

The twenties proved to be a great era for lighthearted comedy, yet these slapstick, bawdy films created a challenge for art direction as the fundamental comedic action was based around the sight gag. Supported by special effects and props, the sets on the comedies of the twenties had to sustain the physical actions of the characters—the built sets provided the comedic setup for the films' slapstick sequences.

Such is the case with the films of comedian Buster Keaton, aka "Great Stone Face." His silent-era classics included *The Navigator, The Cameraman,* and *Steamboat Bill Jr.* These comic masterpieces combined Keaton's talents at physical comedy with his love of trains, daredevil stunts, and death-defying cyclones. Keaton's innovative style and acrobatic prowess became the main focal point of his films.

Perhaps Keaton's greatest film was *The General,* which was based on the true story of a locomotive stolen during the Civil War. This highest-ranked film of the decade included groundbreaking scenes—including the destruction of a reproduction of an authentically detailed steam locomotive. This scene was recorded as one of the most expensive single-shots of the silent film era. Keaton, a stickler for detail, studied Mathew Brady Civil War photographs for inspiration.

Charlie Chaplin's classic film *The Gold Rush* was a comedy mixed with pathos. It followed the story of a lone prospector searching for gold in Alaska. Designed by Charles D. Hall, the film sets included the design of a Klondike town and a dance-hall interior, as well as the infamous cabin that teeters gingerly on the edge of a cliff. Shooting on a back lot in the town of Truckee, California, Hall used 100 barrels of flour and 285 tons of salt for the required Alaskan "snow."

The Gold Rush was a personal favorite of Chaplin, the Little Tramp, as it balanced his trademark pantomime with a certain tenderness and satire. Hall went on to collaborate with Chaplin as production designer on his later films: *The Circus, City Lights,* and *Modern Times.* For *City Lights,* Hall built a modern city on the Universal back lot, while *Modern Times* required the construction of a factory filled with huge pieces of machinery. The cogs and cylinders became the perfect foil for Chaplin's satirical antics.

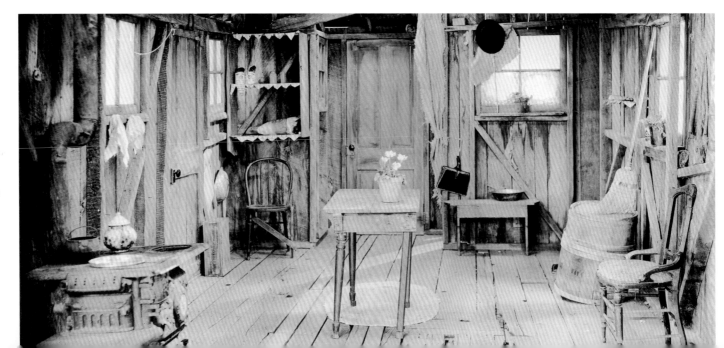

RIGHT: The "Klondike Cabin" set for *The Gold Rush* (1925) • Charles D. Hall, art director

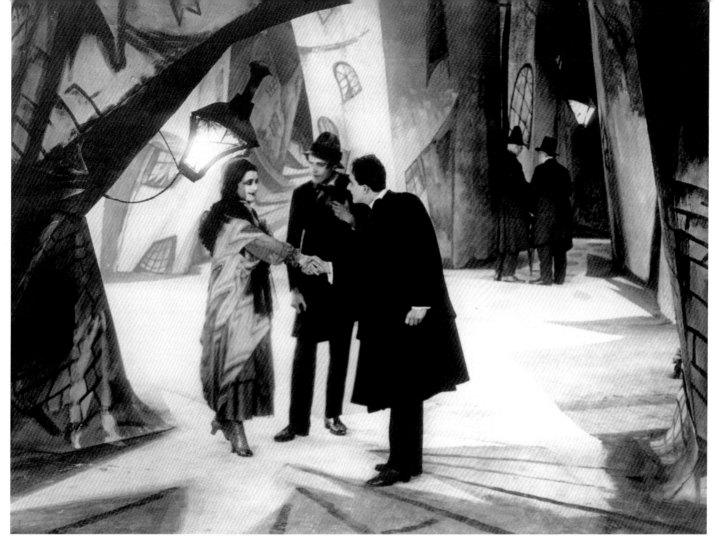

GERMAN EXPRESSIONISM SETS THE SCENE

American films in the twenties drew influence from the prolific and moody films of the German cinema. Known as German Expressionism, the design movement is characterized by the use of dark shadows, dramatic lighting, and distorted and skewed angles. The most important example of the influence of German Expressionism during this era was the 1920 landmark film *The Cabinet of Dr. Caligari.* Production designers Hermann Warm, Walter Röhrig, and Walter Reimann created a nightmarish, anxiety-filled atmosphere like no other seen before—a landscape where tortuous alleyways wove in and out of twisted houses and menacing shadows. The perspective was purposefully distorted throughout the film as contrasting blacks and whites collided onscreen in both the costumes and the sets.

The horror story of a carnival sleepwalker and a mad doctor, *The Cabinet of Dr. Caligari* created a world where the futuristic sets became actors—they visually created a realm so terrifying that audiences felt its dark and looming presence long after the film was over. German Expressionism had a dramatic influence on future generations of

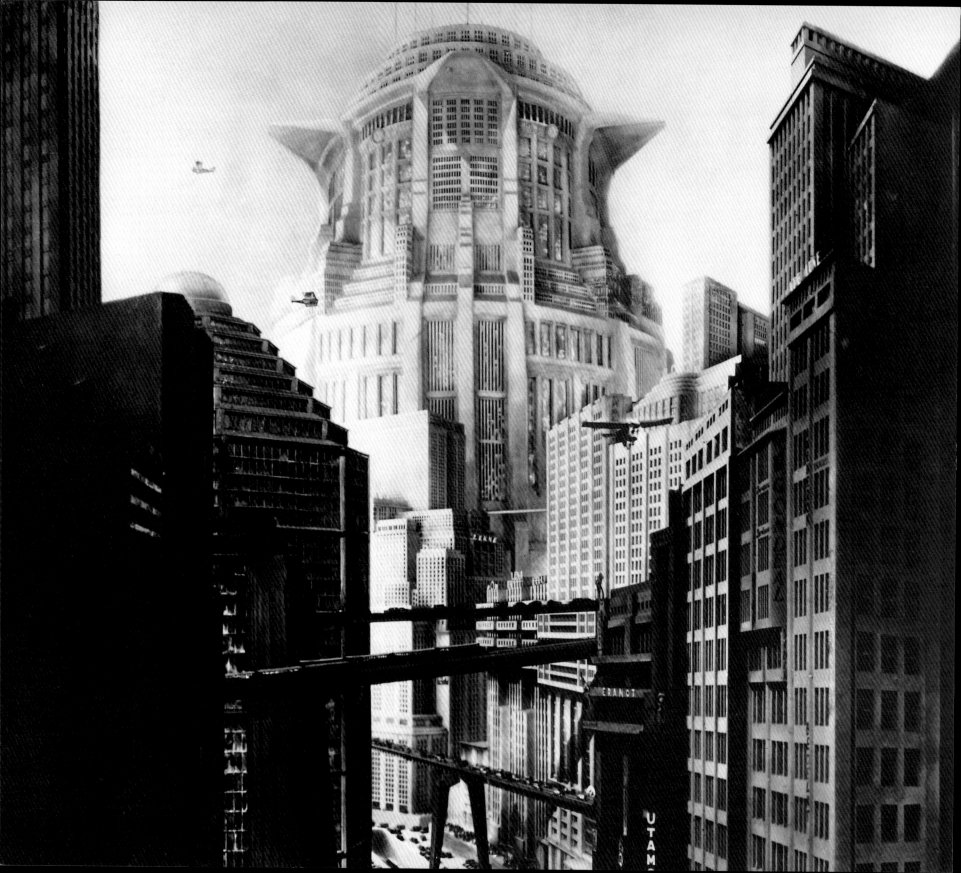

designers—particularly those working in the horror and film noir genres during the thirties and forties. Filmmakers and art directors would turn to German Expressionism throughout the century to convey some of the most frightening, dark, and shadowy moments seen on film—from the jerky movements of the earliest incarnations of Frankenstein's monster to the chiaroscuro shadows of the forties film noir, to such darker films from the latter part of the century as *Edward Scissorhands* and *Batman Returns*.

In addition to traditional horror and film noir of the twenties, filmmakers and art directors turned to German Expressionism to better bring to life some of the century's best science fiction. One of the most famous and influential silent films made in this style was Fritz Lang's *Metropolis*. (Designed by Otto Hunte, Karl Vollbrecht, and Erich Kettelhut, the set's gleaming metallic towers created a city of 2025 and set the standard for science fiction films and futuristic fantasies like the industrial modern cities in *Blade Runner* and *Batman Begins*.) *Metropolis* was the story of man versus machine. The futuristic city set painted a future where bureaucrats sat in their skyscrapers and towered over a world of underground workers below. The film was an architectural achievement. Lang, who was trained as an architect, favored restrained modern designs with cubistic architecture and geometric grid patterns. These motifs can be seen in everything—from the office windows and the shadows in the street to the character Rotwang's apartment. Lang looked to New York City as his muse: "I saw the buildings like a vertical curtain, opalescent, and very light. Filling the back of the stage, hanging from a sinister sky, in order to dazzle, to diffuse, to hypnotize."

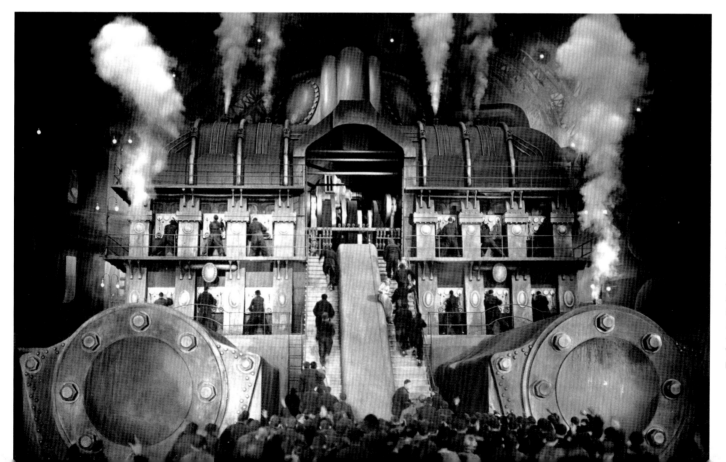

OPPOSITE PAGE AND LEFT: In the futuristic city of Metropolis the wealthy controlled above ground while slaves toiled below. *Metropolis* (1927) • Otto Hunte, Karl Vollbrecht, and Erich Kettelhut, art directors

THE WORLD OF ART DECO

Art Deco emerged in 1920 with the film *Le carnaval des vérités,* yet it was the film *Enchantment* that first introduced American audiences to the designs of art director Joseph Urban. With its roots in modernism, Art Deco utilized symmetrical geometric patterns—and on film, as with the interior design of the era, the design style became synonymous with the worlds of the fashionable and wealthy. Films of the late twenties depicted a glamorous time where the idle rich lived and played in spectacular surroundings—and no studio mastered this motif better than MGM and the head of its art department, Cedric Gibbons. William

Everson, author of the book *American Silent Film,* summed it up best: "MGM's films were always aimed at audiences that were rich—or (according to their own philosophy) poor audiences that envied the rich and thus wanted to see glamour and elegance in films rather than reality. The 'average' MGM family was usually independently wealthy and lived in a mad whirl of cocktail parties aboard yachts, with the source of such unlimited income usually unspecified but taken for granted."

The Art Deco movement originated in Europe in the early twenties but did not really catch on in America until the late twenties. Already invested in depicting the lives of

RIGHT: *Enchantment* (1921) • Joseph Urban, art director

OPPOSITE AND FOLLOWING PAGES: *Our Dancing Daughters* (1928) • Cedric Gibbons, art director

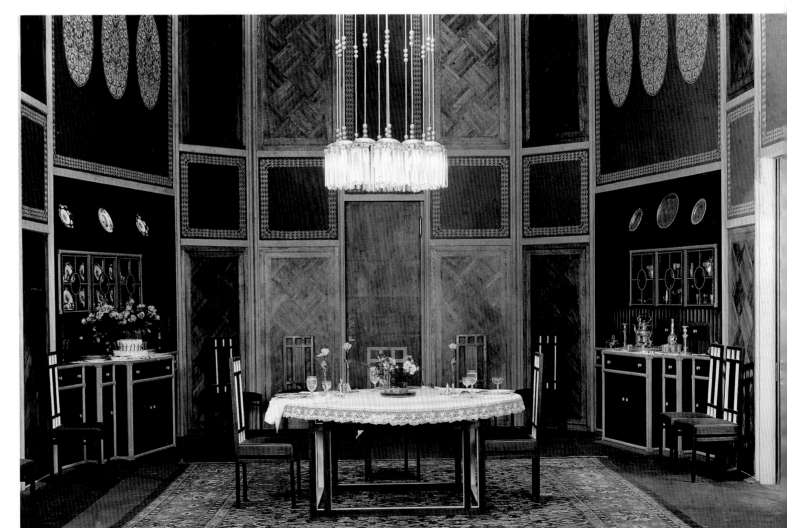

the wealthy, MGM was quick to jump on the growing Art Deco bandwagon, capitalizing on the design trend with the 1928 film *Our Dancing Daughters*. The story of uninhibited and unconventional "flappers," the film marked the debut of actress Joan Crawford as flapper Diana Medford. Cedric Gibbons's sets, with their high-gloss floors, chrome surfaces, and sleek furnishings, took an emerging design style and created a national trend. While the average living room was not the scale of a Hollywood film set, audiences across the United States were quick to adopt venetian blinds and add sleek upholstery pieces to their own homes.

Art Deco is also characterized by the introduction of twentieth-century materials like Bakelite, Vitrolite, and Formica. New geometric forms appeared as well, as seen in the long, vertical wall panels and zigzag patterns included in the set designs for MGM's *The Single Standard* and *The Kiss*. Erté-inspired interiors with highly reflective satin furnishings, platform beds, and statues that towered on marble columns marked the final silent picture at MGM. It was at this historic moment that Gibbons banished the use of all painted backdrops from his sets, insisting on constructed backgrounds.

In their book *Screen Deco*, Howard Mandelbaum and Eric Myers noted that Gibbons "became known as the man who put the glove on the mantelpiece—an action impossible to perform if the mantelpiece were merely a painted backdrop. Some constructed sets had already been in use by this time, but Gibbons was crucial in establishing them as the rule rather than the exception. Already he was displaying his trademarks: lavishness and high style."

As a trend, Art Deco burned bright through the late twenties and early thirties, but would soon fall into decline and morph into a new aesthetic in the late thirties as Streamline Moderne, a style that incorporated both curved and linear forms, with white as the primary color.

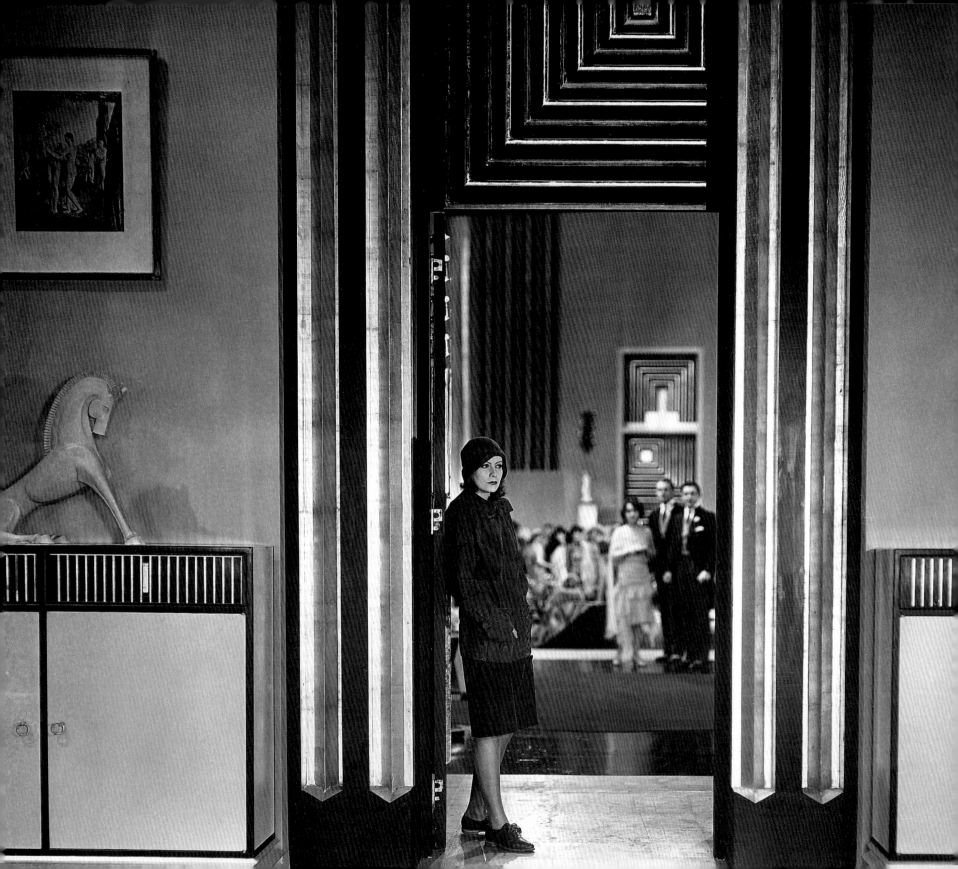

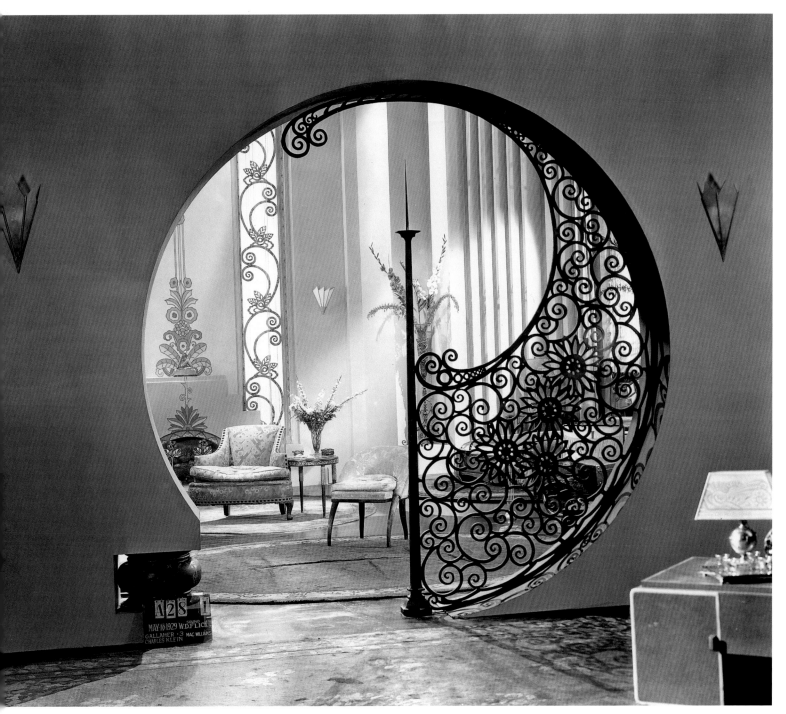

LEFT: With its
circular motif and
iron fretwork, the
stunning entrance hall
in *Pleasure Crazed*
(1929) reflected the
style of the times
• William S. Darling,
art director

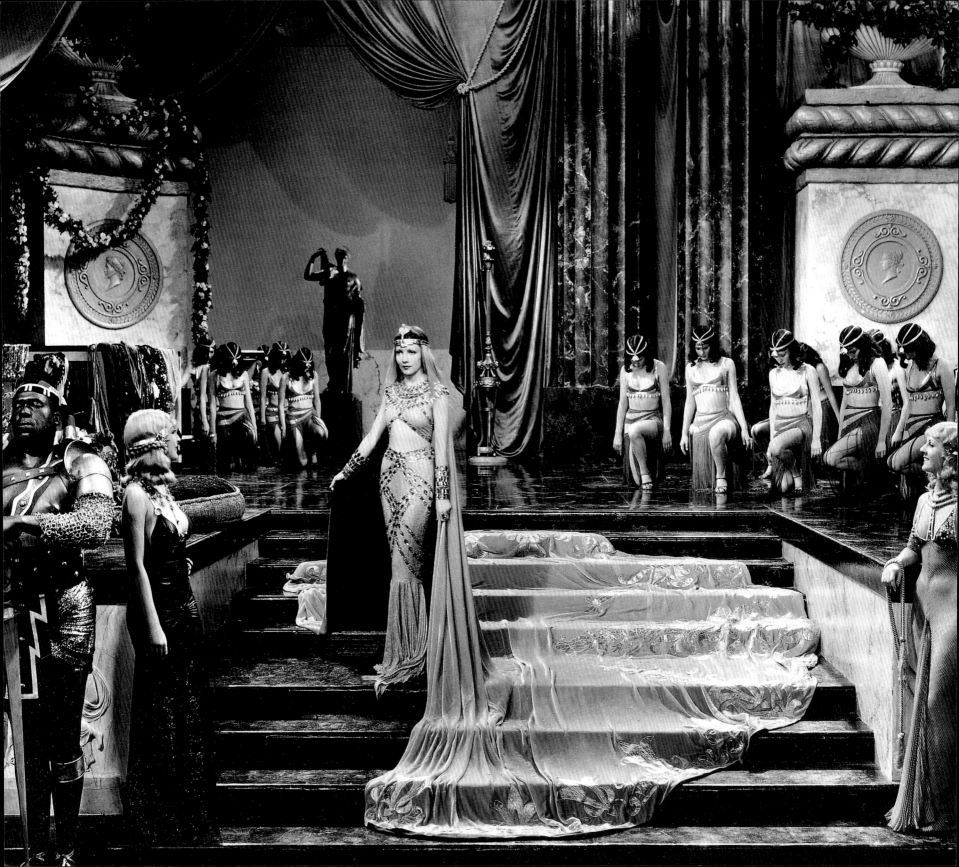

THE THIRTIES

Entertainment as Escape

As the gin-soaked, jazz-filled flapper days of the roaring twenties ended, the Great American Dream turned into the Great Depression nightmare. The country faced the worst economic depression of the century, and now, more than ever, needed the escape of entertainment. Nothing could match the diversion of an afternoon spent at the neighborhood Odeon. Hoping to raise the spirits of the American public, the Hollywood dream machine answered the call: even amid the economic crisis, the five major studios (MGM, Warner Bros., Twentieth Century Fox, RKO, and Paramount) produced forty to fifty films a year.

Throughout the thirties, American filmmaking fixated on creating a glamorous world of make-believe, a place where people dined on caviar, dressed in tuxedos, and danced the night away. These films offered American audiences a rare glimpse into a life they could only dream about. It was a time when Fred and Ginger danced cheek-to-cheek at the Lido in Venice, dancers shuffled off to Buffalo via 42nd Street, and gold diggers invaded Broadway. Audiences were able to check into Berlin's Grand Hotel, fly down to Rio, and vanish to *Lost Horizon*'s Shangri-La without ever leaving their seats.

The modern concept of film genre also came into being during the thirties. Standard categories helped define and differentiate between particular film styles—from musicals to horror films to screwball comedies. Universal

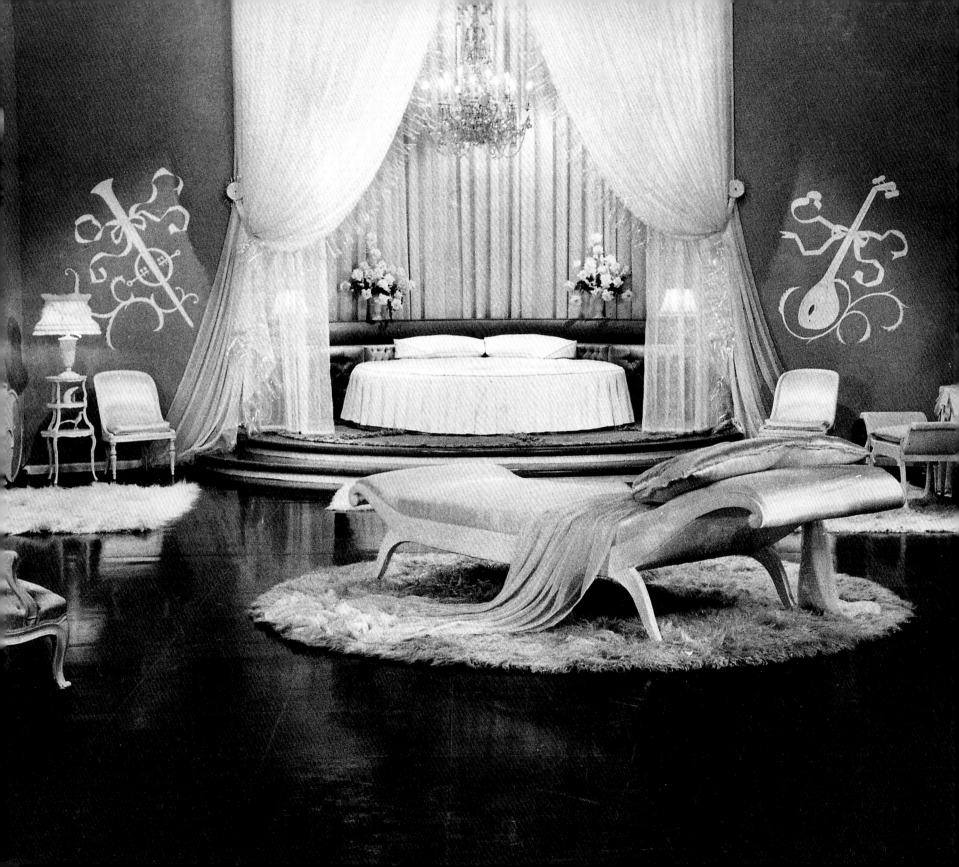

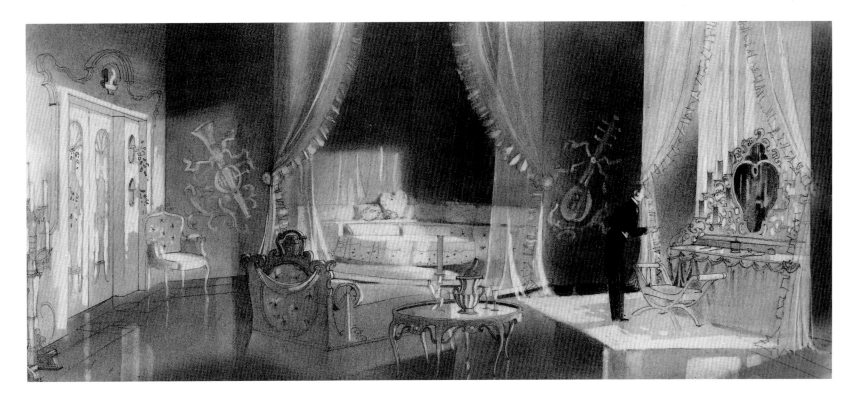

frightened a generation of filmgoers by perfecting such horror genre films as *Dracula* (1931), *Frankenstein* (1931), and *The Invisible Man* (1933), while Warner Bros. gave the gangster genre prominence with *Public Enemy, Little Caesar,* and *Scarface.* Chaplin's Little Tramp surfaced again in *City Lights* and *Modern Times,* but these final productions solidified the end of silent films. The thirties marked a new generation of "talkies," as, in 1934, Cecil B. DeMille introduced filmgoers to the infamous queen of the Nile, *Cleopatra,* as well as the husband-and-wife detective team of Nick and Nora, who quipped their way through investigations in the *Thin Man* series (1934–1947).

The thirties would prove to be one of the most diverse decades in entertainment, beginning with the advance of the "talkies" and ending with three landmark films of the century. Considered by film historians to be one of the most memorable years for films, 1939 gave filmgoers the indelible images of Monument Valley in John Ford's *Stagecoach,* the fantastical land somewhere over the rainbow in *The Wizard of Oz,* and David O. Selznick's cinematic masterpiece of love and turmoil in the Civil War–torn South, *Gone with the Wind.*

Other memorable images of the thirties included the extravagant Art Deco designs of the Fred Astaire and Ginger Rogers musicals. Their first film together was *Flying Down to Rio,* which featured a show-stopping (and show-stepping) oversize white staircase that was used in many of the Hollywood musical numbers. *Top Hat*'s Venice Canal set supported a massive dance sequence unlike any seen before on film.

Swing Time's Silver Sandal (designed by art director

OPPOSITE PAGE AND ABOVE: The bridal suite set (and matching rendering) for *Top Hat* (1935) • Carroll Clark, art director; Van Nest Polglase, supervising art director; Albert M. Pyke, illustrator

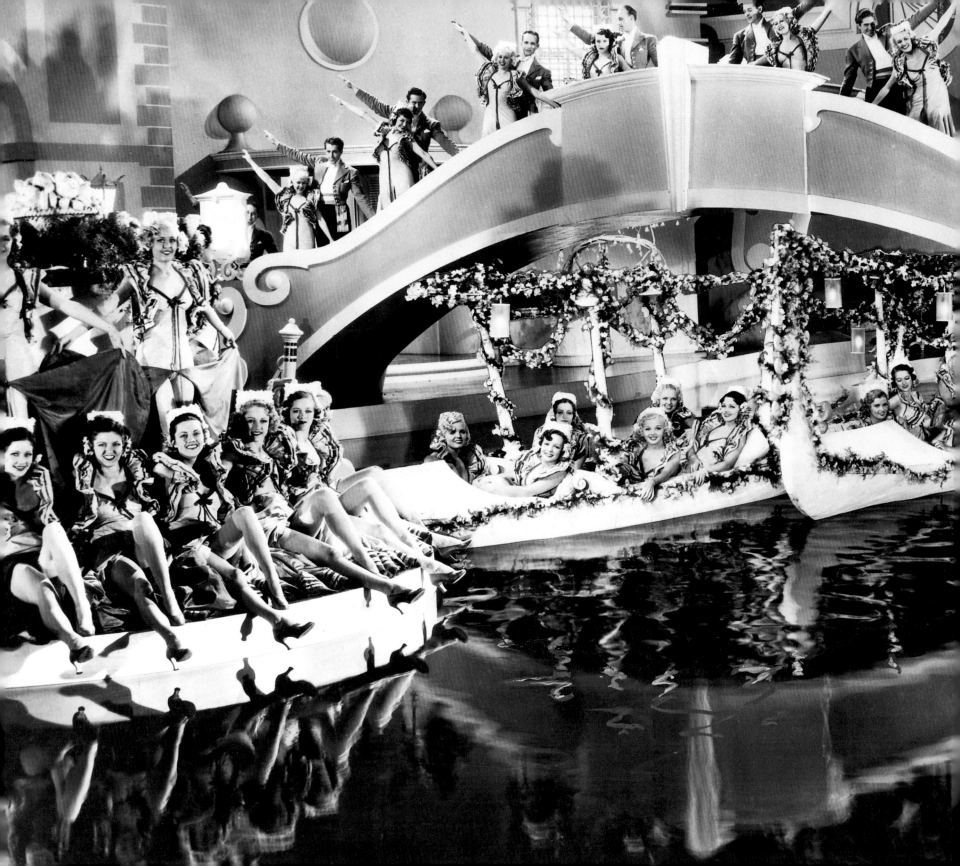

John W. Harkrider), and a streamlined white Art Deco steam liner in *Shall We Dance* also made their film debut. As ocean liners and railroad travel became the norm for the wealthy, these travel-themed movies once again provided yet another window on the times.

Sophisticated white interiors became the leading design trend and an important element in many of the MGM films under the helm of Cedric Gibbons, said to have been the founder of the fad. Gibbons's Art Deco sets of the twenties set the tone for the Streamline Moderne of the thirties. The all-white set could not have been feasible though, if it had not been for the development of incandescent lighting, which gave a crisp (and not blinding) look to the sets.

One of the most representative examples of the white-on-white trend was George Cukor's opulent film *Dinner at Eight*. Adapted from the Broadway play of the same name, *Dinner at Eight* tells the story of a formal dinner party at the height of the Depression, and tackles the classic Park Avenue battle—old money versus new money. With sets decorated by Fredric Hope and Hobe Erwin, the film's most memorable interior is the home of Jean Harlow as an ex-hat-check girl and her husband, played by Wallace Beery. As noted by Howard Mandelbaum and Eric Myers in *Screen Deco*, the style was "known as the 'white-telephone look' as it framed a platinum-haired, white-gowned, white-skinned Jean Harlow in an orgy of white décor . . . Harlow's close-ups were filmed through haystacks of white gauze." A record eleven shades of white were used in the film's interiors.

TRAVEL BY DESIGN

"The Grand Hotel. Always the same. People come. People go . . . nothing ever happens."

MGM's high-powered 1932 star vehicle *Grand Hotel* follows the stories of five guests during their stay in one of Berlin's most expensive hotels. Designed by Cedric Gibbons, the set's interiors play predominantly upon circular shapes. The film's focal point is the round reception desk that acts as the pivotal center of activity dialogue between the characters. Donald Albrecht, author of *Designing Dreams*, compares the circular motif to the metaphor of a "spinning wheel of fortune," a very appropriate image for the chaotic lives of the central characters. The motif is repeated in the hotel's revolving doors and circular atrium, as well as in the ornaments on the railings of the balcony. "Movie plot and architecture have seldom been so closely harmonized," Albrecht writes.

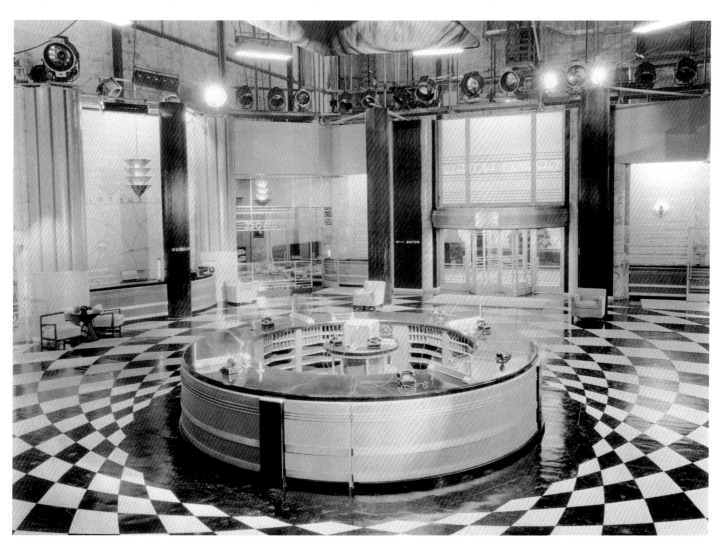

LEFT: *Grand Hotel* (1932) • Cedric Gibbons, art director

Dodsworth

Dodsworth is another example of a film that utilized sets in sophisticated foreign locales. Based on Sinclair Lewis's novel of the same name, *Dodsworth* tells the story of a businessman and his wife, Sam (Walter Huston) and Fran (Ruth Chatterton) Dodsworth, who take a marriage-changing European holiday. Beautifully designed by Richard Day, the art direction showcases the world of upper-class travel—complete with memorable sets from a *Queen Mary* stateroom, stylish hotels in Paris and Rome, as well as a lavish Italian villa.

Back at home, Dodsworth's office reflects the modern aesthetics of the times when skyscrapers dotted the urban landscape, both in metropolitan cities and in the cinema. The grid pattern for the office's large glass windows were seen in the 1928 film *The Crowd*, as well as in *Metropolis*, and became a symbol of executive power. Perhaps one of the finest designers of his generation, art director Richard Day contributed much to the world of art direction. He was best known for his technique of creating the setting as a character, establishing the basic tenet of any good production design. His broad range of films include the sophisticated Manhattan interiors of *Day-Time Wife*, as well as the gritty, realistic sets of *The Grapes of Wrath*, *A Streetcar Named Desire*, and *On the Waterfront*, and the biblical landscape of *The Greatest Story Ever Told*.

In a career that spanned six decades, Day was nominated for an Academy Award eighteen times and took home six. Robert Sennett, author of *Setting the Scene*, notes that "In a film designed by Day, the background and settings always seem to flow from the principal characters' individual sense of the world, and their actions within this world are thus as proscribed as if it were the real one." In a decade known for its opulence, Day's sets are wonderfully realistic, and as Sennett aptly notes, make "a statement without saying anything, one definition of great art direction."

RIGHT AND OPPOSITE PAGE:
Dodsworth (1936)
• Richard Day, art director

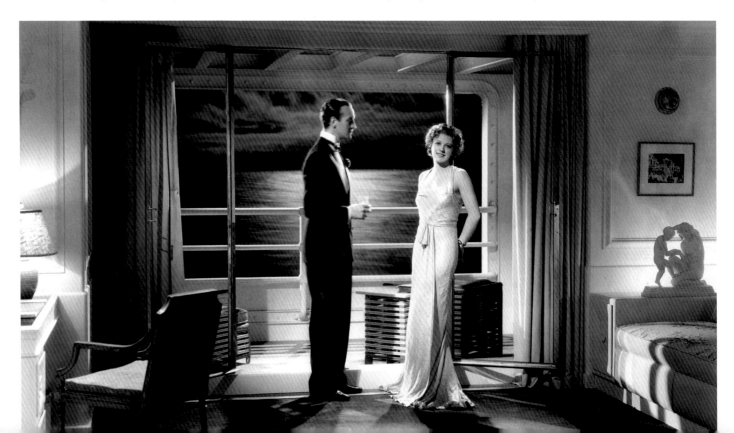

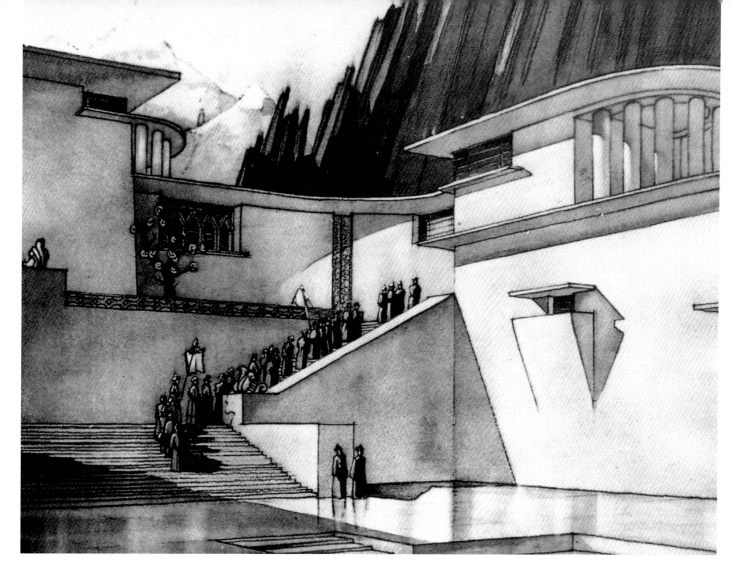

Holiday

The grand interiors of the Seton mansion were a design focal point for the 1938 film *Holiday*. Directed by George Cukor, the film follows a young banker (Cary Grant) who is engaged to the daughter (Katharine Hepburn) of a wealthy scion and contemplates spending the rest of his life "on holiday." Designed by art director Stephen Goosson, much of the film takes place in an elaborate Fifth Avenue mansion, a set that included twenty-four rooms on three levels, a sweeping double staircase with ornate iron fretwork, doorways flanked with classic dentil molding and columns, and rooms filled top to bottom with eighteenth-century antiques.

Lost Horizon

Regarded as one of the iconic films of the decade, *Lost Horizon* was an escapist travel adventure, characteristic of the thirties. Adapted from James Hilton's bestselling novel of the same name, director Frank Capra's film followed the adventures of Bob Conway (Ronald Colman), a British

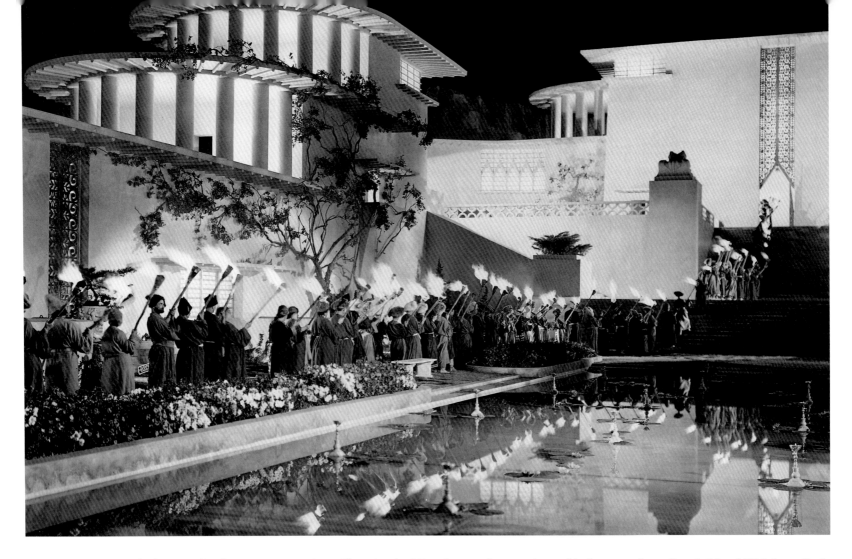

diplomat who discovers a utopian village in the Himalayas after an epic plane crash. Known as Shangri-La, the village is a welcome haven, free from the worries of modern life—an ideal that no doubt struck a chord with filmgoers of the Depression era.

Constructed on the Columbia Pictures ranch, the utopian lamasery was built to full scale and took more than two months to complete. With an original budget of $1.5 million, which eventually doubled, no expense was spared. The Zen-like buildings that were erected with reflecting lap pools and statue-filled courtyards were said to be affected by a variety of influences, from Frank Lloyd Wright to Buddhist architecture. Designed by Stephen Goosson, Shangri-La's sets were somewhat controversial at the time. They prompted novelist and sometimes critic Graham Greene to remark: "This utopia closely resembles a film star's luxurious estate in Beverly Hills: flirtatious pursuits through grape arbors, splashings and diving in blossomy pools under improbable waterfalls." The filmmakers no doubt had the last laugh, as audiences and Hollywood loved *Lost Horizon* and honored the film with the Academy Award for Best Art Direction in 1938.

THE FANTASY FILM, THIRTIES-STYLE
Things to Come: An Art Director Turns Director

Things to Come marked the directorial debut of William Cameron Menzies. Another representation of a utopian world, the United Artists' film was based on H. G. Wells's futuristic tale of the world from 1940 to 2035. Vincent Korda, brother of the film's producer Alexander Korda, designed the film alongside special-effects wizard Ned Mann and under the mentorship of Menzies. (It was said Alexander Korda first approached noted architect Le Corbusier to design the film's futuristic sequences, but was turned down.)

Together Vincent Korda, Mann, and Menzies supervised the construction of the sets of Everytown, an underground city of the future. Sets were minimal at best, and such new materials as Plexiglas and neon were used alongside traditional plaster to create the streamlined, futuristic world. Korda's contemporary utopian city of 2036 featured a monorail, curved balconies, and sleek tubular glass elevators—a literal sign of things to come.

BELOW: *Things to Come* (1936) was Menzies's directorial debut • Vincent Korda and William Cameron Menzies, art directors

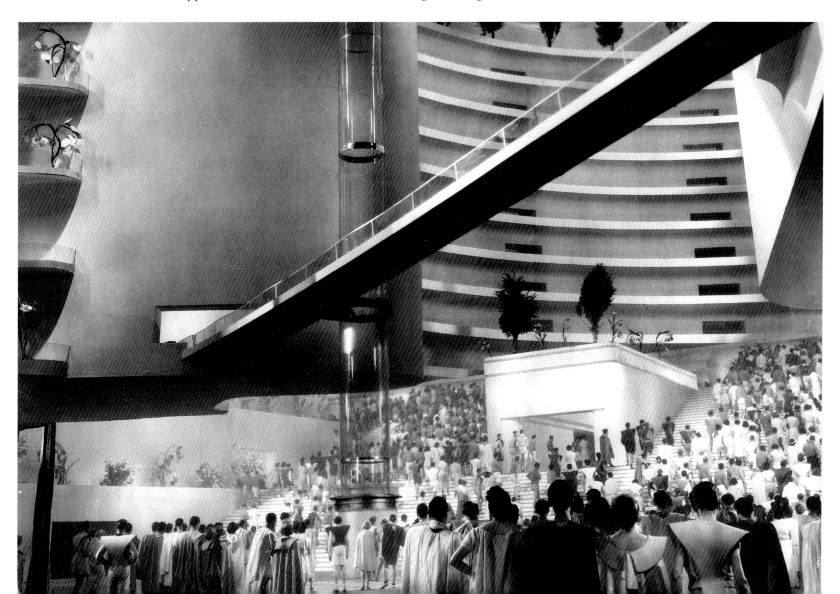

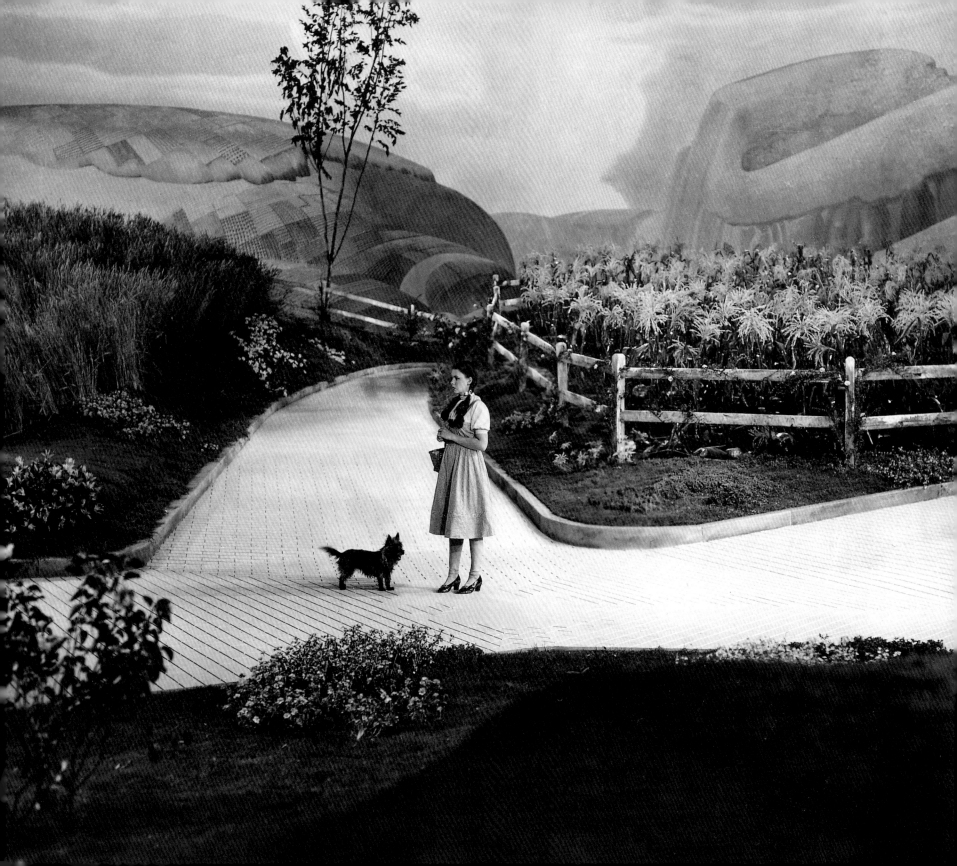

Follow the Yellow Brick Road: Designing the Land of Oz
Adapted from Frank Baum's children's tale, the beloved fantasy musical *The Wizard of Oz* is perhaps one of the most iconic films of all time. The classic film finds Dorothy and her dog, Toto, in the Land of Oz via a Kansas cyclone. On her quest to return home, she is helped by Glinda the Good Witch, as well as a cast of friends she picks up along the way: the Scarecrow, Cowardly Lion, and Tin Man. MGM's Cedric Gibbons assigned William A. Horning, Jack Martin Smith, and Malcolm Brown to be the film's art directors.

From Auntie Em's Kansas homestead to the final destination of Oz—and everywhere in between—the film's sets were said to have numbered over sixty and required 150 artisans and 500 carpenters working around the clock. The art department used almost half a mile of cloth for backdrops, which were painted by many of the industry's leading scenic artists, including the Paris opera's esteemed painter and art director Ben Carré.

The Emerald City still remains one of the film's most memorable sets. Author Aljean Harmetz describes in her book *The Making of the Wizard of Oz* the inspiration: "The Art Department [at MGM] had its own more specialized research department. Somewhere in the clutter of books and magazines on sculpture, architecture, abstract design, and painting, [Cedric] Gibbons found the Emerald City." Production designer Jack Martin Smith notes that Gibbons "found a tiny, a really minuscule photograph of a sketch that had been done in Germany pre–World War I. We looked at the sketch—it actually looked like test tubes upside down—and it crystallized our ideas."

Jack Martin Smith further described how the Emerald City would be filmed: "The camera would dictate how much of each set needed to be built. We always just built the pieces the audience will see," says Smith. "You had to figure out how far they were from the Emerald City when they first saw it, in order to know how much to build." Many of the buildings were actually the result of matte paintings, a photographic technique that uses a painting by a matte artist (a painter who specializes in creating photo-realistic illustrations on masonite or glass surfaces) and combines it with actual footage, as in the case of the exteriors for the Emerald City.

The production team faced numerous and unique design challenges on the production of *The Wizard of Oz*. An acre and a half of poppies had to be wired to the floor for the "Deadly Poppy Field" sequence. "Munchkinland" had to accommodate its famous inhabitants with doors and flower boxes placed at lower heights. And white horses

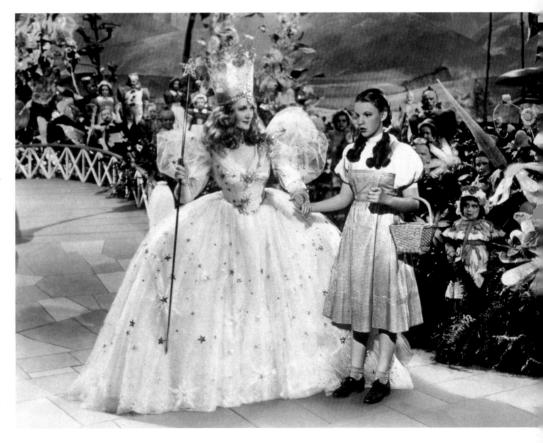

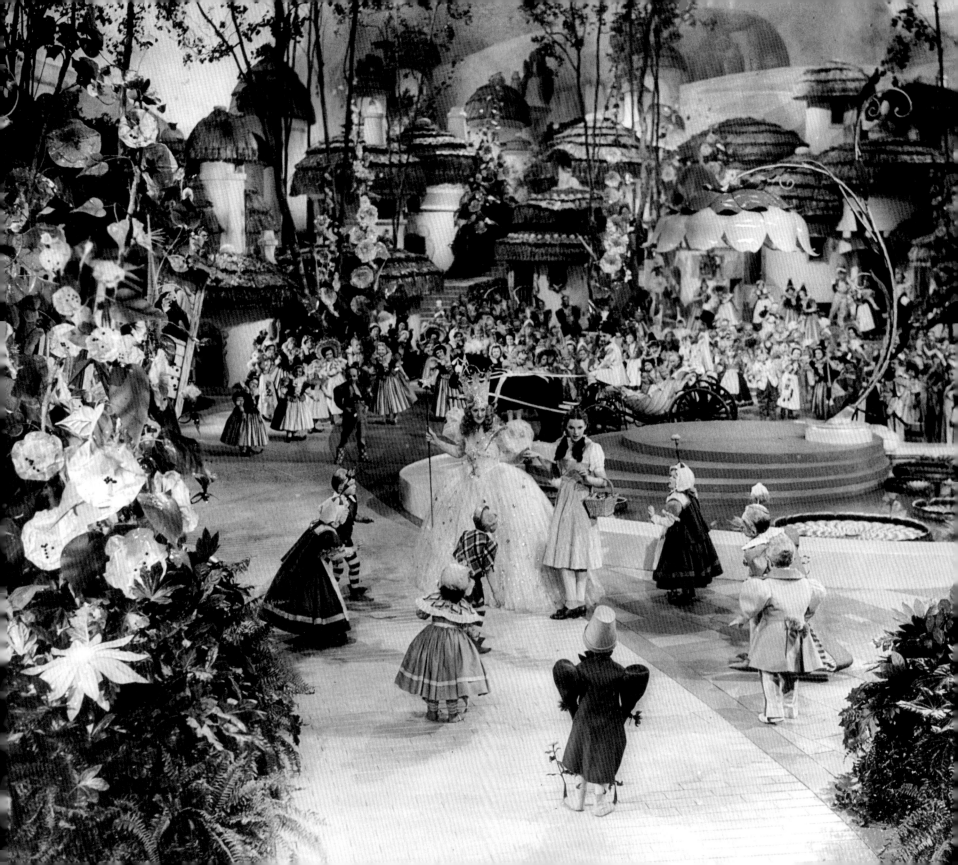

were turned into a variety of colors with the use of Jell-O powder—the only problem was they licked off most of the sugared substance in between shots.

The special effects, created by A. Arnold Gillespie, included fashioning a giant wind sock to mimic a twister for the film's tornado scene. The shot of Dorothy's house falling from the sky was achieved by filming a miniature house being dropped onto a painting of the sky on the stage floor, then reversing the film to make the house appear to fall toward the camera. Beyond its relatively cutting-edge techniques, the film brought brand-new challenges to art direction—Technicolor. As color film was still evolving, many of the colors on set did not register properly, and had to be toned down. While this is not the first film to be shot in color, the production team effectively mixed sepia tones for the Kansas sequences and color for the rest of the film.

A far cry from the opulent streamlined musicals at RKO, *The Wizard of Oz* remains in a class by itself as one of the most beloved films in cinematic history.

GOTHIC HORROR

"I bid you welcome," says Bela Lugosi from a dark, cob-webbed cellar filled with rats and all other sorts of crawling creatures. As anticipation and fear grow palpably, the audience hears a creaking noise. A hand reaches out of a coffin—the Prince of Darkness has arisen. Other caskets open as the vampire brides make their appearance. Wolves howl from all directions and a feeling of unease sets in as Dracula, in his imposing black cape and illuminated face, appears on screen for the first time, and audiences all over America suddenly find it difficult to fall asleep at night.

The setting was a Bavarian castle in Eastern Europe, designed to be Transylvania, and the film, the horror classic *Dracula*. Dracula began a long, storied tradition of Universal horror films, and it is no accident that the studio would specialize in the genre. Studio founder Carl Laemmle grew up in Germany listening to the twisted tales of the evil that could be found in the black mountains and the Black Forest—and no doubt passed along the stories to his son, Carl Jr., who took over the studio in 1930 and produced both the Dracula and the Frankenstein series.

Designed by Charles "Danny" Hall, the films changed the horror landscape for decades to come. Influenced by the German Expressionist techniques seen in *The Cabinet*

RIGHT AND OPPOSITE PAGE:
Dracula (1931)
• Charles D. Hall, art director

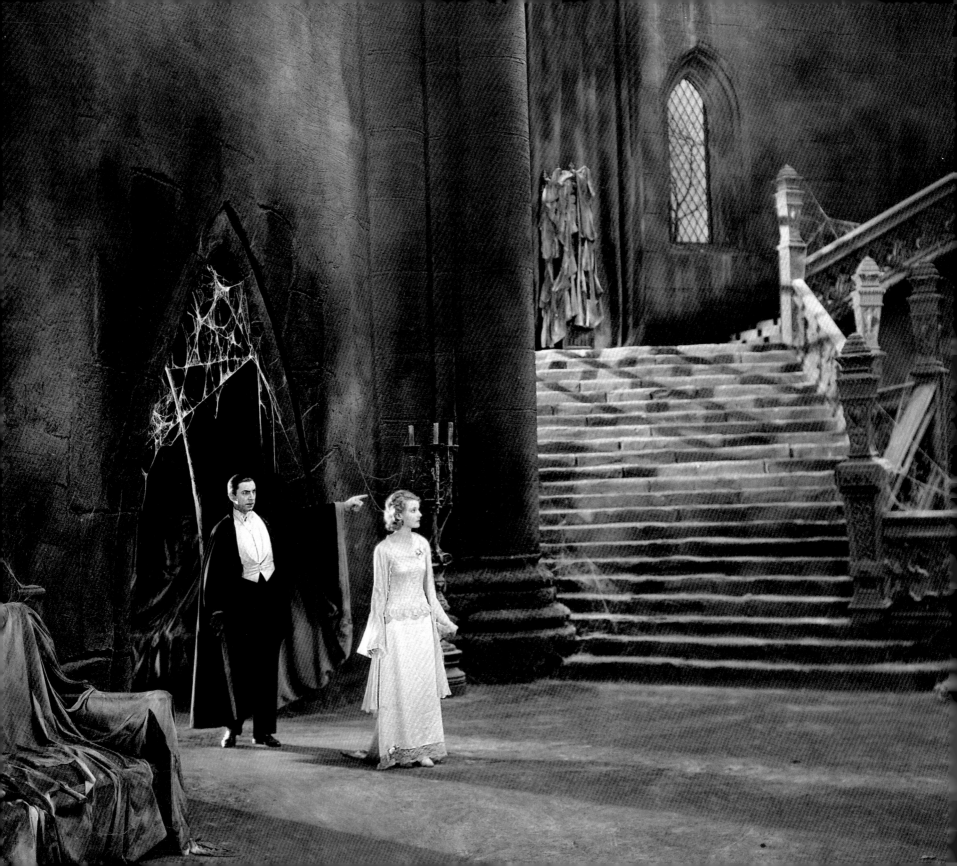

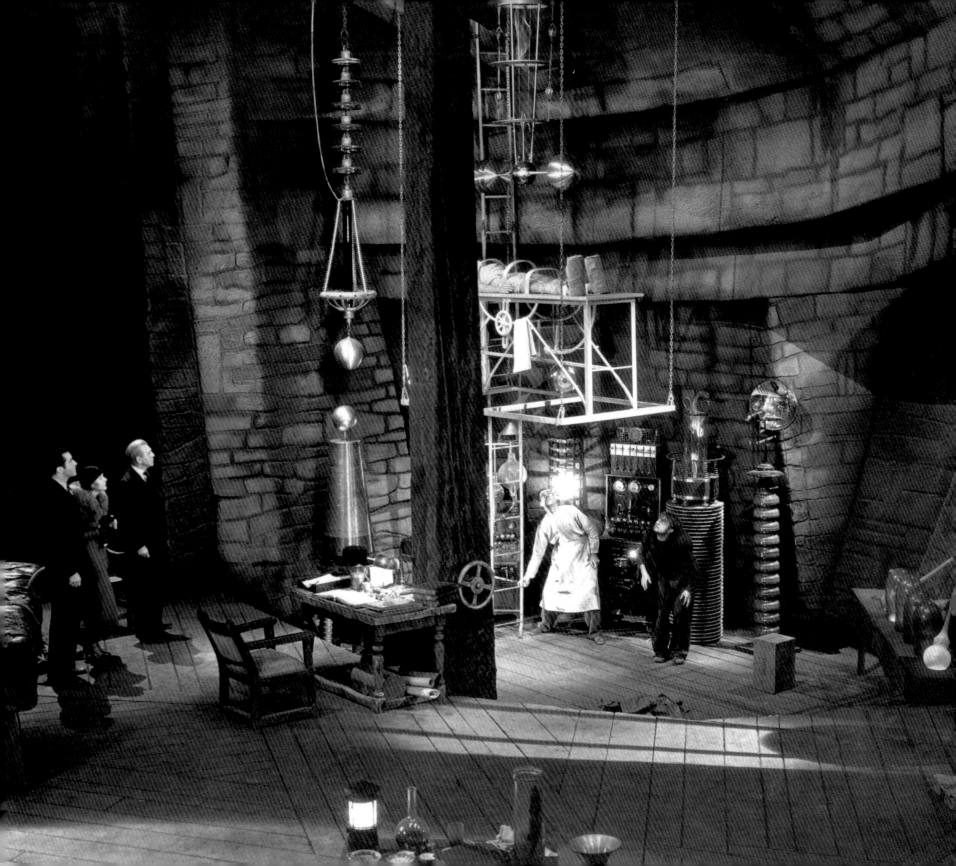

of *Dr. Caligari* and other films of the twenties, Hall built tension through sharp angles, stark contrast, and carefully coordinated shadows and lights. The style Hall created also drew from Gothic architecture and design, which referenced the film's origin in both Gothic and Victorian novels.

The images are vivid and unforgettable—Dracula's once-stately baronial castle crumbling in ruins, cobwebs lining the stairway steps and corners, the opening scene of a carriage racing through a narrow passageway to the castle. The legendary atmosphere preyed upon the audience's most basic fear—that of the unknown. Setting each nightmare tale in the darkest hour, adding fog, creating pregnant moments of anticipation—these strategies were the building blocks of classic horror.

While Dracula remains the ultimate vampire, his horror rival, Frankenstein, became the prototypical monster in Hall's next advancement of the genre, Mary Shelley's horror fable *Frankenstein*. Mad scientist Dr. Frankenstein (Colin Clive) experiments with the forces of nature and creates an artificial life—a creature in the form of a man (Boris Karloff)—but faces dire consequences when he, and society, rejects the monster. Like Dracula, the art direction of *Frankenstein* is influenced by the Expressionist movement. The sets are a bit more technically complicated than those of Transylvania, as the story calls for a detailed laboratory (which has similarities to *Metropolis*). The laboratory is a key set, as it plays home to the monster's moment of conception—the life-giving bolt of lightning, whose current flows down the twisted tubing through the ceiling to reach the once-lifeless collection of parts. Other striking sets include the windmill, as seen in the film's climax, and, of course, the medieval castle itself—a set from the Universal lot that was recycled from a previous classic, *All Quiet on the Western Front*.

THE WAR EPIC

The controversial *All Quiet on the Western Front* was considered the first true antiwar film of the century. Based upon Erich Maria Remarque's bestselling novel, it tells a tale of World War I from a different perspective—that of a German soldier.

The 1930 epic was built on a massive scale. Designed by the talented Charles D. Hall, with a budget of $1.25 million, the film follows a group of young soldiers into battle. Hall built his military battlefield on the historic Irvine ranch near Los Angeles, and used more than two thousand extras for the film's battle scenes—many of whom were actual World War I veterans. Meticulous details went into the construction of a shell-torn French village, as the film set out to emphasize the enormous destruction the war brought to both the cities and surrounding landscape. Memorable sets included a German schoolroom, dug-out underground bunkers, and the incredibly realistic battle scenes, which are often imitated by modern war films today.

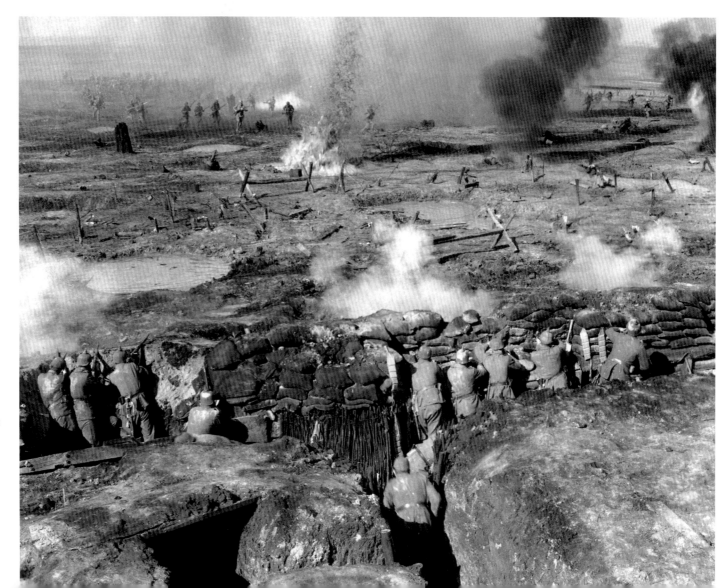

RIGHT: Sets for *All Quiet on the Western Front* (1930) were built on a ranch in Irvine, California • Charles D. Hall, art director

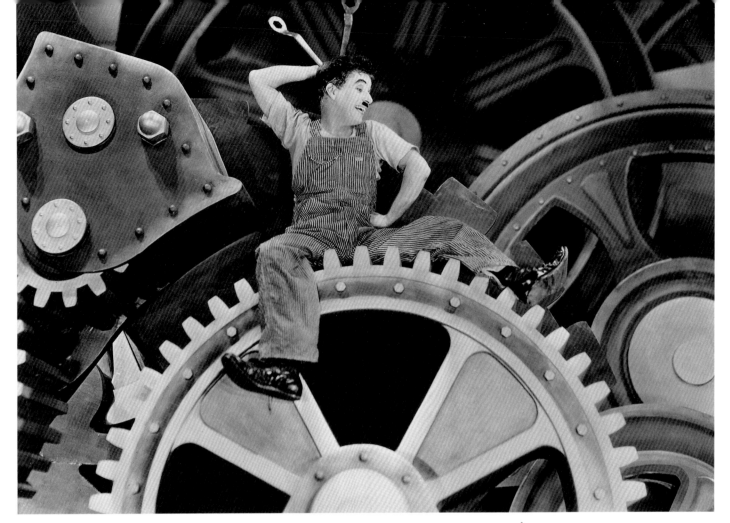

A COMEDY COLLABORATION: CHAPLIN AND HALL

Charles D. Hall collaborated with Charlie Chaplin on two of his most important works: *City Lights* and *Modern Times*. *City Lights* finds the Little Tramp falling in love with a beautiful blind girl. After a case of mistaken identity, the Little Tramp manages to become her benefactor and must leverage a wealthy "friend" to keep up the ruse. Considered Chaplin's greatest work, the film marks his first of the sound era. The sets required Hall to build a modern city on the Universal lot, complete with a millionaire's mansion, a boxing ring, and a nightclub. Authors John Hambley and Patrick Downing note in their book *The Art of Hollywood*, "Most of its components were designed with a particular scene or effect in mind rather than as a generalized background. The opening, with Chaplin asleep in the arms of a statue as it is unveiled by a pompous group of city dignitaries, is given added effect by Hall's equally pompous and impassive sculptured group."

Modern Times marked the duo's last collaboration and represents another remarkable design achievement.

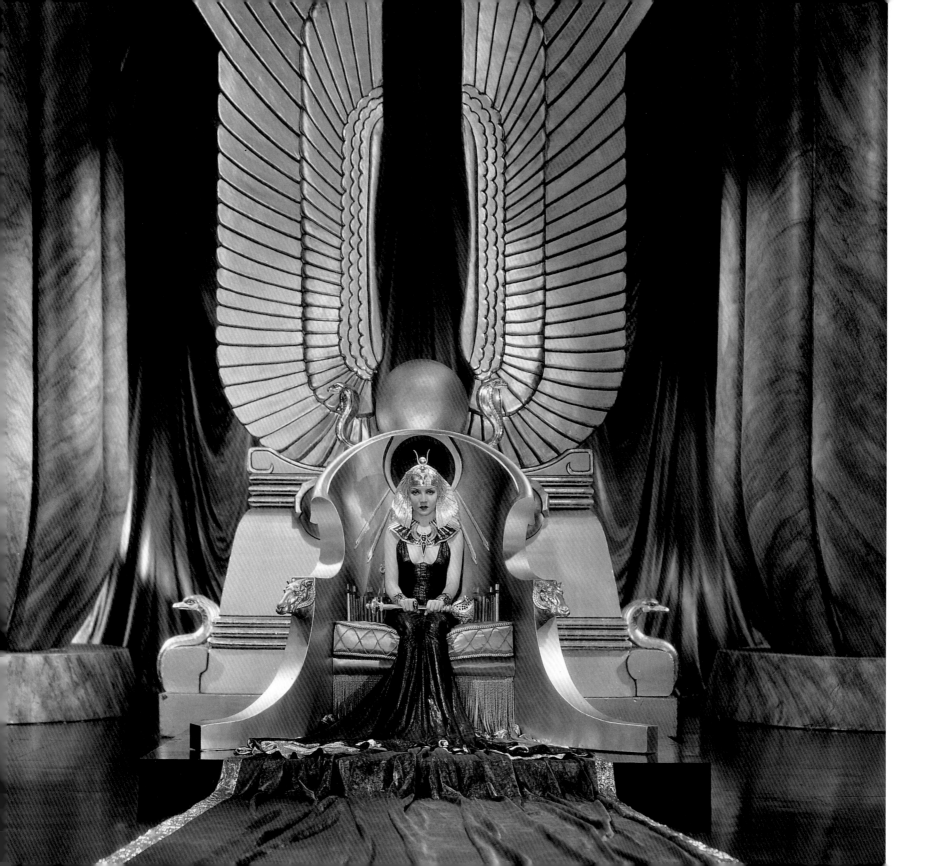

ROME WAS NOT BUILT IN A DAY, PART ONE: THE MAKING OF *CLEOPATRA*

A typical Cecil B. DeMille production almost always means spectacular sets, battle scenes, historical truths and inaccuracies, period costumes, grand entrances, and often tragic endings—all told with a cast of thousands. *Cleopatra* (1934) is one of those epics.

The tale of the infamous rise and fall of the queen of the Nile, and her life and loves, was designed for Paramount by Roland Anderson and Hans Dreier. The sets are strikingly modern—particularly the Streamline Moderne–infused throne, which, if scaled down, would have been right at home in a Cedric Gibbons penthouse interior. The floating palace is also memorable, as Cleopatra reclines on a massive chaise with silk draperies in a bordello-like atmosphere. Her entry into Rome and the battle scenes are quintessential DeMille grandeur.

Classic DeMille opulence was seen everywhere. As with every DeMille production, months of copious research and preparation were the order of the day. The film's massive overscaled sets were said to cover more than 400,000 square feet. Ancient Roman and Egyptian religious and historical artifacts were realistically duplicated and life-size. Even the sultry Egyptian's barge was five hundred feet long. Dreier's Temple of the Philistines set was the most stunning, with its inverted truncated columns and decorative horn finials used as an architectural focal point.

OPPOSITE PAGE: Claudette Colbert as the infamous Queen of Egypt in *Cleopatra* (1934) • Roland Anderson, art director; Hans Dreier, supervising art director

ABOVE: A sketch for *Cleopatra* • Joe de Young, illustrator

TARA, TWELVE OAKS, AND ATLANTA IS BURNING

From the sweeping plantations of Tara and Twelve Oaks to the burning of Atlanta and the ravaged, Civil War–torn countryside to the reconstruction of the Old South, *Gone with the Wind* is a true great American classic. Not only was the masterpiece the first to award the title of production designer in its credits, it also represents one of the most definitive films in art direction.

Production designer William Cameron Menzies was perhaps one of the most important contributors to David O. Selznick's epic tale of a Southern love affair played out during the Civil War. As the film ran through three directors—George Cukor, Victor Fleming, and Sam Wood—Menzies became the proverbial glue holding the production together. He modestly described his role as "an intermediate process between the printed work and its visualization on celluloid." A talented fine artist, Menzies produced more than two thousand watercolor sketches for the storyboard process, ensuring a cohesive shoot that rivaled the intensity and detail of a Cecil B. DeMille production.

Along with art director Lyle Wheeler, Menzies oversaw the authentically accurate interiors of prewar Tara and Twelve Oaks (stately, antique-filled rooms) and postwar Tara (over-the-top designs of gauche new money). With the guidance of historian Wilbur Kurtz and author Margaret

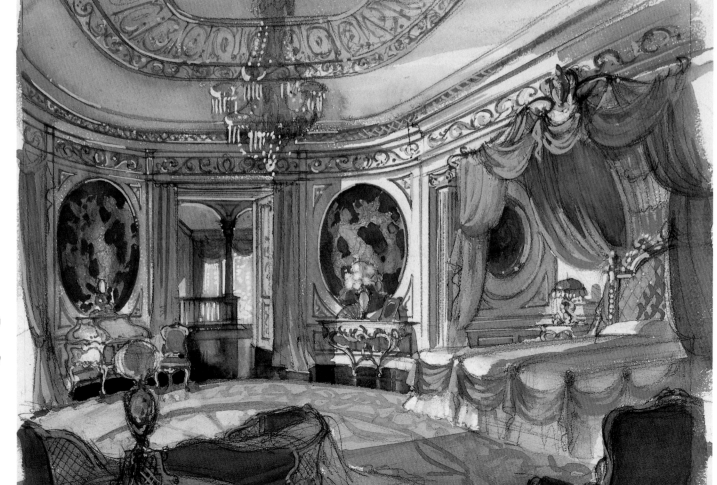

RIGHT: Production designer William Cameron Menzies spent an entire year alone with the novel and script designing the watercolor storyboards for *Gone with the Wind* (1939) • Dorothea Holt-Redmond and Joseph McMillan Johnson, illustrators

OPPOSITE PAGE: Director Victor Fleming explains how to wave a peacock feather fan in *Gone with the Wind* • William Cameron Menzies, production designer; Lyle Wheeler, art director

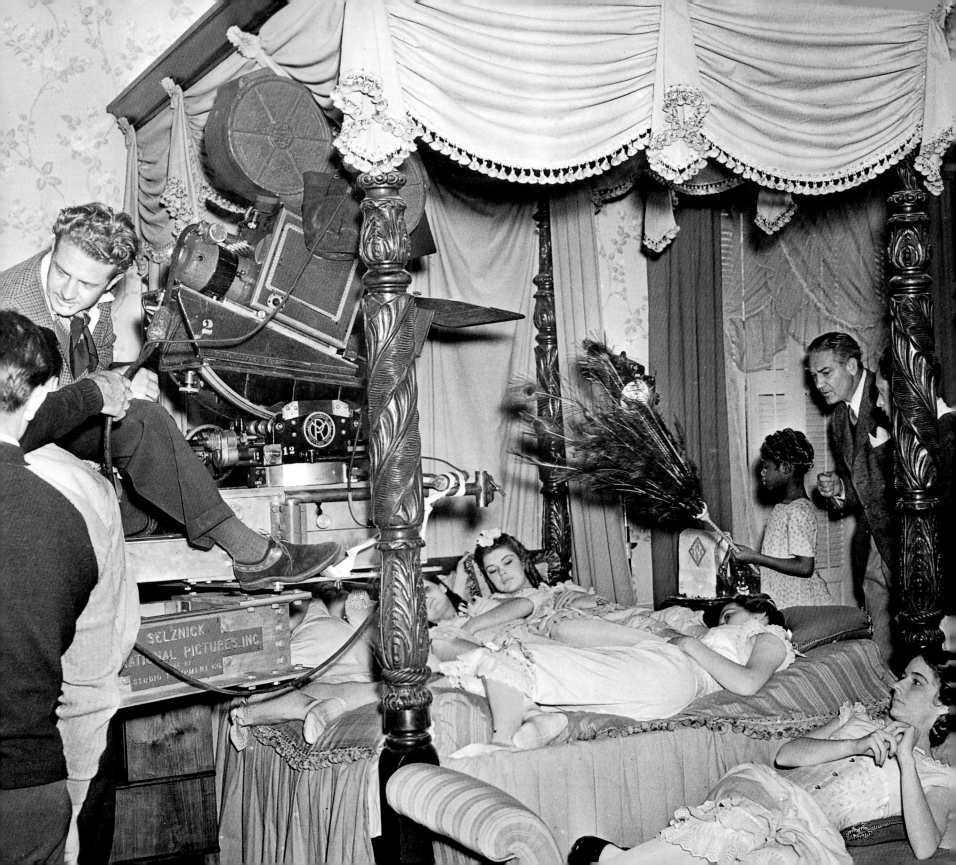

Mitchell—who did not often agree with the design interpretations—Menzies turned Stages 11 and 12 on the Selznick studio lot into the film's most memorable sets: the Twelve Oaks library with its oversize globe, the great hall's imposing double staircase, and Tara's four-poster-filled bedrooms and sitting room, complete with the green velvet curtains that met their fate as Scarlett's infamous dress.

The film's centerpiece, Tara itself, was actually a façade built on the studio's Forty Acres back lot. At a cost of $12,000, the production team created the illusion of a massive, tree-lined plantation, using tricks like wrapping existing telephone poles with artificial tree trunks. The burning of the Atlanta Depot became a production within a production—the crew burned the old spare wooden sets on Forty Acres (which needed to be cleared away for the "New South" sets of Tara and Peachtree Street) under the careful watch of fifty studio firemen. Many of the sets were from previous films, such as the great wall from *King Kong* (1933), which were actually hand-me-downs from Cecil B. DeMille's silent film *King of Kings* (1921). The façades of these sets were rebuilt to resemble warehouses.

As Technicolor continued to evolve and change the face of filmmaking, Menzies turned to color as powerful storytelling metaphor. He used "great masses of red and black" for the burning scene, while orange and brown represented the barren land, a sorrowful relic of the war. The spirit of the Old South was represented with the use of soft pastel colors and crisp whites, while the Reconstruction era was captured by the use of bright greens and reds.

Menzies was considered a prodigy whose talent, attention to detail, and overall contributions to film production design are legendary. His role on a film far surpassed his

RIGHT AND OPPOSITE PAGE:
Gone with the Wind (1939)
• William Cameron Menzies, production designer; Dorothea Holt-Redmond and Joseph McMillan Johnson, illustrators

FOLLOWING PAGES: The mammoth production of *Gone with the Wind* used more than 2,400 extras.

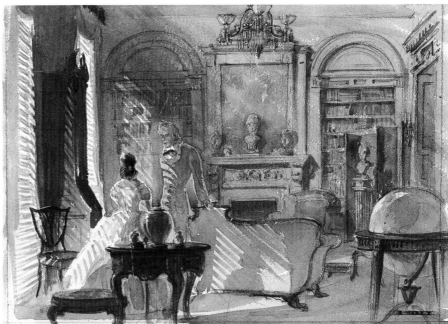

duties as a designer to that of an associate director. He actively worked with the producer and director, shaping the film from the beginning stages and working with the cinematographer on camera angles and lighting issues. His accomplishments paved the way for future generations of production designers to follow suit.

THE THIRTIES WERE truly the decade of the Hollywood dream factory. While the nation suffered an economic crisis, movies brought glamour, luxury, travel, and style through opulent musicals and sweeping epics. Perpetuating the American Dream, designs of wealth and sophistication drew audiences in record numbers, while the increasing demand for horror films ushered in a new form of design. The classics *The Wizard of Oz* and *Gone with the Wind* stood by themselves as artistic achievements in both design and Technicolor.

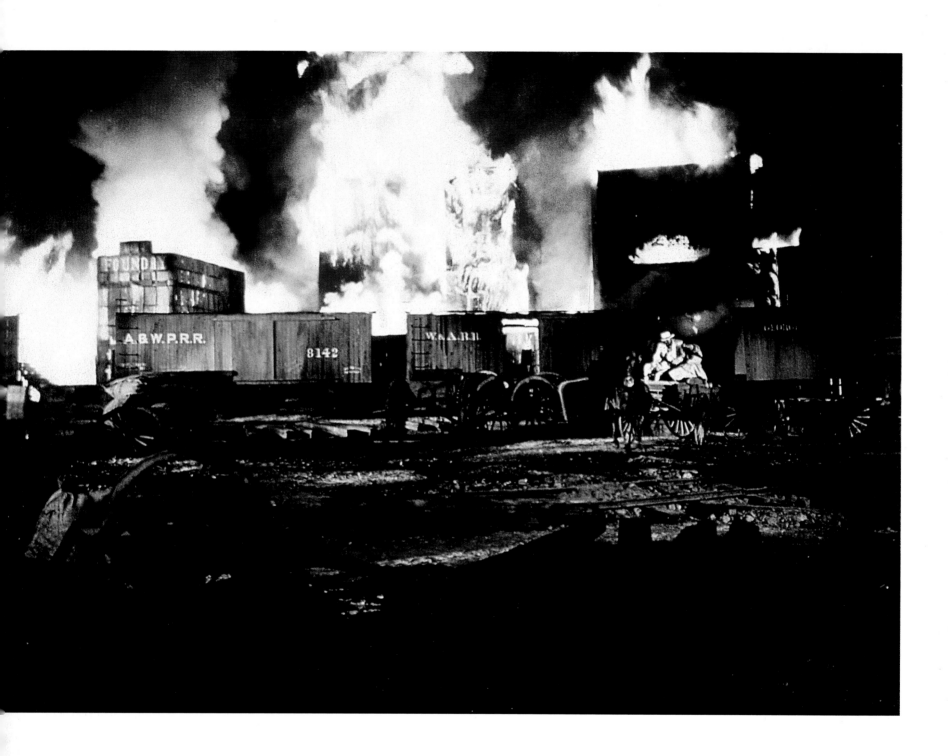

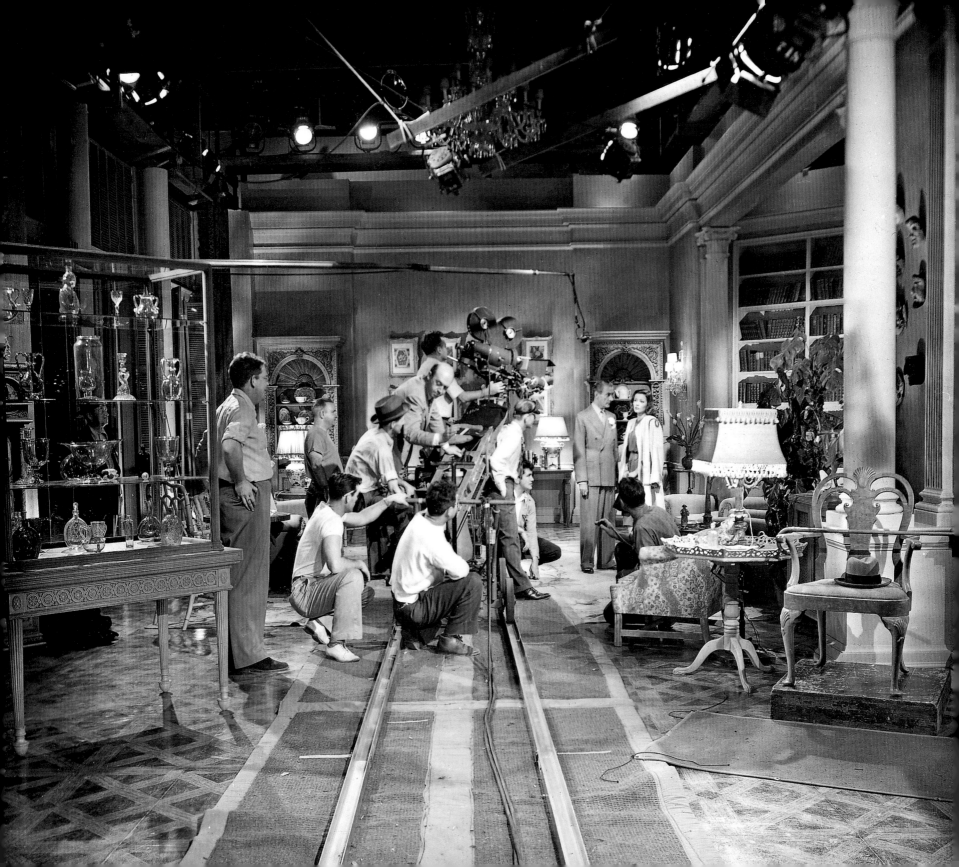

THE FORTIES

The Collapse of the Dream Factory

Take a femme fatale, add a fall guy in the form of a hapless insurance agent or private investigator, then give it an urban setting with dark shadows, alleyways, and fog bouncing off rain-soaked streets. Complete the scene with a haze of billowing cigarette smoke in a downtown nightclub. Mix in several of society's sins—greed, violence, jealousy, and alienation—and, for good measure, shoot from odd camera angles for a touch of doom. And, of course, capture it all in stark black and white. These are just a few of the ingredients that make up the classic film noir, a style made popular in the films of the forties.

Much like the dark horror films of the previous decade, the archetypal genre, named by the French film critic Nino Frank, in part owes its style to the German Expressionist movement. Using a high contrast of light and dark, angular sets, and an atmospheric haze, film noir employed an array of visual techniques to evoke the emotions of the central characters. With the world at war, film noir drew on the general mood of the times—cold war suspicion and the general paranoia. This overwhelming sense of fear and dread provided a marked contrast to the world of the thirties with its musicals and screwball comedies.

Just as audiences that flocked to the theater during the Depression era, the audiences of the forties found their essential escape, a perfect antidote to the changing times of World War II and its aftermath.

"LAST NIGHT, I DREAMT I WENT TO MANDERLEY AGAIN."

—MRS. DE WINTER, *REBECCA*

Rebecca (Selznick International/United Artists, 1940) is the classic Hitchcock thriller centered on a young woman's (Joan Fontaine) marriage to a rich widower, Maxim de Winter (Laurence Olivier). Upon arriving at a mansion called Manderley, the sweeping family estate where the couple will make their home, the young wife finds herself living with the omnipresent ghost of Rebecca, her husband's late first wife. Foreboding and gloomy, the mansion plays an important role in the film—becoming a third major character in the bizarre, ghostly love triangle. Everywhere the new Mrs. de Winter turns, there are constant reminders of Rebecca in the mansion's vast Gothic rooms. Endless staircases, a dismal fog that pervades the property, and the sinister maid Mrs. Danvers (who is always dressed in black and tends to glide across the sets, Dracula-style) all contribute to the film's shadowed world.

The sets for Manderley were designed by Lyle R. Wheeler, who stayed very truthful to the descriptions in Daphne du Maurier's 1938 novel. Once again, noir elements considered in the filming and art direction contribute to creating all sorts of emotions on screen—Maxim de Winter's brooding personality, the young wife's torment and fear, and Mrs. Danvers's sinister domination and loyalty to her original mistress, Rebecca. Film lore has it that Selznick searched all over North America for a manor house to represent Manderley and was finally convinced that a miniature version would work. Wheeler and his crew used the combination of matte shots and live action and thus saved Selznick thousands of dollars in the process.

RIGHT: A sketch of the Manderley estate in *Rebecca* (1940) • Dorothea Holt-Redmond, illustrator

OPPOSITE PAGE: *Rebecca* • Lyle Wheeler, art director

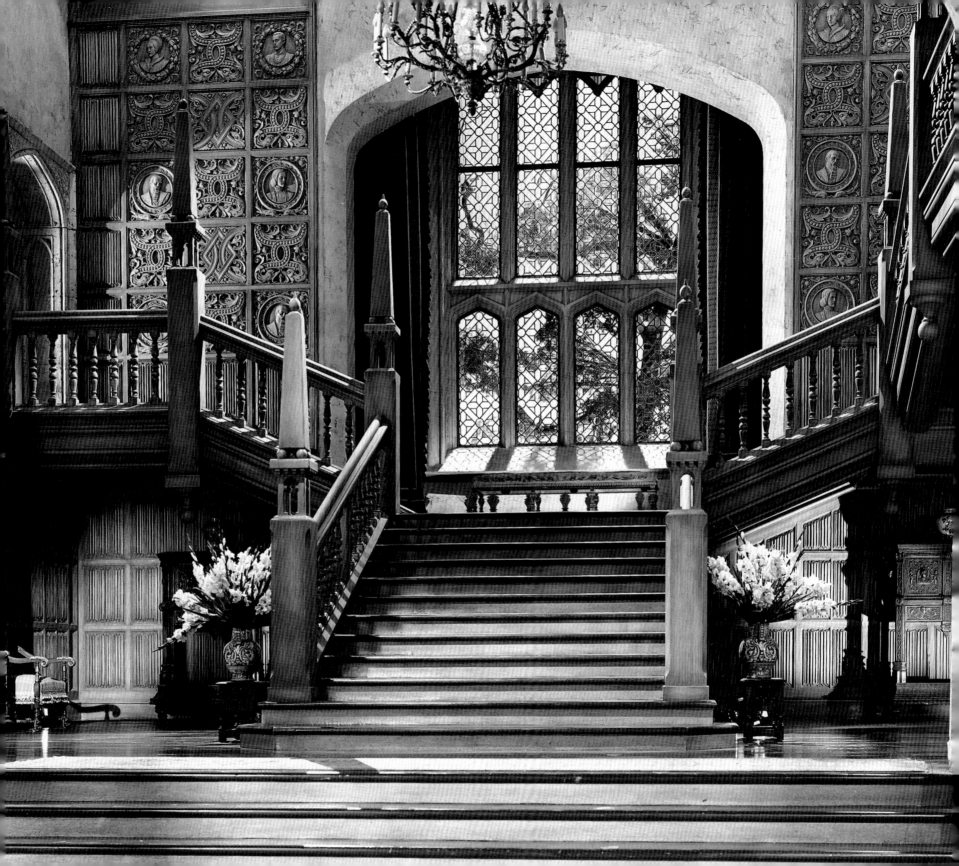

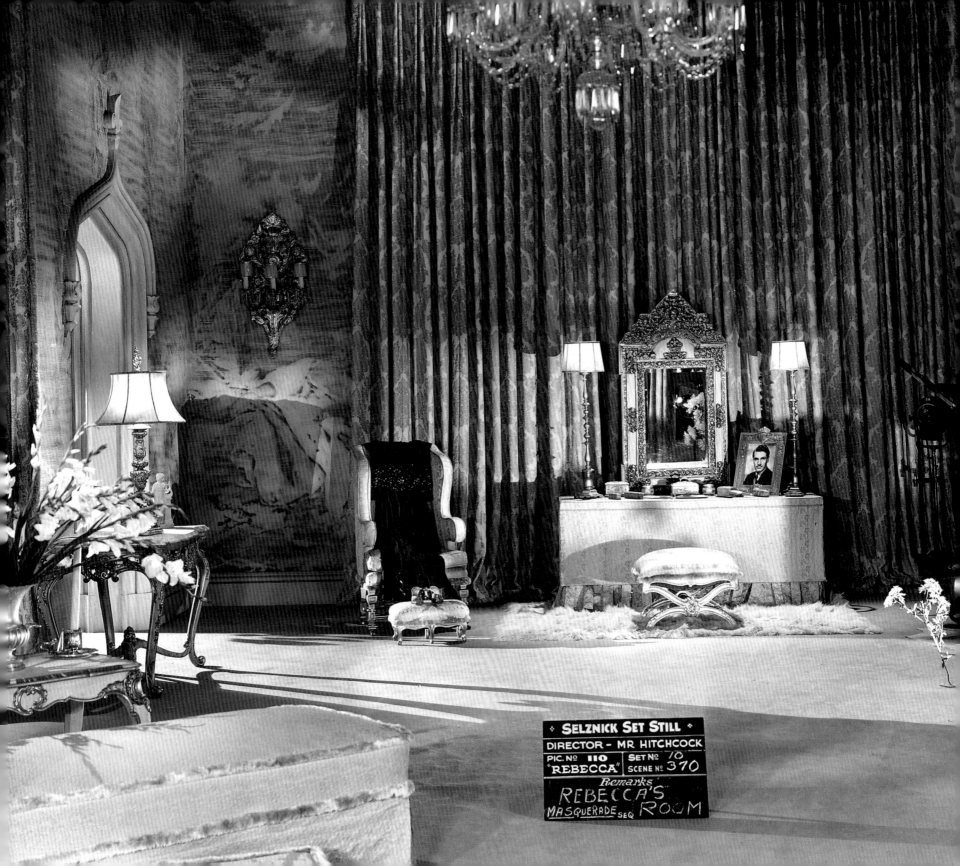

"I ALWAYS GAGGED ON THE SILVER SPOON."

–CHARLES FOSTER, *CITIZEN KANE*

The brainchild of director, writer, and star Orson Welles, *Citizen Kane* (RKO, 1941) is considered by many film historians to be one of the greatest films of all time. It introduced alluring technical images and elevated film design to a higher form. The landmark film is known for its use of unconventional backlighting (adopted by future film noirs), chiaroscuro (low-key lighting), and wide-angle shots that make the sets appear more intriguing and grander than they are.

The classic film depicts the life of an American financier, a rags-to-riches story of a man who grows up from humble roots to become a wealthy, arrogant, and lonely owner of a newspaper, rumored to be influenced by media magnate William Randolph Hearst. *Citizen Kane*'s Xanadu mansion is the central element of the story. A symbol of Kane's vast empire, Xanadu was built to satisfy the gargantuan ego of its owner, and it is filled with the antiques and possessions that match its larger-than-life scale.

The task of designing the film fell to the head of RKO's art department, Van Nest Polglase, but personal problems prevented him from actually doing any of the work. As was

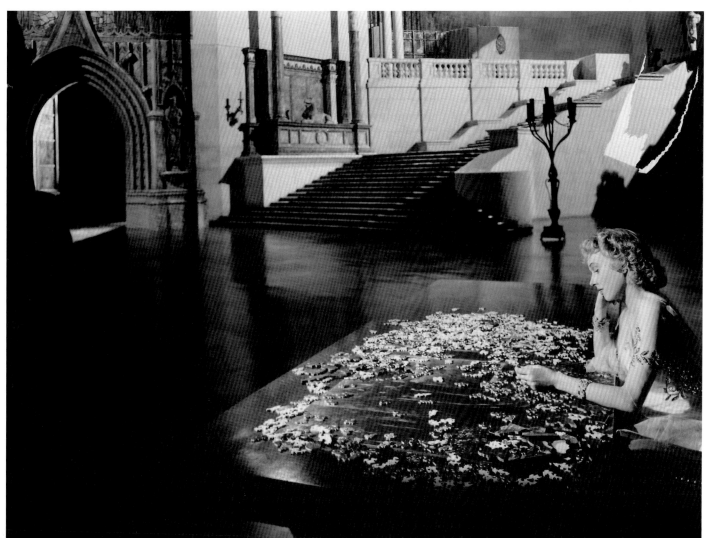

OPPOSITE PAGE: The late Mrs. de Winter's bedroom in *Rebecca* (1940) • Lyle Wheeler, art director

LEFT: "The Great Hall" of *Citizen Kane*'s Xanadu (1941) • Perry Ferguson, art director; Van Nest Polglase, supervising art director

typical of the hierarchy of the Hollywood studio system at that time, Polglase remained in charge in title only, but the actual genius of the film's impressive design was that of Perry Ferguson, the film's associate art director. Ferguson started out as a sketch artist and spent much of his career behind the scenes, working as an associate art director at RKO on such unmemorable comedies as *The Nitwits* and *Hooray for Love,* before his work on *Citizen Kane* placed him on the map. He went on to become art director on such classics as *The Best Years of Our Lives* and Alfred Hitchcock's *Rope.*

Obsessed with the grandiosity of Xanadu, Welles instructed Ferguson and his team to base their designs loosely on the Hearst mansion, San Simeon, and Mont Saint-Michel in France. The bean-counters at RKO had other plans—they reined in Welles and his expanding budget. As a result, Xanadu's "Great Hall" was the primary set for all interior scenes and it became a conglomeration of every type of design style, from Art Deco to Gothic. Plagued by budget problems, Ferguson had to create heavily ornamented rooms with next to nothing. Author Robert S. Sennett explains in his book *Setting the Scene:* "The entire mood of the film was altered substantially by one cost-cutting maneuver that Ferguson dreamed up to appease [cinematographer] Toland's need for deep spaces. Bare parts of the sets were draped with huge rolls of black velvet that when photographed, appear to lead the space on the screen into infinity. Thus rooms that merely consisted of a white plaster balustrade, a candelabra, and a staircase when combined with the proper perspective produced the illusion of traveling hundreds of feet into the background."

The film also shared the deep-focus technique used in Alfred Hitchcock's 1940 film *Rebecca*—an approach to filming where an object in the foreground and one in the background are kept in simultaneous focus. The deep-focus technique was known to produce an interesting two-

dimensional effect. Toland's black-and-white work coupled with the use of wide-angle shots, low-angle ceilings, matte paintings, and artfully arranged artifacts provided a unique visual experience for the audience.

Set decorator Darrell Silvera used set pieces, such as an existing oversize fireplace, to give the film an expensive look and add to the grandeur of the Great Hall. The huge space was also designed to project the growing emotional distance between Kane and his wife, Susan. The mansion begins to feel morose and empty as Kane spends his last years alone, surrounded only by his countless possessions, the most symbolic being the snow globe.

Citizen Kane represented a major departure from RKO's "Big White Sets" of the Fred and Ginger period. Ferguson and his crew received a well-deserved Academy Award nomination in 1942 for Best Art Direction—Interior Decoration, Black-and-White, along with a permanent place in the annals of filmmaking.

OPPOSITE PAGE AND ABOVE: *Citizen Kane* (1941) • Perry Ferguson, art director; Van Nest Polglase, supervising art director

RIGHT: *How Green Was My Valley* (1941) was shot in black and white because the color of the flowers in California did not match those found in Wales • Nathan Juran, art director; Richard Day, supervising art director

OPPOSITE PAGE: *Casablanca* (1942) • Carl Jules Weyl, art director

FROM WALES TO MALIBU

The masterpiece saga *How Green Was My Valley* (Twentieth Century Fox, 1941) is the story of young parents struggling to keep their families together despite hardships in a Welsh mining town. Originally, the film was set to be filmed on location in South Wales, but the Battle of Britain erupted in 1940 (South Wales was a target), and the production had to relocate to the unlikeliest of locations: the hills of Malibu.

Director John Ford and producer Darryl Zanuck decided to film the story in black and white, a choice that better expressed the dramatic content of the film, and masked the shooting location's landscape to provide the illusion of Wales.

The film was designed by Richard Day and Nathan Juran, who won an Academy Award for their efforts in creating a community on the lacerated hillside. The Welsh village was built on an eighty-acre set on the Fox Ranch and reused the following year as a Norwegian village in *The Moon Is Down*.

"OF ALL THE GIN JOINTS IN ALL THE TOWNS IN ALL THE WORLD . . ."
—RICK BLAINE, *CASABLANCA*

Every once in a great while, a jewel of a film comes along where the stars align and the art director and his team have the chance to make history. *Casablanca* (Warner Bros., 1942) was one of those films. This landmark classic has every element an audience could want and a filmmaker could hope for—exotic locales, star-crossed lovers, intrigue and drama set in the early days of World War II. Representing all that is best of classic Hollywood style, *Casablanca* sweeps us away to Morocco, wraps us up in a love story, and captivates audiences until Humphrey Bogart's final, fateful

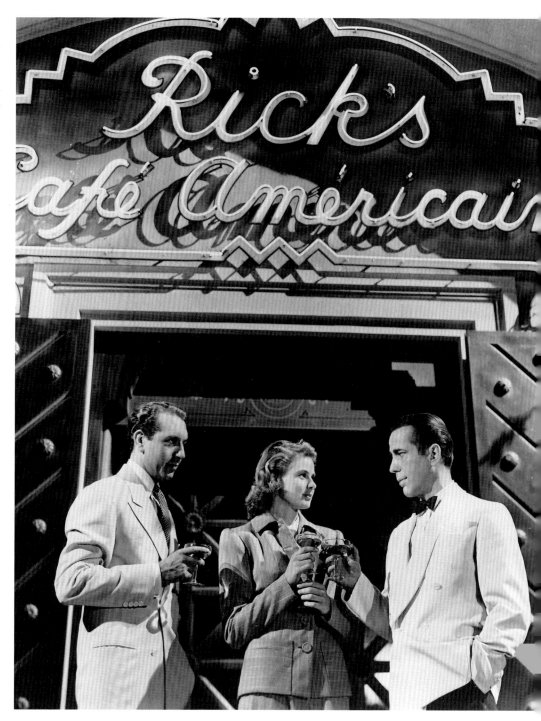

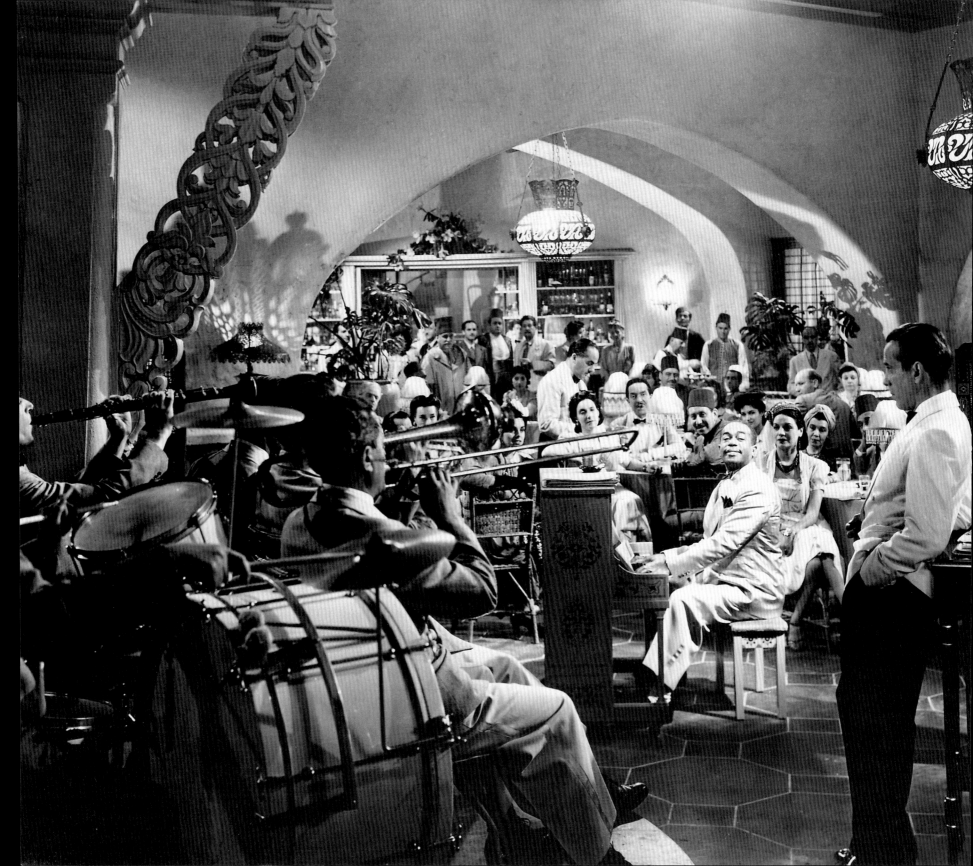

words, "Louis, I think this is the beginning of a beautiful friendship . . ."

In *Casablanca*, Morocco is shown as the last stop to freedom for those fleeing a Nazi-occupied Europe in World War II. At the film's center is Rick's Café Américain, an upscale-nightclub-cum-gambling-den that serves as the epicenter of activity. In true noir style, Rick's café is complete with dark corners, Moorish arches, and shadowy fog that add to its mystery and become the metaphor for the character of Rick and his life.

While it may look convincingly like French Morocco, the film was built on Warner's Soundstage 8 in Burbank, California. Rick's café was one of the few original sets constructed for the film, as the rest were all economically recycled from other Warner Bros. productions. For the initial airport sequence, studio carpenters had to construct the airport hangar interior, as well as a believable two-prop Air

France plane. The plane was scaled down in size to create the illusion that the studio airstrip was larger. Warner Bros.' new fog machine, which was previously debuted on the 1941 film *Sea Wolf,* was used for the final scene—an ironic choice, as a North African desert city would never see fog. The Paris train station where Ilsa deserts Rick was the original New England train station in *Now, Voyager.* The sets for Signor Ferrari's café and the Blue Parrot were borrowed from the film *The Desert Song,* which was shooting simultaneously on the Warner lot.

German-born Carl Jules Weyl was selected as the art director on the film, a backup choice after Anton Grot proved unavailable. Weyl was especially favored by the film's director, Michael Curtiz, and was a natural for the job, having worked on films that involved war, intrigue, and foreign locations, such as *Espionage Agent, Confessions of a Nazi Spy,* and *Men in Exile.* George James Hopkins was named set decorator, a

position that would launch an exemplary career on such films as *Mildred Pierce, A Star Is Born,* and *My Fair Lady.*

The art direction of *Casablanca* accomplishes what is known as "invisible style": a nuanced way of designing where subtle elements like a table filled with martini glasses, or the whirl of airline propellers on a foggy runway, end up meaning as much to a narrative as dialogue. Perhaps one of *Casablanca*'s greatest admirers was another German-born production designer, Ken Adam. Taken with the atmosphere and romance of the drama, Adam felt that the "one thing that I think works in *Casablanca* and which I've lectured a lot about—in terms of what I've been

trying to achieve as a designer—is the film's creation of its own form of reality. I was a strong believer, in the [James] Bond [films] and *Dr. Strangelove,* in departing from actual reality and inventing my own type, what I thought would appeal to the audience. And in a strange way, that's what happened in *Casablanca.* It suited the atmosphere of the film, because you are carried away by it, and it seems absolutely right in terms of the story." Weyl's designs embodied the true magic of art direction—he put fog in a desert and audiences never thought twice about it.

IT ALL BEGAN WITH A PORTRAIT . . .

Heralded as one of the most stylish and elegant film noirs ever made, *Laura* (Twentieth Century Fox, 1944) is the story of a young Manhattan career woman who is murdered before the beginning of the film. The detective investigating the crime becomes obsessed with Laura, by way of the large portrait of her in her apartment. Produced by Otto Preminger, the film employs many of the characteristic film noir techniques: high-contrast black-and-white photography, mood lighting, and decadence.

Art directors Lyle R. Wheeler and Leland Fuller, along with set decorators Thomas Little and Paul S. Fox (who later became known for their cosmopolitan interiors on such films as *All About Eve* and *An Affair to Remember,* respectively) designed the elegant traditional décor and received an Academy Award nomination for the film. In contrast to Laura's apartment, they designed the "lair" of acid-tongued columnist Waldo Lydecker (Clifton Webb) with an oversize marble bathtub on a platform. "It's lavish," Lydecker remarks in the film, "but I call it home."

The set decorators used floral chintz, Aubusson area rugs, and festooned draperies with tricolor trim for Laura's sophisticated apartment, a style that was on the forefront of the decade's trends, and would still be at home with today's English styles. The plot depends upon each character's apartment, as the décor offers the audience various subtle clues. Using flashbacks, the camera jumps from right to left in Lydecker's penthouse, panning across glass shelves filled with objets d'art, Oriental artifacts, and a Baroque grandfather clock. When we see Laura's apartment, her portrait over the fireplace gazes upon us and we see an identical Baroque clock. The seed of a mystery is planted.

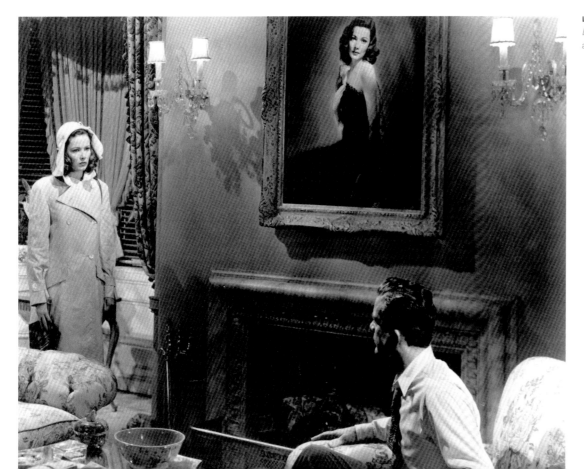

LEFT AND FOLLOWING PAGE:
Laura (1944) • Lyle Wheeler and Leland Fuller, art directors

MOTHER VERSUS DAUGHTER:
MILDRED PIERCE

Mildred Pierce (Warner Bros., 1945) is classic film noir at its finest—an intriguing mix of soap-opera-style drama and murder. By today's standards, it would most likely be called a "chick flick."

Instead of the typical femme fatale protagonist, the central female in *Mildred Pierce* is a homemaker. After her philandering husband leaves her and her daughters, Mildred (Joan Crawford) enters into business, opening her own restaurant. Trouble boils up when Mildred is no longer able to control her spoiled daughter Veda, who also just happens to steal her mother's boyfriend, in true soap-opera style.

Anton Grot designed the memorable sets, including a suburban restaurant, Mildred's bungalow, and Malibu beach

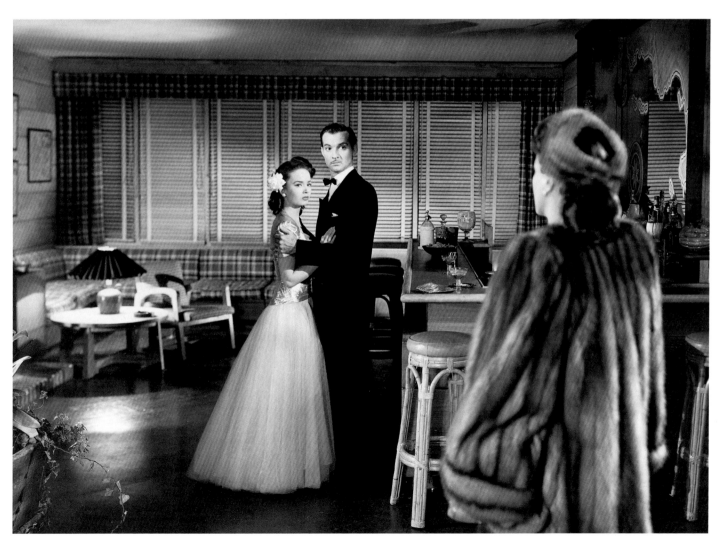

LEFT AND FOLLOWING PAGES LEFT AND RIGHT:
Mildred Pierce (1945) • Anton Grot, art director and illustrator

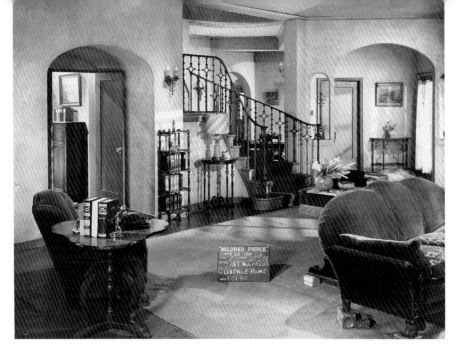

house. The beach house, which is used in the film's opening, as well as other key scenes, was the home of the film's director, Michael Curtiz, and, much like a film noir character, it collapsed into the ocean during a storm in the eighties.

Grot's characteristic use of shadow and light is a technique that served him well during his gangster film design days at Warner Bros., and his unique roots are evident throughout *Mildred Pierce*. He was a master at creating illusion, and his use of menacing dark shadows would literally cast patterns on the walls that only added to the intrigue and suspense in the film's murder at the Beragon beach house.

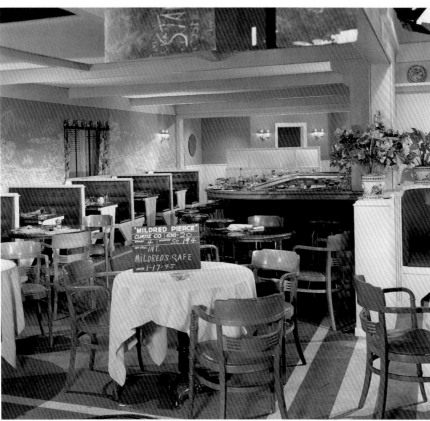

"IT'S A CONSPIRACY, I TELL YOU. THE MINUTE YOU START THEY PUT YOU ON THE ALL-AMERICAN SUCKER LIST. YOU START OUT TO BUILD A HOME AND WIND UP IN THE POORHOUSE."

—MR. BLANDINGS, *MR. BLANDINGS BUILDS HIS DREAM HOUSE*

The domestic problems that plague first-time homebuilders are at the core of this screwball comedy starring Cary Grant and Myrna Loy. Designed by Carroll Clark and Albert S. D'Agostino, *Mr. Blandings Builds His Dream House* (RKO, 1948) is noteworthy for its window on the times—the post–World War II suburbs—as young Americans head there in droves, in search of the American Dream.

The Blandings choose Connecticut as their slice of heaven, fleeing the city in search of a house with rolling hills, a fireplace, and a patio for barbecues. The sets, shot in black and white, are filled with classic forties/fifties décor—rag rugs, chintz sofas, upholstered Queen Anne chairs, and cornice-topped draperies.

RIGHT AND OPPOSITE PAGE:
Mr. Blandings Builds His Dream House (1948)
• Carroll Clark and Albert S. D'Agostino, art directors

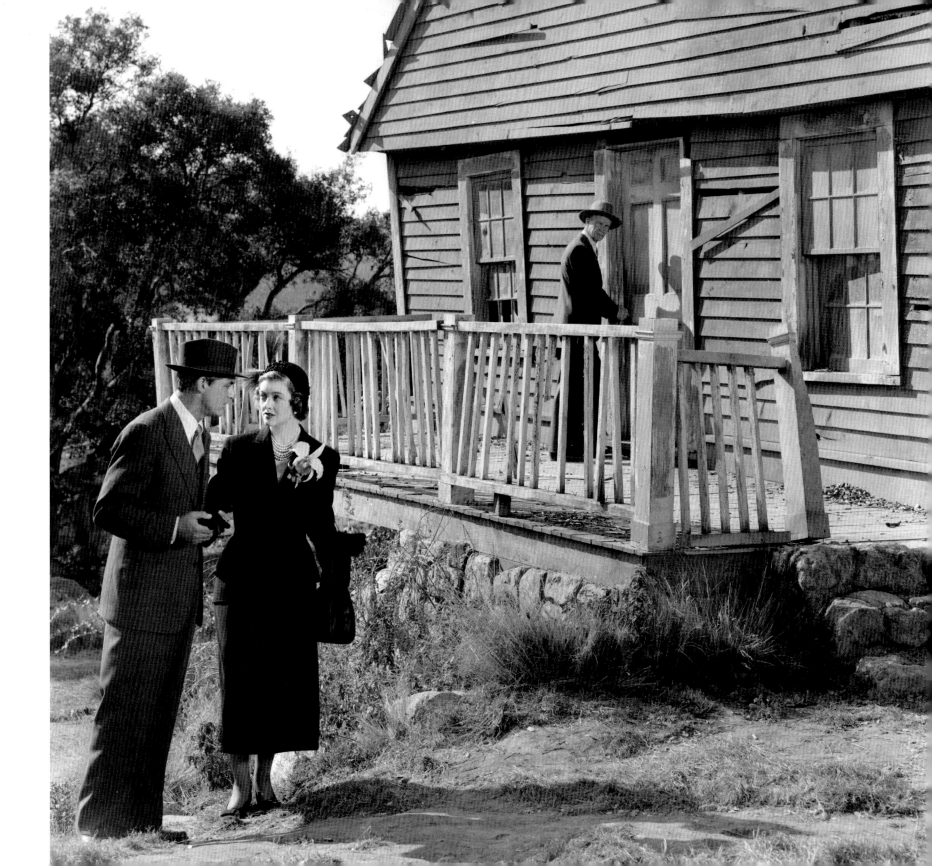

"WHERE BEAUTY AND GENIUS AND GREATNESS HAVE NO CHANCE."

The Fountainhead (Warner Bros., 1949), the film based on Ayn Rand's bestselling novel, paid homage to Frank Lloyd Wright and lauded modern architecture as the new international style of the decade. In the lead role, Gary Cooper portrayed the quintessential maverick architect Howard Roark. Roark is commissioned to design a structure that represents the future of things to come—an experimental luxury apartment building called the Enright House (a nod to Wright). When the local newspaper leads a smear campaign against the building to boost circulation, Roark refuses to compromise and becomes the lone champion struggling against the establishment.

Warner Bros. originally approached Wright to design the film himself, but they were forced to look elsewhere when Wright asked for his usual design fee of $250,000. Instead, Edward Carrere, a young art director and former set designer at RKO, was handed the plum job. While, at the time, he had only worked on four films, Carrere would go on to work on Alfred Hitchcock's *Dial M for Murder,* and to share an Academy Award with production designer John Truscott for their work on the 1967 film version of *Camelot.*

While Wright's influence is felt throughout the film, the house that Roark designs for a client is perhaps the most direct reference, as it is very similar to the famous Fallingwater, with its "floating trays [that are] visually moored by a floating stone chimney block" as noted by *Designing Dreams* author Donald Albrecht. Carrere also took his design cues from the International Style. The style gave us the works of Le Corbusier, Walter Gropius, and Mies van der Rohe. With its characteristic use of steel, glass, and elegance, the look is devoid of ornamentation, much like the characters of *The Fountainhead.*

Carrere's exemplary sets in *The Fountainhead* included an Art Deco office for the head of the newspaper, and the sumptuous bedroom of Dominique Franchon, played by Patricia Neal. Photographed in black and white, the living room set is featured against a winding stairwell that appears suspended in space, while angular tables and furnishings were set on the diagonal against a backdrop of skyscrapers.

While the design elements of the film were actually very much on par with the fashionable and modern designs of the day, ironically, the architectural community (such as architect George Nelson in *Interiors* magazine) reacted negatively to the film. In tune with the emerging style, Carrere used abundant wall-to-wall glass windows, reflective floors, staircases that appeared to float from ceiling to floor, and

BELOW AND OPPOSITE PAGE: *The Fountainhead* (1949) • Edward Carrere, art director

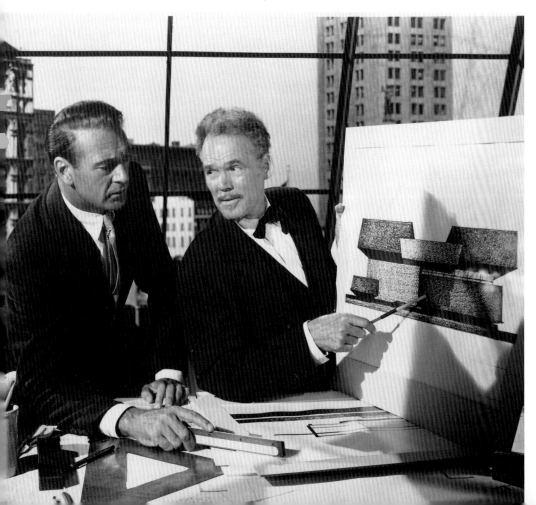

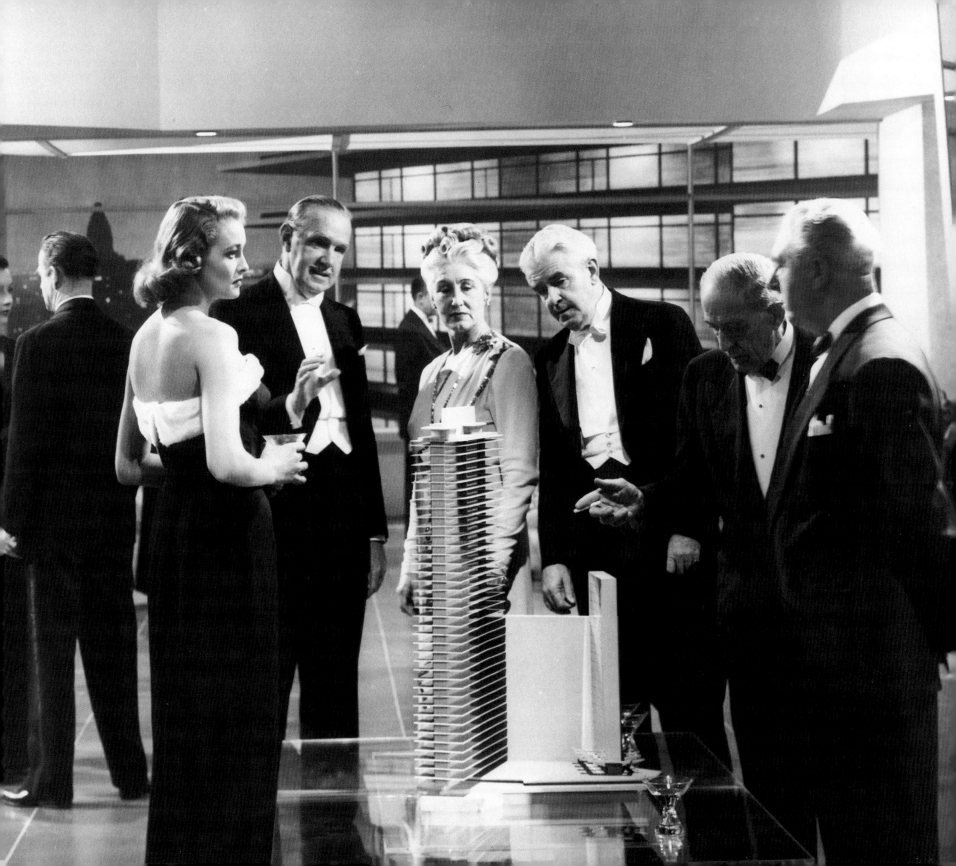

indoor terraces, which would soon appear in postwar New York and other metropolitan city apartment buildings. The consensus was that the designs seen on film were outrageous and represented the worst of modern architecture, which ironically followed the book and film's plot. It seems as though Carrere was just slightly ahead of the times, as *The Fountainhead* is now remembered for its brilliant design aesthetic.

THE FORTIES PERIOD FILM

Two films of the decade that provide great examples of a similar design style are the period dramas *The Heiress* (Paramount, 1949) and *The Magnificent Ambersons* (RKO, 1942). Both depict family turmoil among the upper classes.

Meticulously designed by production designer Harry Horner, the Academy Award–nominated sets of *The Heiress* successfully express the repression of a plain and simple young woman living at home with her wealthy father, surrounded by suffocating period furnishings. Horner designed the house as a symbol of the family's wealth and history and spent more than a year studying nineteenth-century decoration and architecture. The parlor rooms are filled with traditional wallpapers and fabrics of the Gothic Revival movement. While elegant in nature, the interiors were also used as a plot device, creating a sense of confinement for the naïve and suppressed daughter Catherine, played by actress Olivia de Havilland.

The Magnificent Ambersons is the story of a "manor-born" family spanning two generations living in an upper-middle-class Midwestern town. The film depicts their

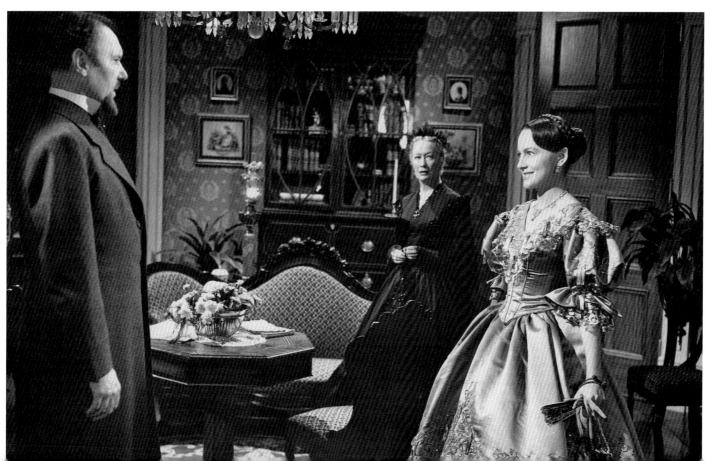

OPPOSITE PAGE:
The Fountainhead (1949) • Edward Carrere, art director

LEFT: *The Heiress* (1949) • Harry Horner, production designer

rise and fall at the dawn of the industrial age and rise of the automobile. Orson Welles produced, directed, and scripted *The Magnificent Ambersons*, his first film since *Citizen Kane* (1941). Welles makes the Amberson mansion a central character in the story. Designed by Albert S. D'Agostino, the stately home is described as the pride of the town with all of its modern luxuries—custom woodwork, hot and cold running water, and stationary washstands in every bedroom.

Much like *Citizen Kane,* the mansion is filled with vast rooms creating distance, literally and figuratively, between characters. Welles employs a familiar touch in making the stairway a focal point for drama. The mansion's dramatic three-story spiral staircase is used as an eavesdropping device throughout the film, and it is designed with pockets of dark shadows to create an otherworldly aura.

Both *The Heiress* and *The Magnificent Ambersons* represent classic film period design, depicting life among the moneyed set in early- and mid-nineteenth-century America, respectively. Through the use of architecture, design, costumes, and even props (such as the prevalent automobiles in *Ambersons*), the well-conceived and -designed sets become an important part of the storytelling.

WHILE WORLD WAR II dominated most of the decade and changed the course of history, Hollywood produced some of the most important films of the century. Many were signs of the times, with stories of heroism and intrigue (*Casablanca*), and life in postwar suburbia (*Mr. Blandings Builds His Dream House*). Other films became masterpieces (*Citizen Kane*) with their use of innovative filmmaking techniques. By the end of the decade, a new genre was born, as film noir's dark and brooding designs and chiaroscuro lighting became a staple in gun-moll- and femme-fatale-filled gangster films and contemporary dramas, such as *Laura* and *Mildred Pierce.*

OPPOSITE PAGE: The design of the spiral staircase became a key plot device in *The Magnificent Ambersons* (1949) as the characters used it for eavesdropping • Albert S. D'Agostino and Mark-Lee Kirk, art directors

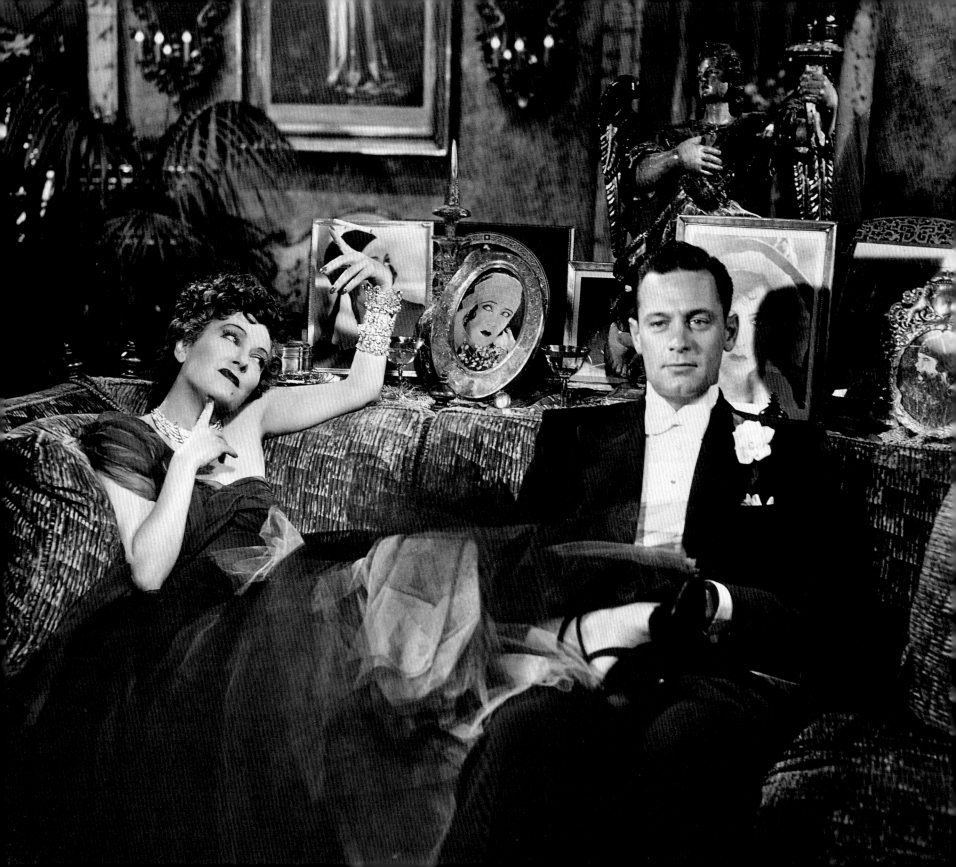

THE FIFTIES

A Decade of Widescreen and Epics

I am big. It's the pictures that got small.

—Norma Desmond, *Sunset Boulevard*

Actually, Norma got it wrong: the pictures did get bigger.

In film, the fifties was the decade of the extravagant epic, the big-budget blockbuster, and the pull-out-all-the-stops musical. Advancing technology raised the bar for adventure films, and historical epics such as *Ben-Hur* set the gold standard for action films to come. Even the screens grew larger with the debut of a litany of widescreen processes—Cinerama, Cinemascope, Panavision, and VistaVision—all designed to attract larger audiences with growing expectations.

The fifties was also the decade of Hitchcock. The Master of Suspense elevated the thriller to an art form with his films *Vertigo* and *North by Northwest*. Director George Stevens gave us his "American trilogy" with the melodrama *A Place in the Sun,* the battle of good versus evil in the classic western *Shane,* and the family saga *Giant*. Film design in the fifties ran the gamut. From the early days of Rome to the streets of Paris, expensive and lavish epic sagas like *The Robe* and *Ben-Hur,* and musicals *An American in Paris, The King and I,* and *Gigi* represented some of the best in production design. Sets designed specifically for high anxiety, melodrama, science fiction, and low-budget westerns were also part of the cinematic landscape.

OPPOSITE PAGE:
Sunset Boulevard (1950) • John Meehan, art director; Hans Dreier, supervising art director

The fifties began with the demise of Norma Desmond, the legendary silent film star from an era whose time was long over. In a case of life imitating art, director Billy Wilder traced an aging film star's fall from the limelight in the cautionary parable *Sunset Boulevard* (Paramount, 1950). This classic film depicts the hard truth that marked the beginning of the fifties—the decline of old Hollywood. *Sunset Boulevard* represented the last remnants of the Golden Age and its dream factory.

"IT WAS A GREAT BIG WHITE ELEPHANT OF A PLACE. THE KIND CRAZY MOVIE PEOPLE BUILT IN THE CRAZY TWENTIES. A NEGLECTED HOUSE GETS AN UNHAPPY LOOK. THIS ONE HAD IT IN SPADES."
—JOE GILLIS, *SUNSET BOULEVARD*

Sunset Boulevard is a noir tale that goes behind the scenes of old and new Hollywood. A Faustian saga, the film tells

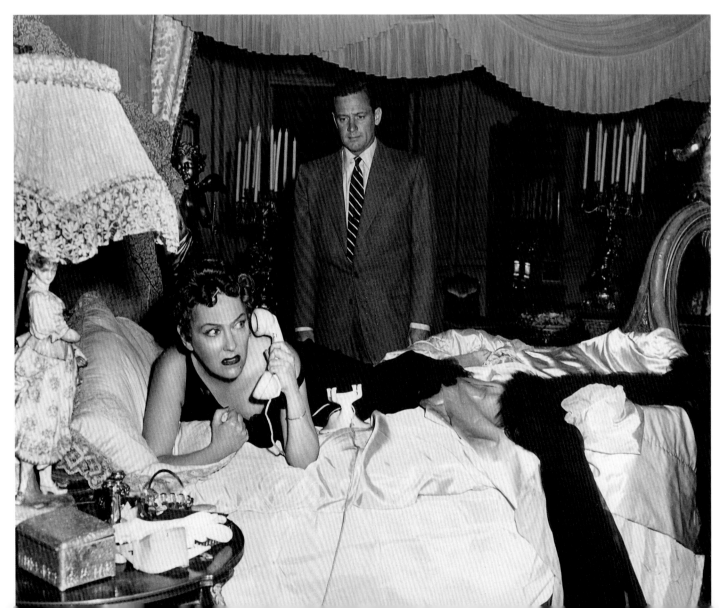

RIGHT: Norma in her "bed like a gilded rowboat" in *Sunset Boulevard* (1950) • John Meehan, art director; Hans Dreier, supervising art director

OPPOSITE PAGE: "You know, this floor used to be wood, but I had it changed. Valentino said there's nothing like tile for a tango"—Norma Desmond (Gloria Swanson) to Joe Gillis (William Holden) in *Sunset Boulevard*

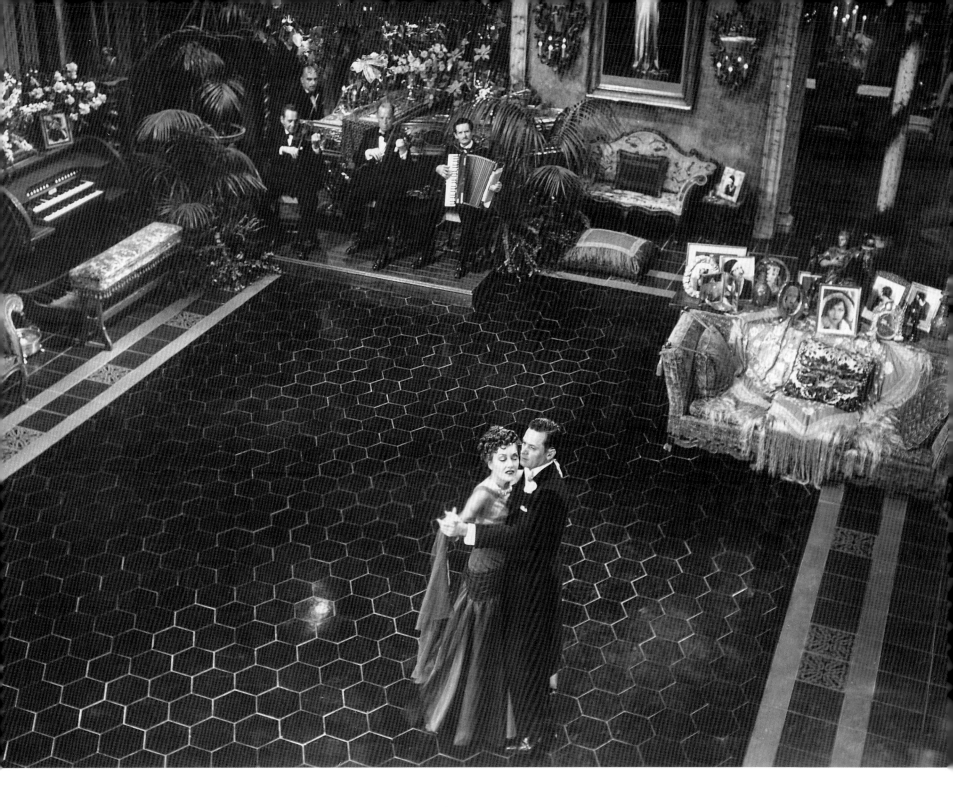

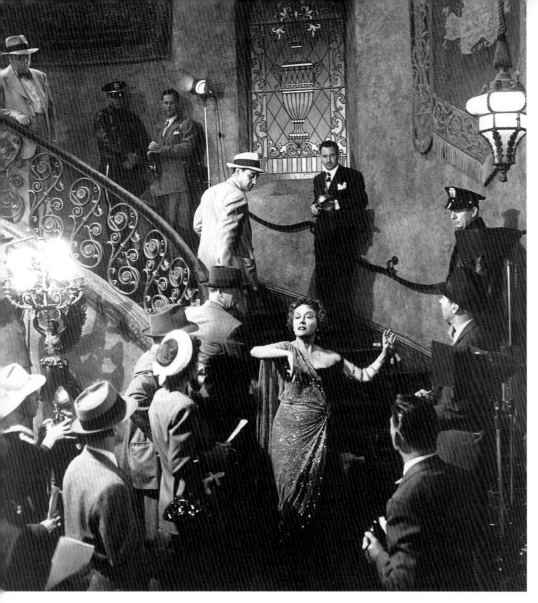

foreboding. As Gillis narrates in a flashback: "The whole place seemed to have been stricken with a kind of creeping paralysis, out of beat with the rest of the world, crumbling apart in slow motion. There was a tennis court, or rather the ghost of a tennis court, with faded markings and sagging net. And, of course, she had a pool—who didn't then? Mabel Normand and John Gilbert must have swum in it ten thousand midnights ago, and Vilma Bánky and Rod La Rocque. It was empty now—or was it?"

The mansion becomes a metaphor for the decay of Hollywood and the emptiness of its owner. The house is surrounded by an atmospheric cloud of despair—the audience can smell the rotting grounds, feel the loneliness, and see the dust settled on the Art Deco tables within the mausoleum-like rooms. Every detail suggests better days gone by, from the eerie outdated pipe organ in the living room to Norma's "bed like a gilded rowboat," yet silver-framed photographs of Norma and her cronies in the silent era give us clues to her glamorous past.

The film was designed by one of the premier art directors of the Golden Age, Hans Dreier, along with John Meehan, who designed *The Heiress*. The atmospheric look of the production was said to draw influence from David Lean's adaptation of Charles Dickens's *Great Expectations*, a similar tale of a fallen-down mansion and its eccentric owner.

Sunset Boulevard also marked the move from traditional studio-controlled soundstages to films shot on location. The mansion set was an actual house built in 1924 and was rented from the second Mrs. Jean Paul Getty. Ironically, it was located on Wilshire Boulevard.

The designs won the production team the Academy Award for Best Art Direction (in black and white) in 1951. Dreier also won the award for Best Art Direction (in color) that same year for his work on *Samson and Delilah*.

ABOVE: *Sunset Boulevard* (1950) • John Meehan, art director; Hans Dreier, supervising art director

the story of a young screenwriter, Joe Gillis (played by William Holden), and his "relationship" with an aging, bitter, and long-forgotten silent film star, Norma Desmond (played by Gloria Swanson).

While the costumes dazzled and the sets spoke of old Hollywood, perhaps the real star at the heart of this classic film is the Sunset Boulevard mansion itself. From the moment we first see the deteriorating estate, we feel a

HITCHCOCK IN HOLLYWOOD: DESIGNING FEAR AND ANXIETY

Spiral Stairs and Hair: *Vertigo*

The twisted coif of the female lead Madeleine, the bell tower's spiral staircase, Detective Scottie Ferguson's chair, a round decorative plate hanging on the wall in his apartment, and the chandelier in the McKittrick Hotel all reflect the recurring "spiral" motif at play in the unique Hitchcock mystery *Vertigo* (Paramount, 1958).

The story revolves around recently retired San Francisco police detective Scottie Ferguson (James Stewart), who develops a fear of heights known as vertigo after his partner is killed. Ferguson is hired to follow the wife of a friend, the cool and mysterious Madeleine (Kim Novak), who seems to have an obsession with death.

The repeating spiral motif becomes a connecting thread through the complex film. Its appearance signals fear and apprehension, from the spiraling iris in Madeleine's eye to Scottie's dreaded ascent upward in the spiral of the bell tower. Perhaps a metaphor for a life spiraling out of control, the film is a true psychological study of love, fear, and obsession.

Filmed in 1957, one of the key scenes took place in the bell tower at the San Juan Batista Spanish Mission. Unfortunately, a real bell tower did not exist on the property and one had to be created with the technique of a matte painting. Many people on the *Vertigo* set recall that Hitchcock's famous attention to detail was more acute than ever. He insisted that the color, visuals, and performances had to be perfect. One of the most expensive sets in the movie was the shipbuilding office, which was built on two levels with seven walls and used processed plates as "scenery" outside every window.

Henry "Bummy" Bumstead was the film's production designer, who graduated from the University of Southern

LEFT AND FOLLOWING PAGE: The spiral motif was used on everything—from the winding staircase to Kim Novak's French chignon—in *Vertigo* (1958) • Henry Bumstead, production designer and illustrator

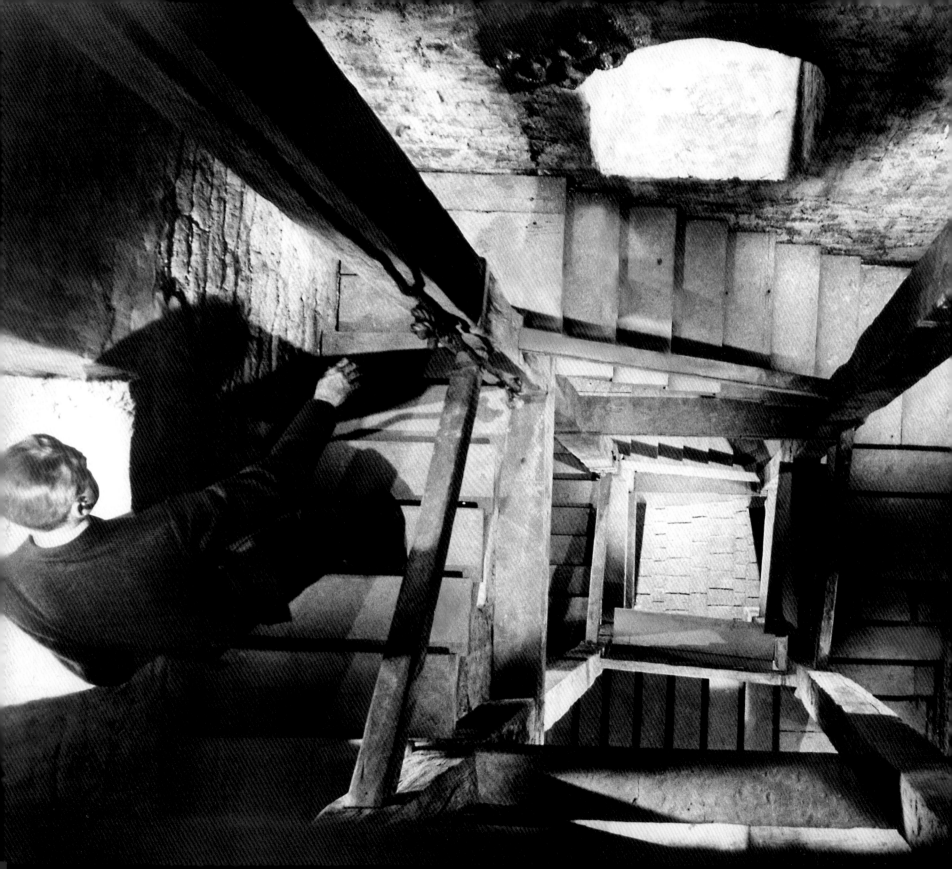

California, having attended the school on a football scholarship. When sidelined by an injury, Bumstead studied art and architecture and eventually landed a job at Paramount, working for $35 a week under Hans Dreier. Dreier became Bumstead's mentor, a teacher who stressed the importance of reading between the scripted lines in order to better understand the personalities of characters in a film. He taught his students how to make sets look truly lived-in through the use of precisely chosen details. Dreier would even go as far as placing a pack of cigarettes and matches in a drawer for a character, even if the audience would never see them—a trait that was surely passed down to Bumstead.

Bumstead is known for his successful collaborations with directors such as Robert Mulligan (*To Kill a Mockingbird*), George Roy Hill (eight films in all, including *The Sting* and *The Great Waldo Pepper*), Martin Scorsese (*Cape Fear*), and, perhaps the longest run of all, Clint Eastwood, with whom he made twelve films (including *High Plains Drifter*, *Unforgiven*, *Flags of Our Fathers*, and *Letters From Iwo Jima*). While "Bummy" has worked on every type of film style, his most celebrated films have been the westerns. "The western is, of course, my favorite, as they are character pictures, such as *High Plains Drifter* and *Unforgiven*," he said in a personal interview, citing his love for the Victorian architecture needed to portray prototypical western towns.

Bumstead's career began in the late thirties with sound-stage sets, evolved to include the location work that made its debut in the fifties, and stretched on to include the production design of today. While he wanted to be a football player or cartoonist, a talent that has proved immensely helpful in doing storyboards, choosing a career in film proved to be the right one, as he won two lifetime achievement awards (Art Directors Guild, 1995, and Hollywood Film Festival, 1998), as well as two Academy Awards for *To Kill a Mockingbird* (1962) and *The Sting* (1973).

Building Mt. Rushmore: *North by Northwest*

North by Northwest presents the classic Hitchcock formula—leading man Cary Grant plays Roger Thornhill, an advertising executive who is mistaken for a spy and hunted across the country, and falls in love with a gorgeous blonde in the process. The legendary film is noted for its spectacular production design, brilliantly executed by Robert Boyle, particularly the memorable climax at Mount Rushmore.

Hitchcock was unable to obtain permission to film the Mount Rushmore scene on location, as the Department of Interior was not keen to have a movie crew shoot a murder scene on a national treasure. Hitchcock felt that the scene "defended democracy, not defaced it," and promised that the actors would never appear on the presidents' "faces." But he was unable to convince the powers that be, and the climactic cliff-hanger sequence was created in miniature on Stage 5 at MGM.

In order to ensure the accuracy of the miniature sets, Boyle first had to do some dangerous scouting work at the actual monument. Hoisting himself down by rope to take photographs, Boyle earned the nickname "the Man on Lincoln's Nose." The crew constructed a final set that reached a mere 30 feet high and 150 feet wide. "The heads you saw were the photographs I made while going down

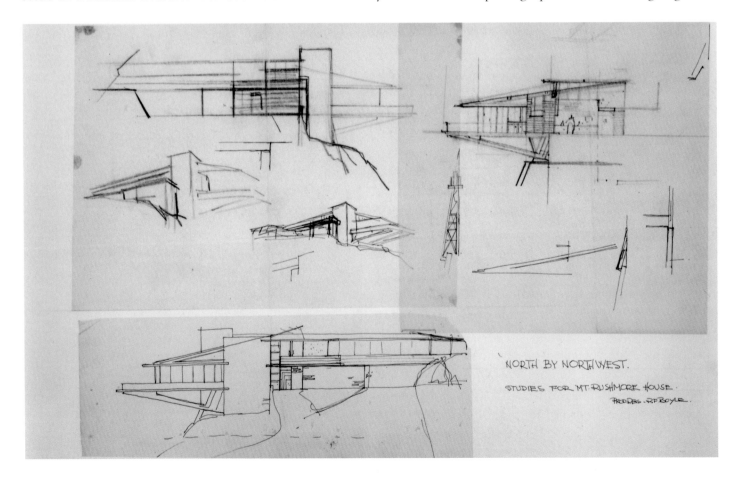

RIGHT: Production designer Robert Boyle's architectural drawings for *North by Northwest* (1959). Frank Lloyd Wright's famed Fallingwater residence was a major influence for the Vandamm house.

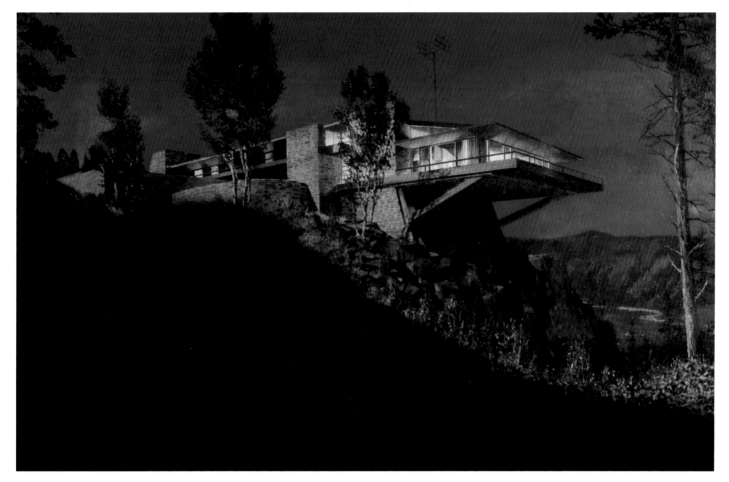

Mount Rushmore," explains Boyle to author Vincent LoBrutto in his book *By Design*. "We'd get a long shot and print the actors into it. We only had little pieces of sets. The set pieces were just large enough to cover the action and placed as foregrounds only, in front of the rear-projected [images]."

Location issues didn't stop at national landmarks—Hitchcock was also unable to obtain permission to film inside the United Nations, so he had his crew shoot the interior with a hidden camera and then replicated the set on a soundstage. The Plaza Hotel and its landmark Oak Bar also required duplication, as the corridors were too narrow for the VistaVision cameras used at the time. Grand Central Station was another New York landmark used for the film. According to Boyle, the amount of light they had to pour into the massive building nearly bankrupted MGM.

Boyle and his crew also found themselves dabbling in forestry—they were forced to hand-plant one hundred ponderosa pines for a scene set in "South Dakota," where Eve Kendall (Eva Marie Saint) reveals her double-agent status. The seven-minute crop-duster chase segment set in a "Midwest cornfield" remains one of the most memorable

shots on film. Most of the work was done on soundstages as "[Hitchcock] disliked the location chaos and loved the controlled environment of a studio," remembers Boyle.

One of the most spectacular sets was the home of the story's villain, Phillip Vandamm, played by James Mason. With a nod to Frank Lloyd Wright's cantilevered Fallingwater house in Pennsylvania, Boyle built the house to meet several specific criteria—as it was imperative that Grant's character be able to "see in the living room, balcony, girl's bedroom," he explained. "You had to be able to climb up to the bedroom. You have to have access and to climb were the two main criteria. It had stonework and a

great handhold for Cary. It had to be a kind of jungle gym for Cary."

Like Bumstead, Boyle was a graduate of the University of Southern California, and with a degree in architecture he was a natural for the job. Unable to find work as an architect during the Depression, he turned to the Hollywood studio system. Seeking work as an actor, a bit player, Boyle met Van Nest Polglase, who referred him to Paramount and to the man who would become his mentor: Hans Dreier. A product of the Golden Age, Boyle made the studio rounds; during his career he worked at RKO, Columbia, Warner Bros., Universal, MGM, and Goldwyn. Boyle recalls that "in the studio system everyone had an enclave all its own. They were marvelous—like little islands all over town. I never intended to do production design as I studied architecture at USC. Economy got me into film and I never looked back."

His big break came when Hitchcock hired him to work on the thriller *Saboteur* as a storyboard artist. All the sets for *Saboteur* were made on the studio lot, including a mock Statue of Liberty for the film's thrilling climax. As a former art director himself, Hitchcock was known as an art director's best friend—he was always interested in projecting the best visual statement possible. "Each shot must make its own statement, it must relate to all the other shots, and there is no such thing as a throwaway shot. That was the major truth I learned from working with Hitchcock," says Boyle.

Hitchcock also believed in an art director's autonomy. "Once Hitch trusted you, you were on your own. I find Hitch a catalyst to my own creative functioning and on each picture I recognized again, as if for the first time, that I was working with a master. He is one of the few who knows his materials of this craft and their effect—and he will use anything—in any combination, in any form, conventional or not—to make his statement, to tell his story."

The psychological elements of Hitchcock's films required sets that were specifically designed to heighten the terror, fear, and anxiety felt by the characters, as well as the audience, and the team of Hitchcock and Boyle proved a masterful combination.

The pair worked on *Shadow of a Doubt*, and Boyle worked as the associate art director on *The Birds* and *Marnie*. In a successful career that spanned over half the century, Boyle designed rich and varied sets from every type of film genre, including *The Thomas Crown Affair* (1968), *Fiddler on the Roof*, *Mame*, and *The Shootist*. He has been nominated for an Academy Award four times, including for his outstanding work on *North by Northwest*.

SALOONS, STETSONS, AND SAGE-BRUSH: DESIGNING THE OLD WEST

One wouldn't necessarily think that western films would require masterful art direction, as the pictorial landscape of Tombstone or Monument Valley alone speaks volumes. But production designers have found that the challenges of natural scenic landscapes can be the most difficult; designers have to virtually create frontier towns and homes from scratch, using materials authentic to the time period. The lone homestead on the prairie, the saloon with its swinging doors, the plank-top tables and dusty floors all have to be carefully and authentically executed.

The design team must work to create sets in these big-sky environments in a believable fashion. Painstaking research is required, and many designers have been known to study the paintings of Remington, who was said to have captured the true romance of the West as no other artist has. Two films that represent the best of the genre in the fifties were the masterpieces *High Noon* and *Shane*.

In a classic battle of good versus evil, Fred Zinnemann's

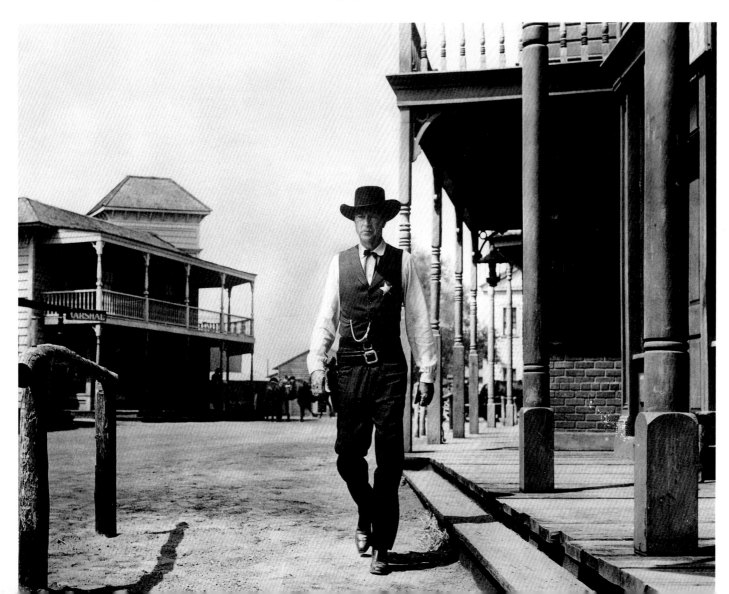

LEFT: *High Noon* (1952) • Rudolph Sternad, production designer

OPPOSITE PAGE
AND LEFT: *Shane*
(1953) • Walter
Tyler, art director
and illustrator; Hal
Pereira, supervising
art director

INT. GRAFTON'S STORE & SALOON

High Noon is considered by many film historians to be one of the best westerns ever made. Production designer Rudolph Sternad and cinematographer Floyd Crosby were instructed to design the film with a washed-out, black-and-white documentary look. Taking Buster Keaton's cue from decades earlier, they studied the Civil War photos of Mathew Brady as a reference. The legendary Los Angeles smog in the valley contributed to the look of the film, as the production experienced hazy days for the entire twenty-eight-day shoot.

Director George Stevens's *Shane* tells the tale of a mysterious gunfighter, played by Alan Ladd, who packs up his gun and holster to settle down. But when problems arise and a cattleman (Van Heflin) needs his help, Shane is forced out of retirement. Shot in panoramic Technicolor glory, *Shane* tackles prototypical western themes of good versus evil through law and order, land disputes, and the influences of changing times. Lauded for the extremely accurate portrayal of pioneer life, art director Walter Tyler and supervising art director Hal Pereira gave the film its authentic

look. With the Teton Range as a backdrop, the film, which was shot mostly on location in Jackson Hole, Wyoming, is situated right in the heart of the Western frontier.

The design team constructed the old town of "Grafton" and the "Starrett Homestead" on the Paramount back lot with the help of set decorator Emile Kuri. With an eye for detail, Kuri took audiences back to the Old West with his interiors for the Starrett homestead—authentic iron stoves, needlepoint patterns draped over a chair, blue checked tablecloths, and lace curtains.

"The legendary epic that's as big as Texas"

George Stevens's film *Giant* (Warner Bros., 1956) is an epic, a western, a melodrama, and a love story. Set in the 1920s and spanning several decades, *Giant* is the story of a moneyed rancher, Jordan "Bick" Benedict Jr. (played by Rock Hudson),

and an ambitious, self-made oil baron, Jett Rink (played by James Dean). It is a family drama, complete with all the requisite themes of love, loyalty, and conflict as told through the rise and fall of three generations of families and fortunes.

The sets for *Giant* were as mythic and as larger-than-life as the state of Texas itself. The film is set on the Benedict ranch, a sprawling piece of land with a stately Victorian mansion sitting in the distance. With virtually no landscaping or neighbors for miles in all directions, the homestead sat alone, a symbol of the mounting loneliness of the Benedicts. Stevens had instructed the film's production designer, Boris Leven, to scout numerous locations. On the advice of a friend, Leven got the idea of a lonely mansion on a plain when he saw a similar one in Decatur, Texas. The "mansion" for the film was built on the plains of Marfa, Texas—but only the front porch and sides of the

RIGHT AND OPPOSITE PAGE: *Giant* (1956) • Boris Leven, production designer

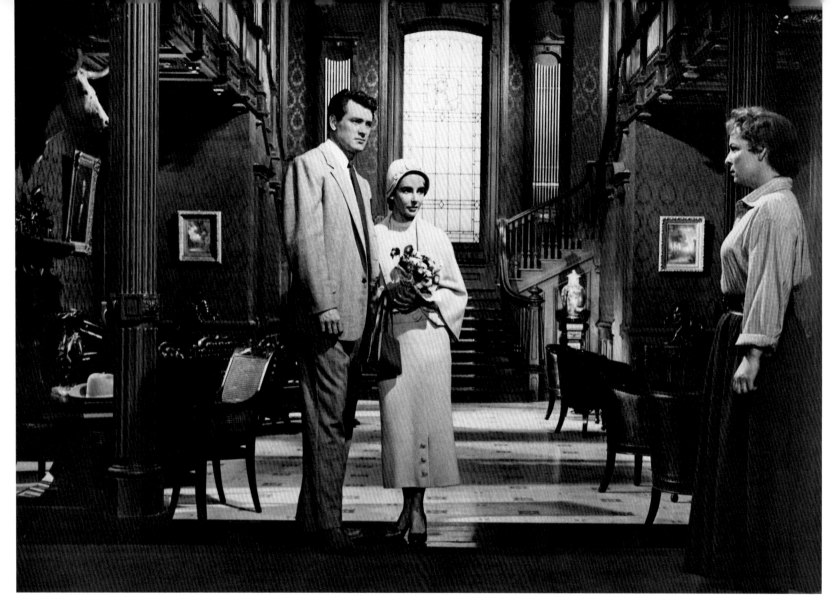

ABOVE: The
Benedicts (Rock
Hudson and Elizabeth
Taylor) in *Giant*
(1956) • Boris Leven,
production designer

Victorian structure were actually erected, as those were the only parts of the home that the camera would see up close. The rest of the mansion and the oil derricks were built on the Warner Bros. lot and shipped to Texas, where the façade remains today.

Russian-born Leven had a very similar background to his contemporaries Boyle and Bumstead—he also studied architecture at the University of Southern California. He entered film in 1933 as a sketch artist at Paramount, working in the "Hans Dreier College." His career spanned forty years and included a diverse range of films, from the sci-fi *Invaders from Mars* to the forties-style sets for Martin Scorsese's *New York New York*. He was nominated eight times for an Academy Award, including for such Julie Andrews vehicles as *The Sound of Music* and *Star!*, and won for his gritty playgrounds in *West Side Story*.

ROME WAS NOT BUILT IN A DAY, PART TWO

MGM's mega masterpiece *Ben-Hur* (1959) was one of the first true blockbusters of modern film. A remake of the 1925 *Ben-Hur* starring Roman Navarro, the tale was directed by William Wyler, who, coincidentally, had been an extra on the original film in the silent era.

Starring Charlton Heston as the hero Ben-Hur, Prince of Judah, the film, at a cost of $15 million, was the most expensive of its time. Its success saved MGM from bankruptcy and garnered a record eleven Academy Awards, including the Academy Award for Best Art Direction, and one other nomination. The lavish sets of Rome, the battleships, and the magnificent chariot race with its fifteen thousand extras all contributed to the grand scale of the production as well as to its massive budget.

Edward Carfagno and William A. Horning shared the monumental task of designing the film. Considered the biggest spectacle in the world to date, *Ben-Hur* was filmed on location in Rome on more than three hundred sets. Years of preparation went into the design and construction of the massive sets—the city of Jerusalem alone covered ten square miles and used one million pounds of plaster and twenty thousand tons of Mediterranean sand.

With its pageantry and impressive arena, the famed chariot race sequence set in the Roman Circus is still one of the most memorable moments on film. The set was constructed on eighteen acres of the back lot at Cinecittà

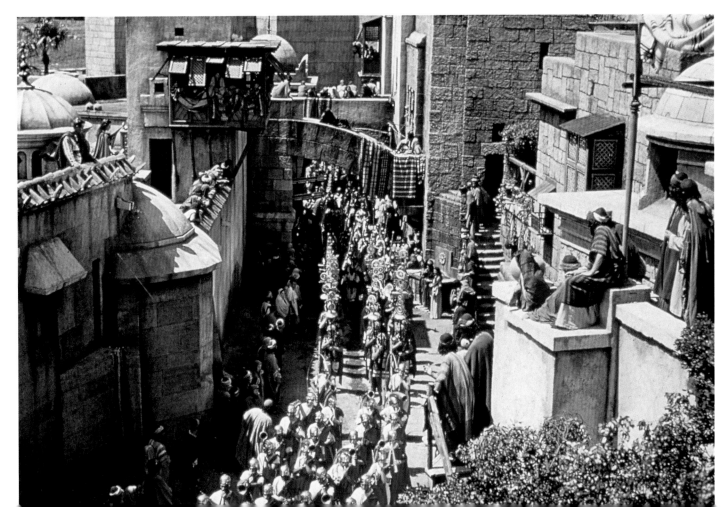

LEFT: *Ben-Hur* (1959) • Edward Carfagno and William Horning, production designers

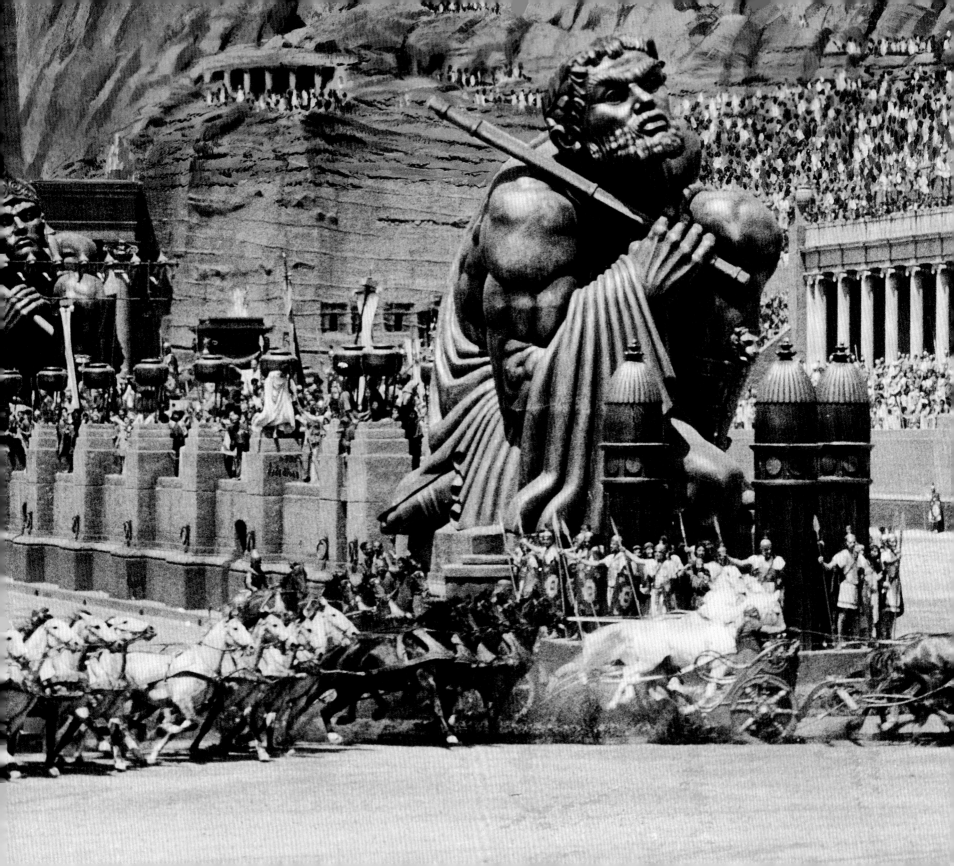

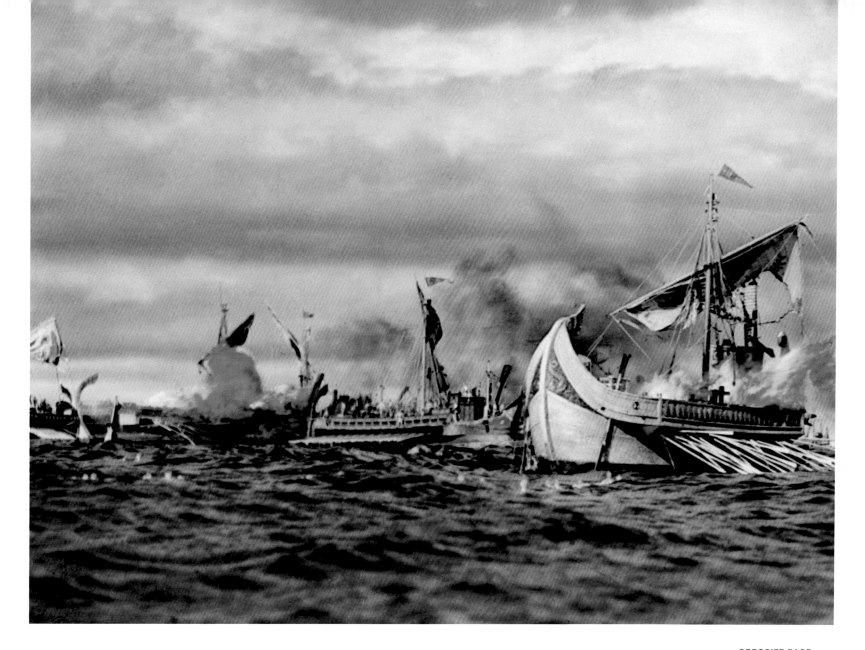

**ABOVE AND
OPPOSITE PAGE:**
Ben-Hur (1959)
• Edward Carfagno
and William Horning,
art directors; Mentor
Huebner and David
Hall, illustrators

Studios outside Rome, and the scene took a full five weeks to film. While thousands of extras were called in as spectators, the production required thousands more. An enthusiastic crowd was also needed to greet the soldiers returning from battle. MGM matte painter Matthew Yuricich simply added dabs of paint on Masonite board to represent the cheering masses. Holes were ingeniously poked in the boards behind the painted figures, which were given the illusion of movement by having another painting placed behind and moved back and forth.

The battle scenes posed another set of problems. MGM wanted authentic-looking Roman rowers and boats and hired someone who had spent his entire career studying Roman naval architecture. Unfortunately, the boats were too heavy and sank. As a result, the filmmakers had sections of two Roman galleys built on two battleships and placed them in a man-made lake. The waters were brown and murky, and required a chemist to dye them the color of the Mediterranean Sea.

Ben-Hur's eleven Oscars include the Academy Award for Best Picture, and the numbers tell the story. It took a year to build a replica of the Roman Circus; 22,000 extras and 100,000 costumes were used, and the famed chariot race required 1,000 workers. As a result, the film was one of the most expensive productions of the decade as well as one of the most successful.

SPOTLIGHT ON THE FIFTIES MUSICAL

I'm a painter, and all my life that's all I've ever wanted to do.

—JERRY MULLIGAN, *AN AMERICAN IN PARIS*

One of the most celebrated musicals of the decade, and perhaps the century, was MGM's *An American in Paris* (1951). The inventive musical was unlike any other, with its unique fantasy sequences and integrated love story set in Paris, against Toulouse-Lautrec- and Dufy-inspired sets. The musical tells the story of Jerry Mulligan (played by Gene Kelly), a struggling American painter who falls in love with Mademoiselle Lise (played by Leslie Caron), who is, of course, already engaged. Since the film is about an artist, and it is a musical, the design team was able to tie in the work of French artists with a touch of whimsy, successfully combining reality and fantasy.

The film is considered a landmark in art direction, as much of the design relied on painted backdrops and not one scene was shot in Paris. Designed by Preston Ames and Cedric Gibbons, the sets exemplify all the joie de vivre of the City of Lights, even though it was actually shot in Los Angeles. The design offers many memorable images, all of which surround the fantasy ballet and dance sequences, famous painters, and Paris landmarks. Examples include the black-and-white backdrop for the opening sequence in the Place de l'Etoile, where a single red rose provides the

RIGHT: *An American in Paris* (1951) • Preston Ames, art director; Cedric Gibbons, supervising art director

OPPOSITE PAGE: Inspired by French Impressionist painter Raoul Dufy, the Place de la Concorde, with its artistic backdrop, was re-created on a studio soundstage

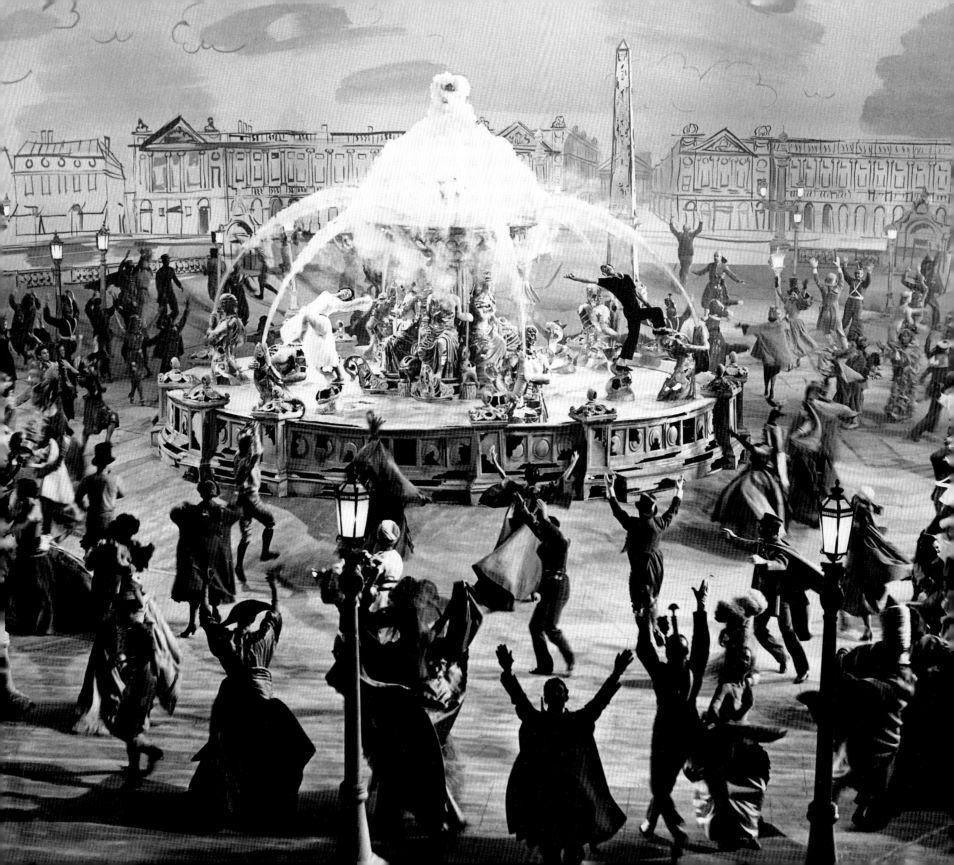

only hint of color; the backdrop of the Place de la Concorde fountain inspired by the artist Dufy; the Madeleine flower market with its Renoir and Manet influences; the Montmartre café setting with Jerry as the Toulouse-Lautrec character Chocolat.

Academy Award winner for Best Art Direction, Ames created his sets primarily out of large canvases painted in the manner of the great artists and used as backdrops. The props were homemade as well; the head of the plaster department made the magnificent fountain seen at the Place de la Concorde. Ames, a former art student at the École des Beaux Arts in Paris, was hired by director Vincent Minnelli largely due to his art-school background. A longtime designer at MGM, Ames worked frequently with Minnelli and followed his success on *An American in Paris* with another Academy Award: for the designs of *Gigi* in 1958.

OPPOSITE PAGE:
An American in Paris (1951) • Preston Ames, art director; Cedric Gibbons, supervising art director

ABOVE AND LEFT:
Gigi (1958) • Preston Ames and William Horning, art directors; Cecil Beaton, production designer and illustrator

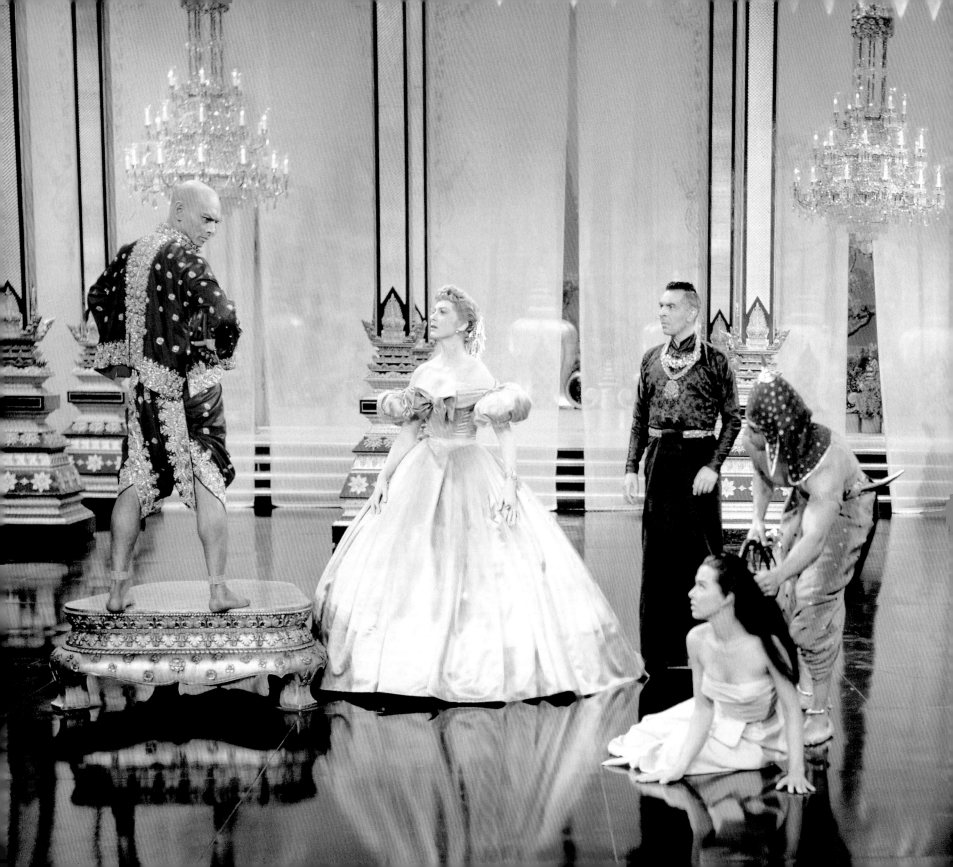

"Et cetera, et cetera, and so forth."

The King and I (Twentieth Century Fox, 1956) is the popular Rodgers and Hammerstein Broadway-musical-turned-film about the King of Siam (Yul Brynner) and the widowed tutor of his children (Deborah Kerr). As is the case with many musicals, the art direction needed to remain faithful to the story while supporting the actors and musical dance numbers. The challenge fell to production designers John DeCuir and Lyle R. Wheeler, along with set decorators Paul S. Fox and Walter M. Scott. The design team won an Academy Award for Best Art Direction for the sumptuous Siam palace.

The sophisticated interiors of the *Snows of Kilimanjaro* (1952), the island Bali Hai of *South Pacific* (1958), the gilt grandeur of *Cleopatra*'s Egypt (1963), and the re-creation of Yonkers for *Hello, Dolly!* (1969) are just a few of the many creations that have sprung from the paintbrush of illustrator and production designer John DeCuir.

Born in San Francisco in 1918, the dashing designer studied at the Chouinard Art Institute before joining Universal in the late thirties. In 1949 he joined Twentieth Century Fox, where he excelled at musicals and other productions with elaborate sets. He was nominated for eleven Academy

OPPOSITE PAGE: AND LEFT: *The King and I* (1956) • John DeCuir, art director and illustrator; Lyle Wheeler, supervising art director

THE ERA OF THE MANHATTAN CAREER WOMAN

The Doris Day–Rock Hudson "romantic comedy romp," as the genre was called in the late fifties and early sixties, began with the classic film *Pillow Talk* (Ross Hunter/Universal, 1959). The film signaled the dawn of a new type of romantic comedy, one where the virginal heroine actually has a career, a great Manhattan apartment, and a maid. The genre captured the urban style of Manhattan in the fifties with its perfectly sanitized, department store–style sets.

Doris Day plays Jan Morrow, a decorator who lives alone in a Park Avenue apartment and shares a "party line" with the playboy Brad Allen, played by Rock Hudson. Naturally, they meet and fall in love, give or take a few plot twists.

The sets were designed by Richard H. Riedel, best known for his work on Douglas Sirk's 1959 film *Imitation of Life*. Riedel was tragically killed in 1960 in a car accident while scouting set locations in Italy. In *Pillow Talk*, Morrow's pied-à-terre was all aglow in virginal white and appropriate, traditional décor. In contrast, Riedel and set decorators Ruby R. Levitt and Russell A. Gausman designed Allen's apartment as a precursor to a Hugh Hefner bachelor pad, signaling the advent of the all-electronic home. At the flip of a switch, lights were dimmed, the stereo played a record, and the convertible sofa turned into a bed. Allen's apartment set the stage for the early sixties version of censored mayhem.

Awards, winning three for *The King and I* (1956), *Cleopatra* (1963), and *Hello, Dolly!* (1969).

Considered an artistic prodigy, he is also known for his glorious color illustrations of film sets. His son, production designer John DeCuir Jr., recalls his amazing ability to start a rendering on one corner of his sketch pad and continuously draw the entire set without lifting the pencil off the page, from one corner to the other.

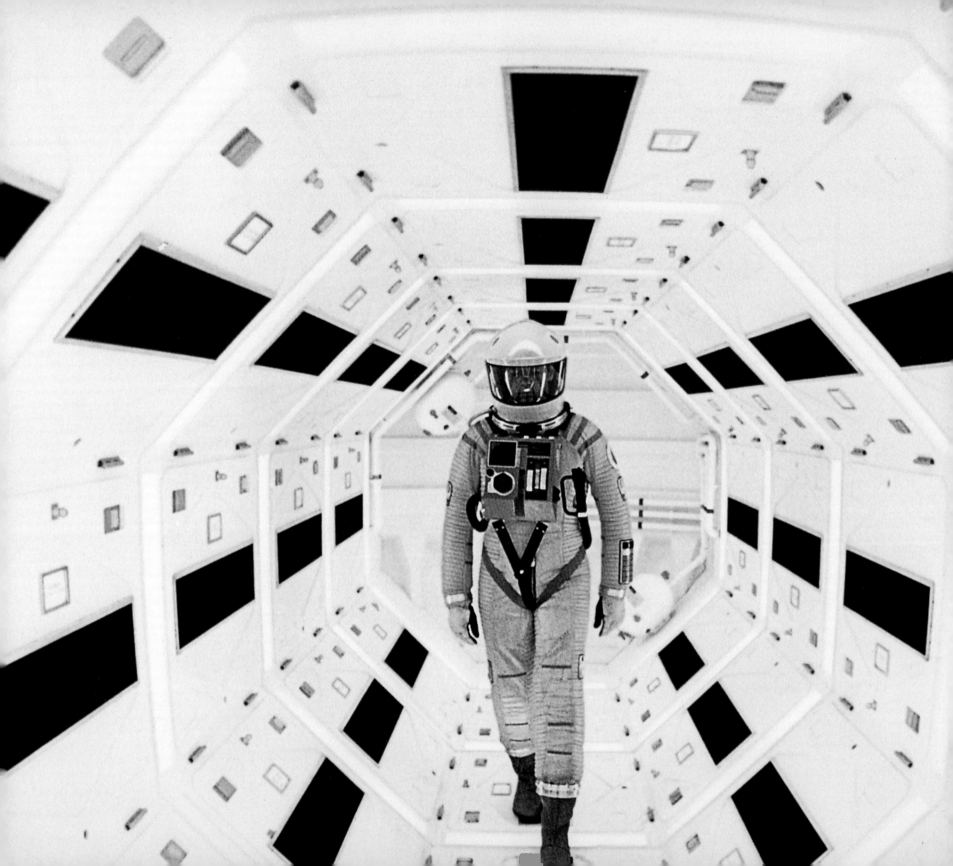

THE SIXTIES

A Decade of Contrast

The sixties was a decade of contrasts both on and off the screen. The rigid conservatism and conformity of the fifties were countered by the social, cultural, and political upheaval of the sixties, and films became a mirror of the times. The decade marked the decline and end of the studio system, and it ushered in a new wave of independent filmmakers. Films ranged the gamut from big-budget musicals and romantic comedies to period sagas and suspense thrillers. *The Graduate*'s Mrs. Robinson spoke for a future generation of baby boomers in the midst of a sexual revolution.

A British invasion of designers, musicians, and directors made their presence known, particularly in filmmaking. Director Stanley Kubrick made two of the most visionary and controversial films of the decade with the cold war political satire *Dr. Strangelove* and the psychedelic masterpiece *2001: A Space Odyssey*—a film that forever altered the science fiction genre. Director Alfred Hitchcock continued to strike fear in the hearts of filmgoers (giving new meaning to the term *bird watching*), while producer and director David Lean took the sweeping historical epic to new heights. And James Bond as the iconoclastic British spy was introduced in the sixties, marking the beginning of one of the most successful franchises in history.

OPPOSITE PAGE:
2001: A Space Odyssey (1968)
• Harry Lange, Ernest Archer, and Anthony Masters, production designers

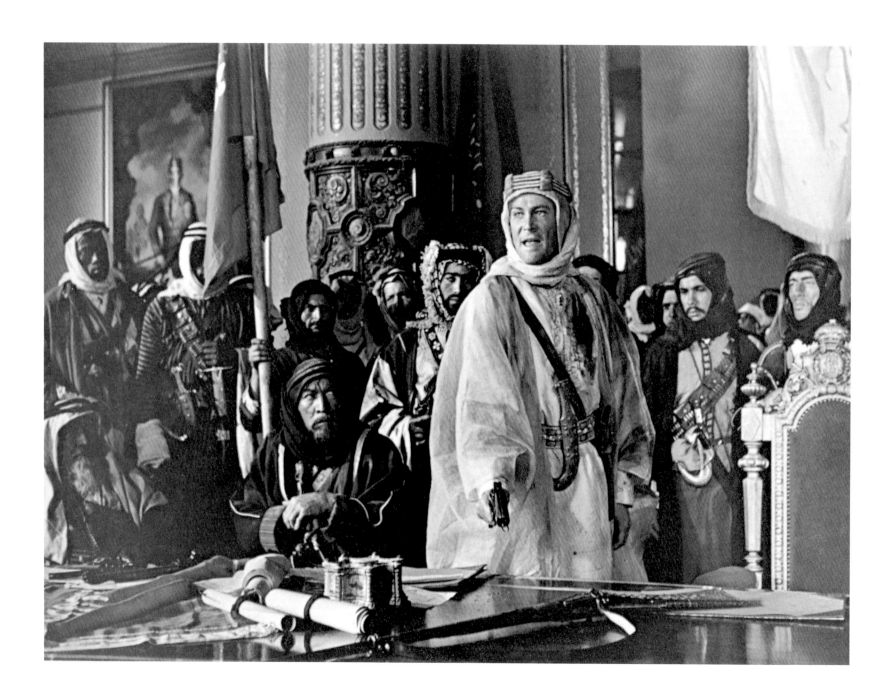

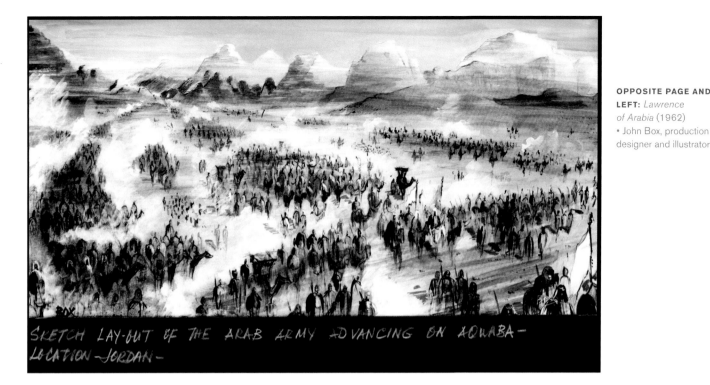

SKETCH LAY-OUT OF THE ARAB ARMY ADVANCING ON AQUABA — LOCATION — JORDAN —

THE EPIC, SIXTIES-STYLE

"An Ocean of Sand with No Beginning or End"

The compelling tale of T. E. Lawrence's *Lawrence of Arabia* (Horizon Pictures/Columbia, 1962) was another early sixties epic. Directed by master storyteller David Lean, the film is the character study of an eccentric messianic adventurer who helps the Arabian Bedouins battle the Turks during World War I.

While the film chronicles the cult hero's compelling tale, the real star of the film is the desert itself, a fact aptly stated by Prince Feisal to T. E. Lawrence: "The English have a great hunger for desolate places." The cinematic backdrop of sand, stretching into infinity as far as the eye can see, becomes a metaphysical metaphor as Lawrence ponders the meaning of his own existence. From the wide expanse of creamy-white sand to the bleached rocks and valleys of the land, the audience can feel the desert heat and the wind of the sandstorms, and at the same time become lost in the romance of the Arabian earth.

The film was designed by British production designer John Box and became the first of his three collaborations with David Lean, the other two being *Doctor Zhivago* (1965) and *A Passage to India* (1984). Box was not Lean's first choice, but the original art director, John Bryan, had fallen ill with kidney trouble and had been forced to resign. Born in London, Box studied architecture and became an apprentice to female art director Carmen Dillon, toiling on low-budget films. *Lawrence of Arabia* was his big break.

Designing a film about "the desert is no small feat," Box said in his memoirs. "The all-important actor is atmosphere. These deserts breathe history and the efforts of man to find a fundamental philosophy. They are magnificent in their scale and can be romantically beautiful." While atmosphere was the main edict for the design of the film, "the scale had to put man in his place, against his surroundings and at the same time accentuate his awareness of himself and his ambitions."

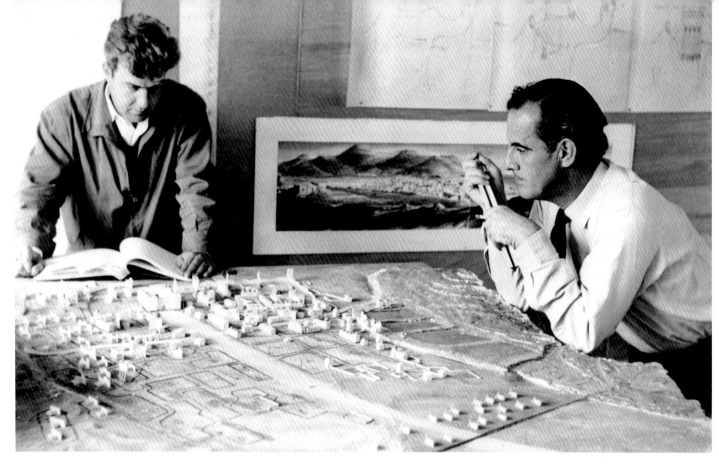

RIGHT: Production designer John Box and assistant art director Terrence Marsh survey a model of Aqaba for the film *Lawrence of Arabia*

OPPOSITE PAGE: The final Aqaba set

As noted by director Martin Scorsese, a David Lean film excels in "personalizing the epic through character." Box was able to achieve this feat by authentically designing the film to support the hero. For *Lawrence of Arabia,* Box noted, "it had to be real and if the costume designer and the art department have succeeded to any degree, then an audience should never be aware that we were at work on the film, and accepts everything as part of Lawrence's life however dramatic it may seem."

The challenge of creating "desolate" desert scenes for the legions of Arabic nomads was no small task either. The desert had to be constantly swept clean, as each take created its own special pattern of footprints. The heat also became a huge factor and many shots had to be filmed at night. Jeeps had to be used to create sandstorms. In one of the film's most memorable moments, Omar Sharif makes his entrance as Sherif Ali riding into the desert as a mirage. Dressing the desert became crucial—Box had to dye the sand on each side of the film's shot black, so as to encourage the viewer's eye to the center of the frame all the while creating the shimmering illusion of a mirage.

With a budget of $12 million, all sets were built on location and not on studio lots. Filmmakers set the "Cairo" sequences of the film in Seville, Spain, as the original Egyptian buildings involved in the story no longer existed. Southern Spain's Moorish Arabic architecture and its natural wall finishes provided the perfect backdrop.

Lean's epic masterpiece took two years to film and received ten Academy Award nominations. It took home seven Oscars, including the statue for Best Art Direction.

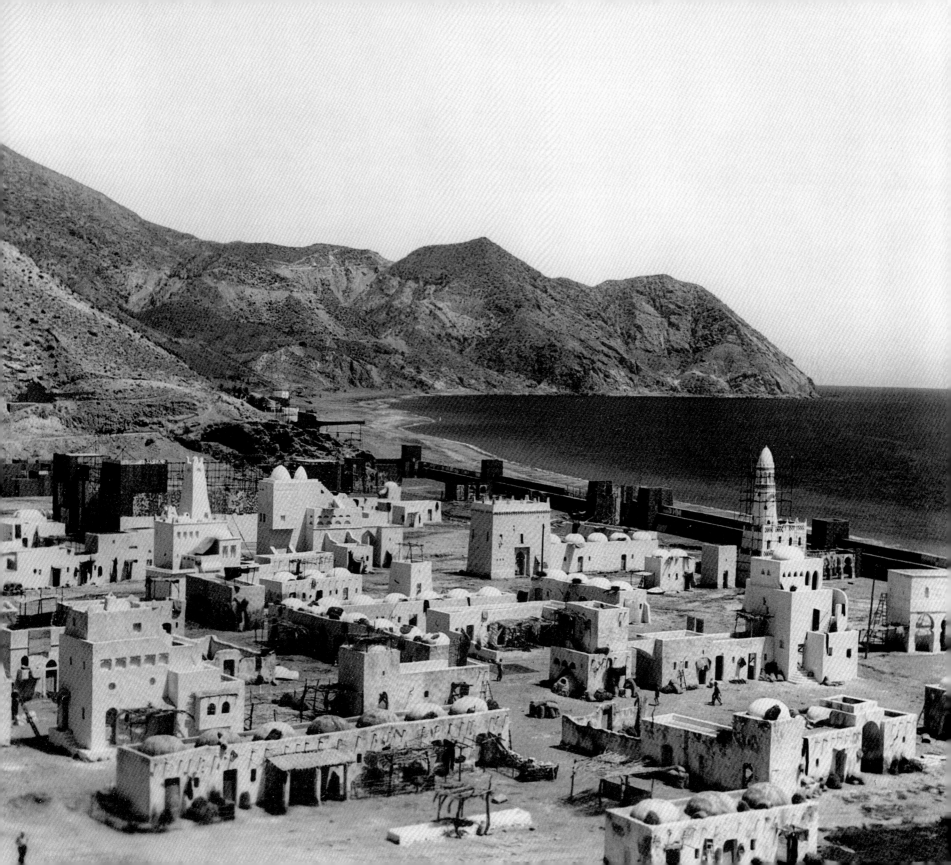

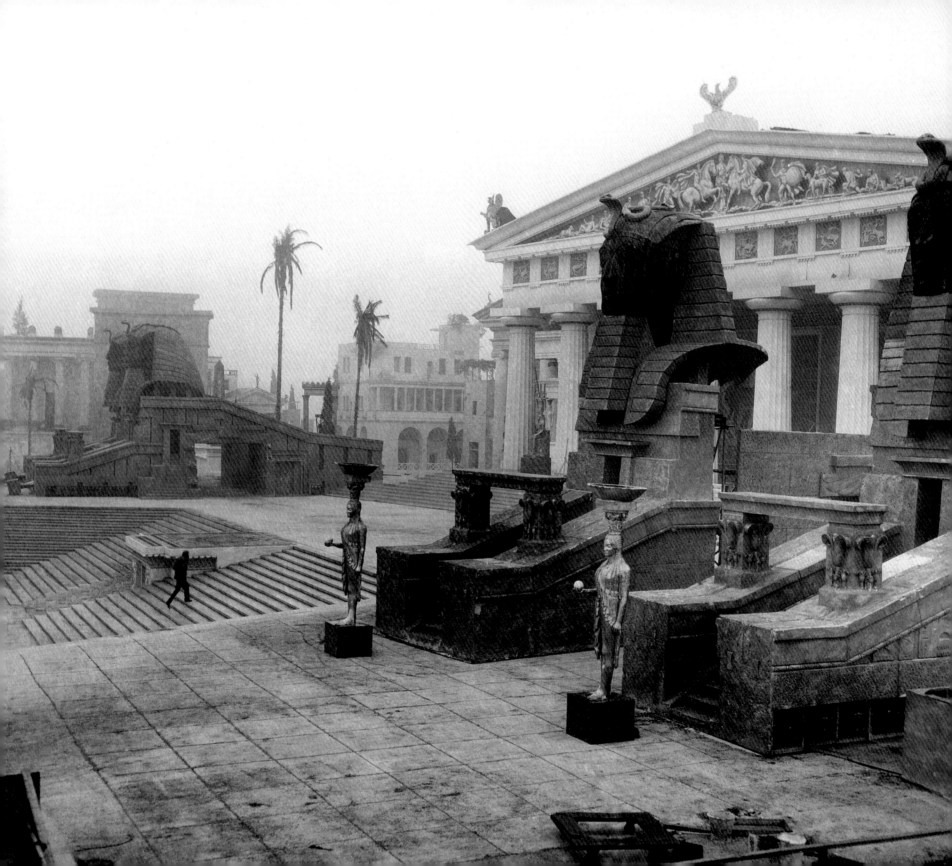

Rome Was Not Built in a Day: Part Three

The infamous *Cleopatra* was the most expensive motion picture ever made to date, and the story behind the scenes is a clear case of life being more interesting than fantasy. It is famously remembered as the film that nearly bankrupted Twentieth Century Fox, broke up marriages, ruined careers, and is considered, by some, to be one of the biggest failures of all time.

In the early sixties, Hollywood was consumed with the idea of the epic—a larger-than-life, opulent, and grandiose Technicolor spectacular. While the genre began with D. W. Griffith and *The Birth of a Nation*, in the sixties Hollywood looked to the tried-and-true tales of life in ancient Rome, as studios had already experienced success with an earlier *Cleopatra* (1934), *Ben-Hur* (both 1925 and 1959), *Quo Vadis?*, *The Robe,* and *Spartacus.*

The epic provided all the essential ingredients that studios needed to lure audiences away from their television sets: action and adventure, romance and betrayal, pomp and pageantry, majestic sets and costumes—all with an abbreviated history lesson included. And the story of Cleopatra clearly fit the bill.

Production on the 1963 *Cleopatra* began several years prior to its release. From the very beginning, controversies

OPPOSITE PAGE: The set of *Cleopatra* (1963) was constructed and abandoned prior to shooting in 1960 at England's Pinewood Studios • John DeCuir, production designer

BELOW: The final production shot of the "Forum" set of *Cleopatra,* which was shot in Rome

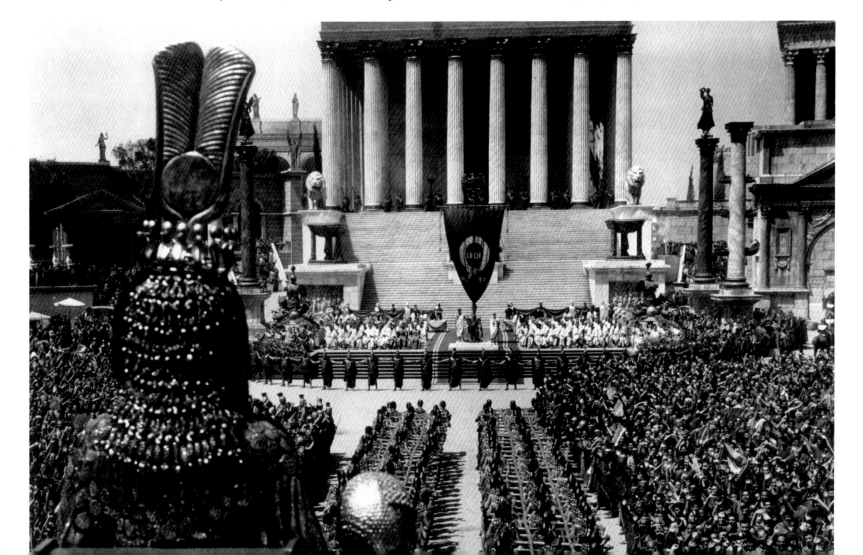

plagued the production. Director Rouben Mamoulian was replaced by Joseph Mankiewicz, actors Peter Finch and Stephen Boyd passed the torch to Rex Harrison and Richard Burton, and Elizabeth Taylor suffered near-fatal illnesses, halting production.

Shooting was set to begin in Rome in 1960, but the producers soon found the city's summer Olympics made finding accommodations impossible. Producer Walter Wanger moved the filming to England, where the port city of Alexandria, Egypt, found an unlikely home at Pinewood Studios on the outskirts of London. Wanger hired the talented John DeCuir, an accomplished artist known for such impressive films as *The King and I* and *South Pacific,* as well as for his innate ability to sketch. With

money out of his own pocket, DeCuir created models of Cleopatra's Egypt and beautifully detailed sketches for Wanger to use in a presentation to Fox executives.

To reflect the splendor of Egypt, the Sphinx and massive temples and palaces with gilt statues were built on Pinewood's twenty acres of English farmland. The construction job was so large that filmmakers could not find enough workers and resorted to running ads for extra help in the local cinemas. The balmy, rainy English weather was not kind; the imported palm trees had to be replaced almost daily and the buildings peeled due to the moisture. Coupled with Taylor's illness and a temporary lack of funding, the production was moved to Cinecittà Studios in Rome.

DeCuir's talent, not only as a designer but an architect, came in handy. According to Mankiewicz's son, Tom, "My father called Johnny [DeCuir] the city planner. He was told to build the Roman forum three times its size, as it was thought the real Roman forum was not impressive enough."

The accomplished production designer and his team built seventy massively scaled sets, causing a shortage of building materials in Italy. Artists, artisans, and workmen on set numbered in the thousands, with experts needed on everything from the gilding to shipbuilding. Everything had to be made from scratch, and excess was the norm of the day—Cleopatra's golden armor was made from real gold and cost a reported $1 million.

Reclining on a mammoth Sphinx, surrounded by throngs of cheering fans, and with African dancers beneath her, Cleopatra's grand entrance into Rome became the film's main attraction and most important scene. Her opulent bedchamber, banquet hall, and even her tomb sparked a whole new movement toward opulence in fashion and design. Andy Warhol considered *Cleopatra* to be one of the most aesthetically influential films of all time.

Contemporary furniture and costume designer Irene Sharoff copied the film's look and drew from the film's geometric shapes; even trendy sixties hairstylist Vidal Sassoon designed a tribute hairstyle.

Originally budgeted at a modest $2 million, the film's costs quickly skyrocketed to an exorbitant $44 million (by today's standards, that is roughly $375 million), mainly due to the costumes, reconstructed sets in London and Rome, and runaway budget costs. It eventually became the highest-grossing film of the year and earned DeCuir and his talented and beleaguered crew an Academy Award for Best Art Direction.

BELOW: *Cleopatra* (1963) • John DeCuir, production designer

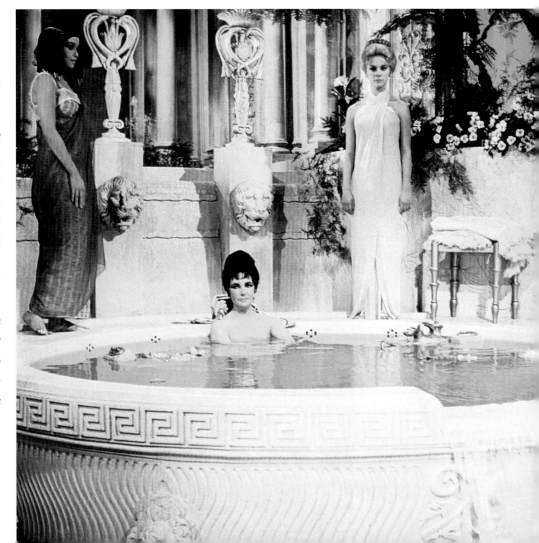

Russia by Way of Spain: Designing *Dr. Zhivago*

David Lean and John Box (along with Omar Sharif) teamed up again, three years later, on *Dr. Zhivago* (MGM, 1965), the epic Russian saga about love and political uprising during the Bolshevik Revolution, based on Boris Pasternak's bestselling novel.

Box and Lean began their work on the film with a ten-thousand-mile scouting expedition for the perfect setting. The pair searched all over Russia, Finland, Sweden, and Yugoslavia before settling on what many would consider an unlikely locale: the streets of Spain.

Box and his design team created the Russian capital of Moscow on the streets of Camillas. Several elements were needed to tell the story of the young Russian doctor: the scale of a large city, a setting that could adapt to the change of seasons, and the two major forms of transportation at the beginning of the century—horses and trains. The film's majestic capital city rose in eighteen months with the help of eight hundred construction workers and technicians. The city's two main streets, the "Street of the Elite" and the "Street of the Poor," had two working trolleys, and the architecture and interiors were historically re-created to scale and were not just façades.

The film's most indelible image was the "ice palace." The Zhivagos' dacha, where the doctor and his lover, Lara, made their refuge, was, unbelievably, filmed in the

RIGHT: *Dr. Zhivago* (1965) • John Box, production designer and illustrator

middle of the summer in Soria, Spain. Box dressed the sets in hot white wax, which was sprayed with cold water to resemble the look of frost and ice. Box recalls the process: a prop person would take "very hot white wax with a bucket and mug and throw it all over the architecture and furniture and I would hit it, when I thought it looked right, with nearly freezing water and it froze." The results were breathtaking.

The precise use of color was also important in the film, as it became an identifiable symbol of class. While gritty grays and dark brown colors were used for the lower classes, Lara's signature color was yellow, as seen in the yellow tulips, while the use of red flags marked the sign of Russian power in the streets of Moscow.

Box won his second Academy Award for Best Art Direction for his work on the film.

LEFT: *2001: A Space Odyssey* (1968) • Harry Lange, Ernest Archer, and Anthony Masters, production designers

"GOOD AFTERNOON, GENTLEMEN. I AM A HAL 9000 COMPUTER."

The year is 2001, and astronaut Dave Bowman flies through a psychedelic corridor of light, capturing the eye with luminous patterns and shapes, which suddenly explode into patterns of color. The journey ends and he wakes up in a white room furnished sparingly with antiques.

This famous journey is one of the numerous visionary scenes in Stanley Kubrick's masterpiece *2001: A Space Odyssey* (MGM, 1968). The landmark science fiction film is filled with defining moments of cinematic wonder and special-effects techniques.

While HAL 9000, a "computer" with the ability to think freely, is at the heart of the film's drama, the film itself was actually created without using computers. Filmmakers relied solely upon models and matte paintings. Huge fifty-four-foot scale models of the spaceship *Discovery* were built in conjunction with a NASA expert and engineers from aerospace company McDonnell Douglas, while IBM offered its expertise with the computer panels.

Designed by Harry Lange, Ernest Archer, and Anthony Masters, *2001* represents Kubrick's interpretation of space and infinity. The film begins with the dawn of man—the audience watches as an ape/man experiences the black

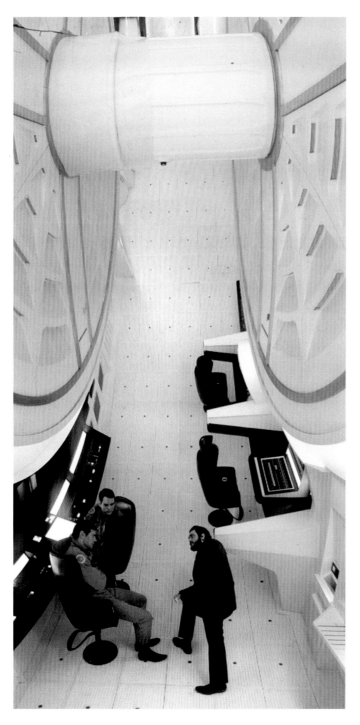

monolith of knowledge—and extends through three lunar space missions. Kubrick's symbolic monolith passageway links the primeval, futurist, and mystical sections of the film.

As with many of the films of the twentieth century, *2001* owes its design aesthetic in its latter parts to Fritz Lang's *Metropolis* and William Cameron Menzies's *Things to Come*. The modular interiors of the space-station lounge also reflect the contemporary design trends of the sixties' interiors. The sophisticated bedroom filled with Louis XVI décor is a contrast to the stylized nonrectilinear furniture that was a nod to the designs of the Finnish-American architect Eero Saarinen and Pop Art looks of the period. A bold use of red and yellow against a stark, reflective white successfully contributes to the futuristic atmosphere as well.

While the film was considered groundbreaking in its imagery, it was nominated but did not win the Academy Award for Best Art Direction. Kubrick, along with Douglas Trumbull, Wally Veevers, Con Pederson, and Tom Howard won the award for Best Special Effects.

OPPOSITE PAGE:
2001: A Space Odyssey (1968)
• Harry Lange, Ernest Archer, and Anthony Masters, production designers

LEFT: Director Stanley Kubrick (*right*) speaks with his actors on set

"THE RAIN IN SPAIN STAYS MAINLY IN THE PLAIN."

Director George Cukor's big-budget musical *My Fair Lady* (Warner Bros., 1964) was a lavish production that was said to have shown "every penny on the screen." The Broadway-play-turned-film followed the story of Professor Henry Higgins (played by Rex Harrison), who wages a bet that he can make common flower-peddler Eliza Doolittle (played by Audrey Hepburn) pass for a member of upper-class English society.

British fashion photographer and Academy Award–winning stage and film designer Sir Cecil Beaton was selected to design the Academy Award–winning sets, along with production designer Gene Allen (who served as art director on the film). Designed almost entirely on a single Warner Bros. soundstage, Beaton wanted to use real locations in England. The celebrated Beaton also won Oscars for costume design for *Gigi* and *My Fair Lady*.

The film is primarily set in Higgins's house, which Allen created on three stories and filled with alcoves and stairways and railroad frames that were used to slide the various

walls in and out for reverse shots. "Having worked with Cukor for many years," Allen details, "I understood the space that he needs to play the scene. The set would evolve shot by shot that I would lay out prior to designing the set, so we covered every bit and piece of the unfolding of the story. You don't want to get bored staying in one room."

A great deal of detail and attention to authenticity went into designing the sets. For the original wallpaper designs in Higgins's study, Allen says, "I went to London and got actual original blocks of period paper and had them printed in London." All designs stemmed from meticulous research—for the cobblestone streets around Covent Garden, stones were made individually, and the sets were carefully aged to create the illusion of centuries-old buildings. A stickler for details, Allen spent hours aging Hepburn's flower-vendor costumes so she wouldn't look too affluent. "I even duplicated pigeon stuff on the columns for the Covent Garden scene—Audrey touched it to see if it was real."

Apparently, Hepburn wasn't the only one to get caught up in the illusion. For the film's Ascot scenes, quarter horses had to be used instead of thoroughbreds. The design team had them race around the set and out the stage door, setting up a black tarp with racetrack railing in front of the commissary to signal their exit. Of course, today's designer would have used a computer.

Allen, a noted artist, producer, Academy Award–winning production designer, and art director, was best known for his work on *A Star Is Born* with Judy Garland and James Mason. A former president of the Academy of Motion Picture Arts and Sciences, and executive director emeritus of the Art Directors Guild, he began his career sketching sets for Lyle R. Wheeler, then head of the Twentieth Century Fox art department, and moved on to Warner Bros., where he met George Cukor and the rest was history. The two worked together for seventeen years.

BELOW AND OPPOSITE PAGE:
My Fair Lady (1964) • Cecil Beaton and Gene Allen, production designers

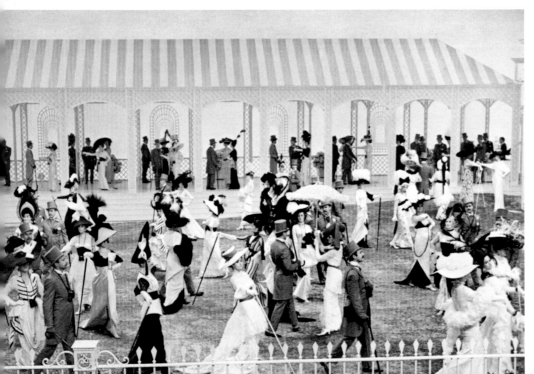

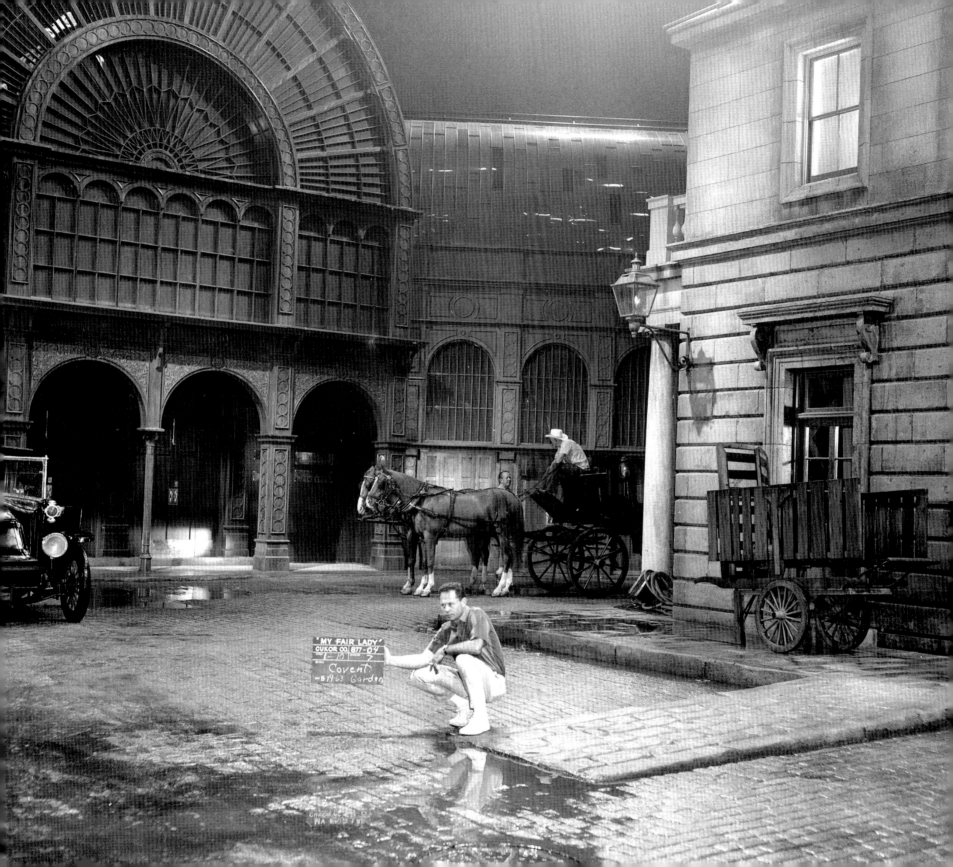

ADAM . . . KEN ADAM

British production designer Ken Adam was one of the most prominent figures in film design of the twentieth century. He made his mark with the James Bond franchise, from *Dr. No* to *GoldenEye,* and, in the sixties, with *Dr. Strangelove or: How I Learned to Stop Worrying and Love the Bomb.*

Born in Berlin, Adam was one of the few German fighter pilots in the Royal Air Force during World War II. He went on to study architecture, at the advice of production designer Vincent Korda. His early film work included a stint as an assistant art director on *Helen of Troy* (1956) and he later became a full-fledged art director on Mike Todd's *Around the World in Eighty Days.*

Adam's career-defining moment came when producer Albert "Cubby" Broccoli tapped him to design the first in a long series of James Bond films, *Dr. No.* Adam's remarkable design style elevated the series of films from basic action adventures to iconic classics. Due, in part, to Adam's production design, Bond films became a multimillion-dollar franchise. From Bond's gadgetry-filled Aston Martin DB5 (complete with an ejector seat) to Oddjob's lethal hat in *Goldfinger,* Adam's revolutionary and yet whimsical use of technology was a hit with moviegoers worldwide.

In addition to his work on seven of the Bond films, his vast résumé includes *The Trials of Oscar Wilde, The Ipcress File, The Owl and the Pussycat,* and *The Madness of King George.* He also had two successful collaborations with Stanley Kubrick: on the "War Room" interior for *Dr. Strangelove* and his beautiful re-creation of eighteenth-century England in *Barry Lyndon.*

Adam's Academy Award–winning work is characterized by an innovative use of modernism and of materials mixed with technology. From a Bond villain's lair to the cold war–era designs for a government gone mad in *Dr. Strangelove,* his work is legendary. He was adept at integrating all the major trends of the period—Mod, Pop, and Op Art, Japanese architecture, and Minimalist furniture—and making the styles work in many of the Bond films. The trademark of an Adam-designed film is his use of "architectural stylization." As noted by the longtime Adam biographer Christopher Frayling, he was even called "the Frank Lloyd Wright of *décor noir.*"

BELOW: Production designer Ken Adam on the set of *Moonraker* (1979)

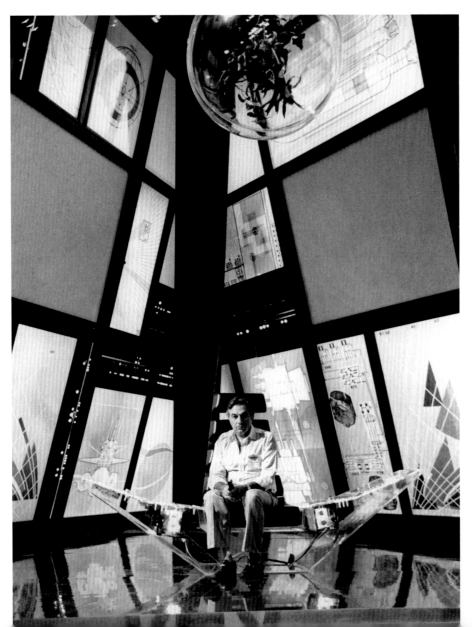

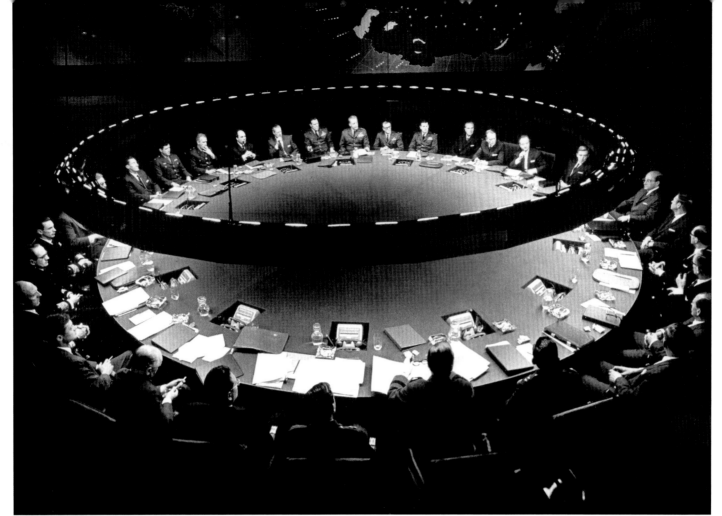

"Gentlemen, you can't fight in here. This is the War Room!"

—PRESIDENT MERKIN MUFFEY, *DR. STRANGELOVE OR: HOW I LEARNED TO STOP WORRYING AND LOVE THE BOMB*

Stanley Kubrick's black comedy *Dr. Strangelove or: How I Learned to Stop Worrying and Love the Bomb* (Hawk Films/Columbia Pictures, 1964) takes on government, bureaucracy, and the growing national paranoia of nuclear war. Shot during the height of the sixties' cold war, the film's dark view of current events touched a nerve and, like much of Kubrick's work, sparked controversy. The film revolves around a delusional general who concocts a scheme to attack the Soviet Union, setting into motion a doomsday scenario that politicians and generals must frantically attempt to stop.

Filmed at London's Shepperton Studios, most of the film's action takes place in the famed "War Room." Kubrick turned to Ken Adam to design the film, as he was fascinated by Adam's World War II record as a fighter pilot and his obvious expertise as a designer. Instructed to make the room "look like world leaders were playing a poker game," Adam designed a large round table—twenty-two feet in diameter—that could seat all of the twenty-six generals. Kubrick had it covered in green felt. As Michel

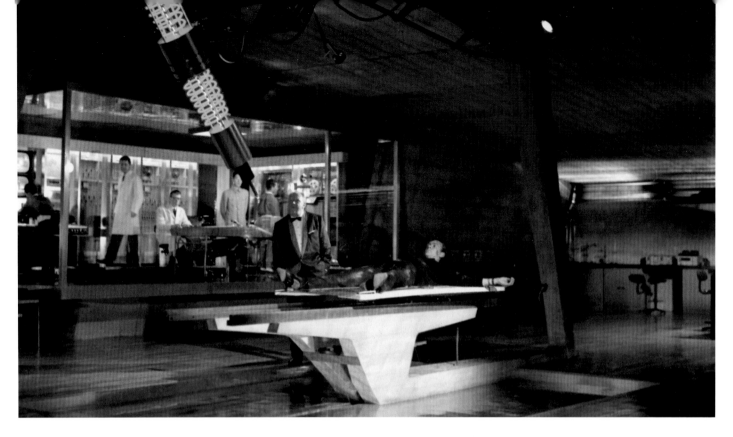

Ciment, author of *Stanley Kubrick,* notes, Adam rendered the set "larger than life to lend the distanced decision-making that occurred there with an appropriately fantastic quality." As it mocked the grandeur of war, the actual "War Room" was built economically with a string of lights and maps projected on the wall. The illuminated symbols on the map displays were actually simple cutouts lit from behind by individual floodlights.

The film's other key sets included an Air Force base and the interior of a B-52 bomber. Adam was not allowed by the U.S. Air Force to view the inside of a bomber, for national security reasons, and was forced to study the photograph of a plane as a design reference. Along with his art director Peter Murton, Adam did such an accurate job on the bomber's interior that the government was sure they had stolen classified information, prompting Kubrick to worry about an FBI investigation. Shot in a black-and-white cinema-verité style,

the sets were claustrophobic and chaotic, representing the mood of the era and unsubtly filled with phallic and sexual imagery, the centerpiece being, of course, the bomb.

Goldfinger and You Only Live Twice

Designing an action/adventure film with a hero as sophisticated as James Bond requires certain parameters—exotic locations, copious dry martinis, bikini-clad women, fast cars with the latest in gadgetry, and an evil super-villain with an eccentric name and equally eccentric plan to blow up the world. From their action-filled plots to their posh fantasy designs, James Bond films represent pure escapist cinema.

One of Adam's most memorable sets was for *Goldfinger* (Danjag/Eon/United Artists, 1964). The third in the budding series, the film boasted ultramodern designs that laid the design foundation for the franchise. A picture of innovation and technology, Bond's Aston Martin came

equipped with an ejector seat and the ability to raise bulletproof shields and activate oil-spraying guns. Bond was no average spy, and Adam's futuristic designs only added to the mystique surrounding him.

But what would Bond be without his counterpart—the villain? Establishing the world of the villain was hugely important. As Adam explains, the villains "wanted to rule the world, conquer space, or rob Fort Knox. I mean, they were real villains! And I dreamed up their palaces."

He was inspired by *The Cabinet of Dr. Caligari* at an early age, and the mixture of Modernism and German Expressionism techniques shows in his interiors. The use of sloping walls with no central line of perspective and a circular motif (as with the "War Room's" light ring and table, in *Dr. Strangelove*) is often a constant in an Adam's design.

Bond's archrival Auric Goldfinger's "Rumpus Room" (the room where he famously "got to the point" with our hero on his laser table) was a favorite set of Adam's. The room

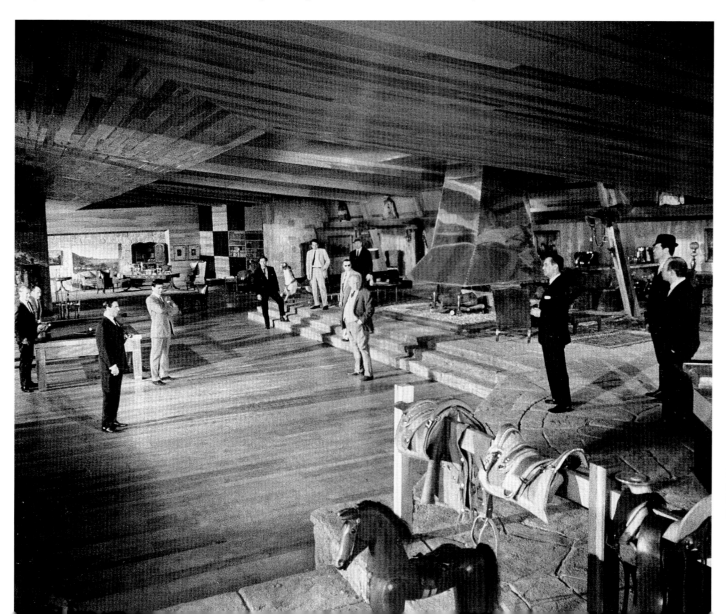

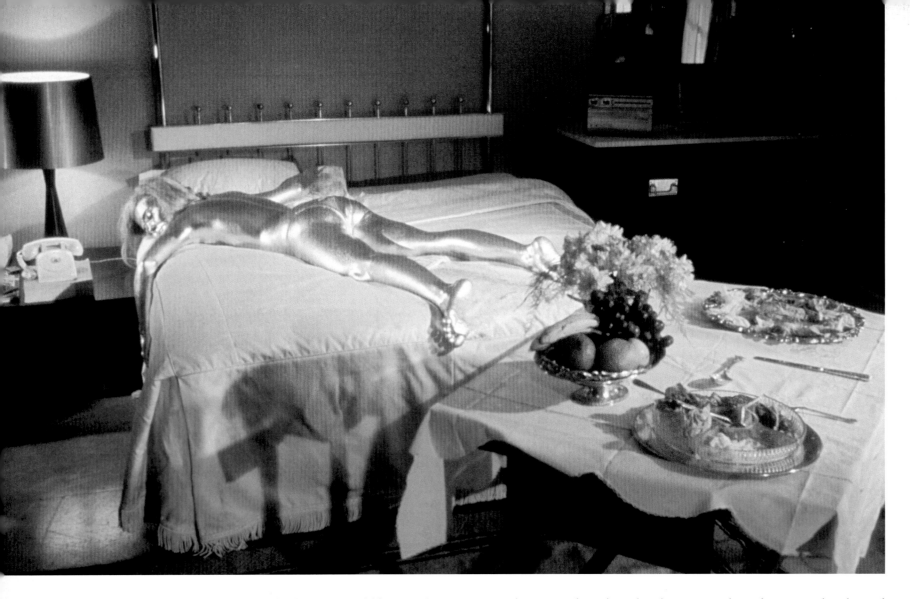

ABOVE: *Goldfinger* (1964) • Ken Adam, production designer

OPPOSITE PAGE: The million-dollar "crater" set from *You Only Live Twice* (1967) • Ken Adam, production designer

had a floor model depicting Goldfinger's plan to conquer the world, which also doubled as a gas chamber for his nemeses.

The scene of the film's central crime, Fort Knox, was another important part of the film's design. As the government would not allow Adam inside the nation's bank, he had to create the interiors from his own imagination. Stacks and stacks of bullion behind mechanized gold doors provide the perfect background for Bond and Oddjob's climactic fight scene.

Adam describes his approach to design as "heightened reality." He explains: "My idea was that [the set] should be completely impractically piled high with gold, forty foot high. It's the biggest gold depository and the audience wants to see all these piles." From ill-fated Jill Masterson's gold-painted body to the villain's gold-painted plane—even the bath fixtures and stewardesses' uniforms were gold!—no detail went unnoticed, or ungilded.

You Only Live Twice (Danjag/Eon/United Artists,

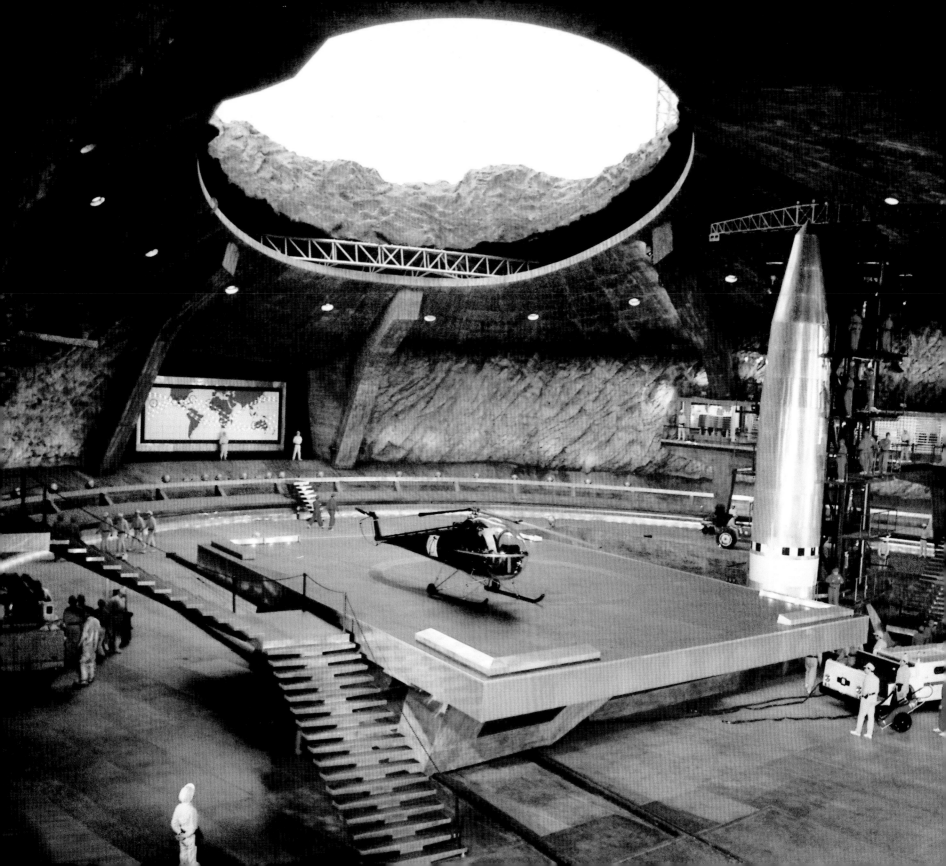

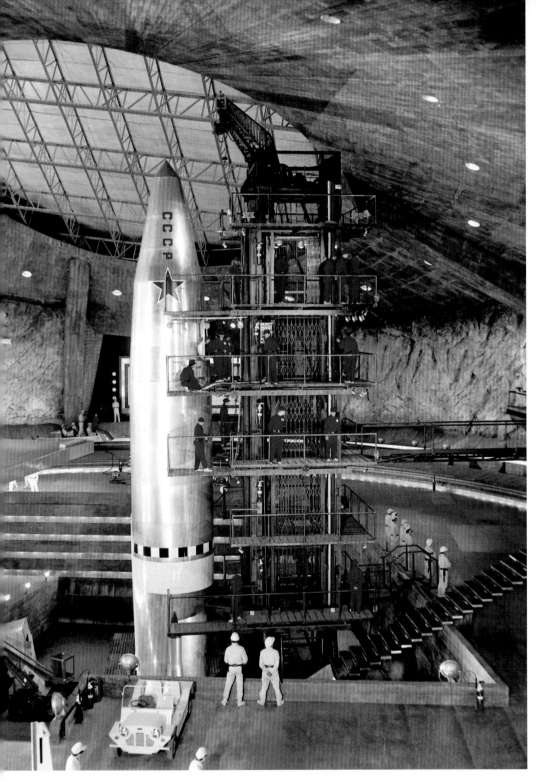

1967) proved to be another fantastic design feat for Adam. This time, the film required an actual volcano. Adam and his design crew found a volcanic area in Japan, "where I imagined a moonscape," he says. "We decided that it would be interesting to have the villain live in one of these extinct craters. Cubby gave me a sidelong glance and said, 'Can you do it?' I said, 'Well give me a chance.' And I started scribbling away. When I had done two or three sketches, I presented them to Lewis [Gilbert] and Cubby, and Cubby said, 'Looks interesting. How much is it going to cost?' I knew it was going to be a gigantic set, but I had no idea, and I quoted a million dollars, an enormous amount of money. Cubby didn't blink an eyelid. He said, 'If you can do it for a million, go ahead.' And then my worries started."

The highly imaginative sets were considered some of the best of the series. Their scale alone was impressive—the script dictated that the volcano interior had to be large enough to receive a helicopter. The crater set became so large that crewmembers kept misreading Adam's dimensions as being in feet, when they were supposed to be meters.

From the biggest sets to the tiniest props, Adam oversaw every detail of the design, including a key component of a Bond film: gadgets—large and small. The gyrocopter known as *Little Nellie* was an important set piece, as Bond used it to ward off his adversaries. In the film, Q, Bond's gadget guru, brought *Little Nellie* to Japan in a kit (which was strictly a mockup for the assembly sequence), which unfolded before the audience's eyes in seconds, ready to fly. Drawing upon his World War II experience, Adam collaborated with Wing Commander Kenneth Wallace of the RAF Bomber Command and designed the weaponry for the mini-gyrocopter: rocket launchers, flamethrowers, and even four red velour-lined crocodile-leather suitcases to house the disassembled model.

OPPOSITE PAGE:
You Only Live Twice
(1967) • Ken Adam,
production designer

LEFT: James Bond's
gyrocopter, *Little
Nellie,* in *You Only
Live Twice*

G·ARZ B

SEAGULLS AND SPARROWS AND CROWS, OH MY!

Melanie Daniels (played by Tippi Hedren) waits on a bench outside the Bodega Bay School. A single crow flies in the background and perches on the playground's jungle gym. As the wind blows, Melanie lights a cigarette, waiting patiently for the school to let out. Four crows gather behind her. Unaware, she waits. Another bird lands, and eventually she turns her gaze in their direction and she sees a terrorizing vision . . . hundreds of birds quietly lined up, waiting for the school bell to ring.

This scene is one of many in *The Birds* (Universal, 1963) designed by production designer Robert Boyle specifically to evoke terror. The story of a California coastal town menaced by unexplained bird attacks of epic proportion, the film is classic Alfred Hitchcock. The visual effects

RIGHT AND OPPOSITE PAGE: Hitchcock used a mixture of live and mechanical birds, and film overlays of birds, for his 1963 thriller *The Birds* • Robert Boyle, production designer

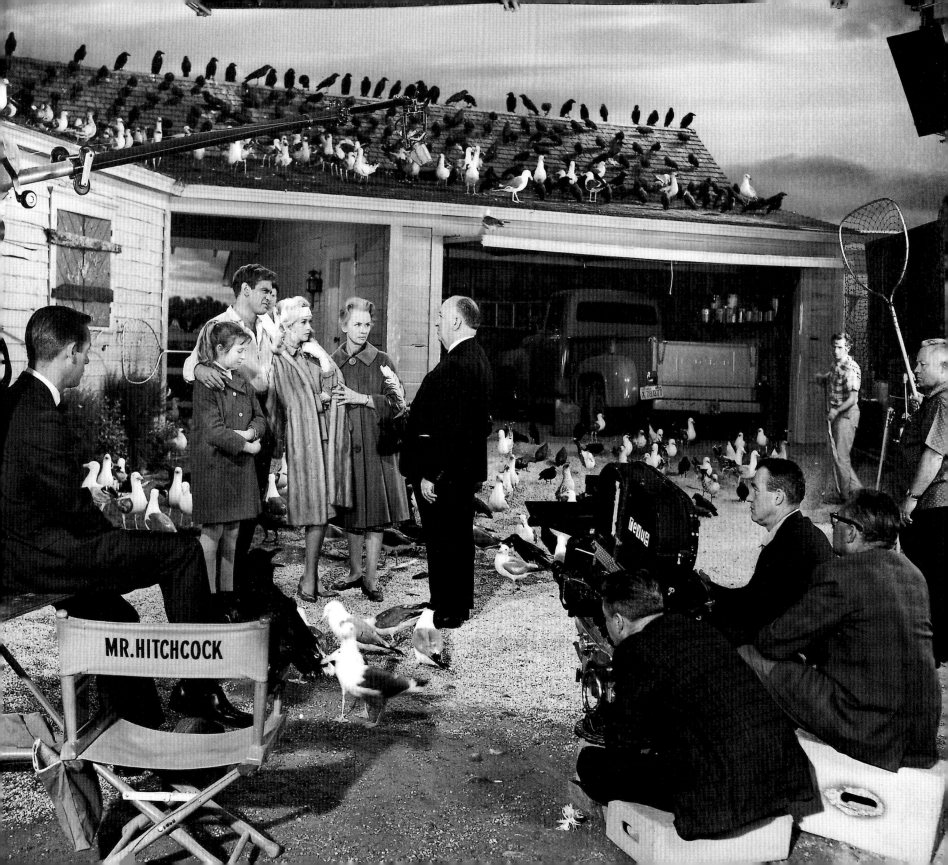

MR. HITCHCOCK

were extraordinary and required the skillful use of hundreds of live trained birds mixed in with mechanical versions. Shot on location in the real-life town of Bodega Bay, the film used a combination of set design and realistic matte paintings by British artist Albert Whitlock. Whitlock, whose career spanned five decades, was the head of Universal's matte painting department in the sixties and seventies. His style, perfectionism, and remarkable talent earned him the title of "Universal's secret weapon," and he painted virtually hundreds of films.

Whitlock was closely linked with his fellow Brit, Hitchcock, and applied his special-effects tricks of the trade to films like *Marnie, Torn Curtain, Topaz,* and *Family Plot.* Along with illustrator and storyboard artist Harold Michelson and production designer Boyle, Whitlock created thirteen matte paintings for *The Birds.* One of the most impressive was the aerial bird's-eye view of Bodega Bay where the seagulls begin to hover overhead—a scene Hitchcock was not able to capture with the camera.

OPPOSITE PAGE: Albert Whitlock's matte painting for *The Birds* (1963). The black area is where the filmed image was inserted into the painting.

BELOW: A sketch for *The Birds* by Harold Michelson

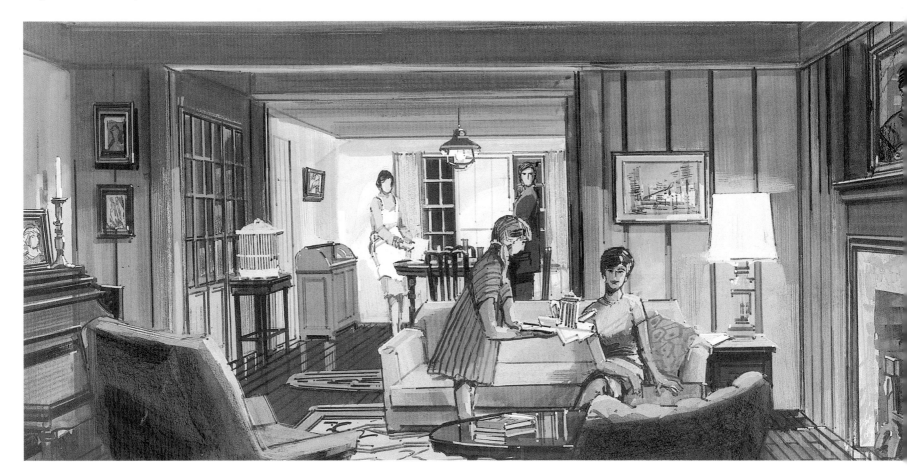

"IT'S A MADHOUSE. A MADHOUSE!"

—GEORGE TAYLOR, *PLANET OF THE APES*

In the year 3978, astronaut George Taylor and his crew crash in the waters of a distant planet. As they venture out of their plane, they find a world inhabited by apes—a world where humans are considered a primitive race and used for experimentation. The film, *Planet of the Apes* (Twentieth Century Fox, 1968), is a futuristic adventure tale, where primates turn the tables on humans.

William Creber served as art director on *Planet of the Apes* and was also known for his work as a production designer on disaster films such as *The Towering Inferno* and *The Poseidon Adventure*. Inspired by the rock formations of Turkey's Goreme Valley, the sets for *Planet of the Apes* were constructed on Twentieth Century Fox's Malibu Ranch. Explains Creber: "I needed to come up with an 'ape' architecture and looked at all the books

I could on Turkey. I liked the shapes, and it was a very strange place that was a troglodyte city carved into a mountain." For the "Ape City" designs, Creber "dreamed up a system to sculpt the buildings out of pencil-rod metal covered with cardboard," which was then sprayed with foam. Foam was just starting to be used in the film business and proved to be very popular in the sixties.

The film's most memorable scenes came from the pen of *Twilight Zone*'s Rod Serling and are considered to be among the most chilling climaxes in motion picture history. Shot on Zuma Beach, Taylor sees a portion of the Statue of Liberty's head buried in the sand, and suddenly realizes the world as he knows it is over. The shot was achieved through a combination of matte painting by Fox illustrator Emile Cosa and the construction of a portion of Lady Liberty's head and back, scaled down to half-size.

ABOVE AND
OPPOSITE PAGE:
Planet of the Apes
(1968) • William
Creber, production
designer

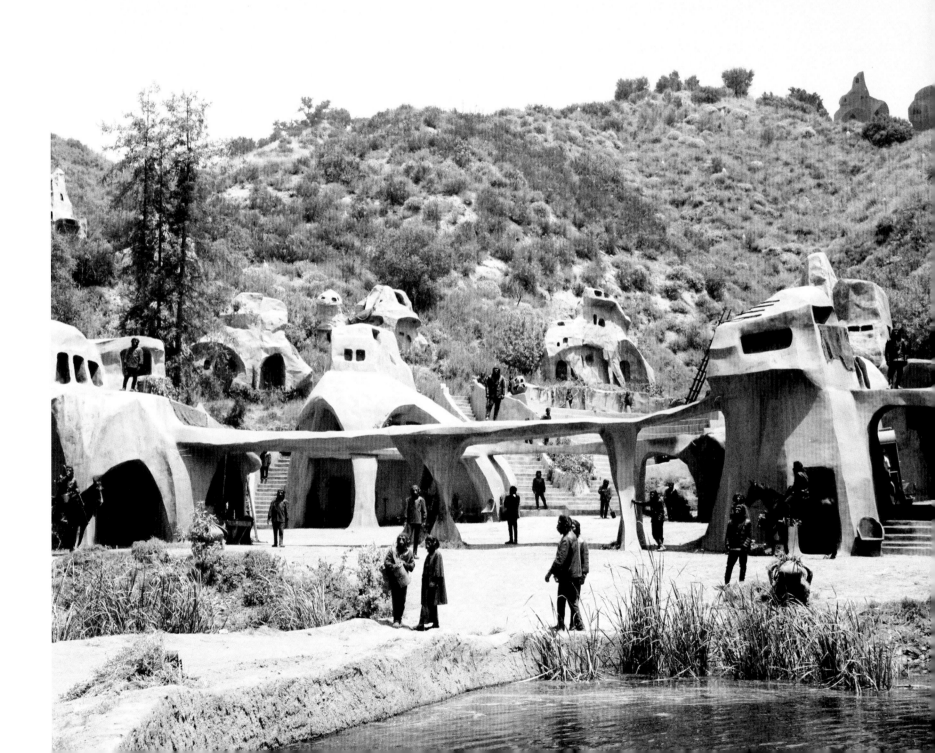

THE MONTAGUES AND THE CAPULETS—SIXTIES-STYLE

The Graduate (Embassy Pictures, 1967) is one of the films that best represent the sixties, as it truly captures the essence of the decade. The rite-of-passage story tells the tale of a recent college graduate, Benjamin Braddock (played by Dustin Hoffman), as he faces an uncertain future and explores the changing sexual attitudes of his generation. The film lampoons modern society—"I have just one word to say to you, Benjamin. Plastics."—and is a marked study in contrasts. The two California families are set up as the Montagues and Capulets—the materialism of southern California against the intellectualism of Berkeley in Northern California.

The satirical comedy marked the second successful collaboration between director Mike Nichols and the venerable production designer Richard Sylbert (1928–2002)—the first being *Who's Afraid of Virginia Woolf?* Sylbert approached the design of the houses of the upper-middle-class Braddocks and Robinsons (or *Romeo and Juliet*'s Montagues and Capulets, as he called them) as a contrast of black and white, and round versus square shapes. Their

RIGHT: *The Graduate* (1967) • Richard Sylbert, production designer

OPPOSITE PAGE: A sketch of the infamous apartment at the Dakota in *Rosemary's Baby* (1968) • Richard Sylbert, production designer; William B. Major, illustrator

houses are identical, but the designs are reversed. The Robinsons have a round staircase, round arches, while, conversely, the Braddocks have square or rectangular openings throughout the house. Both homes are an interplay of black and white—from the marble checkerboard floors to Mrs. Robinson's white shag-carpeted lair. Sylbert used leopard prints in Mrs. Robinson's lingerie, along with the tiger area rug, to highlight her predatory nature. Water also becomes a metaphor in the film as Benjamin ponders his life while looking through an aquarium and at the bottom of a swimming pool—a motif that represents his life drifting without direction.

A colorful, Brooklyn-born Hollywood veteran whose career spanned from the fifties to the millennium, the twin brother of production designer Paul Sylbert (the pair collaborated on Elia Kazan's *A Face in the Crowd*), Richard Sylbert, was a key figure in creating the look of what is known as Hollywood's "New Wave" films of the period. His legendary résumé included working with some of the industry's best filmmakers, such as Roman Polanski, Warren Beatty, and Elia Kazan, and he credits William Cameron Menzies as his mentor. Sylbert had an unprecedented stint as Paramount's head of production, and earned six Oscar nominations over the course of his career, winning for *Who's Afraid of Virginia Woolf?* (1966) and *Dick Tracy* (1990).

Richard Sylbert's prolific work will be remembered for the images of his satanic apartment in the Dakota in *Rosemary's Baby*; a World War II airfield, barracks, and infirmary in *Catch-22*; his Oscar-nominated vision of a corrupt Los Angeles in *Chinatown*; the Beverly Hills mansions and hair salon he created for *Shampoo*; and an iconic Italian restaurant in *Tequila Sunrise*.

Sylbert believed in giving back to young designers and was an inspiration to generations of future production designers such as Rick Carter. Dressed in his trademark khaki safari jacket, he would exclaim, "This safari suit is a uniform. I wear a uniform because to me a movie is a war, and if you don't know it's a war you're missing something. The war is between the problems, the people, and the ideas, and the people with the money. It's the crazies versus the bean-counters!"

THE SIXTIES MARKED the official end of the classic Hollywood studio system. The era of directors and actors being bound by long-term contracts began to fade as studios were taken over by multinational companies. Studio back lots were sold and the number of film productions was at an all-time low as television production rose steadily. As television sets made their way into homes across the country, studios began to look to alternate forms of entertainment, such as "made-for-television" movies. As a result, the glory days of the "dream factories" were over, and the independent filmmaker was born.

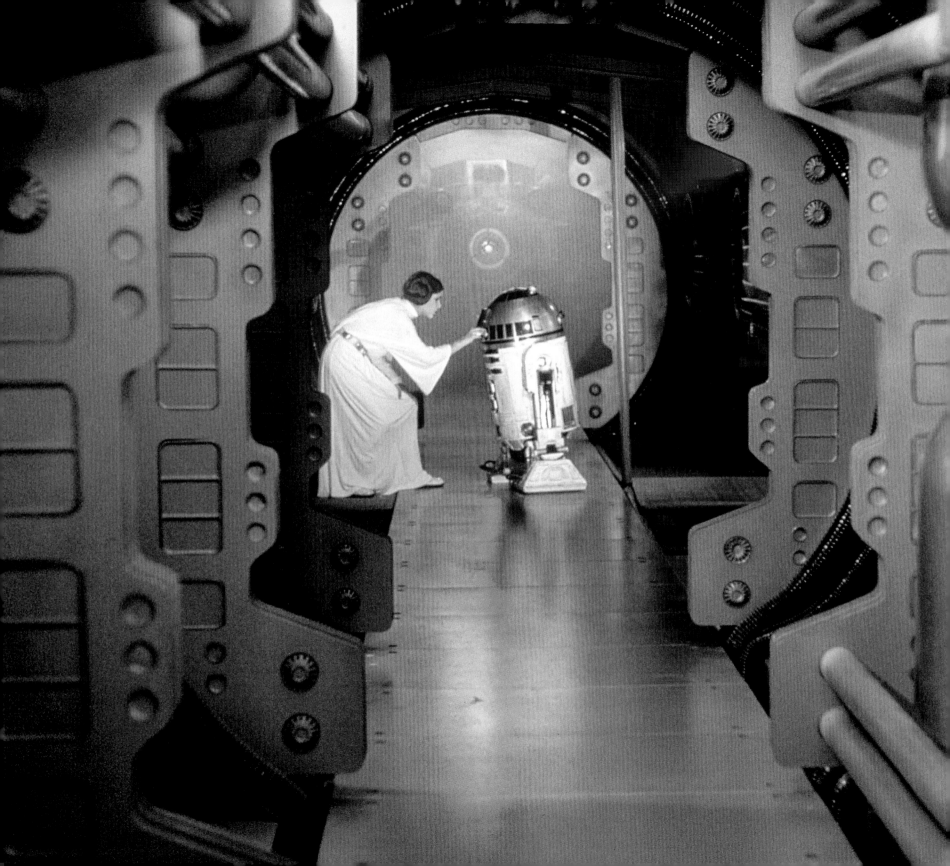

THE SEVENTIES

A Renewed Hollywood—The Birth of the Blockbuster

The seventies was a decade of upheaval—political and cultural—that gave us images many would just as soon forget—napalm-filled jungles and Watergate hearings, discos and platform shoes, and the replacement of social activism with the self-indulgent "I'm OK, you're OK" attitude. The decade appeared to be the flip side of the American Dream.

Thankfully, the death of the studio system marked a time of renewal in Hollywood, and the "blockbuster"—the big-budget, star-studded vehicle that translated into box-office dollars and, often, a string of sequels—was born. From inter-galactic space wars and extraterrestrials, mother ships and man-eating sharks, to disasters in the form of earthquakes, capsized ocean liners, ill-fated airplanes, and fiery towers in the sky, catastrophe and adventure had audiences hooked.

The blockbuster phenomena can be attributed to a new wave of experimental young directors, such as Steven Spielberg and George Lucas, who forever changed the film landscape. Innovative and bold, director Francis Ford Coppola made three of his most powerful films in the seventies, permanently placing *The Godfather* in the American psyche.

While Hollywood had fewer films in production in the seventies, due to the nature of the economic times, the mantra was "bigger and better," a driving idea that provided distinctive challenges for the film's production designers.

OPPOSITE PAGE: Production designer John Barry and art director Norman Reynolds created an interplanetary world like no other in *Star Wars* (1977).

THE DEFINITIVE MOBSTER MASTERPIECE: *GODFATHER I AND II*

In a period film, detail is important. You can't just put a can of soup on the shelf—it has to be the right can of soup.

—DEAN TAVOULARIS, PRODUCTION DESIGNER
OF THE *GODFATHER* TRILOGY

From *The Godfather*'s (Paramount, 1972) opening garden wedding scene, where audiences are first introduced to the Italian-American family and to the secretive, dark office of its patriarch Don Corleone, filmgoers are immediately immersed in the complicated, chilling world of organized crime. Along with its sequels, *The Godfather: Part II* (Paramount, 1974) and *Part III* (Paramount, 1990), perhaps no other film series has seared itself into the collective consciousness quite like this definitive tale of family, obligation, pride, and greed.

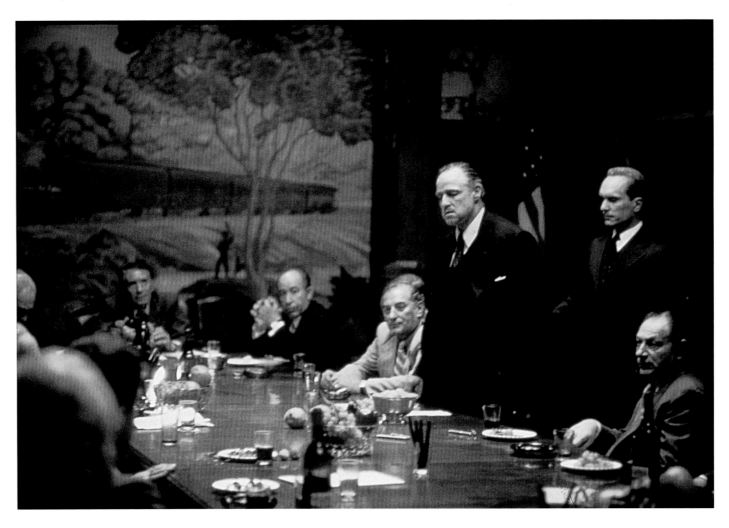

RIGHT AND OPPOSITE PAGE: *The Godfather* (1972) • Dean Tavoularis, production designer

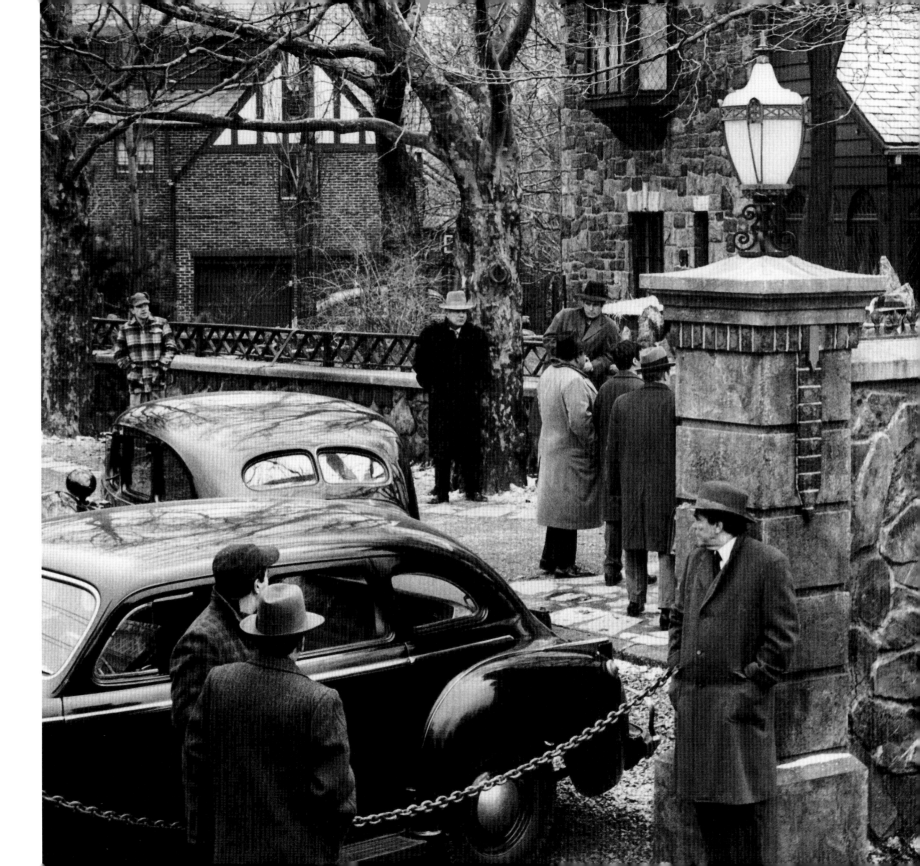

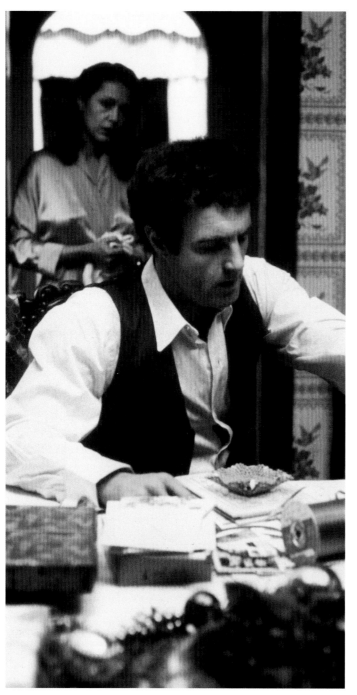

Told over a ten-year period, *The Godfather* details the
life of the aging don (played by Marlon Brando), one of
the five heads of the crime syndicate in New York. He
is succeeded by his once-decent, but soon-to-be-ruthless
son Michael—but not before the family is torn apart over
mob wars and revengeful deaths. *The Godfather: Part II*
(1974) is a parallel story, simultaneously chronicling Mi-
chael's life with his family in Lake Tahoe and tracing the
roots of his father, the young Vito Corleone, in early 1900
Sicily and Little Italy.

Representing the darker side of the American Dream,
the films are important on many levels. They tell intertwin-
ing tales of love, loyalty, and family, revenge, violence, and
betrayal, and, above all, they are magnificently written,
acted, photographed, and designed. Of equal importance is
the rare fact that the sequel contains as many successful ele-
ments as the original—film critics continue to debate over
which film is superior.

The memorable look of the film was brilliantly executed
by celebrated production designer Dean Tavoularis, who is
known as a visionary designer gifted with an acute attention
to detail. The pair tackled together the monumental task of
designing the hellish jungle kingdom of *Apocalypse Now,*
and later collaborated on several other films, including *One
from the Heart, Peggy Sue Got Married,* and *Tucker: The
Man and His Dreams.* Of his work with the famed direc-
tor, Tavoularis says: "He gives you a general direction. He
describes how the idea is born. Then I move, comfortably,
around this axis. Coppola gives you the freedom and op-
portunity to explore your potential."

Tavoularis is known for his remarkable period designs
and use of color to convey a film's underlying themes. For
The Godfather sagas, he and cinematographer Gordon
Willis designed and lit the interior scenes in yellow, amber,

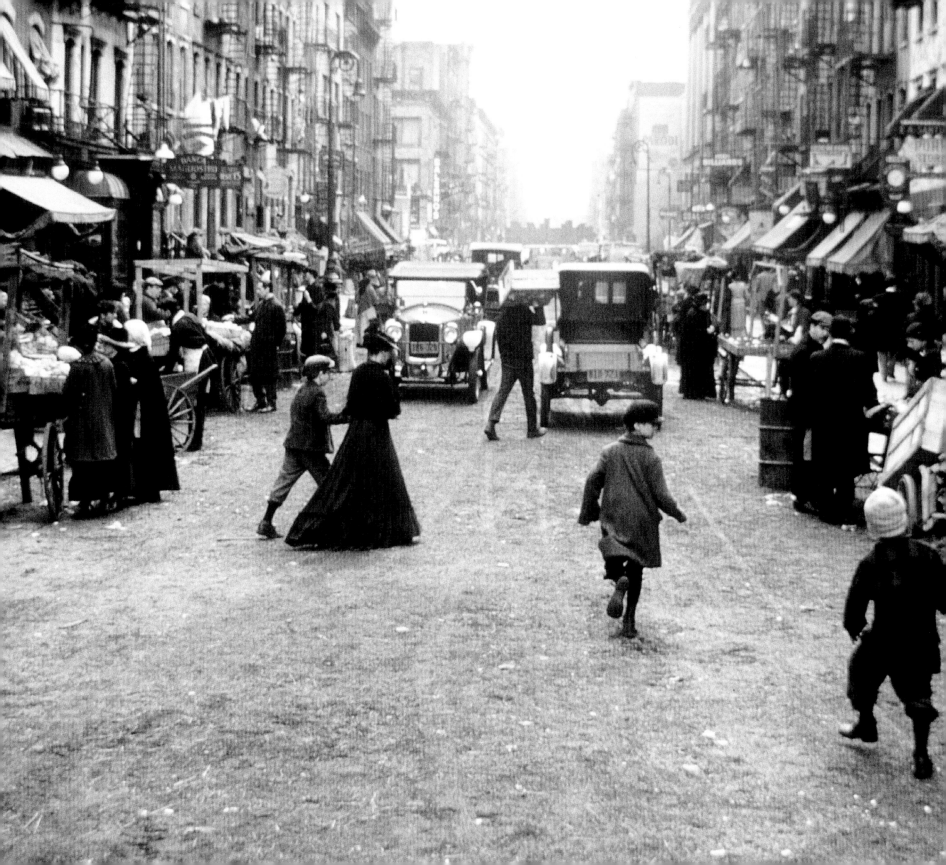

and saturated sepia tones, which gave it a Kodachrome period look—as Coppola wanted a "forties New York grit." For exterior shots, public scenes like *The Godfather*'s family wedding and *The Godfather: Part II*'s Lake Tahoe celebration sequences, Tavoularis turned to brighter, more vivid colors to set a light and jovial mood.

Fruit becomes a metaphor in the film, especially oranges, which seem to serve as a portent of death. In *The Godfather,* Don Corleone is selecting the fruit from a street vendor when an attempt is made on his life, and shortly before his death, he playfully pops an orange rind in his mouth to scare his grandchild. In *The Godfather: Part II,* a senator is framed for murder after playing with oranges in Michael's Lake Tahoe home office, and Johnny Ola brings an orange to the same office before the attempt on Michael's life. In the Little Italy sequence, Fanucci is eating an

orange shortly before he is gunned down by Vito Corleone. Often it's the smallest visual elements—such as the use of an orange—that contribute to the overall mood and design of a film.

The film's memorable interiors were varied and richly detailed; they often involved domestic scenes of family rituals—cooking, christenings, shopping, and funerals (over fifty scenes involve food and drink)—interspersed with violent, bloodletting acts of revenge. For the Corleone compound's interiors, which were shot on a soundstage (the exterior mansion was shot on Long Island), Tavoularis faithfully re-created a modest yet tasteful forties home, complete with religious artifacts and period furniture and wallpaper. He even placed utensils in the drawers of the kitchen cabinets, though the audience could not see them. Tavoularis is known for the unseen details that help actors stay in character. (For Coppola's film *The Conversation,* he had magazines stacked on the desk with subscription labels made out to Gene Hackman's character—for effect.)

His re-creation of Ellis Island, early-nineteenth-century Little Italy, Las Vegas, a compound at Lake Tahoe, and Corleone, Sicily (shot on location in Savoca, Sicily), contributed to the success of the cinematic masterpiece.

An art and architecture student, Tavoularis landed his first job in the industry as a storyboard artist at Disney. He has worked with an impressive list of directors—including Michelangelo Antonioni, Warren Beatty, and Arthur Penn. He designed another period gangster-style film, *Bonnie and Clyde,* with its machine-gun finale that was remarkably prescient of the toll-booth murder scene in *The Godfather.* His background in architecture, along with the ability to storyboard a film, proved beneficial as he created the pictorial landscapes of *Little Big Man* and the sixties sets of *Zabriskie Point.*

THE STING

A story of two con men (played by Paul Newman and Robert Redford) trying to pull off the score of their lives against a mob boss, *The Sting* (Universal, 1973) is one of the most beloved American movies of the century. Set in 1930s Chicago, the Depression-style gangster film was brilliantly designed by veteran Henry Bumstead on the back lot of Universal Studios and on location in Pasadena, California, and Chicago, Illinois.

Drawing upon his extensive background, and perhaps influenced by his expertise in cartoon drawing, Bumstead attributes the film's successful period feel to his choice of color combinations—the sepia tones, golds, browns, and reds that appeared predominantly in the film. Aged period interiors and architecture, particularly for the mean streets of Chicago, work hand in hand with the costumes and automobiles to enhance the overall atmospheric look

of the film. Bumstead studied the Depression-period photographs of Walker Evans and used his work as a reference point in designing the film. *The Sting* marked Bumstead's eighth collaboration with director George Roy Hill and won him an Oscar for Best Art Direction.

ABOVE: Bumstead's attention to 1930s period detail created the atmospheric Depression-era feel of *The Sting*

LEFT: Production designer Henry Bumstead's illustration for *The Sting* (1973)

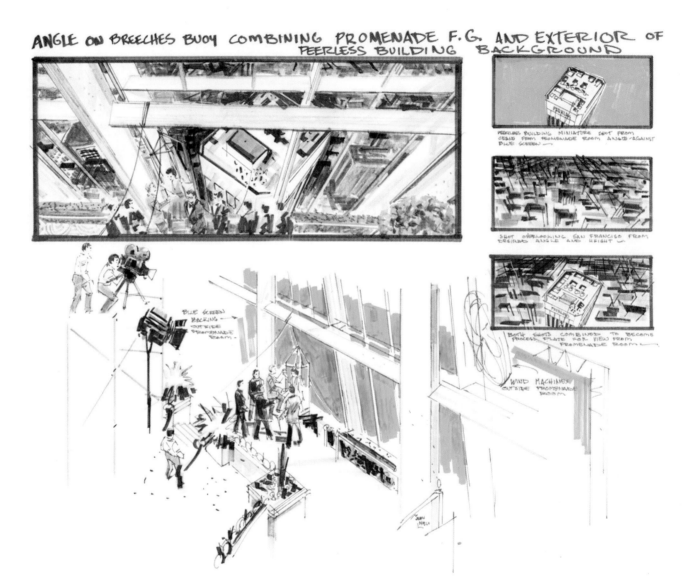

ANGLE ON BREECHES BUOY COMBINING PROMENADE F.G. AND EXTERIOR OF PEERLESS BUILDING BACKGROUND

PEERLESS BUILDING MINIATURE SHOT FROM CEILING FROM PROMENADE ROOM ANGLE AGAINST BLUE SCREEN

SHOT OVERLOOKING SAN FRANCISCO FROM DESIRED ANGLE AND HEIGHT

BOTH SHOTS COMBINED TO BECOME PROCESS PLATE FOR VIEW FROM PROMENADE ROOM

BLUE SCREEN BACKING OUTSIDE PROMENADE ROOM

WIND MACHINES OUTSIDE PROMENADE ROOM

RIGHT: Concept sketches of the escape sequence for *The Towering Inferno* (1974) • Joseph Musso, illustrator

DESIGNING THE DISASTER

Maybe they just oughta leave it the way it is. Kind of a shrine to all the bullshit in the world.

—DOUG ROBERTS, *THE TOWERING INFERNO*

The disaster/blockbuster/soap-opera-in-the-sky film *The Towering Inferno* (1974) was one of the most popular disaster films of the seventies. The story revolves around a 138-story high-rise structure in San Francisco known as the Glass Tower, which, due to poor construction, turns into a fiery hell for its inhabitants. The film has all the classic ingredients of the disaster recipe—a veritable "ship of fools" roster of characters; a predominant fireman hero, Steve McQueen; dazzling special effects; and a cautionary tale at its core. The film both questions and celebrates the modern achievements of architecture.

The film's interior shots were filmed in the lobby of San Francisco's Hyatt Regency Hotel, which featured glass-walled sky elevators that were needed for the disaster scenes (along with interiors on sound stages at Fox). The Bank of America doubled as the tower's exterior façade, while the "actual" burning tower was an eighty-foot-tall miniature fitted with propane gas jets for the fire sequences.

Designed by William Creber, who is best known for his work on the film *Planet of the Apes*, the film cost $14 million and became one of the biggest-grossing films of 1974. Creber specialized in the disaster design genre with his prior work on *The Poseidon Adventure* (1972). The genre is both unique to and synonymous with the seventies; its films tend to have one or more of the following key elements: transportation (airplanes, trains, and ships), climate (earthquakes, tornadoes, and floods), or man-made disasters (epidemics) and, as a result, involve production design of an equally epic nature.

"EITHER YOU BRING THE WATER TO L.A. OR YOU BRING L.A. TO THE WATER."

—NOAH CROSS, *CHINATOWN*

Water is used as a powerful metaphor in Roman Polanski's classic *Chinatown* (Paramount, 1974). Masterfully designed by Richard Sylbert, the neo-noir film tells the story of a private detective who uncovers the crime and corruption surrounding Los Angeles's water rights during a 1937 California drought. John Huston plays the wealthy landowner Noah Cross, who manipulates the water rights for his own benefit. Considered a landmark in art direction, *Chinatown* is one of the most important films made since the days of the studio system, as it is true neo-noir, combining elements of mystery, psychology, and drama.

Filmed on location in L.A., the 1930s period atmosphere is obtained not only through the use of set decorations, automobiles, and costumes, but through Sylbert's use

LEFT: *The Towering Inferno* was representative of the classic disaster films of the seventies • William J. Creber, production designer

of color—from the sun-baked browns and reds of parched landscapes to the sepia tones of the Mulwrays' world. He explains the process: "It has to be during a drought, meaning the sky can't have any clouds. And you should shoot only with a white sky. . . . Then you say, if there's a drought then the colors of this picture can go from white to burnt grass and that's it. All the variations, straw, hay, so on. Except where they have water. Which means then you can have green. Mrs. Mulwray's lawn and the orange orchard. That's all there is in the movie that's green."

Richard Sylbert's California of the thirties is stylishly sophisticated and moody, yet gritty, dark, and intriguing at the same time—a nod to the Raymond Chandler novels and noir films of the forties. Audiences are immediately transported to a Los Angeles of a bygone era, and the images remain unforgettable: the haunting opening trumpet solo; J. J. Gittes sitting in his dark brown, Venetian blind–shaded office with a bandaged nose; and Evelyn Mulwray's pencil-thin eyebrows and palatial mansion.

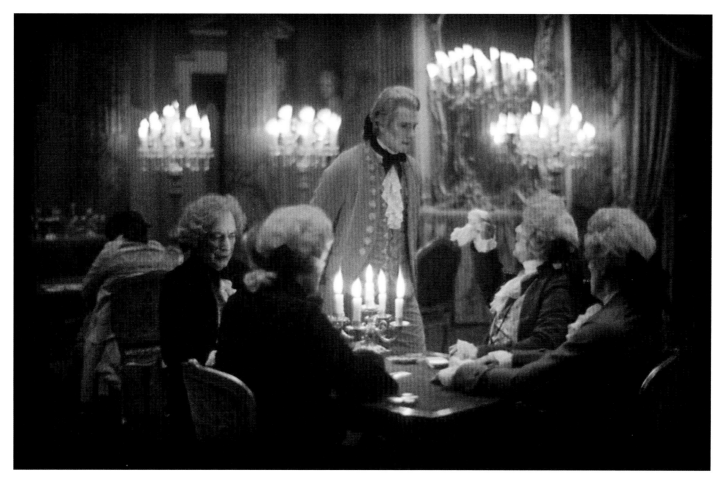

THE PICTORIAL LANDSCAPES OF *BARRY LYNDON*

Stanley Kubrick's historical epic *Barry Lyndon* (Warner Bros., 1975) chronicles the rise and fall of an opportunistic rogue (played by Ryan O'Neal) who travels the countryside attempting to build himself the life of a nobleman through gambling and seduction. Shot against the breathtaking backdrops of Ireland, England, and Germany, this masterful period film, set in the mid–eighteenth century, is the result of the exemplary art direction of Ken Adam. Considered by film historians to be one of the most beautiful films ever made, the landscapes and castles of *Barry Lyndon* appear to jump off the canvas of a Gainsborough or Reynolds painting. Author Nils Meyer notes, "Few directors have ever composed a film with such care, each shot resembles an oil painting and the colors are unparalleled in their intensity. *Barry Lyndon* creates its own world here, the past is indeed another country, gone forever yet still alive."

Together, Kubrick and Adam extensively researched books on the art and history of the time period as references for the film's costumes (which took a year and a half to design), furniture, and architecture. Relying upon

OPPOSITE PAGE, LEFT, AND BELOW: Exterior shots from *Barry Lyndon* are reminiscent of a Gainsborough painting • Ken Adam, production designer

atmosphere as an essential device, Kubrick shot many of the evening and interior scenes by candlelight and oil lamps, and turned to natural light for the daytime scenes as much as possible. The cinematography achieved a unique golden glow.

While the final effect was wonderful on film, it was a production nightmare for Adam, who had to deal with the budget and logistics. He explains one drama: "I ordered a lot of cheap candelabras from Italy and we experimented with different candles to see how much light they gave off . . . the candles started dripping. . . . And the heat given off the candles in the interiors was terrifying. The owners or curators of the stately home didn't want their paintings to be ruined so I had to design big heat shields to protect them."

While many film historians argue about whether the film is a masterpiece or failed effort, the production design remains a true work of art. The Academy thought so too, and awarded Ken Adam, Roy Walker, and Vernon Dixon the Oscar for Best Art Direction.

A SNAPSHOT OF HISTORY: *ALL THE PRESIDENT'S MEN*

The newspaper business is really very concerned about its image. I talked to one reporter and his first reaction was that [All the President's Men] would open with Ray Bolger dancing his way into the newsroom.

—ROBERT REDFORD, STAR AND COPRODUCER
OF *ALL THE PRESIDENT'S MEN*

Two years after the infamous Watergate burglary and a presidential resignation, the film *All the President's Men* (Warner Bros., 1976), based on the bestselling book of the same title, prepared to shoot in Burbank, California. While Hollywood tends to rewrite historical events for film, adding intrigue and drama where the writer and director see fit, filmmakers were adamant about accuracy

and authenticity in *All the President's Men*. Sticking to the facts was crucial in telling the story of the famed *Washington Post* reporters Bob Woodward and Carl Bernstein as they uncovered the details of the Watergate scandal.

The staggering task fell to the multifaceted Broadway, television, and film production designer George Jenkins, best known for his work on *The Best Years of Our Lives* and socially conscious films such as *The Parallax View* and *Klute*. While much of the story took place in the *Washington Post* newsroom, filmmakers were naturally not allowed to shoot any of the interior scenes there. Jenkins and his staff spent months at the *Post*, soaking up the atmosphere and learning the routine of a daily newspaper, and, according to Redford, photographed, measured, and "itemized every single item in the entire newsroom." Coproducer

RIGHT: Robert Redford and Dustin Hoffman as *Washington Post* reporters Bob Woodward and Carl Bernstein in *All the President's Men* (1976) • George Jenkins, production designer

Walter Coblenz further explains: "I can't tell you how important [accuracy] is to us. I've got a list of props correct to the smallest detail. Why, we're making replicas of phone books that don't even exist anymore!"

The realism of the newsroom supported the overall credibility of the film, allowing the actors to virtually feel they were at a desk at 1150 15th Street NW, instead of the sprawling space of not one but two Burbank soundstages.

Jenkins's quest for authenticity included purchasing two hundred identical desks used by the reporters, and painting them the precise custom color. He was also given a brick from the *Post*'s main lobby, which was duplicated in fiberglass for the film's sets. And Hollywood lore proves

correct: the *Post* actually boxed and sent genuine papers to be scattered across the desks of the newsroom. Set decorator George Gaines even duplicated the exact art and posters that hung in the *Post*'s hallways.

At first, Jenkins felt designing the *Post* would be an impossible job, as he saw "a thousand details at a glance." But, in the face of naysayers, Jenkins created the most realistic set possible. "I had rebelled for years against the Hollywood practice of faking things. You might say that my reproduction of the *Post* newsroom was in the spirit of the film." Jenkins would often slip in and take sketches at night, and, ironically, the *Post* reporters were not pleased at having the tables turned as the production crew snooped around their offices.

STEVEN SPIELBERG IN THE SEVENTIES

Two groundbreaking films involving fear, suspense, and actor Richard Dreyfuss were Steven Spielberg's *Jaws* (1975) and *Close Encounters of the Third Kind* (1977). Both films shared another commonality: they were designed by production designer Joe Alves, a genius behind the scenes.

The primary design for the blockbuster disaster film *Jaws* centered around its main star, "Bruce" the mechanical shark. Alves, a former special-effects animator, researched the Great White and began shaping the shark by making small clay models. The models were eventually turned into three life-size mechanical models made of nuts and bolts, tubing and steel. Numerous problems ensued with the temperamental shark, which cost a quarter of a million dollars to build and sank on its first voyage. While the film was plagued with delays and a malfunctioning Bruce, who apparently had an aversion to salt water, the film became a megahit and spawned three sequels.

Close Encounters of the Third Kind spoke to director Steven Spielberg's fascination with UFOs. In the film, an obsessed Roy Neary (played by Dreyfuss) and a young mother and son are mysteriously drawn to a mountain in

246A SHARK IN CABIN - BRODY
i SHOVES AIR TANK IN SHARKS
 MOUTH

246A UNDERWATER SHOT - SHARK
j SINKING DOWN WITH TANK
 IN HIS MOUTH

246A BRODY'S HEAD IS CUT BY
k FLYING GLASS

244a SHARK BREAKS WATER

244b SHARK CRASHES DOWN
 ON TRANSOM

244c GIANT JAWS SNAPPING
 AT EVERYTHING

RIGHT: Production designer and illustrator Joe Alves's storyboards for *Jaws* (1975)

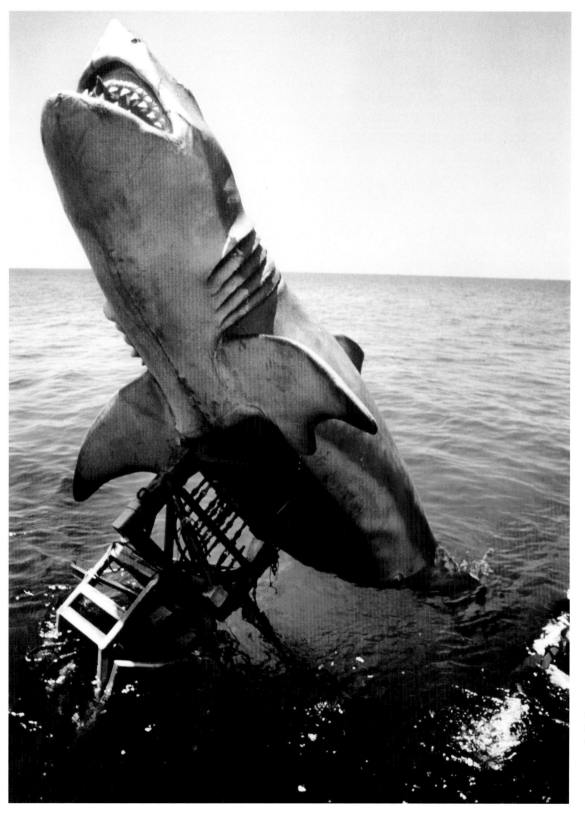

LEFT: Bruce the shark makes a dramatic entrance in *Jaws*

**RIGHT AND
OPPOSITE PAGE:**
*Close Encounters
of the Third Kind*
(1977) • Joe Alves,
production designer;
Ralph McQuarrie,
illustrator

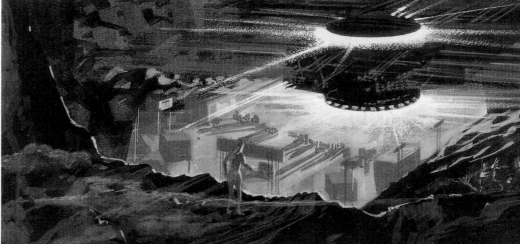

Wyoming. There they experience a "close encounter" with an extraterrestrial being.

Spielberg, who shot *Close Encounters* at the Devil's Tower in Wyoming, was said to have been influenced by the Devil's Rock formation used in *My Darling Clementine*. The "mother ship" was housed in an airport hangar in Mobile, Alabama. It was used for the landing strip complex in the scene when the aliens first land on Earth.

The film became a significant part of film history, as it was made prior to the digital revolution in special effects yet it became Columbia Pictures' biggest-grossing film of all time.

A LONG TIME AGO, IN A GALAXY FAR, FAR AWAY . . .

Star Wars (Twentieth Century Fox, 1977) is not just a motion picture—it is a permanent icon in American pop culture. The product of mastermind director George Lucas, the classic film series was said to be influenced by Lucas's fascination with the Flash Gordon serials of his childhood. Designed by production designer John Barry, the films redefined the science fiction genre by incorporating landmark technological advances that awed audiences in the seventies.

Faced with a limited budget, Barry, along with art director Norman Reynolds and the illustrious Industrial Light and Magic Group, created a dazzling interplanetary world that incorporated an array of varied sets—from the Death Star military complex, to a watering hole known as the "alien cantina," to the innovative space vehicles—and created previously unimaginable futuristic characters like

R2D2 and C3PO. The miniature spaceships traveling at warp speed and the grotesque monster-like creatures all set the stage for future sci-fi films to come. Even as it looked to the future, the film was a nod to the classic western, as it represented the timeless story of good versus evil.

The phenomenal success of the film paved the way for the rest of the series—*The Empire Strikes Back* and *Return of the Jedi* in the eighties, and, twenty years later (and with vastly improved technological advances), *Episode I: The Phantom Menace, Episode II: Attack of the Clones,* and *Episode III: Revenge of the Sith.* The film also put Lucas's Industrial Light and Magic company on the map, as it went on to create special effects for more than three hundred films. ILM's computer-generated imagery (CGI) has enhanced such franchises as *Jurassic Park, Star Trek, Ghostbusters,* and *Pirates of the Caribbean,* as well as made possible *Toy Story* and other Pixar animated features.

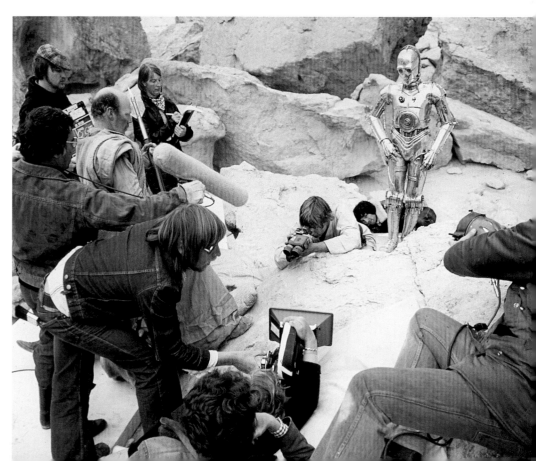

THE SEVENTIES MUSICAL:
ALL THAT JAZZ AND *THE WIZ*

All That Jazz (Columbia Pictures, 1979) is the fantasy film based on the autobiographical story of director Bob Fosse's life on Broadway. Shot in the style of Fellini's *8½*, the film divided its design duties between two veteran New York production designers, Philip Rosenberg and Tony Walton, who together won an Academy Award for Best Art Direction for the film.

Dealing with the themes of theater, sex, and death, Walton provided showbiz glitz to fantasy hospital scenes and flashback sequences, while Rosenberg designed the more traditional New York City sets. The over-the-top film was said to have been the precursor to the music videos of the eighties and nineties.

The design duo also shared credits on director Sidney Lumet's *The Wiz* (Universal Pictures, 1978), an African-American adaptation of *The Wizard of Oz* with an urban

RIGHT: A typical Rosenberg New York City set from *All That Jazz* (1979) • Philip Rosenberg and Tony Walton, production designers

OPPOSITE PAGE: One of Walton's fantasy hospital scenes in *All That Jazz* (1979)

LEFT, OPPOSITE, AND BELOW: The yellow brick road leads to the Chrysler Building in *The Wiz* (1978) • Philip Rosenberg, art director; Tony Walton, production designer and illustrator

twist. Shot on location in New York City, the noteworthy sets included a yellow brick road made of the flooring material Congoleum, and the World Trade Center set up as Oz.

Walton, a celebrated Broadway costume designer and production designer, began his career at age twenty-two and alternated between designing for the London and New York stage throughout the late fifties and early sixties. He entered films as a costumer and consultant on the 1964 film *Mary Poppins* (which starred his then wife Julie Andrews) and as a production designer on *Fahrenheit 451*, moving on to work on such movies as Ken Russell's *The Boy Friend* and Mike Nichols's *Heartburn*. He won the Tony Award for his work on the 1992 Broadway revival of *Guys and Dolls* and Bob Fosse's 1973 production of *Pippin*.

Like Walton, Rosenberg began on the stage. During the course of a prolific career that has spanned four decades, he has designed a variety of New York films, such as *Network*, *Moonstruck*, and *A Perfect Murder*. He specializes in New York–based interiors and locales.

"THIS IS BETTER THAN DISNEYLAND"

— LANCE B. JOHNSON, *APOCALYPSE NOW*

Designing war genre films often presents a challenge for filmmakers, but no film has proven more physically demanding, emotionally draining, and artistically difficult than the making of Francis Ford Coppola's *Apocalypse Now* (Zoetrope, 1979). Adapted from Joseph Conrad's book *Heart of Darkness*, the visually stunning film follows the story of young Captain Willard (played by Martin Sheen), ordered to assassinate a Green Beret corporal who has fled the military and become a living god to a local Cambodian tribe.

Coppola again collaborated with the design team of Dean Tavoularis and Angelo Graham, who served as art director on *The Godfather: Part II*, for the labor-intensive shoot. Filmed in the Philippines, yet set during the Vietnam War, the epic faced numerous complications: Martin Sheen suffered a near-fatal heart attack; sets that took months to build were destroyed by the worst hurricane seen in forty years; Marlon Brando arrived on set too large for his costumes; and the heat and humidity were insufferable to all involved. The production budgeted for seventeen weeks of shooting at a cost of $12 million. Sixteen months and $31 million later, filming ended.

The production's centerpiece was Corporal Kurtz's "jungle kingdom," a set based upon a photograph of a temple in Cambodia known as Angkor Wat. Tavoularis speaks of the experience as one of chaotic madness combined with artistic freedom—much like the compound itself. To provide the actors with a constant reminder of the carnage surrounding the tribal fortress, Tavoularis and his design team brought in real animal bones from local restaurants to set the scene. Unfortunately, the bones attracted rats and had to be constantly replaced. Along with the film's cinematographer Vittorio Storaro, Tavoularis experimented with colored smoke to create the atmospheric look needed for many of the war-torn villages. A noted stickler for detail, Tavoularis was involved in every aspect of the production, even sketching articles of clothing (down to the belt buckle) that the tribe and soldiers might wear.

RIGHT: Production designer Dean Tavoularis and illustrator Alex Tavoularis's sketch for *Apocalypse Now* (1979)

Perhaps the most "normal" set built was the French colonial plantation, which appeared in scenes cut from the original footage. Despite the horrendous shooting conditions, Tavoularis came away from the experience with an Academy Award nomination for Best Art Direction *and* met his future wife, actress Aurore Clément, who acted in the French plantation scene.

THE NEW GENERATION of talent in the seventies—Spielberg, Coppola, Lucas, and many more—laid the groundwork for future sequels and the reinvention of the special-effects- and action-filled blockbuster for decades to come. Aimed primarily at youth audiences, the science fiction, gangster, and disaster films signified the profitable dawn of the sequel in the eighties.

ABOVE: *Apocalypse Now* (1979) • Dean Tavoularis, production designer

32'-0" X 11'-3"

FADED WHITE STAR ON
CANOPY FOR P.B.R. Ⓑ
(NOTE! THIS ① APART from
3 CANOPYS ON P.B.R. Ⓐ)

RADAR UNIT IN
HORIZ. POSITION

GUN TARP
ALSO: ON P.B.R. Ⓐ

55 GAL DRUM ?

GUN TARP

P.B.R. Ⓑ (DIESEL)

AGED DOWN MUCH MORE THAN P.B.R. Ⓐ —
JUNK ON DECK, BEER CANS, 55 GAL
DRUM ON STERN DECK — SOILED FLAG, ETC.

BACKGROUND BOAT Ⓑ

PHASE 1

Sc. 12
P.B.R. DOCK
APOCALYPSE NOW
P.B.R.
· CONTINUITY OUTLINE ·
LOCATION:
SHEET # 3 OF

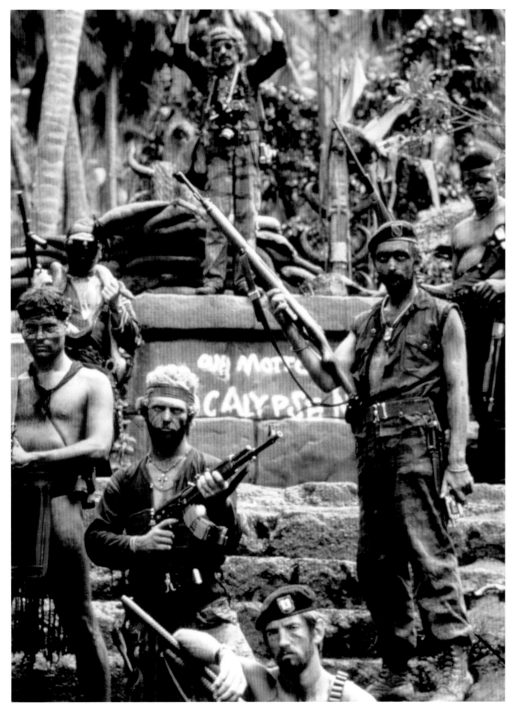

OPPOSITE PAGE:
Production designer
Dean Tavoularis
and illustrator Alex
Tavoularis's sketch
for *Apocalypse Now*
(1979)

LEFT AND BELOW:
A typhoon destroyed
sets, causing a delay
of several months to
the filming • Dean
Tavoularis, production
designer

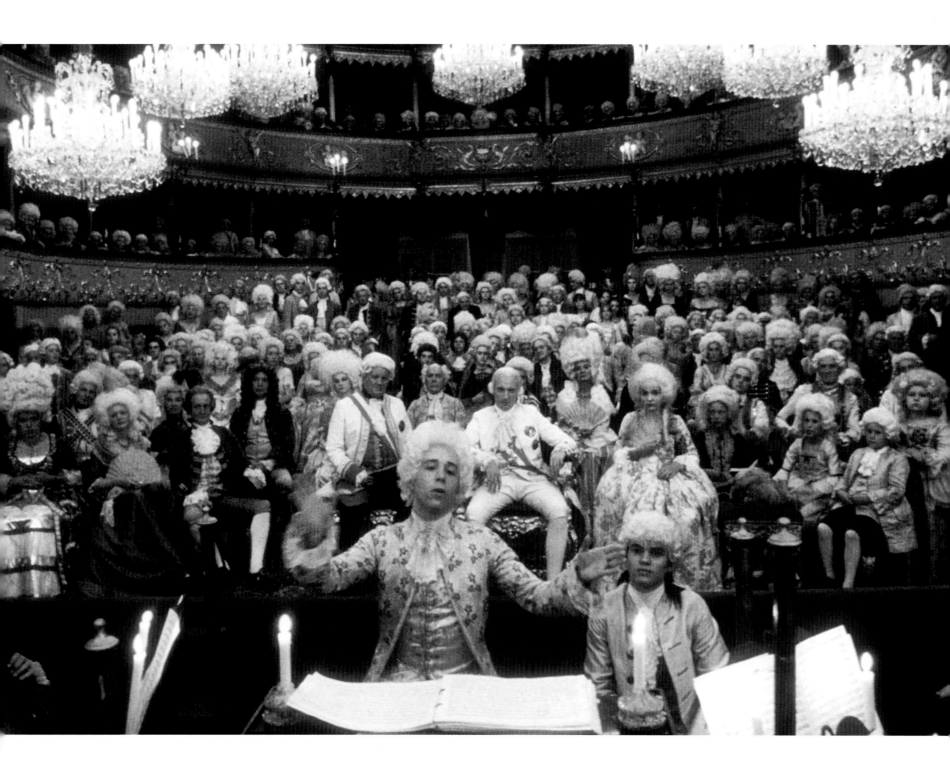

THE EIGHTIES

A Decade of Sequels, Costume Dramas, and "Greed Is Good"

The diverse, high-concept culture of the eighties was mirrored in a variety of its films. It was the decade of the yuppie, of big deals and bigger divorces, as reflected in two hugely popular films *Wall Street* and *The War of the Roses*. Audiences immersed themselves into worlds on film that could be strikingly real—Capone's gangland-style Chicago and *The Shining*'s cold Overlook Hotel—or wholly fantastical, like the world of *The Adventures of Baron Munchausen*. The eighties were marked by economic boom, and the decade's undercurrents of overabundance and deceit were echoed in such films as the period piece *Dangerous Liaisons*. And while the nation was involved in President Reagan's "Star Wars" of its own, audiences continued to turn their attention to a "galaxy far, far away" with the continuation of George Lucas's trilogy in *The Empire Strikes Back* and *Return of the Jedi*.

Action-hero films became the most popular genre of the eighties, as filmmakers were eager to capitalize on newly learned computer-generated special effects. Steven Spielberg's beloved character Indiana Jones, played by Harrison Ford, was cemented into the canon of American heroes as *Raiders of the Lost Ark, Indiana Jones and the Temple of Doom,* and *Indiana Jones and the Last Crusade* became blockbuster hits.

But in terms of art direction, no film in recent memory was more groundbreaking and influential than Ridley

OPPOSITE PAGE: *Amadeus* (1984) was filmed in more than seventy-five locations in Prague • Patrizia von Brandenstein, production designer

Scott's cult science-fiction film, *Blade Runner*. With its dark, futuristic designs of the decayed, industrial wasteland of 2019 Los Angeles, the film spawned the styles of "cyberpunk" and "future noir."

FUTURISTIC FILM NOIR: *BLADE RUNNER*

A dark city is awash in lit skyscrapers and the senses are immediately attacked by multicolor video screens shouting Budweiser, Coke, and Bulova advertisements. Smoke and pollution mingle above overcrowded streets, and neon lights dot the landscape below as the remnants of acid rain collect between buildings.

Welcome to Ridley Scott's *Blade Runner* (Warner Bros., 1982), a futuristic, detective-technological thriller about society run astray with the advent of humanoid robots, based on author Philip K. Dick's novel *Do Androids Dream of Electric Sheep?* Harrison Ford plays Rick Deckard, a "blade-running" detective whose mission is to eliminate killer "replicants," or humanlike robots that have intermingled with the native population.

A mastermind team of production designer Lawrence G. Paull, art director David Snyder, and set decorator Linda DeScenna collaborated on the look of *Blade Runner,* creating the bleak yet visually complex landscapes of the future. The team drew upon a cosmopolitan concoction of urban life in New York, Hong Kong, and Tokyo, and factored in a future of constant acid rainfall and fog, factors which would add to the overwhelmingly dreary city atmosphere. Coupled with fantastic visual effects the film's designs represent an interplay between the past, present, and future of a multinational society. An array of architectural styles ranging from Streamline Moderne to Victorian create a visually eclectic divergence of styles. Scott

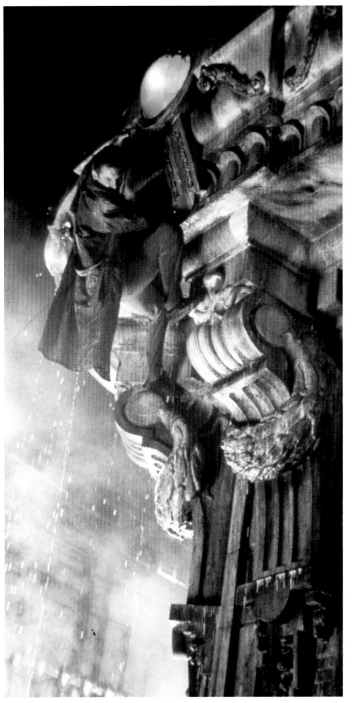

OPPOSITE PAGE: The nightscape of the futuristic city in *Blade Runner* (1982) • Lawrence G. Paull and David Snyder, production designers

LEFT: Los Angeles cop Deckard (Harrison Ford) hangs on the side of a futuristic building in *Blade Runner*

juxtaposed the styles of futurist concept artist Syd Mead and artist Edward Hopper. In particular Hopper's painting *Nighthawks*—a modern, lonely, and vacant view of a scene in a diner—as a point of reference for the overall vision of the film. He also turned to Fritz Lang's *Metropolis* and the cyberpunk comic-book story *The Long Tomorrow* by Dan O'Bannon.

Production designer Lawrence G. Paull's earlier training as an architect proved invaluable on the film, as he literally had to plan an entire working city, complete with waterworks and electricity. He began his film career at Twentieth Century Fox as a set designer under the tutelage of Walter Tyler and John DeCuir on the film *On a Clear Day You Can See Forever*. Known for his skill at architectural drafting, Paull was able to translate Scott's vision of the Los Angeles of the future into reality, giving

the city a sense of authenticity and scale, even as it sprung from a completely imagined world.

Within the city, Deckard's apartment played a pivotal role. Built on a Warner Bros. soundstage, the apartment was inspired by the Frank Lloyd Wright–designed Ennis House in Los Angeles. Set designer Charles Breen used plaster casts from the building's geometric blocks for the set's walls, which were designed to resemble a Mayan cave. The popular eighties design trend known as "high tech"— the use of steel, chrome, and laminates—became the perfect style for the apartment's interior-design scheme.

It's been said that films such as *Batman, Strange Days, Dark City, The Matrix* series, and *Batman Begins* all owe their futuristic industrial look to the original designs of *Blade Runner*, which makes the classic film a touchstone for generations of filmmakers and designers to come.

BELOW: *Blade Runner* (1982) • Lawrence G. Paull and David Snyder, production designers

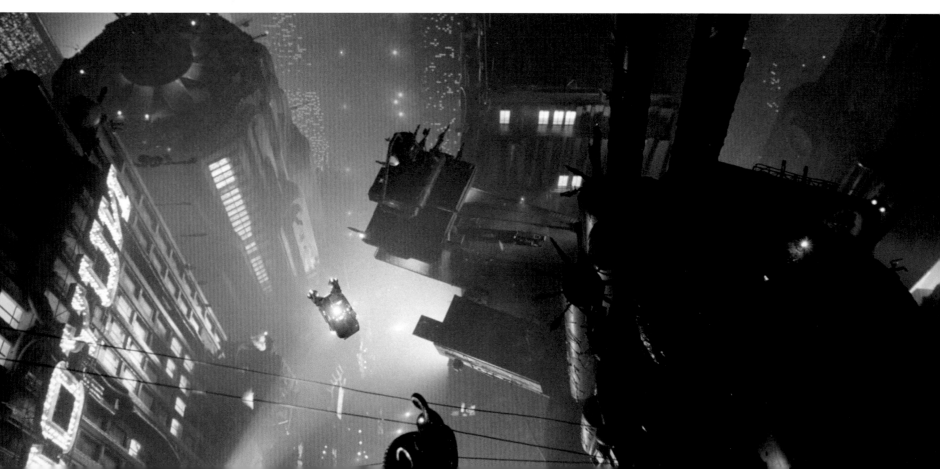

INDIANA JONES: THE HERO
AS ADVENTURER CONCEPT

The "hero as adventurer" concept is as old as the days of Robin Hood, and forms the basis for George Lucas and Steven Spielberg's fedora-wearing protagonist Indiana Jones, also played by Harrison Ford, in *Raiders of the Lost Ark* (Lucasfilm/Paramount, 1981). Ford soon became a major box-office draw in the eighties, starring in *Blade Runner* (1982), *Witness* (1985), and *Working Girl* (1988). This first installment of the Indiana Jones franchise—which grew to four films and the Emmy-winning TV series *The Young Indiana Jones Chronicles*—follows the archaeologist-turned-adventurer as he is hired by the U.S. government to search for the Ark of the Covenant, a reliquary believed to hold the Ten Commandments. The series is an homage to the children-oriented Saturday morning matinees of the thirties, and the films were designed in a period style to match.

British production designer Norman Reynolds executed the film's design to support the action-packed and often breathtaking scenes, which include Jones outmaneuvering tarantulas and avoiding open pits, collapsing walls, and the infamous two-ton rolling boulder, which was actually made of fiberglass. The concept of such "booby traps" came, in part, from Walt Disney's Donald Duck adventures—one cartoon, in particular, involved Donald exploring a lost temple and facing a number of booby traps, including flying darts and a huge boulder. Spielberg was also influenced by *Treasure of the Sierra Madre* and *Casablanca*. John Ford's masterpiece westerns like *Stagecoach* became a particular source of inspiration to the designers of the Indiana Jones franchise, with their mix of constructed sets and frontier landscapes.

One of the most memorable scenes occurs at the "Well

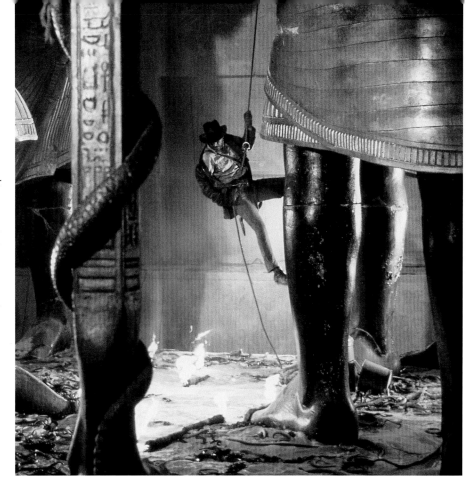

of Souls" set, as Indy faces seven thousand snakes and tarantulas in a pit. While the crew scoured London's pet shops for reptiles, they came up short and had to supplement the live snakes with sliced garden hoses.

Production designer Elliott Scott designed the next film in the series: *Indiana Jones and the Temple of Doom*. *Temple of Doom* contained a variety of sets ranging from a nightclub in Shanghai to the famous sequence where Indy goes on a roller-coaster ride through a mine on a runaway cart. *The Last Crusade* was the lighter story of the series, as the hero and his father (Sean Connery) search for the Holy Grail in Middle Eastern settings, including the memorable temple that housed the coveted artifact.

ABOVE: *Raiders of the Lost Ark* (1981) • Norman Reynolds, production designer

"HEEEEEEERE'S JOHNNY!"

The feeling of isolation is at the very heart of Stanley Kubrick's 1980 film *The Shining* (Warner Bros.). Set high up in the Rocky Mountains, the off-season Overlook Hotel became one of the most fear-inducing locations in history. Based upon Stephen King's 1977 bestselling novel of the same name, the classic horror film tells the story of a young writer, Jack Torrance, played by Jack Nicholson, and his family, who experience the ultimate cabin fever as they act as caretakers for the empty yet haunted lodge. Kubrick took great pains to avoid the usual Gothic interpretations seen in horror films. The sets, designed by Roy Walker, are a mixture of contemporary and American-Indian motifs, and were created at the EMI's Elstree Studios in London. The Timberline Hotel in Mt. Hood National Forest, Oregon, provided the memorable exterior for the Overlook.

The late Kubrick explained his design approach with Walker: "We wanted the hotel to look authentic rather than like a traditionally spooky movie hotel. The hotel's labyrinthine layout and huge rooms, I believed, would alone provide an eerie enough atmosphere. The final details for the different rooms of the hotel came from a number of different hotels. The red men's room, for

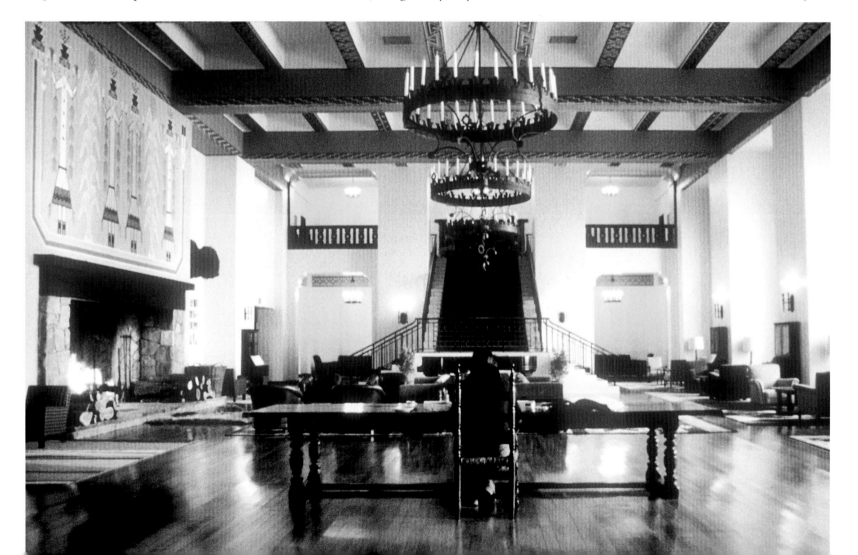

example, where Jack meets Grady, the ghost of the former caretaker, was inspired by a Frank Lloyd Wright's men's room in a hotel in Arizona. The models of the different sets were lit, photographed, tinkered with, and revised. This process continued, altering and adding elements to each room, until we were all happy with what we had."

The garden maze used for the film's finale was also constructed on the London soundstage. The falling "snow" was likely a combination of white sheeting, artificial snow, and shaved ice and the hedge labyrinth was actually a combination of matte painting techniques and artificial hedges. The hedgerow maze, along with the hotel's endless hallways, dead ends, and locked doors become a powerful metaphor for Torrance's slide into madness.

"I HAD A FARM IN AFRICA."

—KAREN BLIXEN, OUT OF AFRICA

Out of Africa (Universal, 1985) is the majestic, romantic portrayal of bittersweet memories of the life and loves of Danish writer Karen Blixen (played by Meryl Streep) in 1914 Africa. Director Sydney Pollack and production designer Stephen Grimes had the difficult task of translating Blixen's real life to the screen and settled on Kenya for the film's location. Pollack chose to film at the Ngong Dairy, in Blixen's namesake town of Karen, as the area was ripe with lush farmland and had a spectacular view of the Ngong Hills. Grimes and his crew renovated the existing farmhouse, which was Blixen's original home.

In one of the film's most memorable scenes, the servants (all dressed in crisp white attire) clumsily attempt to unpack Blixen's crates and steamer trunk filled with crystal, china, and, to their amazement, a cuckoo clock. The audience immediately sees a woman of taste and culture—a woman planning to set up a permanent home. Set decorator Josie MacAvin searched the Kenyan countryside for the real-life Blixen's household belongings, which were sold at the time of her bankruptcy. Antique furnishings such as lamps, draperies, sofas, and paintings native to Denmark proved difficult to purchase on location in Africa, and had to be shipped in from Europe. Using Blixen's photographs, designers attempted to keep the sets as true to life as possible.

Grimes and his crew designed the Kikuyu village (the Kikuyu being one of several African tribes portrayed in film), which consisted of circular cottages built from poles covered in mud and thatched reeds. The designers reconstructed a 1914 Nairobi, a project that involved hundreds of craftsmen and construction workers in addition to tons of lumber, concrete, and plaster. The crew also built from scratch the Muthaiga Club in the town of Langata, where Karen and Bror married. Grimes worked from vintage photographs and original construction plans of the town, faithfully reconstructing hotels, a bank, a railroad station, a bazaar, a doctor's office, and a church. He and the crew spent a year getting the town ready for filming.

Winner of the Academy Award for Best Art Direction in 1986, the film sparked a trend in African and British Colonial décor, adopted by shelter magazines as well as the public in the late eighties.

BELOW AND OPPOSITE PAGE:
Out of Africa (1984) started a trend in British Colonial home furnishings • Stephen Grimes, production designer

DESIGNING THE EIGHTEENTH CENTURY

Mozart, Music, and Milos

Eighteenth-century Austria is the backdrop for the story of the musical prodigy Wolfgang Amadeus Mozart. Directed by Milos Forman and designed by Patrizia von Brandenstein (the film marked their second collaboration, with the first being *Ragtime* two years earlier), *Amadeus* (Saul Zaentz Company, 1984) was actually shot on location in Prague, as the city was home to essential untouched eighteenth-century architecture. Churches, palaces, and opera houses were carefully researched and designed for the elaborate production, a fictionalized story of the rivalry between Mozart (played by Thomas Hulce) and Italian composer Antonio Salieri (played by F. Murray Abraham).

American-born von Brandenstein, considered one of the leading female production designers, spent her formative years abroad as an apprentice at the Comédie-Française theater. Upon her return, she worked in off-Broadway theater through the sixties as a scenic painter and prop-maker. She spent the latter part of the decade with William Ball's American Conservatory Theater in San Francisco, performing double duty as a set and costume designer. Theater work soon led to film, and von Brandenstein cut her teeth as a set decorator on *The Candidate* and costume designer on *Saturday Night Fever,* where she is credited with designing John Travolta's infamous white disco suit. She also found major success in her collaborations with director Mike Nichols on *Silkwood, Working Girl,* and *Postcards from the Edge.* Von Brandenstein excels at designing period sets, notably Chicago in the twenties for *The Untouchables,* the thirties' gangster world of Dutch Schulz for *Billy Bathgate,* and, at the other end of the spectrum, her contemporary Park Avenue settings for the film *Six Degrees of Separation.* For her historical work on *Amadeus,* von Brandenstein's artistic background came into play as she chose a "natural but lively palette. The colors consistently seemed vivid and bright, and they appeared wonderfully rich," she explains. "I have never used primary color in film in my life. I tend to use a tertiary, dark color palette, because the actors look better." She also felt it was imperative for the sets to exude the life and exuberance of Mozart's music. "Mozart's world was reflective, bright, silvery, pastel, brilliant, tingling like crystal, faceted like his music. It was the music that drove the design," she says.

While von Brandenstein's work was a close collaboration with the director and cinematographer, she was also very involved in all aspects of the art direction—from set dressing to costumes. From the stage of the Vienna Opera House to sophisticated ballrooms steeped in Rococo architecture, the designer's sets are filled with ornamentation and period perfect detail.

ABOVE: *Amadeus* (1984) • Patrizia von Brandenstein, production designer

Seduction on Set

Set in eighteenth-century Baroque France, *Dangerous Liaisons* (Warner Bros., 1988) is a story of seduction and deceit amid the ranks of the aristocracy. Against a backdrop of sumptuous Neoclassical and Rococo furnishings, Glenn Close plays the Marquise de Merteuil, a Parisian socialite whose favorite pastime is erotic gamesmanship.

Shot on location in the historical châteaus and palaces of Île-de-France and Picardi, the elegant set became a secondary character—the stage on which the evil treachery and sexual intrigue played out between the characters. In gilded splendor, the majestic interiors played host to a slew of battles large and small; they set the scene for grand entrances and exits, were privy to whispers of gossip and betrayal and, ultimately, of seduction and downfall. The lavishly furnished sets establish a clear sense of decorum, wealth, and power, yet, in their decadence and grandeur, convey an underlying subtext of excess and depravity.

The Academy Award–winning production design was due to the work of production designer Stuart Craig, and his collaboration with art directors Gavin Bocquet and Gérard Viard, and set decorator Gérard James. Craig, a three-time Academy Award winner (he also won for his work on *Gandhi,* in 1982, and *The English Patient,* in 1996), had been designing films for almost forty years. He began as a junior in the art department on *Casino Royale* (1967), and is perhaps best known for his imaginative and innovative work on the *Harry Potter* series.

ABOVE: *Dangerous Liaisons* (1988) • Stuart Craig, production designer

CAPONE'S CHICAGO

Set in Prohibition-era Chicago, *The Untouchables* (Paramount, 1987) is the story of federal agent Elliott Ness, played by Kevin Costner, and his battles with underworld boss Al Capone, played by Robert De Niro. Patrizia von Brandenstein teamed up with director Brian De Palma as a "visual consultant" (along with art director William A. Elliott and set decorator Hal Gausman), and the film was nominated for an Academy Award for Best Art Direction.

A stickler for detail and accuracy, von Brandenstein was delighted when the studio allowed the filmmakers to shoot the entire film on location—twenty-five sites in all, including Union Station. She felt the architecture of Chicago

BELOW: *The Untouchables* (1987) • Patrizia von Brandenstein, production designer

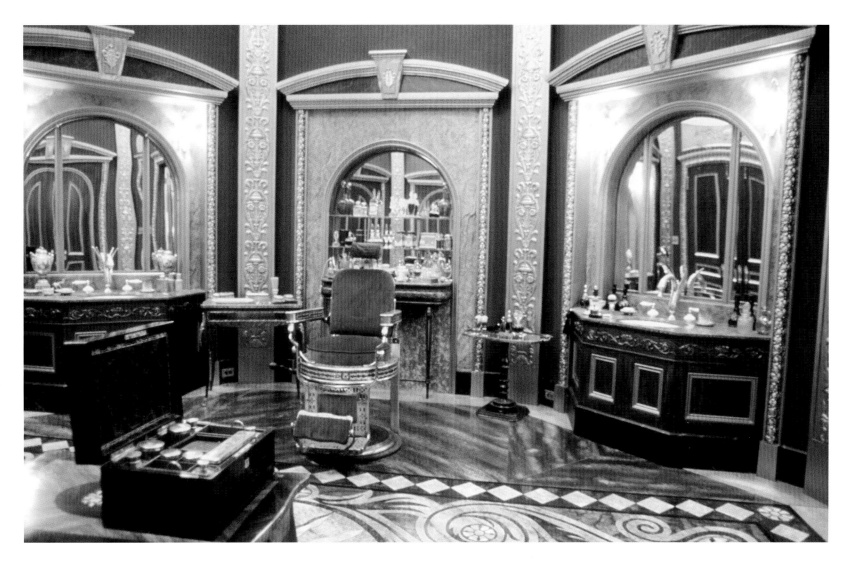

reflected the "extreme contrasts of the period's poverty and wealth, liveliness and certain ugliness, ethnic differences and so on. These elements, jumbled together, form a very powerful image."

Other famous city locales the team shot were the Chicago Theater and the Rookery Building on South LaSalle, which served as the police department's exterior. The gangster sets—Capone's apartment, the barber shop, and boardroom—were purposely very rich in color while the Ness home and the apartment of Jim Malone (played by Sean Connery) were somewhat bland and made to appear working-class. Capone's world was created with opulence—the jewel tones and bright reds in the plush apartment serve as markers of wealth and decadence. Everything, including the parquet floor with diamond patterns, was heavily ornamented and detailed, and, like its owner, larger than life.

ABOVE: The opulent barber shop in *The Untouchables* (1987) • Patrizia von Brandenstein, production designer

"GREED IS GOOD"

—GORDON GEKKO, *WALL STREET*

A cautionary tale at heart, Oliver Stone's *Wall Street* (Twentieth Century Fox, 1987) came seemingly before its time: it was a parable for the nineties—a decade of money, self-indulgence, unabashed narcissism, and consumerism.

Michael Douglas as the ruthless financier Gordon Gekko sums it up in a stockholders' meeting speech when he exclaims his immortal catchphrase: "Greed is good."

The young broker Bud Fox (played by Charlie Sheen) becomes Gekko's protégé.

Designed by Stephen Hendrickson, the film's sets support the characters' luxurious lifestyles, capturing the sensibilities of the rich and ultrarich right down to the last detail. As Bud rises to the top, he purchases a high-rise apartment on the Upper West Side, complete with all the latest yuppie accoutrements, from sushi-makers to over-the-top abstract art. The apartment is designed by society decorator Darien

RIGHT: Bud Fox (Charlie Sheen) at his desk in *Wall Street* (1987) • Stephen Hendrickson, production designer

OPPOSITE PAGE: Gordon Gekko (Michael Douglas) in his high-rise office in *Wall Street*

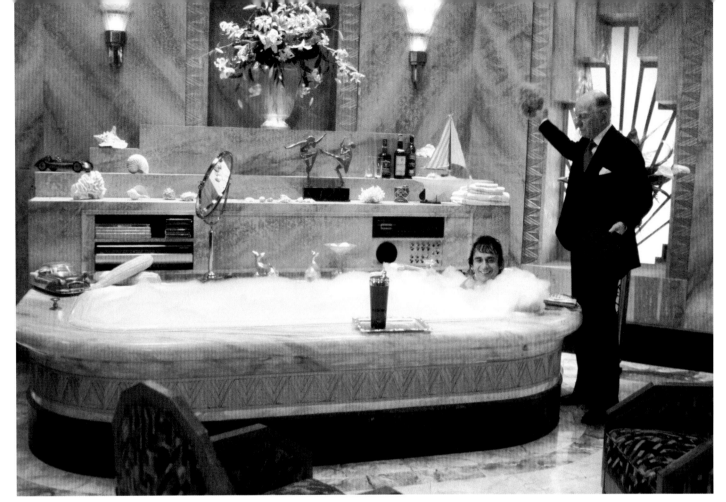

Taylor (played by Darryl Hannah), who plans to "do for furniture what Laura Ashley did for fabrics" and have Bud take her company public.

The overall look is one of abandoned chic where the interiors appear to work at cross purposes—exposed brick is adorned with gilt, regal moldings appear decayed. Stone described the desired design for the apartment as "deconstructionist style" in which the hand-painted walls have exposed "faux brick" in various places, glass coffee tables have jagged edges or no top at all, and works from the latest contemporary artists of the moment adorn the walls. Gekko's pristine beach house is filled with even more expensive art, while his downtown Wall Street office is the ultimate power shrine. Everything is large-scaled and commanding, much like Gekko himself.

Stephen Hendrickson may have drawn inspiration from his previous work on New York sets for another film about wealth: *Arthur* (Orion Pictures/Warner Bros., 1981). *Arthur* is the tale of a drunken playboy and heir to a vast fortune who has to marry a woman of his family's choosing, but instead falls in love with a waitress. The title character's New York City digs are elegant yet playful, like the child within the man. A throwback to the thirties, the peach marble Art Deco bathroom is the scene of the most famous line of the film—"I'll alert the media"—uttered by Hobson, the butler, when he is asked to run Arthur's bath.

THE EIGHTIES DIVORCE:
THE WAR OF THE ROSES

Divorce was a much-publicized "epidemic" of the eighties and is lampooned in the dark comedy *The War of the Roses* (Twentieth Century Fox, 1989). Directed by Danny DeVito, the film centers around the Roses (played by Michael Douglas and Kathleen Turner), who are the epitome of the couple that has it all.

Production designer Ida Random and set decorator Anne D. McCulley decorated the Roses' two-story house to the hilt, complete with a designer kitchen straight from the pages of *House and Garden*. Poking fun at the decade's obsession with consumerism, the Roses take materialism to new heights. Their accessories and furnishings play a central role as plot devices—the beloved Staffordshire figurines become bargaining tools, the chandelier becomes their lifeline and ultimate demise.

TERRY GILLIAM AND THE FANTASY FILM

Brazil (Embassy Pictures/Universal, 1985) is the story of a bureaucrat, Sam (played by Jonathan Pryce), who becomes an enemy of the state in a "retro-future" world. The dark, Orwellian tale is most noted for its visionary designs and visual effects, designed by production designer Norman Garwood. With a nod to *Metropolis*, the concept of technology and its eventual failure becomes the film's driving theme.

Director Terry Gilliam's vision was one of a monochromatic combination of the forties and the twenty-first century—and the decades in between—all combined to form an alternate future universe. High-rise monolith structures are filled with retrofitted offices in a maze of depressing narrow hallways. A former animator, Gilliam is known for his visually stunning and sometimes bizarre designs, often having no apparent roots in reality.

Gilliam also melds the themes of fantasy and special effects in *The Adventures of Baron Munchausen* (Columbia, 1988). A cult classic, the film spins the fantastic tale of an aristocrat who tries to save an eighteenth-century town from defeat by the invading Turks. In true Gilliam style, and with the collaboration of production designer Dante Ferretti, some of the most intriguing sets include a trip to the moon, a giant sea monster, a moving paper city, a three-headed chicken, and a stunning hot-air balloon made of ladies' undergarments.

Gilliam assembled these unique cinematic elements into a style he calls "eighteenth-century science fiction" and compared the mythic tale to *The Thief of Bagdad* (both 1924 and 1940). Filmed near the town of Zaragoza, Spain, and at Cinecittà Studios in Rome, the film was a follow-up to his movie *Time Bandits*.

RIGHT: *Brazil* (1985) • Norman Garwood, production designer

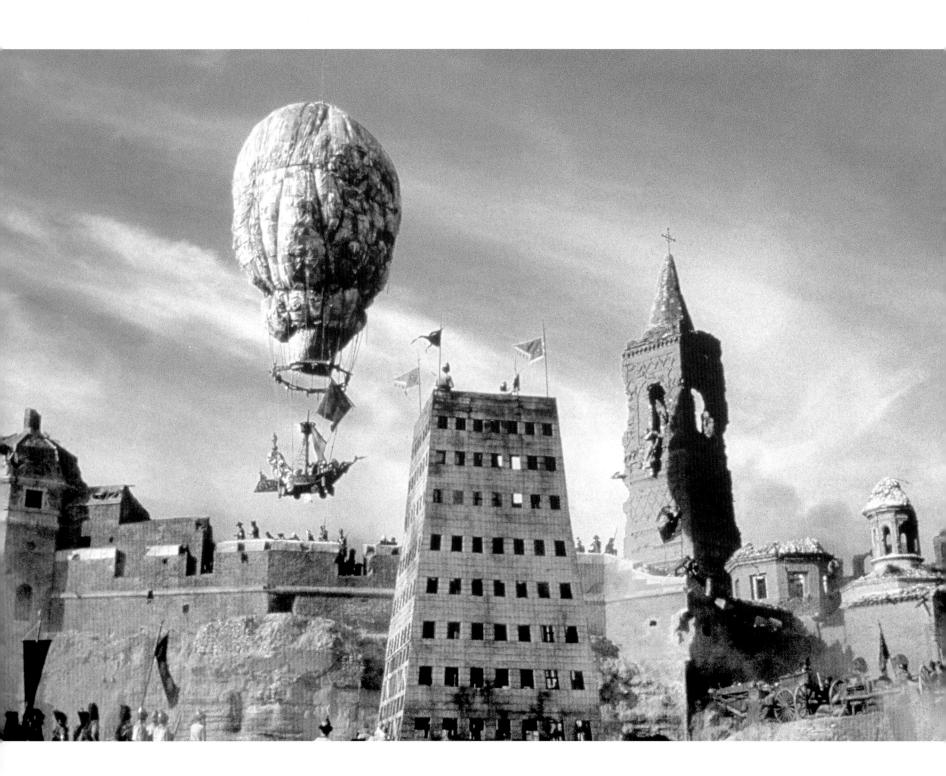

THE EIGHTIES WERE characterized by the growth of blockbusters—the formulaic large-budget features that boasted spectacular CGI special effects and high-concept production design. From Bond and Indiana Jones to *Star Wars* and *Star Trek*, the sequel as franchise concept proved to be both lucrative and popular with moviegoers. Dramas and dark comedies that mirrored the times continued to be a cinema mainstay as author Douglas Brode explains in his book *Films of the Eighties:* "If the eighties was the first era in which life imitated the movies, it was yet another era wherein movies reflected life."

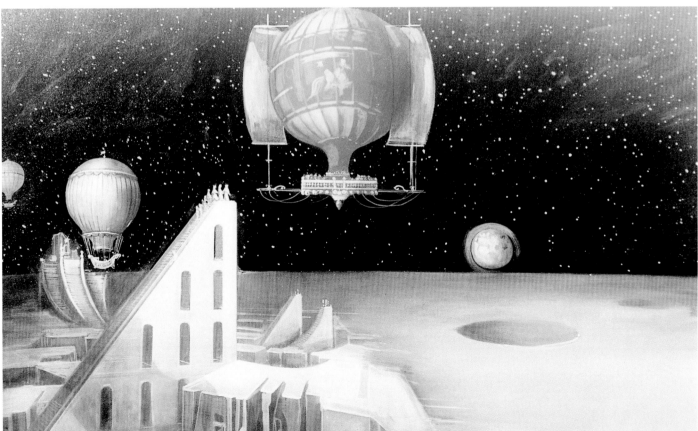

OPPOSITE PAGE AND ABOVE: *The Adventures of Baron Munchausen* (1988) • Dante Ferretti, production designer

LEFT: Production designer Dante Ferretti and illustrator Mauro Borrelli's rendering for a trip to the moon in *The Adventures of Baron Munchausen*

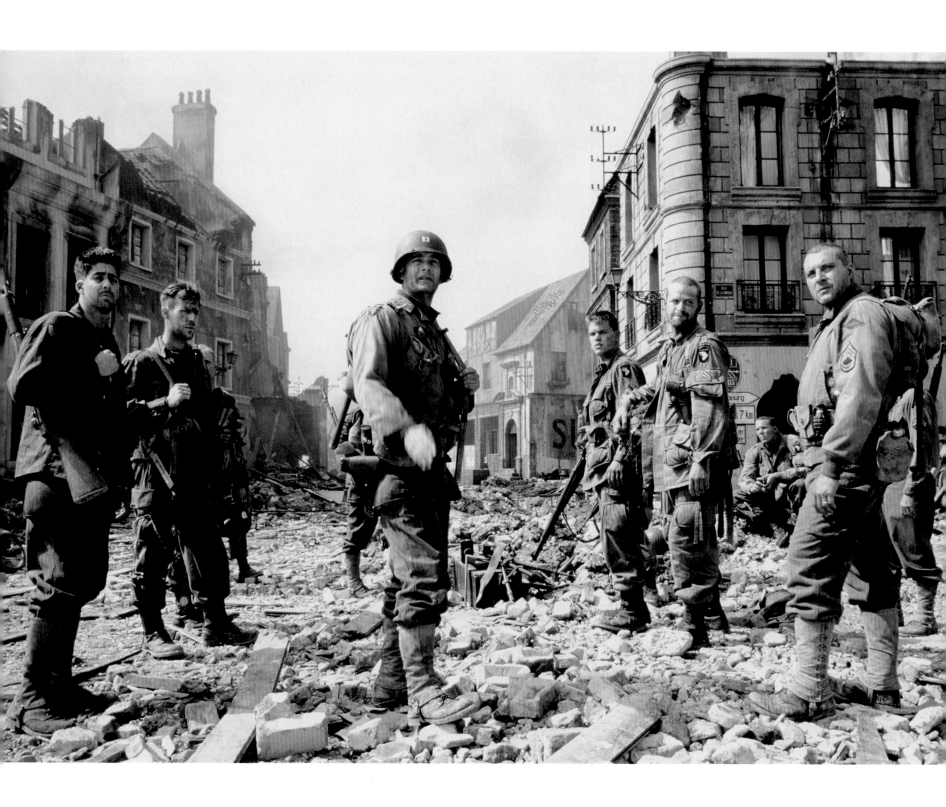

THE NINETIES

The Genres Redefined

OPPOSITE PAGE:
Saving Private Ryan
(1992) • Thomas E.
Sanders, production
designer

The nineties proved to be a prolific decade for filmmaking as the use of visual effects reached a new zenith and the major studio blockbuster reigned supreme with films such as *Jurassic Park, Mission Impossible, The Matrix,* and the highly successful and mega-expensive *Titanic.* The decade was one of diversity and innovation—pulling audiences into unknown worlds and carefully reimagined histories. The decade brought audiences a fantasy world designed completely with scissors, real roaming buffaloes and computer-generated dinosaurs, Big Whiskey and Omaha Beach.

Audiences watched the magnificent Edwardian sets go down with the *Titanic,* while *Forrest Gump* gave us a sprawling lesson in American history. Filmmakers revisited Hollywood in the forties and fifties with *Bugsy* and *L.A. Confidential,* while Martin Scorsese and Merchant Ivory transported us to an era gone by with their films *The Age of Innocence* and *The Remains of the Day,* respectively. The concept of suburbia was in vogue, as film-makers explored a culture of sameness that ranged from the black-and-white 1950s world of *Pleasantville* to the dark ennui of the Burnham family's life in *American Beauty.* And from penthouse to townhouse, the age of conspicuous consumption continued, as reflected in the visually stunning, art-filled interiors of the New York location films of the nineties, such as *A Perfect Murder, Bonfire of the Vanities,* and *The Thomas Crown Affair.*

THE FANTASY WORLD OF
EDWARD SCISSORHANDS

It all began as a childhood fascination with fairy tales. "I was always intrigued by the images and ideas of them, but I never related specifically to them," says Tim Burton, director of the film *Edward Scissorhands* (Twentieth Century Fox, 1990). A Frankenstein-type fairy tale turned on its head in typical Tim Burton fashion, *Edward Scissorhands* tells the Gothic tale of a young man (played by Johnny Depp) whose "unusual" appearance and quirky talents create a sensation in a suburban neighborhood trapped in a culture of sameness.

Burton, who was trained as an animator, is known for taking a simple world and adding another, more surreal dimension to it, as seen in his work on *Beetlejuice, Batman, Batman Returns,* and *Sleepy Hollow.* An accomplished painter, Burton approaches film with a vivid palette, providing a fantastical canvas for his design team.

Designed by Bo Welch, the stunning visuals of *Edward Scissorhands* were influenced by German Expressionism, Gothic fables, and Frankenstein horror films. The production designs include masterful topiary sets, a hauntingly beautiful Gothic mansion, and a wonderfully bizarre suburbia set, complete with pristine streets and pastel-colored cookie-cutter houses. The topiary designs, which the crew researched in England, proved to be one of the most eye-catching designs of the film, growing, as they were, out of Edward's sense of childlike whimsy. Welch explains: "We asked, what would the character be interested in creating if he was naïve? He would be fascinated by the same things children would be, such as circus animals, mundane objects. We even had a guy bowling." The topiaries were actually chicken-wire-sculpted forms covered in small plastic plant sprigs.

OPPOSITE PAGE:
Edward Scissorhands (1990) • Bo Welch, production designer

LEFT: Director Tim Burton on set

THE WESTERN REVISITED:
DANCES WITH WOLVES

ABOVE: Production designer Jeffrey Beecroft took his design cues for *Dances with Wolves* from director Kevin Costner. Costner wanted the film to be like a child's first view of the West.

In *Dances with Wolves* (Tig/Majestic, 1990), actor/producer/director Kevin Costner looks to tell the story of the West through the eyes of the Native American Indians. Costner wanted to make the film, beautifully designed by production designer Jeffrey Beecroft, a distinctive western, yet he viewed the genre with fresh eyes, imagining what it would be like for a child to see the West for the first time. In many ways, Costner's character, Lieutenant John Dunbar, was this child, as he "had never been to the West, and it was the first time he'd seen buffalo, the first time he'd seen Indians, and it must have been an awe-inspiring sight," says Beecroft. As the genre had remained an industry standby since the thirties, it was important that the audience see the landscape of the Wild West with fresh, new eyes as well.

Beecroft began his research by studying John Ford's westerns, the films *Little Big Man* and *Once Upon a Time in the West,* and Mathew Brady's Civil War photographs. He even took a trip to Santa Fe to look firsthand at materials on the Plains Indians. He and the film's producer Jim Wilson extensively researched locations and found South Dakota had all the elements they needed, including hundreds of four-legged "extras" at the 55,000-acre Triple U buffalo ranch.

Determining the color palette of the West was another important design decision for Beecroft. In the opening Civil War sequence, the colors were harsh—blues, grays, and reds. "The film opens with blood, so we started with that world. When the film was in the East, it was more about the color of blood, bright reds," says Beecroft. "As we moved West, the color drained out of the landscape and [we used]

ruddy browns as opposed to blood-red. In the last part of the film, the golds of autumn with the cottonwood trees and aspens were used and you start getting the color back." He also worked closely with Dean Semler, the film's cinematographer, and Elsa Zamparelli, costume designer, to coordinate the story's earth-toned color palette.

The filmmakers strove for a high level of authenticity in their designs. Beecroft and set decorator Lisa Dean sought out and hired a company in Montana that built teepees for the Lakota village. They also found a couple, Bill and Cathy Brewer, who owned some Native American artifacts that were otherwise very hard to find or authentically replicate. These included pipe bags, weapons, shields, and saddle bags. For the film's opening Civil War sequence, the crew was unable to shoot in the South, so the team built a

set in the middle of Dakota's parched earth. They irrigated the land, planted a thousand trees, and grew hybrid corn. When it came time to shoot the fall sequence, a giant orchard sprayer painted the trees gold.

A GILDED CAGE: *SLEEPING WITH THE ENEMY*

A stunning contemporary beach house becomes the gilded cage for an unhappy wife, Laura (played by Julia Roberts), held emotionally captive by her abusive husband Martin (played by Patrick Bergin) in the film *Sleeping with the Enemy* (Twentieth Century Fox, 1991).

Production designer Doug Kraner built the structure for the house from the ground up on the North Carolina coast at Wrightsville Beach. Kraner, who worked under Patrizia von Brandenstein on *The Untouchables,* designed the beach house with a beautiful yet cold interior, complete with perfectly appointed yet sparse furnishings. The entire design concept centers on the notion of the film being divided visually into two worlds, that of Laura's life in the beach house on the coast and later her experience in the small town in Iowa where she escapes.

"Both [the director] Joe Ruben and I felt that the beach house needed to provide a cold and sleek yet seductive environment that would reflect the husband's character and power and would provide a strong contrast to the warmth of Julia's character's house in Iowa," says Kraner. "To me, this dictated a contemporary structure of stark flat planes floating on reflective glass. The unbroken expanses of glass would also allow a strong connection to the ocean in every interior angle. Bringing the live ocean into the interiors created a feeling of being at sea, isolated and vulnerable."

Kraner decided the beach home needed to fit the husband's distant personality and appear alienating to his wife. "The beautiful modernist house is geometric, formal, and filled with exquisite objects," he explains. "Glass walls together with the reflective quality of the granite floors gave the rooms an unstable feeling, like going out to sea. There is no way to know when the floor stops and the walls begin."

RIGHT AND OPPOSITE PAGE: A beach house was built from scratch for the film *Sleeping with the Enemy* (1991) • Doug Kraner, production designer

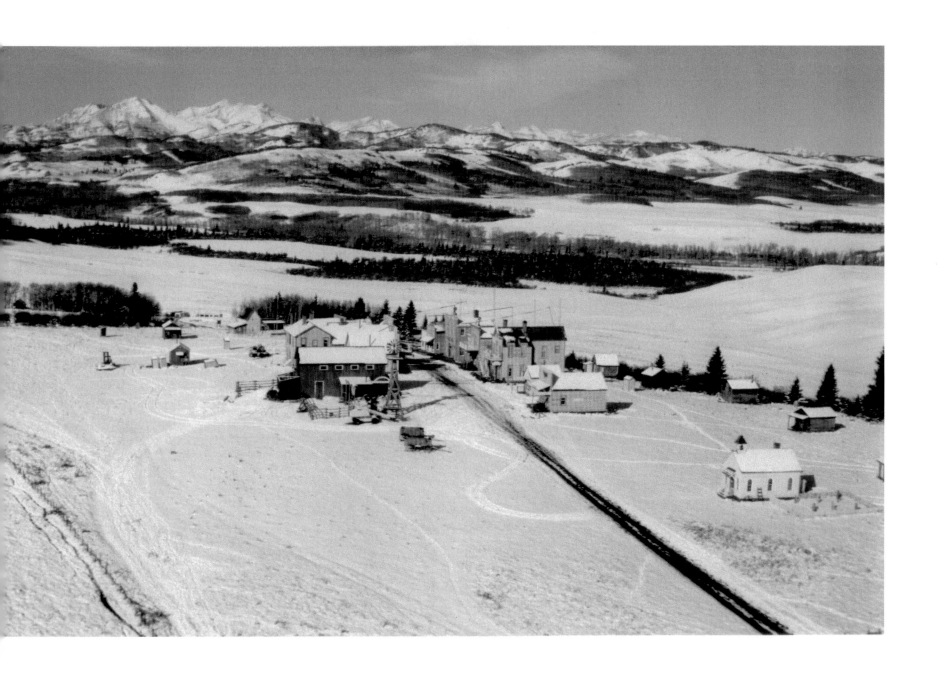

THE WORLD OF BIG WHISKEY

Unforgiven (Malpaso/Warner Bros., 1992) is a dark, film-noir western starring actor/producer/director Clint Eastwood, complete with traditional western themes—redemption and retribution, good versus evil. Eastwood plays William Munny, a widower who goes head to head with Little Bill Daggett (played by Gene Hackman), the evil sheriff of the town of Big Whiskey, Wyoming.

The Academy Award–winning film, nominated for Best Art Direction, marks the eleventh of thirteen collaborations between Eastwood and production designer Henry Bumstead. The film was shot in an astonishing thirty-nine days, and the veteran designer faced a daunting design challenge: building a western town in Calgary, Canada, as soon as possible. Accompanied by his head painter, Doug Wilson, who had worked with him since the sixties, Bumstead headed to Canada armed with his own detailed drawings, and created the simple and uncomplicated period set in just thirty-two days.

The town of Big Whiskey had all the western essentials: a billiard hall, saloon, and bedrooms for the ladies of the night. Bumstead and his crew built the town's sets with both an interior and exterior. Every building was used to its fullest, whether for shooting or basic storage. Of the experience, Bumstead says: "We had very little time to build a set and make it look lived-in, so I used all the tricks I knew."

OPPOSITE PAGE: The town of "Big Whiskey" was constructed in Alberta, Canada, for *Unforgiven*.

ABOVE: *Unforgiven* (1992) • Henry Bumstead, production designer

THE PERIOD FILMS OF THE NINETIES

An Age of Opulence: *The Age of Innocence*

New York in the late 1800s was a period unparalleled in its rigid societal structure and opulent lifestyles. The film *The Age of Innocence* (Cappa Production/Columbia Pictures, 1993), is based on the bestselling novel by Edith Wharton. Directed by Martin Scorsese and designed by Dante Ferretti with set decorators Robert Franco and Amy Marshall, the film centers around society scions Newland and May Archer (played by Daniel Day-Lewis and Winona Ryder) and the illicit love Newland feels for May's cousin Countess Olenska (played by Michelle Pfeiffer).

The brilliant set designs are sumptuous and designed to perfection—from the heavily ornamented Victorian parlors to the artfully prepared seven-course meals served at the antique mahogany dining table. The colors are vivid, and deep rich reds provide the perfect backdrop for the many paintings and antiques displayed in the film's numerous interiors. Through the use of detailed production design, the audience is immediately transported to the nineteenth century.

From Mrs. Mingott's sitting room to the Archers' parlor, Ferretti's formal interiors offer a suffocating mood that mirrors Newland Archer's own feelings of being smothered by the edicts and codes of society. The film's design was accurate down to the last detail—two hundred reproduction paintings were created for all the sets' interiors.

Meticulous details played an extremely important role in the production. Scorsese spent eighteen months on research alone, and a historical consultant was hired. Their combined efforts paid off, as the film was nominated for Best Art Direction.

RIGHT AND OPPOSITE PAGE:
The Age of Innocence (1993) • Dante Ferretti, production designer and illustrator

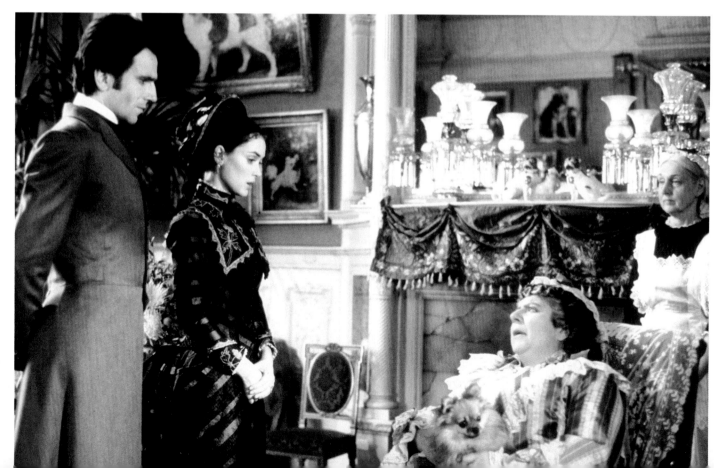

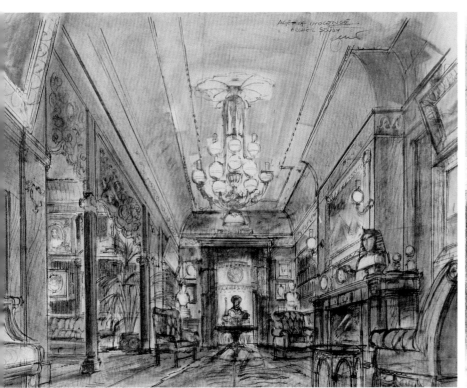

AGE OF INNOCENCE
ARCHER STUDY

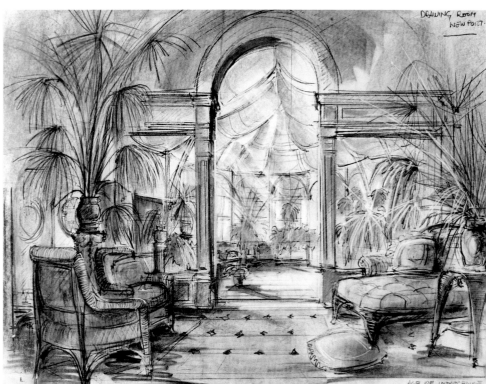

DRAWING ROOM
NEW PORT

AGE OF INNOCENCE

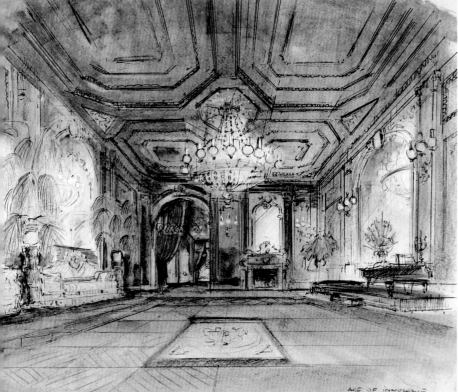

AGE OF INNOCENCE

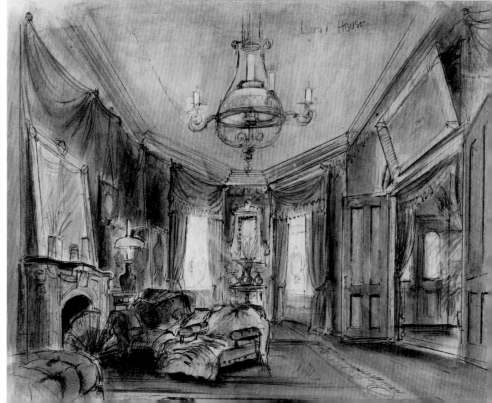

LUMI HOUSE

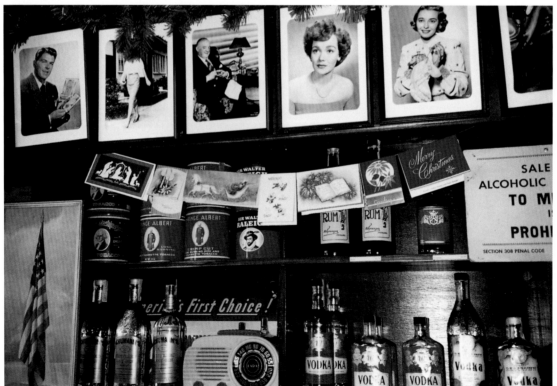

RIGHT: Photos and bottles for a Los Angeles liquor store and a neon street sign for the Night Owl Café were just some of the many period accoutrements required for *L.A. Confidential* (1997)

OPPOSITE PAGE: Production designer Jeannine Oppewall used architect Richard Neutra's house as Pierce Patchett's home in *L.A. Confidential*

Off the record, on the QT, and very hush-hush.
When you think of the Los Angeles film noir set in the forties and fifties, *The Big Sleep*, *Chinatown*, and perhaps *Mulholland Falls* immediately come to mind. But director Curtis Hanson had a different vision for his tale of crime and corruption on the police force in 1950s Hollywood: *L.A. Confidential* (Warner Bros., 1997).

Hanson hired production designer Jeannine Oppewall and set decorator Jay Hart (the pair earned an Academy Award nod for the film) to execute the look, a Los Angeles with a naturalistic, casual period look. As Hanson explains, "My goal was to find locations that would not call attention to themselves as 'period locations' and not tell the story through the lens of nostalgia."

The film involved ninety-three separate sets in various Los Angeles locations. "You have to establish each one as a separate place where a separate piece of action takes place really quickly," Oppewall stated. "I had done many smaller period pictures, so this was kind of a culmination." In addition, the filmmakers wanted to make the designs still feel contemporary today.

Using architect Richard Neutra's house in Los Feliz,

Oppewall and Hart created spectacular sets with upscale fifties modern furnishings (with a nod to American furniture designers Charles and Ray Eames) for Pierce Patchett's character. Built in 1929, Neutra's house is said to be the first with an all-steel frame, becoming an inspiration for the Case Study Houses built after 1945. The bungalow house of Lynn Bracken (played by Kim Basinger) was renovated on location with white-on-white interiors reminiscent of set design from the 1930s.

Oppewall comes to the field of production design via a background in art history and experience working with the renowned furniture designer Charles Eames, who once explained the value of her natural raw talent in saying: "I can teach someone how to draw, but I cannot teach someone how to think and see." Oppewall also has a literary background, which proves invaluable in the film world, as the ability to tell and interpret a story is vital component to her work in production design. Production designer Paul Sylbert was also an esteemed mentor, as Oppewall began her career as a draftsperson and then set designer. Her first big break as art director was on the 1983 film *Tender Mercies*.

Pleasantville, It's Just Around the Corner

The town of *Pleasantville* (New Line Cinema, 1998) represents the hermetically sealed world of a black-and-white 1950s sitcom. When two teenagers, David and Jennifer (played by Tobey Maguire and Reese Witherspoon), suddenly find themselves thrown into this seemingly alternate universe, their modern influence begins to color, literally and figuratively, the lives of the people around them.

Production designer Jeannine Oppewall and set decorator Jay Hart again collaborated on the Academy Award–nominated film. Designing the complicated film, which is both black-and-white and color, involved many collaborations; most important, with the film's cinematographer, John Lindley. As Lindley explains, "Black and white are separated by tones of gray—the guy in a pale blue shirt versus a pale blue wall can all blend together with the same gray value. The values have to be separated with lighting."

Of her work on the film, Oppewall says: "Pleasantville was meant to be a generic All-American town." The sets had to be constructed from the ground up, and she was advised to "call really old art directors and find out how they did it." Oppewall explains, "I had to teach myself—I ended up using two cameras, a black-and-white and a color. [I]

compared this green and that red, and then read the same value with black-and-white. . . . Materials such as the brick color, awning, and wallpaper all had to have a graphic contrast and it had to be appropriately emotional."

The sets for the film were built on a soundstage as well as on location in Malibu State Park. Oppewall felt that the film's story and design allowed the audience to "go back to our personal childhood memories of small-town America. Pleasantville represents the quintessential fifties' small-town America."

As one of the leading women working in production design, Oppewall says: "When I first got into the union, it genuinely seemed to be a gentlemen's club. It was a little uncomfortable, but I just ignored that and marched on ahead. Women seem to make very good designers and I think we are breaking ground. It's got to have more time—it's building."

In addition to her work on *Pleasantville* and *L.A. Confidential,* Oppewall was also nominated for an Academy Award for her work on *Seabiscuit.*

RIGHT: Jeannine Oppewall

OPPOSITE PAGE: Peppard Cottage in *Howards End* (1992) • Luciana Arrighi and John Ralph, production designers

THE FILMS OF MERCHANT IVORY

The late producer Ismail Merchant and director James Ivory are known for producing the most visually stunning period films of the century. From *The Bostonians* and *A Room with a View* to *Howards End* and *The Remains of the Day,* their lavish literary adaptations remain true to both the story and setting, and never disappoint.

"The poor are the poor, and one's sorry for them—but there it is."
—HENRY WILCOX, *HOWARDS END*

Social class, with its distinctions and dilemmas, is a recurring theme in Merchant Ivory films, as is the case with *Howards End* (1992). The film explores three social classes in England at the turn of the century—the Edwardian capitalist Wilcoxes, the bourgeois Schlegels, and the working-class Basts.

Longtime collaborator and production designer Luciana Arrighi is responsible for the film's look and is known for her exquisite period work. "I love doing period pieces," she says, "you have to create the whole atmosphere of the age in people's houses and how they live, that's what really fascinates me." It is this detailed character study that defines the three families of *Howards End,* as each family's house depicts their own unique style and offers clues to their class standing in English society.

For the self-important, aristocratic Wilcox family, Arrighi went for a "claustrophobic, Edwardian opulence," while the philanthropic Schlegels' interiors received cool gray and green tones with a slightly Germanic touch for the furnishings. The Schlegels' daughters had "inherited items such as their father's sword and a landscape over the fireplace, all of which were mentioned in either the book or the script," she says. For Leonard Bast's cramped dwelling, she used dark, depressing colors.

OPPOSITE PAGE:
The Schlegel home in
Howards End (1992)
• Luciana Arrighi,
production designer
and illustrator

LEFT: Production
designer Luciana
Arrighi's famous glass
cathedral for *Oscar
and Lucinda* (1997)

Arrighi, an accomplished artist, made watercolor sketches of the sets, explaining, "I do my research if it needs to be done, and then I color and conceptualize the film, the mood, and the colors and run through most of the scenes working with the script." Arrighi designed the film along with art director John Ralph, and the sets were decorated by Ian Whittaker. The film won the Academy Award for Best Art Direction.

Born in Australia, Arrighi got her start with the BBC in England, first teaming with Ken Russell on the 1970 feature *Women in Love*. She went on to become the set decorator on John Schlesinger's *Sunday, Bloody Sunday,* and, sixteen years later, was promoted to production designer on *Madame Sousatzka*. Some of Arrighi's most notable achievements were the creation of Picasso's two-story Parisian atelier in the film *Surviving Picasso* and a pivotal glass cathedral for *Oscar and Lucinda*.

In *Howards End,* the filmmakers used a location in Oxfordshire, England, named "Peppard Cottage," a charming house that was covered in wisteria, flower blossoms, and a long history, as it was formerly owned by Lady Morrell, the influential literary hostess of the early twentieth century. The bay windows and porch of the former seventeenth-century farmhouse were perfect for the story.

The Edwardian Age sets provide a visual feast for the audience—with the carriage-drawn horses on cobblestone streets, lush English countryside, domed railway stations, and stately homes with their antique-filled rooms and wine cellars. All are unmistakable elements of a classic Merchant Ivory period film.

"Let them know they're in England and order and tradition still prevails."

– JAMES STEVENS, *THE REMAINS OF THE DAY*

Luciana Arrighi, along with the successful team of art director John Ralph and set decorator Ian Whittaker, followed the success of *Howards End* (1992) with a second turn on the period film *The Remains of the Day* (1993), earning the film an Academy Award nomination for Best Art Direction. The story revolves around the deep-seated tradition of personal service—Anthony Hopkins plays Stevens the butler and Emma Thompson plays Miss Kenton the housekeeper—revealing a wealth of repressed emotions within the two central characters. Set at the beautifully designed Darlington Hall, the film features a subplot involving pre–World War II political intrigue.

One of the most important elements was, naturally, "Powderham Castle," which was filmed on location at Darlington Hall. Director James Ivory explains, "We had to find a location based on two things—most of all the back stairs of the house—and we had to have rooms, kitchens, pantries,

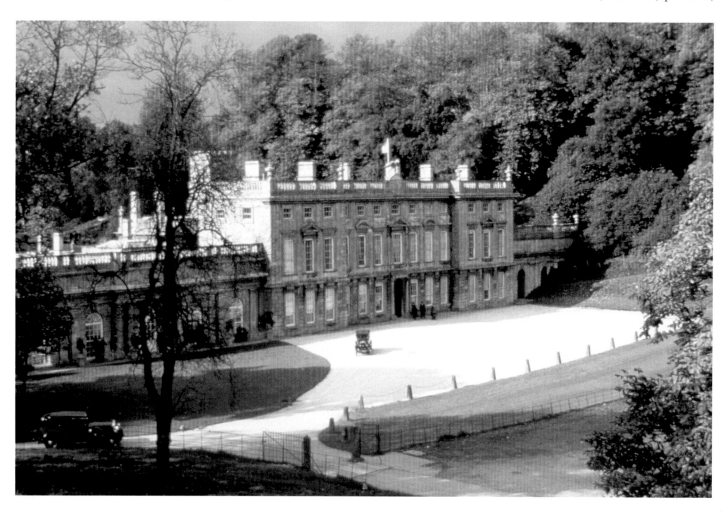

RIGHT: "Powderham Castle" (filmed on location at Darlington Hall) in *The Remains of the Day* (1993) • Luciana Arrighi, production designer

LEFT: Production designer Luciana Arrighi's designs for the butler and pantry in *The Remains of the Day*

servants' dining rooms that were still in good shape. In most of these big houses these rooms had been turned into gift shops or 'let out' to people who lived in them." The design team had to piece together the ideal house, using "one room here and one room there," according to Arrighi. "We went for houses and locations that had these amazing bright colors."

Even more impressive is the design team's ability to produce such gorgeous films on a limited budget—the sets for the film were budgeted at a mere $160,000. Fortunately for the filmmakers, location managers and homeowners jumped at the opportunity to have their entrance hall or tea service in a Merchant Ivory film. As Arrighi explains, "There is a lot of goodwill toward us—for public relations or credit, people would give or lend things which they wouldn't do to other commercial film companies, because they know it's almost an art film."

ABOVE: Director
Steven Spielberg
speaks with actor Tom
Hanks on set

BEHIND ENEMY LINES:
DESIGNING WORLD WAR II

Perhaps some of the most difficult scenes for a production designer to tackle involve re-creating the battles and ravages of war—particularly when it is on the massive scale of Steven Spielberg's *Saving Private Ryan* (DreamWorks SKG/Paramount, 1998).

Saving Private Ryan is the story of a squad of American soldiers tasked with going deep into enemy territory in order to rescue a fellow private and send him home. Production designer Thomas E. Sanders and set decorator Lisa Dean, along with hundreds of others, began by researching the battles of WWII—focusing on the landscape of France destroyed during the war. D-Day, the invasion at Omaha Beach, was a major part of the story; the shoot required a thousand soldiers as extras. Every effort was made to ensure authenticity—the filmmakers restored original boats and guns for the spectacular battle scenes.

Spielberg and his crew scouted locations all over France, Ireland, and England, finally settling on the Irish landscapes and beaches, due to their close resemblance to Normandy. Ireland was also chosen because it offered an army for hire, which would be used for the invasion landing scene. Sanders and his team filled the Irish coastline with defensive Belgian gates and iron hedgehogs, both historically accurate tools of war. "Pillboxes"—the forts used by the Germans, which enabled them to fire relentlessly—lined the beach's towering cliffs.

After three research trips to France, Sanders and his production team built a model of a French village for the film's final battle scene. "We made this whole town in model form and then we slowly carved out the places where the bombs would've hit," says Sanders. "[The model for this] whole town took us five weeks to build in L.A. and then we shipped it over there. It's a great tool for

the director and the cinematographer to use. They see the setup in color and in three dimensions."

The actual village was built on an aerospace facility outside of London. The airfields on site provided a back lot to create the French town. The crew built a full-scale reproduction of the model village, as well as a bridge and a river. "We had to build these buildings because we couldn't find anything like this in Europe," explained Sanders. "It's all historically accurate."

ABOVE: Production designer Thomas E. Sanders thoroughly researched the battles, landscapes, and the destruction of France during WWII for *Saving Private Ryan* (1992).

"AND MAN CREATED DINOSAURS . . ."

Dropped on a remote tropical island, the audience enters Jurassic Park just as the central characters do—through massive mechanical gates that slowly open to reveal the Disney World–like dinosaur park held within. As we are lulled into the tranquil setting and dazzled by the seemingly plausible science of extracting prehistoric DNA from mosquitoes preserved in amber, a tremor in a puddle of water provides an ominous glimmer of events to come.

Steven Spielberg's *Jurassic Park* (Universal, 1993) is the first in a trilogy of films including *The Lost World: Jurassic Park* (Universal, 1997) and *Jurassic Park III* (Universal, 2001), based on Michael Crichton's two best-selling novels and their characters. The challenge of designing the world of *Jurassic Park* was as enormous as the dinosaurs themselves. The massive undertaking fell to seasoned production designer Rick Carter, who was known at the time for his work on *Back to the Future Part II* and *Part III,* and *Death Becomes Her.* He's since lent his talents to the cutting-edge design of Steven Spielberg's *War of the Worlds* and James Cameron's *Avatar.*

In past films, dinosaurs have been created through the technique of stop-motion photography, from the reptiles of *The Lost World* (1925) to *One Million Years B.C.* Yet for *Jurassic Park,* Spielberg wanted to push the envelope further than ever before—he envisioned live-action, full-size animals, and went about creating them through the use of advanced visual and special effects. After months of consultation with paleontologists, museums, and hundreds of textbooks, and with a budget of half a million dollars for research and development alone, the impossible world of *Jurassic Park* and its main attraction—real dinosaurs—became a reality.

Like many art directors of the past, Carter received his degree in art and architecture from the University of Southern California. He began his career in production design on the set of Hal Ashby's *Bound for Glory,* and moved over to special-effects work on the television show *The Six Million Dollar Man.* The experience was, in his words, similar

RIGHT AND OPPOSITE PAGE: The visitors center in *Jurassic Park* (1993) • Rick Carter, production designer; Tom Cranham, illustrator

to "working on a GM production assembly line," and he soon left television to focus solely on film. Production design seemed a natural fit for him, with his artistic background.

Jurassic Park's advertising tag line was "God creates dinosaurs. God destroys dinosaurs. God creates man. Man destroys God. Man creates dinosaurs" is actually a quip from Carter—and it both sums up the plot and acts as a larger metaphor for the film's discussion of faith and religion versus science. *Jurassic Park* utilized the technological advances of the decade and would come to usher in the era of the digital revolution. Animatronics designed by Stan Winston Studios, along with computer-generated imagery by Industrial Light and Magic, were used to digitally create the dinosaurs for an authentic effect.

The visual designs are as intriguing as the dinosaurs themselves, particularly the theme park's visitors center. Architecturally styled with influences from Jerusalem, the set was built on Universal's Stage 24. Carter looked at the interior design from a unique point of view—from that of the raptor. Asking himself, "What has a raptor never done? It has only seen its reflection in water," Carter and the design team made all of the surfaces in the kitchen completely mirrored—so that the dinosaurs would see themselves and ultimately fight each other, and their reflections, instead of the humans.

SOUTHERN AMERICANA: DESIGNING *FORREST GUMP*

Forrest Gump (Paramount, 1994) is the beloved tale of everyman Forrest Gump (played by Tom Hanks), a onetime football star, soldier in Vietnam, Olympic Ping-Pong player, shrimp boat captain, and multimillionaire, whose life story is told through a series of pivotal events in American history.

Production designer Rick Carter first approached the project by "mining [his] own subconscious" and getting into the head of the central character. *Forrest Gump* was about "someone who is really stupid, but never did anything stupid. I always design a movie from something truthful emotionally," says Carter.

The Gump family home plays a central role in the film and, naturally, its design and location were very important. Carter and director Bob Zemeckis scouted locations searching specifically for "Forrest Gump's South." While the home is, according to Forrest, one quarter mile off Route 17, county of Greenbow, Alabama, the filmmakers chose Beaufort, South Carolina, for the location shoot.

an illustration of how he envisioned the exterior. This illustration was transferred into a digital image, and the house was then set to proper scale within its surroundings. After Zemeckis reviewed the digital composition to make sure the house was in the right place, the house's façade was constructed.

Carter's goal was to "create the perfect world for Forrest while fitting in the emotional aesthetic criteria needed to tell the story." By placing Forrest in major historical events through the use of CGI visual effects and chroma key techniques (combining two images together such as Forrest shaking hands with archival footage of President Kennedy), we see a tapestry of iconic American history through his eyes. The designs earned Carter and set decorator Nancy Haigh an Academy Award nomination.

Carter and Zemeckis found a vacant property dripping with Spanish moss where they would build the "Gump House," which was not only a family home, but also a boardinghouse. For the design, they looked at a number of houses in the area and "came up with an amalgamation of a very simple yet Southern-style house, one that could be a boardinghouse yet an iconic form of what Forrest represented," explains Carter.

This homestead became the foundation of Forrest's world—while the rest of his universe changed, his home remained the same. The original house set on the lot had a foundation with steps that had survived for hundreds of years. A function of smart producing, the lot served triple duty—it was also used for the house where Jenny (played by Robin Wright Penn) grew up, and also served as the location for the Vietnam sequences, only requiring thirty or so palm trees for a realistic look.

Carter liked the idea of sticking to designs that conveyed a "clear and clean American imagery," turning to classic Norman Rockwell paintings as a reference point. Carter began the process of creating the Gump home with

DESIGNING THE BLOCKBUSTER, NINETIES-STYLE

Another period film that was noted for its lavish production design was the 1997 epic blockbuster *Titanic* (Paramount/Twentieth Century Fox, 1997)—the fictional romantic account of a rich-girl-meets-poor-boy on the ill-fated maiden voyage of the RMS *Titanic*.

While the story is a compelling one, the ship is truly the star, making its commanding presence felt in almost every frame of the film. Peter Lamont, the film's production designer, built portions of the ship on a soundstage the size of a football field. While the full ship appears on film thanks to CGI effects, the only real decks constructed were the boat deck and the A-deck, and only the starboard side of the ship's exterior was built for filming. The team built a number of sets of the ship at different angles; while massive at 770 feet, the exterior was 10 percent shorter than the original *Titanic*. CGI techniques were used to fill in

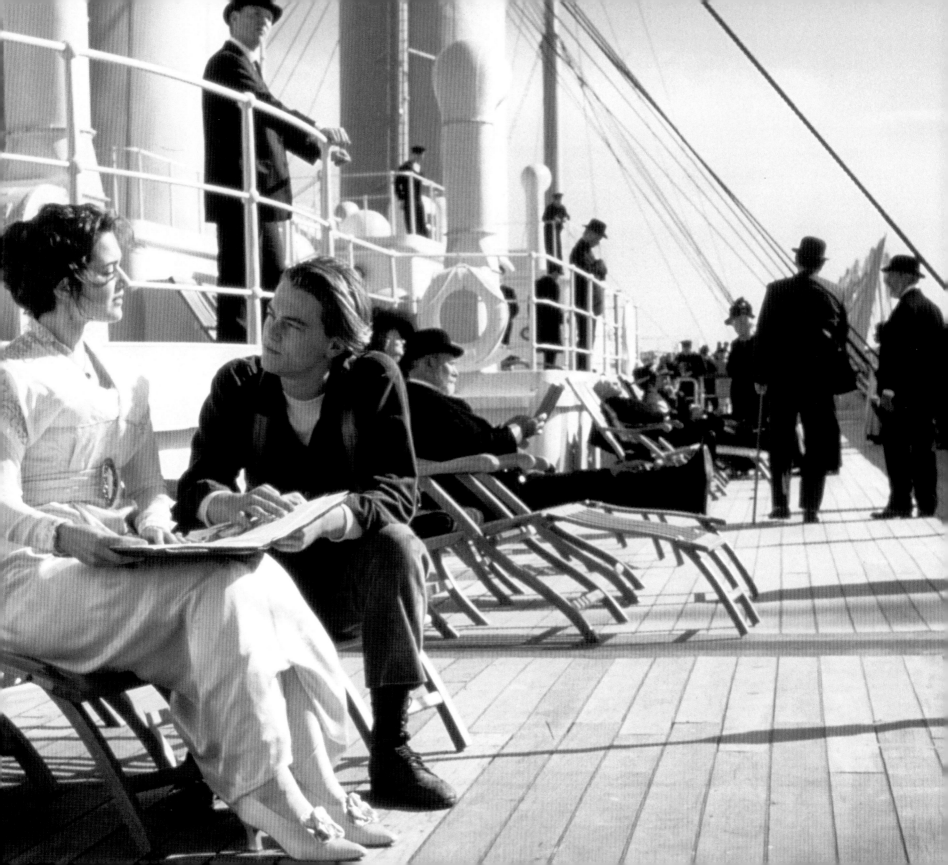

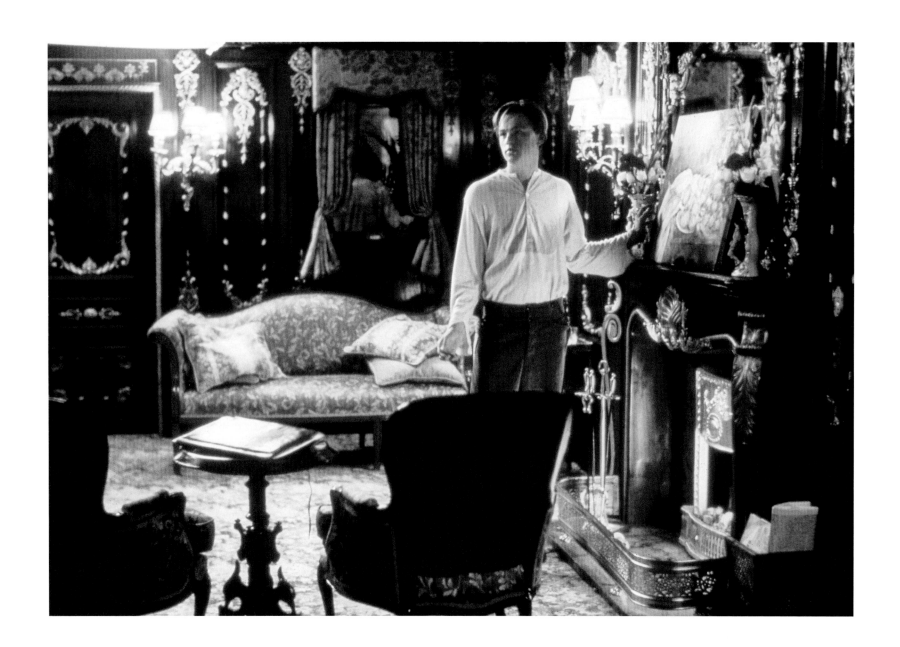

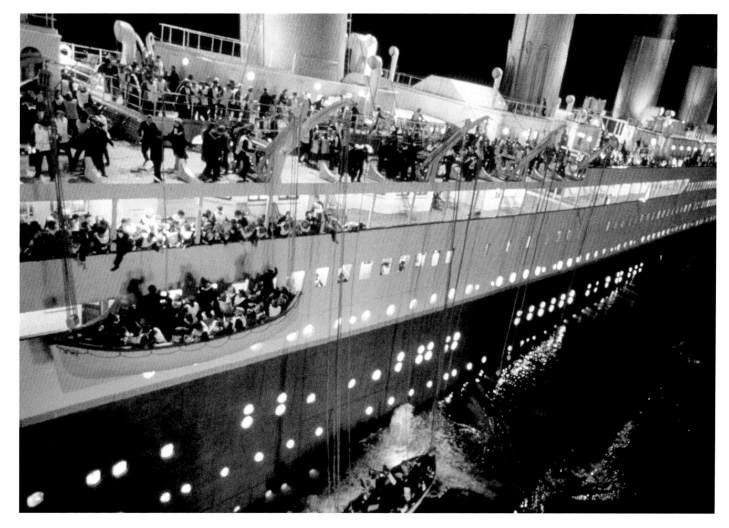

OPPOSITE PAGE, LEFT, AND FOLLOWING PAGE LEFT: *Titanic* (1997) • Peter Lamont, production designer

the remaining portions of the ship, and created the ship's sinking. Digitally designed passengers and crew fell down the tilted decks to their death. As a result of the enormous amount of special effects required for the film, James Cameron launched a state-of-the-art digital production studio known as Digital Domain.

Steps were taken to successfully replicate the *Titanic*. Lamont (known for his work on the James Bond film *The Spy Who Loved Me* and Ridley Scott's sci-fi thriller *Alien*)

and art director Martin Laing secured the original blueprints for the ship from Harland and Wolff Boatyards in Belfast, Ireland. They authentically re-created many rooms, including the first-class dining room, the Palm Court Café, the Empire staterooms, as well as the more austere rooms below sea level for the third-class passengers, the boiler and engine rooms, and the Marconi wireless room. The magnificent three-story staircase and first-class dining room were life-size and built on a hydraulic platform as

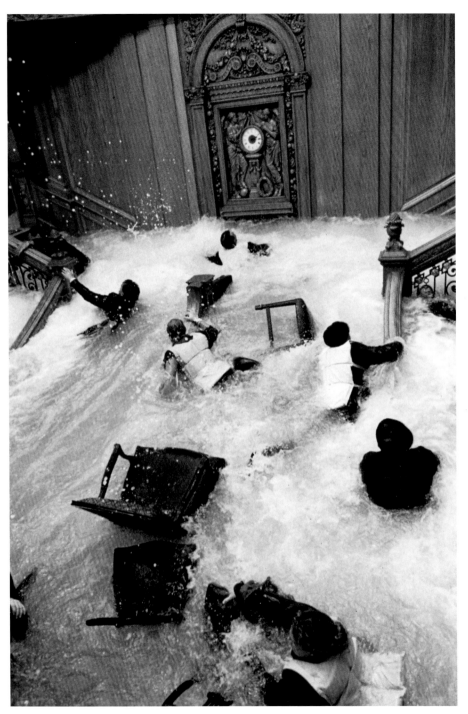

they had to be flooded with 5 million tons of unfiltered seawater from the ocean just yards away.

The film's set decorator, Michael Ford, authentically reproduced the deck chairs, table lamps, beaded curtains, and White Star crystal and china. Sets and furnishings were made in Mexico City, New York, and Los Angeles, and several of the original manufacturers were still available to re-create such items as the dining room's patterned carpet. The interiors were all filled with the appropriate, painstakingly researched furnishings from the period's Edwardian style.

At a budget of $200 million, the movie cost more than the actual *Titanic* and its stately rooms. Fortunately, the production grossed more than a billion dollars worldwide, earning eleven Academy Awards, including a well-deserved Best Art Direction and Best Picture.

THE CINEMATIC CITY: NEW YORK ON FILM

The world's most easily identifiable film set is New York City. Whether it's taxicabs zipping along Park Avenue, the Empire State Building, the store windows of Tiffany & Co., the glittering view of skyscrapers from any one of the city's penthouses, terraces, or office buildings, New York City is the perfect film location and often becomes a central character in itself. Not all the environs are glamorous, as New York can often evoke feelings of danger, fear, intrigue, and even oppression with its menacing alleyways, bleak tenements, and dark underworld.

Every decade boasts a number of memorable images of the city, and the nineties proved to be no exception. From masters of the universe and titans of industry to social conflicts and drama, New York provides an ideal backdrop filmmakers continue to court.

For the film audience, Manhattan appears to be one expensive—and enviable—apartment after another. Ironically, many of these co-ops, townhouses, and penthouses are not filmed in the city's dwellings, but instead in outer borough locations.

The Bonfire of the Vanities

A Queens soundstage was home to the Upper East Side location designed by Richard Sylbert for the 1990 Warner Bros. film *The Bonfire of the Vanities*. Tom Wolfe's bestselling-novel-turned-film chronicled the characteristics of many levels of Manhattan society—on Park Avenue, Wall Street, and the Bronx. It is the scathing story of Sherman McCoy (played by Tom Hanks), a Wall Street "Master of the Universe"; his "social X-ray" decorator wife (played by Kim Cattrall); and opportunistic journalist Peter Fallow (played by Bruce Willis).

Sylbert conducted exhausting research for the design-conscious film. The McCoys' Upper East Side apartment reflected the ostentatious, "obsessed-with-all-things-Anglophile" and instant "old-money pedigree" of the couple and their world. Sylbert began by making a list of all the ingredients needed—oil paintings of dogs, chintz upholstery, window treatments dripping in passementerie, and lacquered and faux-painted walls. Chester Jones's book on the designs of Colefax & Fowler became his bible, providing inspiration and guidance for the sets that perfectly portrayed the current interior-design trends.

LEFT: Production designer Richard Sylbert on the set of *The Bonfire of the Vanities* (1990)

The Prince of Tides

Another lavish nineties Manhattan penthouse was created by production designer Paul Sylbert and set decorator Leslie Ann Pope for psychiatrist Susan Lowenstein (played by Barbra Streisand) and her husband, a world-renowned violinist, Herbert Woodruff (played by Jeroen Krabbe) in *The Prince of Tides* (Columbia Pictures, 1991).

The apartment interiors were designed to reflect the exquisite tastes of a perfectionist as well as set the stage for the film's brewing conflicts—the relationship rifts between husband and wife, husband and his lover, and mother and son. Sylbert used the idea of reflection as one of the driving design themes in the film—large glass windows and tables and a high-gloss shiny floor appear throughout the film. Sylbert wanted the place to convey the temperament of a "very powerful man, a great violinist" as the apartment would be all about him and his ego. Pulling the decoration choices out of the character's demeanor, Sylbert chose interiors that were "very Napoleon" with a "cross between Empire and Biedermeier bourgeois elements."

Six Degrees of Separation

The film *Six Degrees of Separation* (MGM, 1993), adapted from the play by John Guare, was shot entirely on location in Manhattan. The film centers around "Flan" and "Ouisa" Kittredge (played by Donald Sutherland and Stockard

RIGHT: The Upper East Side penthouse apartment in *The Prince of Tides* (1991) • Paul Sylbert, production designer

Channing), two wealthy Park Avenue art dealers. Their life changes one evening when they are visited by a young man, Paul (played by Will Smith), who professes to be a friend of their son at Harvard. Designed by Patrizia von Brandenstein, art director Dennis Bradford, and set decorator Gretchen Rau, the Kittredges' Fifth Avenue apartment was actually two condominiums that rented for a combined cost of $200,000 for four months of filming. The color red was chosen as the main color scheme for the interiors, as it represented power, prosperity, and upper-class lifestyle—elements near and dear to the Kittredges' hearts.

A two-sided "Kandinsky" painting—rather a copy of one—became both a plot device and the basis for the complete design scheme. Created in ten days by scenic artist Etta Davy, the work was painted from transparencies supplied by the Guggenheim Museum as a guide—all the filmmakers had to do was promise that both sides would be slashed at the close of filming.

Meet Joe Black

The 1998 film *Meet Joe Black* (City Light Films) is the story of a media titan, William Parrish (played by Anthony Hopkins), who literally has death knock on his door in the form of a man named Joe Black (played by Brad Pitt). Superbly designed by Dante Ferretti, the film required interiors that conveyed the power of one of the world's wealthiest men. Parrish was an avid reader and art collector, and would have to live in an elegant, sophisticated home that clearly reflected his tastes and image. Ferretti and his team created the Parrish "New York apartment" in the former National Guard Armory in Brooklyn. (According to Ferretti, the location was supposed to actually be on top of the Pierre Hotel.) The football field–size armory was perfect for the film's most spectacular set—an enclosed two-story swimming pool that was built to full scale (and functioned), complete with hand-painted murals on the ceiling.

OPPOSITE PAGE: Ferretti and his design team built a two-story swimming pool, complete with hand-painted ceiling murals

ABOVE: The ultimate power boardroom with contemporary art

LEFT: *Meet Joe Black* (1998) • Dante Ferretti, production designer

A Perfect Murder

A Perfect Murder (Warner Bros., 1998) centered on Steven and Emily Taylor (played by Michael Douglas and Gwyneth Paltrow) as a "global couple"—he is a Wall Street financier and she works at the United Nations. Their "Upper East Side" apartment, which was shot on a Queens soundstage, offers a large, open space for their vast art collection.

Designed by Philip Rosenberg with set decorator Debra Schutt, the apartment was designed "like a chess set," visually symbolizing the cat-and-mouse games occurring between Steven and Emily. The design team researched a number of Manhattan apartments, as well as the Temple of Dendur in the Sackler Wing of the Metropolitan Museum of Art, the latter providing their design scheme of tans and sand colors to support the artwork displayed in the apartment. Schutt used a Moroccan theme for the interiors, mixed with sophisticated Oriental, English, and contemporary furnishings. The influence can be seen in the banquettes of the dining room, and the rich mustard and turquoise colors of the kitchen, especially the kitchen tiles.

RIGHT: Production designer Philip Rosenberg and set decorator Debra Schutt designed the Moroccan-meets-contemporary–Fifth Avenue interiors for *A Perfect Murder* (1998)

The Thomas Crown Affair

Production designer Bruno Rubeo and set decorator Leslie Rollins not only had to create an art-and-sculpture-filled townhouse for the nineties remake of *The Thomas Crown Affair* (United Artists/MGM, 1999), but also were faced with the task of re-creating one of New York's most storied and recognizable buildings—the Metropolitan Museum of Art. In the film, a rich, successful, yet bored playboy Thomas Crown (played by Pierce Brosnan) amuses himself by ripping off the Old Masters from the Robert Lehman Wing of the Metropolitan Museum and evading the insurance collector hired to arrest him, Catherine Banning (played by Rene Russo). Artwork plays a central role in the film as Crown is the consummate collector—collecting priceless paintings as well as antiques, yachts, gliders, and all that the high life has to offer. Crown's Fifth Avenue townhouse expresses his extravagant life in every detail, yet it, like other "Manhattan" residences on film, was built in a warehouse in Yonkers.

ABOVE: A wing of the "Metropolitan Museum of Art" in *The Thomas Crown Affair*

LEFT: Production designer Bruno Rubeo commissioned many of the sculptures and paintings in *The Thomas Crown Affair* (1999) from a group of Parisian master forgers.

DESIGNING SUBURBIA

CAROLYN BURNHAM: *Lester, you're going to spill beer on the couch.*

LESTER BURNHAM: *So what, it's just a couch.*

CAROLYN BURNHAM: *This is a $4,000 sofa upholstered in Italian silk. This is not just a couch.*

The suburban ennui and dark humor that dominates the Academy Award–winning film *American Beauty* (Dream-Works SKG, 1999) offers strong parallels to the 1989 film *War of the Roses*. Both bleak comedies involve unhappy marriages, life in suburbia, conspicuous consumption, and, tragically, death. Tales of family life in the suburbs are not a new topic to Hollywood, but the Burnhams represent a decidedly darker and more cautionary tale, a departure from the idyllic lives of Mr. and Mrs. Blandings in the forties, and the Doris Day/Rock Hudson/James Garner films of the sixties.

Director Sam Mendes looked to the films *Sunset Boulevard, The Apartment,* and the repressed suburban drama *Ordinary People* for inspiration for *American Beauty*. To execute his vision, he hired production designer Naomi Shohan, art director David Lazan, and set decorator Jan K. Bergstrom. Against a backdrop of whites and cool grays, Shohan used red as the predominant accent color. Red is the color of Carolyn's roses—the American Beauty hybrid, to be exact—the flower petals in the fantasy sequence, the car in the driveway, the Burnhams' front door, and the eventual pool of blood spilling out on the kitchen table in the film's closing scenes. The roses signify beauty, something missing in the Burnhams' shallow, lonely, and materialistic life.

Shohan's designs create a cold, distant, and antiseptic view of the Burnhams' upper-middle-class culture, giving the satire of the Burnhams' white-picket-fence existence its unique look. The film's interiors were decorated sparsely,

indicating the emotional distance of the family, while the front yard remains colorful and inviting, underscoring the paradox of their lives.

AS THE DECADE of big-budget blockbusters and innovative special effects drew to a close, filmmaking in the millennium promised even more advanced computer-driven films with mass appeal. *Titanic* proved to be not only the most expensive film ever made at the time, it also had the biggest box-office draw in U.S. film history, grossing more than $1.84 billion worldwide. (James Cameron's next blockbuster, *Avatar,* would surpass the record in box-office receipts.) With the advent of new digital technologies the art of narrative production design entered a whole new realm of possibilities, freeing the designer, director, and writer to visualize and realize the world of the story in ways never before imagined or possible. With this new technology came the responsibility of discerning which is the right tool, or combination of tools, to use in the service of the story.

OPPOSITE PAGE:
American Beauty (1999) • Naomi Shohan, production designer

ABOVE: Shohan used red as a thematic accent throughout the design of *American Beauty*

THE MILLENNIUM

Advanced Special Effects, Big-budget Musicals, and Social Commentary

The films of the twenty-first century represent a wide array of production styles and genres as Hollywood continues to adapt to changing technology and reflect the trends, mores, and needs of modern audiences. Beloved fantasy tales came to life in the whimsical *Harry Potter* series and the much acclaimed *Lord of the Rings* trilogy. Relying heavily on computer animation, special effects, and evolving 3D and IMAX technology, the decade gave us another look into the heroes and villains of *Batman*, and produced the previously unimaginable world of Pandora in James Cameron's *Avatar*.

Social commentary took center stage in the 2000s as well. Such films as *Good Night, and Good Luck, Marie Antoinette,* and *Far from Heaven* offered pointed social observations while effectively portraying a given moment in time. Romantic comedies such as *Something's Gotta Give, The Holiday,* and *It's Complicated* signaled a growing interest in set decoration geared toward real-world application, and started new trends in interior design.

The big-budget musical made a comeback, with the stage-to-screen hit *Chicago* becoming the first musical to win an Academy Award since *Oliver!* in 1968. *Moulin Rouge* and *Nine* redefined and glorified the genre as well. Unlike their predecessors, the musicals of the millennium have become even more lavish—and computer-generated—than ever before. Yet production design remains just as vital to the film's narrative as it's ever been,

as underscored in the period films of the decade. In the 2000s production design was as diverse and as celebrated as ever—from Hollywood's Golden Age shown in *The Aviator,* to the elegantly appointed castles in the English countryside in *Gosford Park* and *Pride & Prejudice,* to the battlegrounds of Japan in *The Last Samurai* and the Roman Coliseum in *Gladiator.*

ROME WAS NOT BUILT IN A DAY: PART FOUR

Perhaps the chance to build the Roman Empire for the *Braveheart*-meets-*Ben-Hur* adventure epic *Gladiator* (Dreamworks SKG, 2000) proved too tantalizing a challenge for director Ridley Scott. A visionary director, Scott is known as "the production designer's director" for his keen eye, vast knowledge, and interest in the process. After extensive research, Scott and production designer Arthur Max (known for his work on *Se7en* and *Black Hawk Down*) discovered that every aspect of culture in ancient Rome revolved around the iconic structure of the Coliseum, originally begun in A.D. 70. The scene of the famed gladiator games, the arena was the true centerpiece of the story.

Re-created for the film in Malta, the architecture for the "ancient" Coliseum had to be as accurate as possible. The construction crew made more than thirty thousand mud bricks to build the structure, giving it the look of a centuries-old patina. Time and budget made it impossible to construct the mammoth arena to original scale; thus only one-third of the circumference was built, along with the bowels of the building, which housed elevators to lift the battling gladiators and tigers onto the central field.

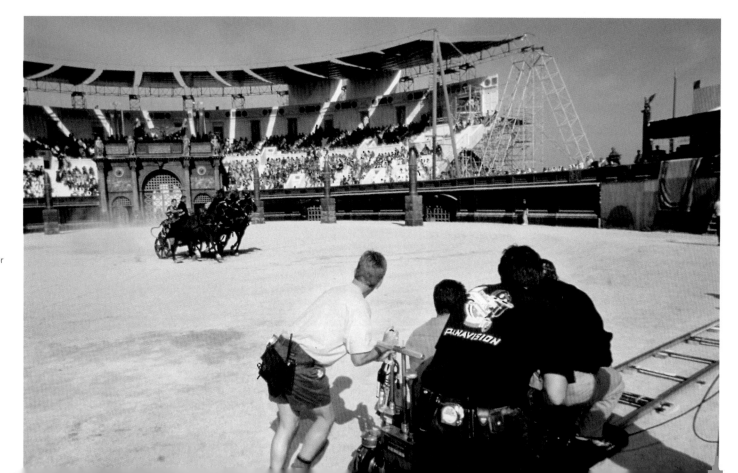

RIGHT: Only one-third of the Coliseum structure was built for the sets of *Gladiator* (2000) • Arthur Max, production designer

OPPOSITE PAGE: A velarium shades the spectators at the Coliseum

The other two-thirds of the Coliseum were CGI generated by John Nelson, the film's visual effects supervisor. The production team oversaw the production of the ingenious "velarium," a retractable canvas awning that was used to shade the spectators from the sun. Likewise, CGI came in handy for the crowd scenes, as it would be impossible to seat 35,000 extras.

The film also provided Arthur Max a chance to use his training in art and architecture: "I had the advantage of having lived and worked in Rome and done some of my architectural training there. I knew the actual locations firsthand and had a sense of place. For me, the greatest challenge was how to achieve the scale and convey the vastness of the empire."

Perhaps the gargantuan challenge can be summed up best by Ridley Scott. "I love to create worlds and every facet of that world has to work within the rules of the story. You must smell the battleground and experience the beauty and light of the golden city."

TEA AT FOUR. DINNER AT EIGHT. MURDER AT MIDNIGHT: THE WORLD OF *GOSFORD PARK*

Director Robert Altman's *Gosford Park* (USA Films, 2001) is the story of the upper-crust world of nobility and their servants in 1930s England, with an Agatha Christie murder twist thrown in for good measure.

Production designer Stephen Altman, the director's son, was responsible for creating the authentic period interiors for the *Upstairs/Downstairs*–themed film, shot on location in the United Kingdom. Taking his cue from his father, Stephen strove to make sure the "details for the varied activities carried out in a house above and below stairs [were] correct."

The sequences "above the stairs"—a term signifying the wealthy owners and their guests—were shot in a country house north of London, while "below the stairs"—the domestic help and their world—in sets at England's Shepperton Studios. Altman and set decorator Anna Pinnock took painstaking care to use furnishings and colors peculiar to the period, with red being the predominant color. "In houses like these, there are antiques from two or three hundred years before, so we just added in layers of modernity. We wanted to make sure it was comfortable and livable, since many of the stately homes we'd seen were like museums and didn't seem like homes," Altman elaborates.

The film's interiors became a combination of design aesthetics pulled from rooms the design team had come upon while researching and scouting locations. Designing in a confined space proved challenging, as "most of the real 'below stairs' places were like labyrinths, which would have been very difficult to shoot. Hence, we added some crossing corridors and windows that are not entirely fictitious," Stephen Altman explains.

The activities below the stairs required some extensive research. The Academy Award–nominated production benefited from hiring a consultant butler and cook who had been in domestic service during the thirties. From the proper table settings to the appropriate wardrobe for the staff, Altman and his team wanted to make sure they portrayed domestic life in a noble home in an accurate fashion. Rooms were designed for sewing, ironing, making jams and jellies, and even a "brushing room" was added, where guests would be "brushed down" and thus not carry any mud or dirt into the house.

OPPOSITE PAGE:
Gosford Park (2001) •
Stephen Altman,
production designer

HOMAGE TO THE FIFTIES: LIFE IN SUBURBIA

Cathy Whitaker (played by Julianne Moore) has it all: a beautiful home in Connecticut, a successful husband, and two wonderful kids. Her perfect Jell-O mold of a life is turned upside down when she learns that her husband (played by Dennis Quaid) has "another life"—a fact that pushes Whitaker toward a socially taboo relationship as well. *Far from Heaven* (Focus Features, 2002) depicts this "perfect" suburban world in the 1950s.

The highly stylized film is an homage to the melodramas of the fifties, a period when a character's seemingly idyllic existence was often an illusion. Director Todd Haynes, along with production designer Mark Friedberg, were influenced greatly by the style and films of Douglas Sirk, the brilliant director of the fifties, known for such films as *Magnificent Obsession, Written on the Wind,* and *Imitation of Life.*

Haynes wanted the audience to "see the world through a contemporary version of past years," and the designs needed to reflect that. The highly saturated colors of the film reflect the Technicolor aesthetic popular with films of the fifties and sixties.

Through the use of various levels, the architecture of the house is used as an emotional device and the story's tension and release. During the film's party scene, society hostess Cathy is "talked down" to by her husband in the downstairs living room, while upstairs she is in command with the servants. Low-angle ceilings create a feeling of suffocation, representing the trapped feeling of the main characters.

OPPOSITE PAGE: A 1950s suburban den in *Far from Heaven* (2002) • Mark Friedberg, production designer

RIGHT TOP AND BOTTOM: Sketches of a multilevel house in *Far from Heaven*

WITH THE RIGHT SONG AND DANCE, YOU CAN GET AWAY WITH MURDER: THE MAKING OF *CHICAGO*

Director Rob Marshall teamed up with production designer John Myhre for the much acclaimed *Chicago* (Miramax, 2002), a Broadway musical that, as a movie, won a total of six Academy Awards. The story of Roxie Hart (Renée Zellweger) and Velma Kelly (Catherine Zeta-Jones), two murderesses in twenties Chicago, earned Myhre and his team an Academy Award for Best Achievement in Art Direction.

Translating the Broadway play to film revolved around one major caveat: all the sets had to naturally accommodate singing and dancing. The primary setting for most of the musical numbers was the fictitious Onyx Theater (designed on a soundstage in Toronto), which served as the opening scene, where the two women see each other for the first time. To make sure the dance scenes were shaping up as planned, Myhre and Marshall spent a week in New York attending intensive rehearsals and going over the choreography.

Myhre designed the theater to represent "beautiful, faded glory," where "we've got wallpaper crinkling off the wall, lighting fixtures cracked and broken, beads hanging off chandeliers, and that is followed through with the design of everything." The result was the perfect backdrop for the

smoky jazz numbers performed by Velma and dreamed of by Roxie. Myhre also visited Studio 54, a New York icon of seventies disco, to study the size and scale for the Onyx Theater. "We wanted a small auditorium," he explains, "so that everything would be very intimate, and a big stage. We wanted a tight feel with balconies almost overhanging the stage." While in New York, Myhre discovered the painting of Reginald Marsh, an artist known for his "gritty scenes of New York in the thirties," says Myhre.

Another famous landmark that appears prominently in the film is the Chicago Theatre. For the film's finale, where Velma and Roxie perform "Hot Honey Rag," only portions of the original theater were used. While it was built in 1921, the interior had obviously changed and a new marquee had to be created. The new surroundings also featured a subway stop, and neighboring modern buildings were eliminated by matte painters at Toybox, a special-effects company. The process took six months, as technicians and animators combined the Chicago Theatre and a cobblestone street with period cars in Toronto.

Another challenge on *Chicago* was the duality of the sets. "Being on the courtroom set was really amazing, because that sequence is exactly as you see it," says Myhre. "We stood in that space as it transformed in front of our eyes from a courtroom into this fantastic circus. And we stood there as these beautiful girls fell out of the sky, throwing sequins. It was as magical, even more magical if you can imagine physically being there on the set."

One of the film's most memorable scenes was the "Cell Block Tango" dance number, shot against a red screen. Myhre and set decorator Gordon Sim had to be very conscious of making the set look like a real prison while the bars needed to be removable for the dancers.

The results were spectacular, and Myhre and his team gave the audience what they came for: "the old razzle-dazzle."

HOMAGE TO THE SIXTIES: DORIS AND ROCK

Magazine editor Barbara Novak (Renée Zellweger) has the ultimate early-sixties Manhattan apartment, complete with a chrome winding staircase, pale pink sofa and automatic drapes to match, and a view of the skyline. Contrast this with the lair of her nemesis-soon-to-be-lover Catcher Block (Ewan McGregor), designed with all the accoutrements of a bachelor on the prowl—a couch that converts electronically to a bed, hidden bar, stereo, and waterfall.

The film, *Down with Love* (Fox 2000, 2003), was an homage to all the Doris Day–Rock Hudson romps of the sixties. Designed by production designer Andrew Laws

OPPOSITE PAGE:
Chicago (2002)
• John Myhre, production designer

BELOW: *Down with Love* (2003) • Andrew Laws, production designer

and set decorator Dan Diers, the satire successfully invokes images from *Pillow Talk* and *Lover Come Back*.

Each character had his or her own individual color palette, not only for the costumes but for the interiors as well. Barbara's world was filled with "virginal pink" and white, creating an innocent yet softly romantic atmosphere with the addition of bubble-gum and sherbet accents. The design team used Miró-esque panels to adorn the walls,

allowing Laws "to take my favorite pieces of midcentury architecture and my favorite [architects], such as Mies van der Rohe, Alvar Aalto, and [Eero] Saarinen and create a slightly more whimsical world with pieces and samplings from the luminaries of the period."

Diers decorated Catcher's lair with Danish Modern– and International-style furnishings, and many of the sixties items were found on the hunting grounds of eBay.

THE HOUSE DEFINES THE CHARACTER: THE ROMANTIC COMEDY

The hallmarks of a romantic comedy are most often a love triangle, snappy dialogue reminiscent of the classic 1950s Hepburn-Tracy films, and of course, trend-setting interiors in luxurious locations. Director and writer Nancy Meyers and her production designer Jon Hutman collaborated on three of the most trendsetting and design-forward films of the decade. All were huge hits with moviegoers as well as the interior-design community.

Perhaps one of the most talked-about, copied, and envied interiors of the decade are the "Hampton beach house" sets for the romantic comedy *Something's Gotta Give* (Columbia Pictures, 2003). Hutman and set decorator Beth Rubino created the sets with the owner of the house, playwright Erica Barry (played by Diane Keaton), in mind—a very accomplished, divorced woman in her midfifties. The house was the ultimate reward for years of hard work, a peaceful retreat from life in the city.

Built on a soundstage, the interior sets offer many subtle clues to Erica's character. The designs are flawless and the house immaculate, reflecting Erica's ordered, writerly lifestyle. While the designers wanted a comfortable look of a vacation home, the designs signify a more elegant and tailored side of Erica. The atmosphere of the ocean and sand are evident in the room's furnishings, which include faded floral chintz and toile fabrics, an all-white dining room, and pale blue upholstery anchored by an ocean-stripe dhurrie.

LEFT: *Something's Gotta Give* (2003) • Jon Hutman, production designer

Hutman and Rubino scouted dozens of homes in the Hamptons to find the right look and to find the right home to support the film's plot—a love triangle between Erica, her daughter's boyfriend, Harry Sanborn (played by Jack Nicholson), and his doctor, Julian Mercer (played by Keanu Reeves). They achieved their goal beautifully.

For the 2006 film *The Holiday* (Columbia Pictures), a pair of women swap homes during the holidays and, in true Hollywood fashion, find love and a happy ending. Hutman used the exterior of a Wallace Neff bungalow in Los Angeles for Amanda Woods's (played by Cameron

LEFT: Amanda Woods's elegant living room in *The Holiday* (2006) • Jon Hutman, production designer

FOLLOWING PAGE, LEFT: Meyers gives Kate Winslet notes while filming *The Holiday*

FOLLOWING PAGE, RIGHT: *It's Complicated* (2009) • Jon Hutman, production designer

Diaz) home, juxtaposing it with Iris Simpkins's (played by Kate Winslet) classic chintz-filled cottage in Surrey.

Hutman, with set decorators Cindy Carr, Anna Pinnock, and David Martin Smith, created serene interiors for Woods by mixing earth tones of gray, brown, and green with sleek modern furnishings. Inspired by designer Marcel Wolterinck's book *In/Ex*, Meyers's design directive was simple—make Woods's home "classic and elegant and only slightly edgy and young."

In the film *It's Complicated* (Universal Pictures, 2009), a divorced bakery owner and empty nester, Jane, (played by Meryl Streep) decides to renovate her 1920s Spanish-style ranch house. The project immerses her not only in blueprints, but in a complicated love triangle with her ex-husband (played by Alec Baldwin) and the architect (played by Steve Martin), who both help her with the renovation. A casual yet elegant Santa Barbara home becomes the backdrop for most of the film, and the small interior details help to establish who Jane really is. "Since more than half of the movie takes place in the house, we really get to know the place," says Meyers. "What the characters wear and how they live and decorate really say something about them."

Working on this third film with Meyers, and again

alongside set decorator Beth Rubino, Hutman explains, "my job is to try to understand and interpret Nancy's vision. What I do, with strong and special guidance from Nancy, is make the sets real, striking something in people." Hutman and Rubino designed the sets with a key component in mind—storytelling. "I like the sets to look the way they feel to the character," he says. The overall design direction came directly from Meyers, who wanted a "Belgian look that is reflected in the house's furnishings and a quiet palette with natural linen."

Color plays an important consideration in the design concept as well. From cashmere throws and chair upholstery to a bowl of fruit on the dining table, the color orange (think of the orange/brown color of an Hermès box) is used as an accent throughout the film. The décor also had to accent Streep's fair complexion, so Meyers used "[her] favorite creams and beiges that would capture the beauty of her skin." The design aficionado also took her design cues from the color of the rooftops of the idyllic coastal town of Santa Barbara. "What I like about Santa Barbara is the rich color that saturates your vision at every turn," Meyers says.

"SHOW ME ALL THE BLUEPRINTS. SHOW ME ALL THE BLUEPRINTS. SHOW ME ALL THE BLUEPRINTS. SHOW ME ALL THE BLUEPRINTS . . ."

Production designer Dante Ferretti and set decorator Francesca Lo Schiavo teamed up for their tenth film together with *The Aviator* (Warner Bros./Miramax, 2004), a sprawling film showing twenty years in the life of the legendary and eccentric director and aviator Howard Hughes. Director Martin Scorsese and the talented husband-and-wife designing duo of Ferretti and Lo Schiavo were no strangers to period films, having previously collaborated on such historical dramas as *The Age of Innocence* (Ferretti and Scorsese), *Kundun,* and *Gangs of New York*; in addition, Ferretti and Lo Schiavo worked on director Anthony Minghella's *Cold Mountain*. Ferretti jokingly admits that working with Scorsese on their fifth film together is "a bit like a marriage, one that I hope doesn't end in divorce!"

Acute attention to detail and painstaking research of Hollywood's glamour in the twenties, thirties, and forties played a major part in designing the homes of Howard Hughes (played by Leonardo DiCaprio) and Ava Gardner (played by Kate Beckinsale). The design team also faced the challenges of building an airline hangar, Hollywood's legendary Coconut Grove, Grauman's Chinese Theatre, and rooms purposefully disarrayed to show Hughes at the height of his obsessive-compulsive disorder.

The Coconut Grove became an important timepiece for the film, as it marked the changing decades of the story. For their opulent vision of Moroccan and Turkish furnishings, Ferretti and Lo Schiavo studied archival photographs and press clippings—the only problem was they were in black and white. Ferretti and Lo Schiavo translated the colors onto the screen themselves. Re-created on a Montreal soundstage—in an astonishing four weeks—everything

was perfect in detail down to the very last of six hundred lampshades. The sets became a tremendous challenge as the story evolved, as Scorsese wanted to imitate the changes in film stock over the three-decade period. The process involved using blue and green colors for the twenties and sharply turning up the color temperature for the subsequent thirties and forties.

Ferretti and his staff had the daunting task of building Hughes's plane, the *Spruce Goose*, dubbed the world's largest airplane at the time. Its hangar also became Hughes's

ABOVE: Ava Gardner's (Kate Beckinsale) Hollywood mansion in *The Aviator*

office, depicting his constant hands-on approach; the Pan Am office of his rival Juan Trippe (played by Alec Baldwin) is Art Deco, complete with a world-map mural on the wall and painted stars on the ceiling.

Lo Schiavo dressed the sets in Spanish furnishings, which were considered contemporary décor of the times. The interiors also had to reflect the drama and madness of Hughes's decline, complete with a study littered with hundreds of wads of paper and strings forming a cobweb-like design. Gardner's mansion mirrored the great actress herself, with high glamour and touches of red being the driving design element.

Ferretti also turned to his idol, Cedric Gibbons, for inspiration. While decades apart, Ferretti and Gibbons shared a common bond: one loves the Golden Age and the other contributed to its birth. Ferretti loves the black-and-white look of films from the past, as the designs "look so much better than color." No doubt Gibbons's influence strongly affected the sets of *The Aviator*.

Ferretti's design process for a film involves not only creating the ambience of a period on film, but actually living in it as well. It is a style parallel to method acting for an actor. "In studying the period, I like to become a part of it. I have to be like a chameleon," he explains. "[I] jump from one place and period to another. I don't want to just copy a period . . . I want to live in it." Born in Macereta, Italy, Ferretti studied art and set design at Rome's Academy of Fine Arts and worked as an assistant to art director Luigi Scaccianoce. He got his first big film break in 1964, on the Pier Paolo Pasolini film *Medea*. The classical Old World designs suited Ferretti's aesthetic perfectly and became a wonderful training ground for his great body of work to come. He also designed for the colorful director Federico Fellini, helping form the visions on such films as *Satyricon*, *Prova d'Orchestra*, and *La voce della luna*.

Of his work with Fellini, Ferretti recalls that the great director encouraged him to reflect his dreams, perhaps as a way of opening up the channels of creativity. "I learned to be a liar! He would ask me what did you dream last night, and I would say nothing. Then after three or four times he'd ask me [and] I would have to invent some dreams!" He laughingly says, "Fellini just wanted me to make a story," and as a result, he learned the technique of telling a design story through a film's narrative.

OPPOSITE PAGE AND BELOW: *The Aviator* (2004) • Dante Ferretti, production designer and illustrator

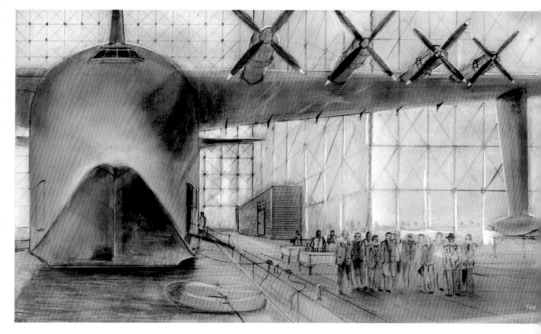

PERIOD REALISM: *PRIDE & PREJUDICE*

While the quaint background of country homes, English estates, and pastoral fields is essential to a Jane Austen novel–based film, the filmmakers of *Pride & Prejudice* (Focus Features, 2005) wanted to make sure it was just that—the background. Focusing on the main characters, as opposed to shooting the "picturesque tradition" (letting the camera linger on an antique chair to establish it's a period film), became one of director Joe Wright's goals.

Designed by the Academy Award–nominated team of production designer Sarah Greenwood and set decorator Katie Spencer, the film was primarily shot on locations in half a dozen counties on seven different English estates. According to Greenwood, many of the homes "required a large amount of work to make them pertinent to our interpretation. Nothing exists in the United Kingdom that is untouched by the twenty-first century."

One thing that did exist in a prior century was the wall on the Bennet family's "Longbourn estate," which was actually Groombridge Place in Kent. The designers wanted an

RIGHT: Set dressings for the drawing room in *Pride & Prejudice*

OPPOSITE PAGE: *Pride & Prejudice* (2005) • Sarah Greenwood, production designer

"in and out" feeling for the interiors and exteriors that could not be achieved with a stage-built set. The historic location consisted of brown wood paneling that the production team was explicitly not allowed to paint, and thus a set was built within the house, as distressed walls were needed as a period detail. The present gardens on the location were pristine and had to be taken back to "the eighteenth-century chaos seen in the film," Greenwood explains. The design team got a lucky break as the house was about to change hands for the second time in four hundred years, and the new owners agreed to redecorate after production was finished.

England in 1797 was filled with great social upheaval and the film required an authentic and realistic style for the interiors and costumes. In this tale of class-conscious lovers, the director wanted the sets to reflect the bucolic past and show something no Jane Austen film had shown before: realism. The costumes and interiors were allowed to show wear and tear, and the eighteenth-century interiors of the "Longbourn" house reflected the design trend known today as "shabby chic." The "Longbourn" house was overrun by a family of women, and while it was the home of a genteel family, they were not a wealthy one and the interiors needed to reflect that quality. For the "nouveau riche" rental house needed for the Bingley characters, an octagonal drawing room, complete with red-felt-upholstered walls, had to be built on a soundstage.

Greenwood and her team achieved the ultimate goal of successful production design as "people came away believing in the world that we created—it is, sadly, a world that no longer exists."

ABOVE: A period-appropriate octagonal room for *Pride & Prejudice* (2005) • Sarah Greenwood, production designer

RIGHT: Architectural drawings for Bingley's Netherfield in *Pride & Prejudice*

A SNAPSHOT OF HISTORY

Journalist Edward R. Murrow's sign-off phrase "good night, and good luck" became one of the most symbolic phrases in broadcast history. The Academy Award–nominated film *Good Night, and Good Luck* (Warner Independent Pictures, 2005) is a story of overzealous politics and the watchdog efforts of broadcast journalism.

The film's director, George Clooney, chose to release the film in black and white, although it was shot on color film stock, to give it a cinema-verité tone. The heart and soul of the production, Clooney also cowrote the film with Grant Heslov, and played the role of producer Fred Friendly. He hired production designer Jim Bissell, who had the important qualities of being "able to apply himself to anything. And he's stunning at building big, silent, rotating sets," says Clooney.

Designing the 1950s proved to be an interesting challenge for Bissell, art director Christa Munro, and set decorator Jan Pascale. Clooney wanted the film to have a "claustrophobic look" and to be shot all on a single soundstage. The team looked to capture the mood of the times, but had to balance achieving the cramped feel with staying true to scale and size.

Bissell read several books on Edward R. Murrow, the "patron saint of broadcast journalism," and used photographs from his actual studio as well as the broadcast offices at CBS as reference. "I made the decision to accurately replicate those photographed spaces whenever appropriate in our fictional space," said Bissell. "Research had already revealed to me that, in fact, most of the spaces in the script were not in the same location. So, from the very beginning, the design of the film was not about re-creating historical

LEFT: The CBS studio designed by production designer Jim Bissell for *Good Night, and Good Luck* (2005)

spaces but about creating a sense of veracity in a totally designed dramatic space."

The sets, which included the control room, newsroom, executive offices, and lobby, were built on one floor. "The newsroom was placed in the center of the design with corridors surrounding it. Fred Friendly's office was the hub of tension during and after broadcasts," says Bissell.

CBS chairman William Paley's office was also a key set. "The large, simple geometric forms were used as an inexpensive evocation of period corporate design and to diminish the scale of the individual. Paley's office, which in reality was decorated with sofas upholstered in chintz, continued this motif to reflect power in the architectural lexicon of the day. In an inexpensive, but (I hope) effective way, it was meant to diminish the stature of even someone as formidable as Edward R. Murrow as he waited patiently at the gates of corporate America," explains Bissell.

Bissell designed the sets in a three-dimensional program called SketchUp (which eventually translated into a foam-core model), which allowed him to show Clooney simulated mock-up shots from anywhere in the set. Designing in black and white proved to be a test as, according to Bissell, it meant "retraining my eye to look exclusively at value, especially in the midrange." He explains further that "Often, this meant comparing colors or swatches to grayscale cards, and, when I felt my eyes were betraying me, taking a photograph of something and desaturating it in Photoshop. Getting the right tonal value between floors, walls, and props was important, especially given the sparsity of the décor in the newsroom."

The film became the first black and white to be nominated for Best Picture (and Best Art Direction) since the 1980s film *The Elephant Man*.

OPPOSITE PAGE:
Good Night, and Good Luck (2005) • Jim Bissell, production designer

LEFT: Detail shots of the 1950s CBS office

A TALE OF TWO JAPANS

Japan provided the breathtaking setting for two of the decade's most beautifully detailed films—*The Last Samurai* (Warner Bros., 2003) and *Memoirs of a Geisha* (Columbia Pictures, 2005).

For *The Last Samurai,* the Warner Bros. back lot was transformed into the streets of 1876 Japan. The historical adventure is the tale of a former Civil War captain, Nathan Algren (played by Tom Cruise), who is hired to help train Japan's army and forms an unlikely alliance with the army's leader. While the back lot streets of "Japan" had been used on two other Warner Bros. films, *Robin and the Seven Hoods* (a 1964 "Rat Pack" caper set in Prohibition-era Chicago) and *Lethal Weapon 4,* production designer

Lilly Kilvert converted the sets to period Japan. Kilvert, who was nominated for an Academy Award for her work on *Legends of the Fall* and her team of 150 craftsmen spent three months affixing "add-ons"—Japanese-style façades with plastic tile roofs and bamboo gutters—to the original New York–style buildings. Rickshaws and carts were also brought in to authenticate the look.

For the samurai village setting and battle-scene sequences, Kilvert scouted locations as far away as New Zealand, seeking the perfect bucolic setting for the samurai Katsumoto's village. The village was built complete with historical Japanese-style houses, gardens, trees, and a waterfall. The minimalist and modular tatami rooms of the house did triple duty as they became the center for dining,

OPPOSITE PAGE:
The Last Samurai
(2003) • Lilly Kilvert,
production designer

RIGHT: *Memoirs of a
Geisha* (2005) • John
Myhre, production
designer; Darek
Gogol, illustrator

playing, and sleeping and—most important of all—the walls were removable to accommodate the cameras.

Memoirs of a Geisha marked the second collaboration for Rob Marshall and John Myhre, earning them their second Academy Award nomination. The film adaptation of the bestselling novel tells a story of a young, impoverished Japanese girl who becomes a celebrated geisha. While the elaborate ambience of the city's *hanamachi* (geisha district) transported the viewer to a different culture, Myhre and set decorator Gretchen Rau re-created the pre–WWII Japan sets on an old ranch in Thousand Oaks, California. Marshall and Myhre were unable to shoot the movie on location, as the city of Kyoto was filled with all the modern trappings of the twenty-first century—from cable-television

antennas to wall posters. According to Myhre, "there was not much of 1930s Japan left."

While thousands of miles from Japan, the California sets proved astonishing; the design team built a 250-foot river to flow through the geisha district, and flanked it with two-story houses with verandas, complete with serene wooden-framed tatami rooms authentically decorated with star mats and low, bench-style tables. Myhre became a virtual city planner, designing the river and forty structures with connecting cobblestone streets in just fourteen weeks. To add to the feel of the film, Marshall "shot the interiors through bamboo and silk, so the audience would be 'peering through.' It was all about the layering of this world," Myhre explains.

BELOW: *Memoirs of a Geisha* (2005) • John Myhre, production designer

LA DOLCE VITA

Italian culture has captivated audiences for decades—the food, language, romance, and stunning landscapes have played host to some of the most timeless American films. Two emerged in the 2000s that captured the good life in Italy—a screen adaptation of Frances Mayes's bestselling novel *Under the Tuscan Sun* (Touchstone, 2000), and the sequel to the millennium remake of a Rat Pack caper, *Ocean's Twelve* (Warner Bros., 2004).

In *Under the Tuscan Sun* a recently divorced writer, Frances (played by Diane Lane), travels to Tuscany on vacation and buys a villa in order to start a new chapter in her life. The film set off an immediate design trend—and perhaps a lifestyle trend as well—with its Italian country-style interiors. Designed by production designer Stephen McCabe, the film chronicles the many pitfalls of restoring the villa. Ultimately, Frances's renovation success becomes a metaphor for her achieving a newfound fulfillment in life and love.

The husband-and-wife team of production designer Philip Messina and set decorator Kristen Toscano Messina are responsible for the sumptuous settings of *Ocean's*

LEFT: *Under the Tuscan Sun* (2000) • Phillip Messina, production designer

RIGHT AND BELOW LEFT: *Ocean's Twelve* (2004) • Philip Messina, production designer

BELOW RIGHT: A soundstage in Los Angeles became the home of a museum in "Rome"

Twelve (Warner Bros., 2004). The film follows Danny Ocean (played by George Clooney) and his gang of fellow con artists as they pull off heists all over Europe. One of the most memorable interiors was for the mansion owned by the character Toulour, which was originally the home of the late Italian film director Luchino Visconti on the shores of Lake Como. The villa was completely empty, so the design team dressed the sets in Italian damask and antiques and added the intricate ironwork seen on the veranda. The scene-stealing bed, designed for the character Van der Woude in Amsterdam, and the art museum in "Rome," which was authentically replicated on a soundstage, also proved to be unforgettable sets.

LET THEM EAT CAKE: CREATING THE WORLD OF *MARIE ANTOINETTE*

Director Sofia Coppola's story of the young ill-fated queen of France, *Marie Antoinette* (Columbia, 2006), is a departure from the standard costume dramas of the past. The highly stylized film looks at history through a contemporary lens. The film's colors, costumes, and interiors sets dazzle onscreen and offer a fresh take on the period—complete with a pop music score. Designed by production designer K. K. Barrett (who also worked with Coppola on *Lost in Translation*), the film featured a wide array of bright, sherbet-colored settings—from over-the-top banquet tables filled with elaborate candelabra and pastries

LEFT: *Marie Antoinette* (2006) • K. K. Barrett, production designer

RIGHT: *Marie Antoinette* (2006)
• K. K. Barrett, production designer

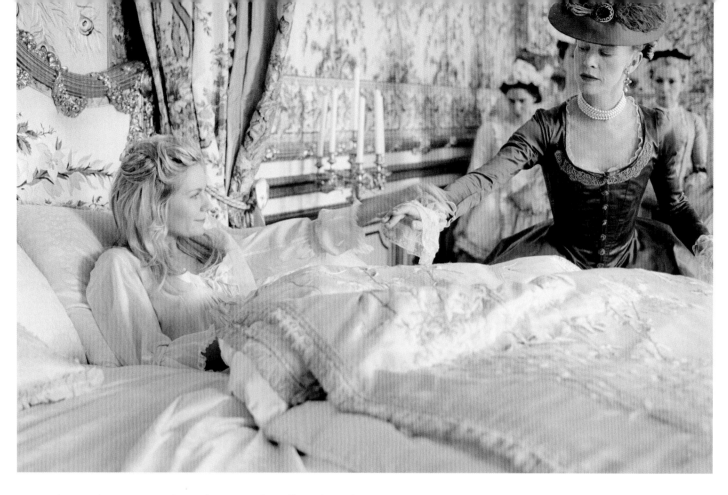

to opulent palace rooms draped in tassels, silk, gilt and chintz. Cinematographer Lance Acord worked hand in hand with Barrett and explained, "Marie Antoinette lived in a world of luxury goods. Everything from her furniture, to her wardrobe and bedding was to be fresh and new. The color palette was inspired by Ladurée macaroons. We were excited by the idea that we could open this world up, make it brighter, more 'Pop.'"

The design team was allowed access to the famed Hall of Mirrors in the Palace of Versailles to film the wedding scene of Marie Antoinette and Louis XVI. While shooting at the majestic chateau was inspiring, problems ensued. "In some rooms, we couldn't open the blinds because just exposure to sun could destroy the color in the fabric and/

or cause it to start to disintegrate," Barrett details. "We also couldn't use any of the furniture in Versailles, which we immediately respected, but it meant we had the task of finding and bringing in our own furniture that would be competitive with the scale of what was already on the walls, which was pretty daunting." The sophisticated yet staid grandeur of Antoinette's life at Versailles was contrasted in the design of her retreat of Le Petit Trianon. The pastoral gardens were faithfully re-created from research, but with a much lighter hand to reflect Coppola's interpretation of the character. Playing off of Marie Antoinette's infamous quote "let them eat cake," Coppola took a memorable candy and cake approach to the film's costumes, colors, and interiors.

MANHATTAN IN THE MILLENNIUM

The undeniable glamour and sophistication that is indicative of the most recognizable city on the planet continued to be both a subject, and backdrop, for films of the millennium. From the hallowed halls of a Park Avenue co-op to the sleek and steely offices of a publishing icon—the Big Apple played a major role in several of the biggest films of the decade and continues to be one of Hollywood's most favored sets.

"You are in desperate need of Chanel."
—NIGEL, *THE DEVIL WEARS PRADA*

The ultimate power office—an imposing and authoritative corner space with sleek clean lines and a well-ordered desktop—sets the tone for the film *The Devil Wears Prada*

(Fox 2000, 2006). The story centers around the cold and powerful Miranda Priestly (played by Meryl Streep), editor in chief of a major fashion magazine, *Runway,* and her lowly and underappreciated assistant, Andy (played by Anne Hathaway).

Production designer Jess Gonchor based his designs for the film on two factors—a makeup compact and photos of the offices of *Vogue*'s editor in chief Anna Wintour. The result was an elegant color scheme of beiges and whites with touches of black, mixed with leather, chrome, and glass, all seamlessly depicting the worlds of fashion and high-profile magazine publishing. The octagonal mirror, photographs, carefully selected art, and obsessively organized glass-top desk are eerily similar to those of Wintour's domain, and it's rumored she redecorated shortly after the film's release.

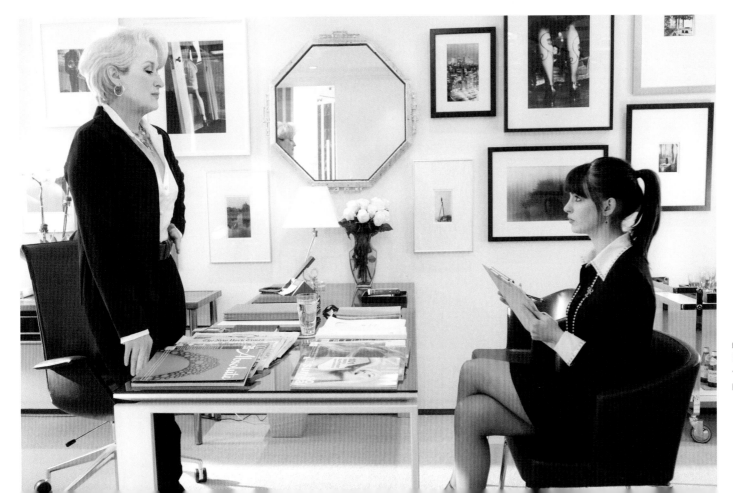

LEFT: *The Devil Wears Prada* (2006) • Jess Gonchor, production designer

The Millennium's Mary Poppins:
Designs for *The Nanny Diaries*

With a flying red umbrella, carpetbag of magical tricks, and tony Edwardian digs, Mary Poppins had it made. But the beloved heroine of our youth has given way to a new brand of nanny, whose job now includes negotiating a child's jam-packed agenda, giving French lessons, and tutoring toddlers in SAT prep.

Based on the bestselling novel of the same name, *The Nanny Diaries* (Weinstein Company, 2007) is the story of an NYU-college-student-turned-nanny (played by Scarlett Johansson) who is in charge of a spoiled five-year-old son of wealthy and unhappy Mr. and Mrs. X (played by Paul Giammati and Laura Linney). Set in Manhattan's chic Upper East Side, the couple's sprawling and luxuriously designed twelve-room apartment becomes the fifth character of the film. Responsible for the interiors (which included eighty-five sets) were production designer Mark Ricker and set decorator Andy Baseman. The pair based the interior designs on the characters' posh lifestyle and demanding personalities, while keeping in mind the need for an upper echelon "old money" look—all within a limited budget and grueling eight-week schedule. The apartment had to feel traditional, comfortable, and inviting, but also had to be striking and modern to reflect Mrs. X's former life as the manager of the Gagosian art gallery. As with all successful film design, the goal was to create a believable backdrop, yet also, in this case, "have the audience chuckle at the decadence," explains Ricker.

Baseman, an accomplished Manhattan interior designer, and no stranger to high-end residential work, created an instant pedigreed "Fifth Avenue look" while relying on local antique stores, thrift shops, and flea markets for props. In a true case of design reflecting character,

Baseman decorated Mrs. X's bedroom with "pale blues, creams, and whites with mirrored surfaces and crystals" to reflect her icy façade. In contrast, Mr. X's study was painted in a lacquered oxblood color to reflect his "go for the jugular" profession.

"We all had a vision in our heads of what we remembered of the classic Walt Disney film," says Ricker. "And the goal was to create a contemporary New York City version of Disney's Edwardian London."

OPPOSITE PAGE AND ABOVE: *The Nanny Diaries* (2007) • Mark Ricker, production designer

FANTASY BY DESIGN

BELOW: The elaborate Ministry of Magic in *Harry Potter and the Order of the Phoenix* (2007) • Stuart Craig, production designer

OPPOSITE PAGE:

Harry Potter and the Chamber of Secrets (2002) • Stuart Craig, production designer

One of the most creatively challenging genres for a production designer is the fantasy film. The audience is taken into another world unlike any they have ever seen, a world that usually involves magic and myth, imagination and illusion, and the ultimate escape. The subject matter ranges from comic-book and superhuman heroes to mythological creatures. And for a design team, the bar of special effects and creativity is moved higher and higher with each ground-breaking film.

Harry Potter

A mysterious shape looms ominously in the distance as a speeding train twists through the darkness. A mystical, medieval castle appears offering a welcoming, yet puzzling sight to a young Harry Potter and his fellow first-year students. The castle is the famed Hogwarts School of Witchcraft and Wizardry, the whimsical yet dark central location for the wildly popular *Harry Potter* series of books by J. K. Rowling.

Stuart Craig, the mastermind production designer behind

the magical *Harry Potter* series of films (Warner Bros., 2001–2009), was responsible for realizing the famous Hogwarts, the centerpiece of the six films. "Hogwarts is a thousand years old, so that process and that knowledge lead you to realizing and finding that the only architecture that exists for [the characters] is the real cathedrals. That was the starting point, that was the trigger, the key that unlocked the whole thing," says Craig.

Another starting point is, naturally, the J. K. Rowling books themselves. "I think [the sets are] pretty faithful to the book. [Rowling] is legendary for her description and the wealth of detail in her description, and so we have tried to keep faithful to all of that," explains Craig. But the production design for all six films (the final two films are slated for release in 2010 and 2011), which began in 2001 with *Harry Potter and the Sorcerer's Stone* (Warner Bros.) has not remained static; Craig has seen changes in

the design throughout the decade, particularly in the area of evolving computer-generated effects. Yet, even with these advances—and while each film is unique in its tone, filming style, and costume choices—Craig also had the important task of reflecting a sense of design continuity from film to film.

Some of the standout designs throughout the series included the atrium in the Ministry of Magic seen in the fifth film *Harry Potter and the Order of the Phoenix* (Warner Bros., 2007). More than 200 feet in length, the Ministry was one of the largest, and most expensive, sets built to date for the franchise.

The thoroughly imaginative designs run the gamut from flying Quidditch broomsticks and living oil paintings, to the designs of the Great Hall dining room. Like many films in this genre, the designs are a combination of actual sets, miniatures, and computer-generated effects.

The Lord of the Rings

The Lord of the Rings (New Line Cinema, 2001–2004) trilogy represents another successful fantasy franchise of the millennium. Directed by Peter Jackson, who shot the film in his native New Zealand, the trilogy was one of the highest-grossing film series of all time, and the winner of a combined seventeen Academy Awards. Designed by a New Zealand local, production designer Grant Major, the films coupled breathtaking locations and dazzling special effects with amazing imaginative characters and fabulous architecture. Based on the classic J. R. R. Tolkien books, the films tell the story of the mythological inhabitants of Middle Earth, the legendary Rings of Power, the Wizard Gandalf (Ian McKellen), the brave hobbit Frodo (Elijah

LEFT: Bilbo Baggins's home in the Shire for *The Lord of the Rings: The Fellowship of the Ring* (2001) • Grant Major, production designer and illustrator

Wood), and the adventures that arise in trying to destroy the ring of a dark and evil lord.

Designing the films was a task of epic proportions, as Major explains: "The most memorable thing about the designing and conceptualizing [the films] was [that it's] a mind game. Actually turning it into reality was this gigantic challenge." He oversaw the creation of the intricate kingdom of Rivendell, the grassy knolls of Hobbiton, and the underground mines of Moria. Hobbiton even had its own vegetable and flower gardens that Major oversaw. "We were always trying to make every set as real in time and place as could be imagined," says the Academy Award–winning production designer.

A Series of Unfortunate Events

Lemony Snicket's A Series of Unfortunate Events (Paramount, 2004) was another popular children's book that was successfully adapted for the big screen. As with the designs for the *Harry Potter* series, the settings needed to stay true to the book, and keep to the original spirit of unpredictable plot. The task fell to production designer Rick Heinrichs and set decorator Cheryl Carasik. "One of the great things about the world I was asked to create is that once you're in it, you're not exactly sure where or when you are," says Heinrichs.

Heinrichs began his career in the Disney Character Animation Program with another young animator, the up-and-coming director Tim Burton. Together they worked on the stop-motion animated short *Vincent* and the feature film *The Nightmare Before Christmas*. The pair also collaborated on the spooky settings for *Sleepy Hollow*, which won them an Academy Award for Best Art Direction in 1999.

Of his Academy Award–nominated work on *Lemony Snicket*, Heinrichs states that his goal was to take "advantage of all the cinema tricks in the camera bag: creating painterly images using forced and atmospheric perspective, using light expressionistically to emphasize and subtract, using texture, contrast, and color as emotional tools, using visual effects where necessary to extend sets, landscapes, to move skies and water."

RIGHT: The reptile room in *Lemony Snicket's A Series of Unfortunate Events* (2004) • Rick Heinrichs, production designer

The production design is one of the most prominent "characters" of the story. Alongside the central characters, the sets are faced with a series of unfortunate happenings, such as fire and hurricanes, just to name a few. The filmmakers decided to shoot in the controlled environment of a soundstage with an overall "Dickens's New England" look—with a twist of the unexpected and a touch of Gothic.

The awe-inspiring sets include the decrepit mansion of the mean-spirited Count Olaf (played by Jim Carrey) and the teetering seaside home of Aunt Josephine (played by Meryl Streep), which hangs precariously on a cliff. Uncle Monty's (played by Billy Connolly) "Reptile Room" was a unique set, as it called for as many as seventy snakes and reptiles of all varieties—from tortoise to python. The design called for "organic architectural shapes that require a lot of fine-tuning, which, due to the nature of the 'actors' of the set, were fortunately fine-tuned through Photoshop," explains Heinrich.

While details in design are of the utmost importance, it's often the subtle ones that help define the character. For Count Olaf's mansion, Heinrichs and Carasik used a series of portraits of the self-enamored character in a variety of different roles to emphasize his ego. His home is also filled with an "eye" detail, which is seen at every turn and signifies that Olaf is always watching.

ABOVE: *Lemony Snicket's A Series of Unfortunate Events* (2004) • Rick Heinrichs, production designer

Gotham Reinvented: A *Batman* for the Millennium

Comic-book superheroes have been popular since the explosion of comic books in the forties and fifties, and have provided the material for fantasy films for decades. No character has been more popular than the saga of the Caped Crusader himself, with a total of seven films to date. Perhaps one of the best, darkest, and original films of the series is *Batman Begins* (Warner Bros., 2005).

Director Christopher Nolan and production designer Nathan Crowley teamed up (both worked on *Insomnia* three years earlier) for *Batman Begins,* a film that portrays the origins of Bruce Wayne and explains how he came to be Batman. One of the many challenges that Crowley faced was the design of Gotham, a place where the rich lived in cocoons and the rest were forced to fend for themselves. Crowley looked to *Blade Runner,* a similarly dark, futuristic, urban-set film, as a design influence: "I knew

I had to reinvent and be radical enough to make a difference. Our theory was let's go for realism. Gotham is New York on steroids. It's slightly in the future. Chaos. And it's confined by waterways," he explains.

It needed to be a modern city based on many periods of architecture. Crowley felt that "there is no Utopian city; it would have to be influenced by the chaos of modern architecture based on buildings of hundreds of years." The freeways of Tokyo and multilayered streets of Chicago were also influential in Gotham's city planning.

The primary interiors were shot at England's Shepperton Studios. The Wayne Manor house, where Batman grew up, began as a wonderful place, filled with light. But after Wayne's parents are murdered, the house becomes a dark and eerie residence. Crowley also pondered how to make the Batcave and tried to apply logic as he designed. "How do you pour two hundred tons of concrete in a

OPPOSITE PAGE:
Batman Begins
(2005) • Nathan
Crowley, production
designer

LEFT: *The Dark Knight*
(2008) • Nathan
Crowley, production
designer

cave in a secret hiding place for a car underneath? Where did he get the Batmobile and how would he build it in secret?" asked Crowley. The cavernous hideout, designed like catacombs, is made primarily of rock walls, a river, and two waterfalls, all located underneath the foundation of the manor.

Nolan and Crowley collaborated again for the 2008 sequel *The Dark Knight* (Warner Bros.). The film relied heavily on CGI effects and introduced new gadgetry such as the Batpod, a vehicle that can be steered by the driver's shoulder, which was the brainchild of Nolan and Crowley. The film was again set in Gotham City (which was filmed on location in Chicago), and the production team had to rebuild much of what was destroyed in the earlier film. Gritty and dark, the two films are a dramatic departure from the series originals such as *Batman* (1989) and *Batman Returns* (1992), which often had the heightened feel of a comic book. Crowley's work on *The Dark Knight* was nominated for an Academy Award for Best Art Direction.

A TALE OF TWO WORLDS: THE DESIGNS OF *AVATAR*

It is fitting that the millennium closes with one of the most groundbreaking production designs of the century. The innovative film *Avatar* (Twentieth Century Fox, 2009) is a hybrid of digital techniques, physical design, live action, and animation, and it's revolutionary in its use of three-dimensional visual effects. The blockbuster tells the tale of a paraplegic marine who searches for new life on the lush jungle moon of Pandora only to find himself engaged in a battle between men and the indigenous population, the Na'vi, a race of blue creatures with a strong environmental connection. Directed by James Cameron (this was his first film since the megahit *Titanic*), the film uses innovative

Fusion Digital 3D cameras to mix live-action sequences with special effects.

Production designers Rick Carter and Robert Stromberg approached the film's designs with two worlds in mind—a real world and a dream world. Through the use of stunning 3D technology, the film engages the viewer in a wholly new way. As Carter notes, "I think the component that's been added in this movie is the three-dimensional space that's not coming to where you are, but asking you to come into the screen." Designers Carter and Stromberg designed the "phantasmagoric" world of Pandora, a process that took two different art departments—one concentrated on Pandora's ecosystem of plants and animals and the other focused on humans and machines. Influences for the designs

BELOW: *Avatar* (2009) • Rick Carter and Robert Stromberg, production designers

ranged from China's Huang Shan mountains, which inspired the film's floating and jagged Hallelujah Mountains, to oil rigs in the Gulf of Mexico, which acted as a template for the mining colony's structures.

Considered one of the most expensive films ever made, the film also became the highest grossing of all time. *Avatar* won three Academy Awards, for Best Art Direction, Cinematography, and Visual Effects.

THE 2000s WERE marked by a string of blockbuster franchises: fantasy, comic-book, and adventure remakes ruled the decade. As long as these continue to prove successful—like the *Twilight* saga that continues to draw record audiences—filmmakers will continue to pursue the trends. As we head into a new decade of filmmaking, Hollywood will also see an increase in live-action fantasy and computer-animated films (particularly 3D and IMAX releases) as the studios continue to receive critical acclaim, Academy Award nominations, and box-office profits, and seek a larger and younger demographic audience.

If the close of the first decade of the new century is any indication, production design and art direction will reach even newer heights in the technological revolution. From the simple creation of a design concept by hand to complex computer-generated models, designers will take the best from the annals of film design and merge with the digital tools of the future.

However, even as the industry evolves, one constant holds true: the process of translating the narrative remains unchanged. Unlike ever before designers are experiencing a period where they can overcome any challenge that a story may present and achieve almost any result. Creative problem solving exists at the very core of all of the designers working today who continue to push the boundaries of what is possible and contribute to the timeless art of designing for the moving image.

ACKNOWLEDGMENTS

The inception, research, writing, and publication of this book have been quite a journey, enduring many starts and stops along the way. While patience has never been my strong suit, I am reminded of the old adage that all good things come to those who wait.

Design and film have been passions of mine for the past several decades, and I am both thrilled and honored to have helped collect this massive volume of stories, images, and knowledge that will hopefully be shared among students, scholars, and members of the film industry, as well as movie buffs and aficionados alike.

First and foremost, a huge debt of gratitude goes to Tom Walsh, president of the Art Directors Guild, whose valuable time, patience, advice, and guidance were absolutely crucial in the success of this project. I am immensely grateful to the Art Directors Guild and its board of directors for its participation. A special thanks goes to the Guild's executive director Scott Roth as well as to Lydia Zimmer, Amy Jelenko, and Marjo Bernay, manager of awards and events, for their wonderful assistance in helping open doors to the many talented members whose work made this book possible. A special thanks goes to the keen eyes and sharp pens of production designers Peter Wooley and Michael Baugh (also editor of the Guild's *Perspective* magazine) for their editorial recommendations.

A book of this magnitude could never have happened without the generous support and time of the Hollywood, New York, and British film communities. To the many production designers and art directors who opened up their homes to me for an afternoon, took time out of their busy day for an interview, logged countless e-mails,

and provided me with great stories, my sincere appreciation goes to the following:

Stephen Altman for sharing stories of his father and the historical designs for *Gosford Park*; Luciana Arrighi for a very long-distance interview and sharing images of her work with Merchant Ivory; Jeffrey Beecroft on his adventures on *Dances with Wolves*; and James Bissell on *Good Night, and Good Luck*. I was privileged to spend a memorable afternoon with Robert Boyle and the late Henry Bumstead: thank you gentlemen for taking me back to the Hollywood of Hitchcock, Eastwood, and yesteryear.

Rick Carter and his experience on the groundbreaking films of *Jurassic Park* and *Forrest Gump;* Nathan Crowley and his designs for the Caped Crusader's world; and John DeCuir Jr. for the fabulous and always entertaining stories of his talented father. Despite language barriers, I enjoyed an immensely entertaining interview with Dante Ferretti on his incredible body of work; and I appreciated the time spent with Sarah Greenwood on *Pride & Prejudice,* Rick Heinrichs on *Lemony Snicket,* Stephen Hendrickson on *Wall Street,* Jon Hutman and his work with director Nancy Meyers, Lilly Kilvert on *The Last Samurai,* Doug Kraner on *Sleeping with the Enemy,* Andrew Laws on *Down with Love,* and Grant Major's amazing designs for *The Lord of the Rings* trilogy.

Catherine Martin and her generous time spent in Sydney, Rob Marshall and John Mhyre for talking with me about their work on *Chicago*; Lillian and the late Harold Michelson for a fascinating afternoon of conversation at your research library; Jeannine Oppewall for her candid tales on the industry, *L.A. Confidential,* and *Pleasantville*; Laurence Paull for his iconic images on *Blade Runner*; Phillip Rosenberg on *All That Jazz* and *A Perfect Murder*; and Paul Sylbert for his tales on *Prince of Tides.*

I was honored to spend an afternoon at the home of Dean Tavoularis. His stories on *The Godfather* series and *Apocalypse Now* were spellbinding. Thanks to the incredibly diverse and talented Tony Walton, I appreciated your time in New York as well as your artwork for the book.

I am appreciative of several interviews conducted many years ago—Patrizia von Brandenstein on *Amadeus* and *Working Girl,* the late Gene Callahan, the late George Jenkins on *All the President's Men,* and Bo Welch on *Edward Scissorhands*. I also spent a very special afternoon with the late Richard Sylbert on his celebrated work on *Chinatown, Bonfire of the Vanities,* and *Rosemary's Baby*. Thank you to his widow, Sharmagne Leland St. John, for providing me with his cherished artwork.

Many thanks for the advice, information, and images from the following: Gene Allen, Joe Alves, Steve Arnold, Mauro Borrelli, Phil Bray, Albert Brennan, Gae Buckley, W. Stewart Campbell, Martin Childs, Mark Friedberg, Jack De Govia, Dennis Gassner, Jess Gonchor, Adrian Gorton, David Gropman, James Hegedus, Louise Huebner, Santo Loquasto, Lydia Marks, Stephen McCabe, Alex McDowell, Mark Mansbridge, Phillip Messina, Chris Burian Mohr, John Muto, Jan Pascale, Ida Random, Norman Reynolds, Barry Robison, Bruno Rubeo, Naomi Shohan, Rusty Smith, Missy Stewart, Garreth Stover, Alex Tavoularis, Wynn Thomas, Peter Wooley, Eugenio Zanetti, and Kristi Zea.

The Set Decorators Society of America was another group that was very instrumental with the book. Karen Burg and Rosemary Brandenburg were extremely helpful in tracking down just the right contacts and images. I am also in debt to Andrew Baseman, Jan Bergstrom, Susan Tyson-Bode, Ellen Christiansen, George de Titta Jr., John Dwyer, Daryn Goodall, Jay Hart, Sara Andrews-Ingrassia, Beth Kushnick, Marvin March, Kristen Messina, Barbara

Munch, the late Gretchen Rau, Cloudia Rebar (you have been a great friend as well!), Leslie Rollins, Beth Rubino, Debra Shutt, Gordon Sim, David Smith, and Katie Spencer for their time, insights, and most important, opening up their portfolios. Thanks to Jeffrey Bowman for his initial help on day one.

A book of this undertaking could never be possible without the support of the film archives, libraries, and photo agencies. A very special thanks to the tireless assistance of Faye Thompson and the staff at the Academy of Motion Picture Arts and Sciences' Margaret Herrick Library. Faye went above and beyond the call of duty on so many occasions, searching for just the right photograph. She continually kept me focused and organized on the book and was a wonderful source of information. Many thanks go to Barbara Hall and her assistant, Jenny Romero, as well as the tolerant library staff. I apologize for the countless library rules I must have broken!

I would also like to give my sincere thanks to the ever patient Ron and Howard Mandelbaum of Photofest, twin brothers with a razor sharp knowledge of design in film and owners of one of the country's best collections of photographs. This book could never have been a reality without the two of you. A special thanks to Buddy Weiss for his assistance. Howard and Eric Myers are the authors of *Forties' Screen Style* and *Screen Deco,* which were an enormous influence on me as well as an informative chronicle of film sets of the twenties through the fifties. An afternoon perusing through your images is sheer heaven! Thanks also to Herbert Klemens of the German photo agency Film Fundus for your unique collection of color images and for your help with my research.

I would also like to thank Ned Comstock and Don Thompson at the Warner Bros. Archives/University of Southern California, Julie Graham at UCLA's Charles Young Research Library, the staff of the Welles Library, Marc Wanamaker of Bison Archives, Daryl Maxwell at the Special Collections at Disney, Deidre Thurman at Universal, Gilbert Emralino at Sony/Columbia Archives, and Barry Dagestino at MGM for their help with my research. Corbis, Kobal/The Picture Desk, Everett Collections, and Getty Images were also very accommodating. The Nashville Public Library and its amazing collection of film books were also a valuable resource.

My heartfelt appreciation goes to Ann Maine and Candace Manroe of *Traditional Home* magazine for publishing my articles on design in film that helped launch the book. I am forever in your debt. Thanks to Randi MacColl, associate publisher of *Architectural Digest* and James Munn, special projects editor, for their continued interest in the subject as well.

A special thanks goes to my researcher, Mia Cho, who was my eyes and legs on the project when I could not be in Los Angeles. Lawrence Kim provided valuable insights and research as well. Thanks to fellow film writers James Sanders, Jim Piazza, Howard Gutner, Emily Evans Eerdman, and Deborah Nadoolman Landis, author of the HarperCollins book *Dressed,* for their insights and advice.

Thank you to HarperCollins for their interest, enthusiasm, and support of *Designs on Film.* My undying gratitude goes to Judith Regan, who championed the book, and to Jason Puris and Ann Volkwein for their initial involvement and expert editing. A special debt of gratitude goes to my editors Cal Morgan and Brittany Hamblin, who were so instrumental in shaping the outcome of the book. Brittany, I am especially grateful to you for your edits, patience, and guidance. I know it's been a long journey and thank you for seeing the project to its fruition.

The last-minute push on this book was nothing short of a marathon sprint, and I am sincerely thankful for the help of Craig Barron, Marjo Bernay, Anne Coco at AMPAS, Kristine Krueger at the National Film Service, Joseph Musso, Norm Newberry, Dennis Michaelson, and Marc Wanamaker at Bison Archives. Both Tom Walsh and I are forever in your debt!

On a personal note, many thanks to the support of my family, friends, patient clients, and magazine editors who understood the meaning of a deadline: your encouragement, advice, and support were immeasurable. Friend and fellow author Elizabeth Betts Hickman provided much-needed advice and proofreading—you have my gratitude. I am also grateful to Paul Fargis and Burt Solomon for their help, along with a loyal, supportive group who helped me mentally see the project from beginning to end. There is not enough ink and paper to list all the personal and professional friends who offered their encouragement, and I hope you know who you are.

And last, thanks to all the "unsung heroes" who make the cinema such a memorable experience.

NOTES

INTRODUCTION

5 "It is often some": Joe Alves, interview with author, 2010.

THE ART DIRECTOR: THE HOLLYWOOD STUDIO SYSTEM

9 "He must have knowledge": William Cameron Menzies (lecture, University of Southern California, Los Angeles, CA, 1929) quoted in Michael Webb, *Hollywood Legend and Reality* (New York: Little, Brown and Company, 1986), 87.

10 "If anyone is ever inclined": Cecil B. DeMille, *Autobiography of Cecil B. DeMille* (Englewood Cliffs, NJ: Prentice Hall, Inc., 1959).

17 Beyond his contributions: Robert S. Sennett, *Setting the Scene: The Great Hollywood Art Directors* (New York: Abrams, 1994), 199.

26 "If MGM films had polish": John Baxter, *Hollywood in the Thirties* (New York: Tantivy/Barnes, 1980), 36.

26 "Hans used to say": Robert Boyle, interview with author, 1993.

28 Hall "had no pretensions": Patrick Downing and John Hambley, *Thames Television's The Art of Hollywood: Fifty Years of Art Direction* (London: Thames Television Ltd., 1979), 50.

THE PRODUCTION DESIGNER

31 "Designing a movie": *Masters of Production: Hidden Art of Hollywood*, DVD, directed by John J. Flynn (Timeline Films, 2004).

32 "We create that world": Barbara McKenna, "UCSC Alum Returns to Tell About Life in Hollywood," *Currents* (University of California Santa Cruz) 2, no. 24 (February 9, 1998), http://www.ucsc.edu/oncampus/currents/97-98/02-09/carter.htm.

33 "One is taking bits and pieces": *Masters of Production.*

33 "A production designer looks at nothing": Peter Wooley, *What! And Give Up Show Business? A View from the Hollywood Trenches* (McKinleyville, CA: Fithian Press, 2001).

The Set Decorator

35 "I am sure you've seen barren sets": William J. Mann, *Behind the Screen: How Gays and Lesbians Shaped Hollywood 1910–1969* (New York: Penguin Putnam, 2001), 215.

35 "Not so long ago": Marc Wanamaker, "Building the Movies: Tracing the Evolution of Set Design," *Architectural Digest,* April 1994, 108.

37 "Like the production designer": Rosemary Brandenburg, interview with the author, 2006.

The Silent Era and the Twenties: The Birth of the Epic

55 "I saw the buildings": *Metropolis*, DVD, directed by Friz Lang (Paramount Pictures, 2003).

56 "MGM's films were always aimed": William K. Everson, *American Silent Film* (New York: Da Capo, 1998).

59 Gibbons "became known": Howard Mandelbaum and Eric Myers, *Screen Deco: A Celebration of High Style in Hollywood* (New York: St. Martin's Press, 1985), 32.

The Thirties: Entertainment as Escape

68 "known as the 'white-telephone look' ": Howard Mandelbaum and Eric Myers, *Screen Deco: A Celebration of High Style in Hollywood* (New York: St. Martin's Press, 1985), 34.

69 "spinning wheel": Donald Albrecht, *Designing Dreams: Modern Architecture in the Movies* (Santa Monica, CA: Hennessey + Ingalls, 1986), 140.

70 "In a film designed by Day": Robert S. Sennett, *Setting the Scene: The Great Hollywood Art Directors* (New York: Abrams, 1994), 186.

74 "This utopia closely resembles": Graham Greene, quoted in Mandelbaum and Myers, *Screen Deco,* 170.

77 "The Art Department [at MGM]": Aljean Harmetz, *The Making of the Wizard of Oz* (New York: Hyperion, 1998), 214–15.

77 "The camera would dictate": Ibid., 211.

85 "Most of its components": Patrick Downing and John Hambley, *Thames Television's The Art of Hollywood: Fifty Years of Art Direction* (London: Thames Television Ltd., 1979), 45.

90 "great masses of red": Aljean Harmetz, *On the Road to Tara: The Making of Gone with the Wind* (New York: Abrams, 1996), 97.

The Forties: The Collapse of the Dream Factory

101 "The entire mood of the film": Robert S. Sennett, *Setting the Scene: The Great Hollywood Art Directors* (New York: Abrams, 1994), 113.

106 "one thing that I think works": Mark Monahan, *Filmmakers on Film: Ken Adam* (January 14, 2006), www.film.telegraph.com.

114 "floating trays [that are] visually moored": Donald Albrecht, *Designing Dreams: Modern Architecture in the Movies* (Santa Monica, CA: Hennessey + Ingalls, 1986), 171.

The Fifties: A Decade of Widescreen and Epics

127 "The western is . . . my favorite": Henry Bumstead, interview with the author, 2004.

128 "The heads you saw": Vincent LoBrutto, *By Design: Interviews with Film Production Designers* (Westport, CT: Praeger, 1992), 10.

131 "see in the living room": Ibid., 9.

132 "in the studio system everyone had": Robert Boyle, interview with the author, 1993.

132 "Each shot must make its own statement": Mary Corliss and Carlos Clarens, "Designed for Film," *Film Comment* (May/June 1978): 33.

132 "Once Hitch trusted you": Leon Barsacq, *Caligari's Cabinet and Other Grand Illusions: A History of Film Design* (Paris: Edition Seghers, 1970), 199.

THE SIXTIES: A DECADE OF CONTRAST

155 "the desert is": Robert L. Morris, *Lawrence of Arabia* (New York: Doubleday, 1992), 73.

156 "personalizing the epic": Ibid., xv.

156 "it had to be real": Ibid., 73.

161 "My father called": *Cleopatra*, DVD, directed by Joseph L. Mankiewicz (Five Star Collection DVD, Fox Home Video, 2001).

164 "very hot white wax": Stephen M. Silverman, David Lean (New York: Abrams, 1989), 160.

168 "Having worked with": *My Fair Lady,* DVD, directed by George Cukor (Warner Home Video, 1998).

168 "I went to London": Ibid.

168 "I even duplicated": Ibid.

170 "the Frank Lloyd Wright of *décor noir*": Christopher Frayling, *Ken Adam and the Art of Production Design* (London: Faber and Faber, 2005), xii.

172 "larger than life": Michel Ciment, *Kubrick* (New York: Holt, Rinehart, and Winston, 1983).

173 "wanted to rule the world": Alex Wiltshire, "Ken Adam," *Icon Magazine,* November 2005.

174 "My idea was": Christopher Frayling, *Ken Adam and the Art of Production Design* (London: Faber and Faber, 2005), 139.

176 "where I imagined a moonscape": John Cork and Bruce Scivally, *James Bond: The Legacy* (New York: Abrams, 2002), 103.

182 "I needed to": *Behind the Planet of the Apes*, DVD, directed by Kevin Burns and David Comtois (Twentieth Century Fox, 1998).

187 "This safari suit": Richard Sylbert, interview with the author, 1993.

THE SEVENTIES: A RENEWED HOLLYWOOD — THE BIRTH OF THE BLOCKBUSTER

190 "In a period film": Harlan Lebo, *The Godfather Legacy* (New York: Simon & Schuster, 1997), 68.

192 "He gives you a general direction": Maria Katsounaki, "The Magician of Hollywood to Show Paintings in Greece," *Kathimerini* (English Edition), (November 7, 2005), http://www.ekathimerini .com/4dcgi/_w_articles_civ_1_07/11/2005_62741.

198 "It has to be during a drought": R. L. Carringer, "Designing Los Angeles: An Interview with Richard Sylbert," *Wide Angle* 20, no. 3 (1998): 97.

199 "Few directors have ever composed": Jurgen Muller, *Movies of the 70s* (Cologne, Germany: Taschen, 2003), 354.

201 "I ordered a lot of cheap candelabras": Christopher Frayling, *Ken Adam and the Art of Production Design* (London: Faber and Faber, 2005), 124.

202 "The newspaper business": Tom Shales, Jeannette Smyth, and Tom Zito, "When World's Collide: Lights! Camera! Egos!" *Washington Post*, April 11, 1975. http://www.washingtonpost.com/wp-srv/ style/longterm/movies/features/dcmovies/postinfilm .htm.

202 "itemized every single item": *Telling the Truth About Lies: Making All the President's Men*, DVD, directed by Gary Leva (Warner Brothers, 2006).

203 "a thousand details at a glance": Mary Corliss and Carlos Clarens, "Designed for Film," *Film Comment* (May/June 1978): 48.

The Eighties: A Decade of Sequels, Costume Dramas, and "Greed Is Good"

224 "We wanted the hotel to look authentic": Stanley Kubrick, interview with Michel Ciment, "Kubrick on *The Shining*," 1982, http://www.visual-memory.co.uk/amk/doc/interview.ts.html.

228 "natural but lively palette": Patrizia von Brandenstein, interview with the author, February 2006.

228 "Mozart's world was reflective": Vincent LoBrutto, *By Design: Interviews with Film Production Designers* (Westport, CT: Praeger, 1992), 186.

231 "extreme contrasts of the period's poverty": Ibid.

239 "If the eighties was the first era": Douglas Brode, *Films of the Eighties* (New York: Carol Publishing, 1990), 24.

The Nineties: The Genres Redefined

243 "We asked, what would the character": Bo Welch, interview with the author, 1993.

244 "had never been to the West": *Dances with Wolves,* DVD, directed by Kevin Costner (Tig/Majestic Productions, 1995).

244 "The film opens with blood": Ibid.

246 "Both Joe Ruben and I": Doug Kraner, interview with the author, 2005.

249 "We had very little time to build": Henry Bumstead, interview with the author, 2006.

253 "My goal was to find locations": *L.A. Confidential,* DVD, directed by Curtis Hanson (Warner Home Video, 1997).

253 "You have to establish each one": Jeannine Oppewall, interview with the author, 2006.

253 "I can teach someone how to draw": Ibid.

255 "Black and white are separated by tones": "The Art of Pleasantville," *Pleasantville,* DVD, directed by Gary Ross (New Line Video, 1998).

255 "Pleasantville was meant to be a generic": Jeannine Oppewall, interview with the author, 2006.

256 "go back to our personal childhood": Ibid.

256 "When I first got into the union": Ibid.

256 "I love doing period pieces": Luciana Arrighi, interview with the author, 2006.

256 "claustrophobic, Edwardian opulence": Ibid.

259 "I do my research": Ibid.

260 "We had to find a location": *Remains of the Day: The Filmmakers Journey,* HBO Documentary, DVD (Sony Pictures, 2001).

261 "one room here and one room there": Luciana Arrighi, interview with the author, 2006.

261 "There is a lot of goodwill": Ibid.

263 "We made this whole town": Steven Spielberg, *Saving Private Ryan: The Men, the Mission, the Movie* (New York: Newmarket Press, 1998).

263 "We had to build these buildings": Ibid.

266 "working on a GM production assembly line": Rick Carter, interview with the author, 2006.

266 "What has a raptor never done?": Ibid.

267 "Mining [his] own subconscious": Ibid.

268 "came up with an amalgamation": Ibid.

268 "create the perfect world": Ibid.

274 "a very powerful man": Paul Sylbert, interview with the author, 2005.

The Millennium: Advanced Special
Effects, Big-budget Musicals, and Social
Commentary

287 "I had the advantage": Ridley Scott, *Gladiator:
The Making of the Ridley Scott Epic* (New York:
Newmarket Press, 2000), 8.

287 "I love to create worlds": Ibid., 64.

287 "details for the varied activities": *Gosford Park*, USA
Films Production Notes, 2001.

287 "In houses like these": Ibid.

289 "see the world": *Far From Heaven*, Anatomy of a
Scene DVD (Universal Studios, 2002).

291 "beautiful, faded glory": Peter Kobel, *Chicago* (New
York: Newmarket Press, 2003).

293 "Being on the courtroom set": Ibid., 163.

294 "to take my favorite pieces": *Down with Love*,
directed by Peyton Reed, DVD (Twentieth Century
Fox, 2003).

297 "classic and elegant": *The Holiday*, production notes
(Sony Pictures, 2006).

297 "Since more than half": Nancy Meyers, interview
with the author, 2009.

300 "my job is to try to understand": Jon Hutman, inter-
view with the author, 2009.

300 "[her] favorite creams": Nancy Meyers, interview
with the author, 2009.

301 "a bit like a marriage": Dante Ferretti, interview with
author, 2006.

303 "look so much better than color": *The Aviator*, "Con-
structing *The Aviator:* The Work of Dante Ferretti,"
DVD (Warner Home Video, 2004).

303 "In studying the period": Phillip Williams,
"Dante Ferretti's Designing Dreams," *Moviemaker*
(February 9, 2003), http://www.moviemaker

.com/directing/article/dante_ferrettis_designing
_dreams_3257/.

303 "I learned to be a liar!": Dante Ferretti, interview
with author, 2006.

304 "required a large amount of work": Sarah Green-
wood, interview with author, 2006.

306 "the eighteenth-century chaos": *Pride & Prejudice*,
Working Title Films Production Notes, 2005.

306 "people came away believing": Sarah Greenwood,
interview with author, 2006.

307 "able to apply himself to anything": Jan Pascale,
"Good Night, and Good Luck," *Set Décor* (Winter
2006): 85.

307 "I made the decision": James Bissell, interview with
the author, 2006.

309 "The newsroom was placed": Ibid.

309 "The large, simple geometric forms" Ibid.

309 "retraining my eye to look": Ibid.

312 "there was not much of 1930s Japan": Jeff Turrentine,
"Re-creating the Feel of Pre–World War II Kyoto
on a California Horse Ranch," *Architectural Digest*,
March 2006.

312 "shot the interiors through bamboo": Ibid.

316 "Marie Antoinette lived in a world": "Marie
Antoinette," Studio production notes, cinemare
view.com, http://www.cinemareview.com/
production.asp?prodid=3647.

316 "In some rooms, we couldn't open": Ibid.

319 "have the audience": Mark Ricker, interview with the
author, 2007.

319 "pale blues, creams, and whites": Andrew Baseman,
interview with the author, 2007.

319 "We all had a vision": Mark Ricker, interview with
the author, 2007.

322 "Hogwarts is a thousand years old": *Harry Potter and the Sorcerers Stone,* "Capturing the Stone," DVD (Warner Brothers, 2007).

322 "I think [the sets are] pretty faithful": Heather Newgen, "Harry Potter Set Visit" (June 25, 2007), www.Comingsoon.net.

325 "The most memorable thing about the designing": Steven Horn, "A Conversation with Grant Major," IGN Movies, October 31, 2003.

325 "We were always trying to make": Grant Major, interview with the author, 2006.

326 "One of the great things": "Lemony Snicket's," Writing Studio, http://www.writingstudio.co.za/page803.html.

326 "advantage of all the cinema tricks": Ibid.

327 "organic architectural shapes": Ibid.

329 "I knew I had to reinvent": Nathan Crowley, interview with author, 2006.

329 "there is no Utopian city": Ibid.

329 "How do you pour two hundred tons": Ibid.

331 "I think the component that's been added": David Schwartz, "Best of Both Worlds: Production Designer Rick Carter on the Dream States of Avatar," *Moving Image* (February 16, 2010), www.movingimagesource.us/articles/best-of-both-worlds-20100216.

DESIGNER CREDITS

The history of chronicling the design credits of those who have contributed their talents to the motion picture industry is poor at best. Regarded as "work for hire" in the production of an entertainment product intended for mass consumption, a combination of indifference and the passage of time has made the accurate representation of crediting those most responsible as almost impossible.

The following represents not the final or complete last word of who did what but rather a snapshot using the best information currently available. Corrections or additions to any of the following categories are welcomed, as this should be regarded as a living document.

The credits that follow are the principal craft categories represented by the Art Directors Guild. Set Decoration is also included, which though not a Guild craft originated within the discipline of art direction and continues to be the most critical collaboration amongst the many crafts that art direction depends upon.

TITLES—ART DIRECTORS GUILD KEY

Art Direction: The profession of narrative design for the moving image.

Art Department: The collective of designer/artists responsible for the conception and realization of the visual narrative.

Production Design by: Post-1939 title signifying the creative head of the art department who is most responsible for the conception and realization the visual narrative.

Set Decoration by: The principle associate of the production designer/art director who is most responsible for the dressing of all of the settings and environments required by the narrative.

Supervising Art Direction by: Originated within the studio system (1910 to 1970) to signify the managerial head of the art department. Currently used to identify the key art director on a large film that requires multiple art directors. The supervising art director of today is the first associate of the production designer.

Associate Art Direction by: For the purposes of brevity for these credits this term is applied here to represent the efforts of location, set, and assistant art directors, all of whom have defined design and supervisory responsibilities and report to the supervising art director and/or the production designer.

Illustrations by: The artist who creates visual concepts of persons, places, or things, storyboards of sequences, or any other type of pre-visualization required by the narrative.

Set Design by: The draughtsman (or woman) who creates the measured drawings and preliminary models required for the construction of the settings or their environments.

Matte Painting by: The artists charged with creating visual set extensions or complete immersive environments intended to be composted within the final image and to seamlessly complement or replace the live-action settings of the narrative.

Scenic Painting by: The painters who create photo-realistic dimensional representations of three-dimensional forms on backdrops or settings.

Graphic Design by: The artists who create letter- or image-based visual elements required for the settings or props of the narrative.

DESIGNER CREDITS

Frontmatter
Cleopatra (Twentieth Century Fox, 1963)
Production Design and Illustrations by: John DeCuir
Set Decoration by: Paul S. Fox, Ray Moyer, Walter M. Scott and Richelieu
Art Direction by: Herman A. Blumenthal, Hilyard M. Brown, Boris Juraga, Maurice Pelling, Jack Martin Smith, Elven Webb, and Don Picton
Illustrations by: Harold Michelson
Set Design by: Bill Dennison and Giovanni Natalucci
Matte Painting by: Ralph Hammeras and Joseph Nathanson
Scenic Painting by: Ferdinand Bellan and Italo Tomassi

Introduction

The Thief of Bagdad (Douglas Fairbanks Pictures/United Artists, 1924)
Art Direction and Illustrations by: William Cameron Menzies
Associate Art Direction by: Park French, Harold Grieve, Anton Grot, H. R. Hopps, Edward M. Langley, Irvin J. Martin, William Utwich, and Paul Youngblood

Top Hat (RKO, 1935)
Art Direction by: Carroll Clark
Supervising Art Direction by: Van Nest Polglase
Set Decoration by: Thomas Little
Illustrations by: Albert M. Pyke

Angel (Paramount Pictures, 1937)
Art Direction by: Robert Usher
Supervising Art Direction by: Hans Dreier
Set Decoration by: A. E. Freuderman

The Wizard of Oz (Metro-Goldwyn-Mayer, 1939)
Art Direction by: William A. Horning, Jack Martin Smith, and Malcolm Brown
Supervising Art Direction by: Cedric Gibbons
Set Decoration by: Edwin B. Willis
Associate Art Direction by: Elmer Sheeley
Illustrations by: Hugo Balin
Set Design by: E. Preston Ames, John Bossert, Edward C. Carfagno, Marvin Connell, Harvey T. Gillett, William Hellen, K. Johnson, Ted Rich, Jim Roth, J. Russell Spencer, Steffgen, Charles B. Steiner, Marvin Summerfield, John J. Thompson, Leonid Vasian, and Woody Woodward
Matte Painting by: Warren Newcombe and Candelario Rivas

Scenic Painting by: George Gibson, Leo F. Atkinson, John Coakley, Randall Duell, William Gibson, Clem Hall, F. Wayne Hill, Ray Perry Sr., Clark M. Provins, Arthur Grover Ryder, and Duncan Spencer

PART ONE

Chapter One

Le Voyage dans la lune (A Trip to the Moon) (Star Film, 1902)
Art Direction by: George Méliès

Robin Hood (Douglas Fairbanks Pictures, 1922)
Art Direction by: Wilfred Buckland
Associate Art Direction by: Edward M. Langley, Irvin J. Martin, Anton Grot, and William Cameron Menzies
Set Design by: Lloyd Wright

The Thief of Bagdad (Douglas Fairbanks Pictures/United Artists, 1924)
Art Direction and Illustrations by: William Cameron Menzies
Associate Art Direction by: Park French, Harold Grieve, Anton Grot, Edward M. Langley, Irvin J. Martin, and Paul Youngblood

Gone with the Wind (Selznick International Pictures, Metro-Goldwyn-Mayer, 1939)
Production Design by: William Cameron Menzies
Art Direction by: Lyle R.Wheeler
Set Decoration by: Edward G. Boyle and Howard Bristol
Illustrations by: Dorothea Holt-Redmond and Joseph McMillan Johnson
Set Design by: Hope Erwin and Joseph B. Platt

Matte Painting by: Byron L. Crabbe, Fitch Fulton, Jack Shaw, and Albert Simpson

A Midsummer Night's Dream (Warner Bros., 1935)
Art Direction and Illustrations by: Anton Grot
Set Decoration by: Ben Bone
Set Design by: Harper Goff

Little Caesar (Warner Bros., 1931)
Art Direction by: Anton Grot
Set Decoration by: Ray Moyer

The Night Is Young (Metro-Goldwyn-Mayer, 1935)
Art Directon by: Frederic Hope
Supervising Art Direction by: Cedric Gibbons
Set Decoration by: Edwin B. Willis and Henry Grace

The Wonder of Women (Metro-Goldwyn-Mayer, 1929)
Art Direction by: Cedric Gibbons

Top Hat (RKO, 1935)
Art Direction by: Carroll Clark
Supervising Art Direction by: Van Nest Polglase
Set Decoration by: Thomas Little
Illustrations by: Albert M. Pyke

Modern Times (Charles Chaplin Productions, 1935)
Art Direction and Set Decoration by: Charles D. Hall
Associate Art Direction by: J. Russell Spencer

All About Eve (Twentieth Century Fox, 1950)
Art Direction by: George W. Davis
Supervising Art Direction by: Lyle R. Wheeler
Set Decoration by: Thomas Little and Walter M. Scott

The Production Designer
The Scarlet Empress (Paramount Pictures, 1934)
Art Direction by: Hans Dreier
Set Design by: Peter Ballbusch
Scenic Painting by: Richard Kollorsz

Lady in the Lake (Metro-Goldwyn-Mayer, 1947)
Art Direction by: E. Preston Ames
Supervising Art Direction by: Cedric Gibbons
Set Decoration by: Thomas Theuerkauf and Edwin B. Willis

Portrait in Black (Ross Hunter Pictures/Universal Pictures, 1960)
Art Direction by: Richard H. Riedel
Set Decoration by: Julia Heron

The Set Decorator
Lawrence of Arabia (Horizon Pictures, 1962)
Production Design and Illustrations by: John Box
Set Decoration by: Dario Simoni
Art Direction by: John Stoll and Anthony Masters
Associate Art Direction by: Terrence Marsh, George Richardson, Tony Rimmington, Roy Rossotti, Jose Alguero, and Wallis Smith
Illustration by: Charles Bishop
Set Design by: John Graysmark, Roy Stannard, and Roy Walker

Julia Misbehaves (Metro-Goldwyn-Mayer, 1948)
Art Direction by: Daniel B. Cathcart
Supervising Art Direction by: Cedric Gibbons
Set Decoration by: Edwin B. Willis

PART TWO

The Silent Era and the Twenties

The Thief of Bagdad (Douglas Fairbanks Pictures/United Artists, 1924)
Art Direction and Illustrations by: William Cameron Menzies
Associate Art Direction by: Park French, Harold Grieve, Anton Grot, H. R. Hopps, Edward M. Langley, Irvin J. Martin, William Utwich, and Paul Youngblood

The Birth of a Nation (D. W. Griffiths Corp., 1915)
Art Direction by: Frank Wortman
Scenic Painting by: Cash Shockey

Intolerance: Love's Struggle Throughout the Ages (1916)
Art Direction by: Walter L. Hall
Set Design by: Frank Wortman

The Thief of Bagdad (Douglas Fairbanks Pictures/United Artists, 1924)
Art Direction and Illustrations by: William Cameron Menzies
Associate Art Direction by: Park French, Harold Grieve, Anton Grot, H. R. Hopps, Edward M. Langley, Irvin J. Martin, William Utwich, and Paul Youngblood

Ben Hur: A Tale of the Christ (Metro-Goldwyn-Mayer, 1925)
Supervising Art Direction by: Cedric Gibbons
Art Direction by: Horace Jackson, Harry Oliver, and Camillo Mastrocinque
Set Decoration by: Horace Jackson and Edwin B. Willis
Associate Art Direction by: Ferdinand P. Earle

Set Design by: A. Arnold Gillespie and Harold Grieve
Scenic Painting by: E. H. Tate

The Goldrush (Charles Chaplin Productions/United Artists, 1925)
Art Direction and Set Decoration by: Charles D. Hall
Scenic Painting by: Peter Stitch and Mr. Wood

The Cabinet of Dr. Caligari (Decla-Bioscop AG, 1920)
Art Direction by: Walter Reimann and Walter Rohrig
Set Decoration by: Hermann Warm

Metropolis (Universum Film [UFA], 1927)
Art Direction by: Otto Hunte, Erich Kettelhut, and Karl Vollbrecht
Set Design by: Edgar G. Ulmer

Enchantment (Cosmopolitan Productions/Paramount Pictures, 1921)
Art Direction by: Joseph Urban

Our Dancing Daughters (Metro-Goldwyn-Mayer, 1928)
Art Direction by: Cedric Gibbons
Set Decoration by: Edwin B. Willis

The Single Standard (Metro-Goldwyn-Mayer, 1928)
Art Direction by: Cedric Gibbons
Set Decoration by: Edwin B. Willis

Pleasure Crazed (Fox Film Corp., 1929)
Art Direction by: William S. Darling

The Thirties

Cleopatra (Paramount Pictures, 1934)
Art Direction by: Roland Anderson
Supervising Art Direction by: Hans Dreier
Illustrations by: Boris Leven and Joe De Young

Top Hat (RKO, 1935)
Art Direction by: Carroll Clark
Supervising Art Direction by: Van Nest Polglase
Set Decoration by: Thomas Little
Illustrations by: Albert M. Pyke

Dinner at Eight (Metro-Goldwyn-Mayer, 1933)
Art Direction by: Hobe Erwin and Frederic Hope
Supervising Art Direction by: Cedric Gibbons
Set Decoration by: Edwin B. Willis

After the Thin Man (Metro-Goldwyn-Mayer, 1936)
Art Direction by: Harry McAfee
Supervising Art Direction by: Cedric Gibbons
Set Decoration by: Henry Grace and Edwin B. Willis

Grand Hotel (Metro-Goldwyn-Mayer, 1932)
Supervising Art Direction by: Cedric Gibbons
Set Decoration by: Edwin B. Willis

Dodsworth (Samuel Goldwyn Company, 1936)
Art Direction by: Richard Day
Set Decoration by: Paul Widlicska

Holiday (Columbia Pictures, 1938)
Art Direction by: Stephen Goosson
Associate Art Direction by: Lionel Banks
Set Decoration by: Babs Johnstone

Lost Horizon (Columbia Pictures, 1937)
Art Direction by: Stephen Goosson
Associate Art Direction by: Lionel Banks and Paul Murphy
Set Decoration by: Babs Johnstone
Illustrations by: Carey Odell

Things to Come (London Film Productions/United Artists, 1936)
Art Direction by: Vincent Korda and William Cameron Menzies
Associate Art Direction by: Frank Wells, John Bryan, and Frederick Pusey
Matte Painting by: W. Percy Day and Peter Ellenshaw

The Wizard of Oz (Metro-Goldwyn-Mayer, 1939)
Art Direction by: William A. Horning, Jack Martin Smith, and Malcolm Brown
Supervising Art Direction by: Cedric Gibbons
Set Decoration by: Edwin B. Willis
Associate Art Direction by: Elmer Sheeley
Illustrations by: Hugo Balin
Set Design by: E. Preston Ames, John Bossert, Edward C. Carfagno, Marvin Connell, Harvey T. Gillett, William Hellen, K. Johnson, Ted Rich, Jim Roth, J. Russell Spencer, Steffgen, Charles B. Steiner, Marvin Summerfield, John J. Thompson, Leonid Vasian, and Woody Woodward
Matte Painting by: Warren Newcombe and Candelario Rivas
Scenic Painting by: George Gibson, Leo F. Atkinson, John Coakley, Randall Duell, William Gibson, Clem Hall, F. Wayne Hill, Ray Perry Sr., Clark M. Provins, Arthur Grover Ryder, and Duncan Spencer

Dracula (Universal Pictures, 1931)
Art Direction by: Charles D. Hall
Associate Art Direction by: John Hoffman and Herman Rosse
Set Decoration by: Russell A. Gausman
Matte Painting by: John P. Fulton
Scenic Painting by: Charles A. Logue

Frankenstein (Universal Pictures, 1931)
Art Direction and Illustrations by: Charles D. Hall
Associate Art Direction by: Herman Rosse
Set Decoration by: Ed Keyes and Ken Strickfaden

Son of Frankenstein (Universal Pictures, 1939)
Art Direction and Illustrations by: Jack Otterson
Associate Art Director: Richard H. Riedel
Set Decoration by: Russell A. Gausman
Matte Painting by: John P. Fulton

All Quiet on the Western Front (Universal Pictures, 1930)
Art Direction and Set Decoration by: Charles D. Hall
Associate Art Direction by: William R. Schmidt

Modern Times (Charles Chaplin Productions, 1935)
Art Direction and Set Decoration by: Charles D. Hall
Associate Art Direction by: J. Russell Spencer

Cleopatra (Paramount Pictures, 1934)
Art Direction by: Roland Anderson
Supervising Art Direction by: Hans Dreier
Illustrations by: Boris Leven and Joe De Young

Gone with the Wind (**Selznick International Pictures, Metro Goldwyn Mayer, 1939**)
Production Design by: William Cameron Menzies
Art Direction by: Lyle R. Wheeler
Set Decoration by: Edward G. Boyle and Howard Bristol
Illustrations by: Dorothea Holt-Redmond and Joseph McMillan Johnson
Set Design by: Hope Erwin and Joseph B. Platt
Matte Painting by: Byron L. Crabbe, Fitch Fulton, Jack Shaw, and Albert Simpson

The Forties
Laura (Twentieth Century Fox, 1944)
Art Direction by: Leland Fuller
Supervising Art Direction by: Lyle R. Wheeler
Set Decoration by: Thomas Little and Paul S. Fox

Rebecca (Selznick International Pictures, 1940)
Art Direction by: Lyle R. Wheeler
Set Decoration by: Howard Bristol and Joseph B. Platt
Illustrations by: Dorothea Holt-Redmond
Matte Painting by: Albert Simpson

Citizen Kane (RKO, 1941)
Art Direction by: Perry Ferguson
Supervising Art Direction by: Van Nest Polglase
Set Decoration by: Darrell Silvera, Al Fields
Associate Art Direction by: Hilyard M. Brown
Illustrations by: Charles Ohmann, Al Abbott, Chesley Bonestell, Claude Gillingwater Jr., Albert Pyke, and Maurice Zuberano
Set Design by: John Mansbridge
Matte Painting by: Mario Larrinaga and Chesley Bonestell

How Green Was My Valley (Twentieth Century Fox, 1941)
Art Direction by: Nathan Juran
Supervising Art Direction by: Richard Day
Set Decoration by: Thomas Little
Matte Painting by: Chesley Bonestell and W. Percy Day

Casablanca (Warner Bros., 1942)
Art Direction by: Carl Jules Weyl
Set Decoration by: George James Hopkins
Set Design by: Harper Goff

Laura (Twentieth Century Fox, 1944)
Art Direction by: Leland Fuller
Supervising Art Direction by: Lyle R. Wheeler
Set Decoration by: Thomas Little and Paul S. Fox

Mildred Pierce (Warner Bros., 1945)
Art Direction and Illustrations by: Anton Grot
Set Decoration by: George James Hopkins

Mr. Blandings Builds His Dream House (1948)
Art Direction by: Carroll Clark
Associate Art Direction by: Albert D'Agostino
Set Decoration by: Harley Miller and Darrell Silvera

The Fountainhead (Warner Bros., 1949)
Art Direction by: Edward Carrere
Set Decoration by: William L. Kuehl
Illustrations by: Harold Michelson
Matte Painting by: Chesley Bonestell

The Heiress (Paramount Pictures, 1949)
Production Design and Illustrations by: Harry Horner

Associate Art Direction by: John Meehan
Set Decoration by: Emile Kuri

The Magnificent Ambersons (RKO, 1942)
Art Direction by: Albert S. D'Agostino and Mark-Lee Kirk
Set Decoration by: Darrel Silvera and A. Roland Fields
Set Design by: Mark-Lee Kirk
Matte Paintings by: Chesley Bonestell

The Fifties
Sunset Boulevard (Paramount Pictures, 1950)
Art Direction by: John Meehan
Supervising Art Direction by: Hans Dreier
Set Decoration by: Ray Moyer and Sam Comer

Vertigo (Alfred Hitchcock Productions/Paramount Pictures, 1958)
Art Direction by: Henry Bumstead
Supervising Art Direction by: Hal Pereira
Set Decoration by: Frank R. McKelvy and Sam Comer

North by Northwest (Metro-Goldwyn-Mayer, 1959)
Production Design and Illustrations by: Robert Boyle
Art Direction by: William A. Horning and Merrill Pye
Set Decoration by: Henry Grace and Frank R. McKelvy
Illustrations by: Mentor Huebner
Matte Painting by: Matthew Yuricich

High Noon (Stanley Kramer Productions/United Artists, 1952)
Production Design by: Rudolph Sternad
Art Direction by: Ben Hayne
Set Decoration by: Murray Waite

Shane (Paramount Pictures, 1953)
Art Direction and Illustrations by: Walter H. Tyler
Supervising Art Direction by: Hal Pereira
Set Decoration by: Emile Kuri

Giant (Warner Bros., 1956)
Production Design and Illustrations by: Boris Leven
Set Decoration by: Ralph S. Hurst

Ben-Hur (Metro-Goldwyn-Mayer, 1959)
Art Direction by: Edward C. Carfagno and William A. Horning
Associate Art Direction by: Vittorio Valentini and Ken Adam
Set Decoration by: Hugh Hunt
Illustrations by: Mentor Huebner, David Hall, and Harold Michelson
Matte Painting by: Matthew Yuricich
Scenic Painting by: Italo Tomassi

An American in Paris (Metro-Goldwyn-Mayer, 1951)
Art Direction by: E. Preston Ames
Supervising Art Direction by: Cedric Gibbons
Set Decoration by: F. Keogh Gleason and Edwin B. Willis

Gigi (Metro-Goldwyn-Mayer, 1958)
Production Design and Illustrations by: Cecil Beaton
Art Direction by: E. Preston Ames and William A. Horning
Set Decoration by: F. Keogh Gleason and Henry Grace

The King and I (Twentieth Century Fox, 1956)
Art Direction and Illustrations by: John DeCuir
Supervising Art Direction by: Lyle R. Wheeler
Set Decoration by: Paul S. Fox and Walter M. Scott

Pillow Talk (Universal International Pictures, 1959)
Art Direction by: Richard H. Riedel
Set Decoration by: Russell A. Gausman and Ruby R. Levitt

The Sixties
2001: A Space Odyssey (Metro-Goldwyn-Mayer, 1968)
Production Design by: Ernest Archer, Harry Lange, and Anthony Masters
Set Decoration by: Robert Cartwright and Oliver Mourgue
Art Direction by: John Hoesli
Illustrations by: Robert T. McCall, Anthony Pratt, John Rose, Roy Carnon, and John Young
Set Design by: Brian Ackland-Snow, Martin Atkinson, Peter Childs, John Fenner, Alan Fraiser, John Graysmark, Tony Reading, John Siddall, Wallis Smith, Alan Tomkins, and Frank Wilson
Matte Painting by: Jeremy Hume

Lawrence of Arabia (Horizon Pictures, 1962)
Production Design and Illustrations by: John Box
Set Decoration by: Dario Simoni
Art Direction by: John Stoll and Anthony Masters
Associate Art Direction by: Terrence Marsh, George Richardson, Tony Rimmington, Roy Rossotti, Jose Alguero, and Wallis Smith
Illustrations by: Charles Bishop
Set Design by: John Graysmark, Roy Stannard, and Roy Walker

Cleopatra (Twentieth Century Fox, 1963)
Production Design and Illustrations by: John DeCuir

Set Decoration by: Paul S. Fox, Ray Moyer, Walter M. Scott, and Richelieu

Art Direction by: Herman A. Blumenthal, Hilyard M. Brown, Boris Juraga, Maurice Pelling, Jack Martin Smith, Elven Webb, and Don Picton

Illustrations by: Harold Michelson

Set Design by: Bill Dennison and Giovanni Natalucci

Matte Painting by: Ralph Hammeras and Joseph Nathanson

Scenic Painting by: Ferdinand Bellan and Italo Tomassi

Dr. Zhivago (Metro-Goldwyn-Mayer, 1965)

Production Design and Illustrations by: John Box

Set Decoration by: Dario Simoni and Jose Maria Alarcon

Art Direction by: Terence Marsh and Gil Parrondo

Associate Art Direction by: Ernest Archer, Benjamin Fernandez, William Hutchinson, and Roy Walker

Set Design by: Wallis Smith

Scenic Painting by: Eddie Fowlie

2001: A Space Odyssey (Metro-Goldwyn-Mayer, 1968)

Production Design by: Ernest Archer, Harry Lange, and Anthony Masters

Set Decoration by: Robert Cartwright and Oliver Mourgue

Art Direction by: John Hoesli

Illustrations by: Robert T. McCall, Anthony Pratt, John Rose, Roy Carnon, and John Young

Set Design by: Brian Ackland-Snow, Martin Atkinson, Peter Childs, John Fenner, Alan Fraiser, John Graysmark, Tony Reading, John Siddall, Wallis Smith, Alan Tomkins, and Frank Wilson

Matte Painting by: Jeremy Hume

My Fair Lady (Warner Brothers, 1964)

Production Design by: Cecil Beaton and Gene Allen

Set Decoration by: George James Hopkins

Illustrations by: Jim Reynolds

Moonraker (Danjag/United Artists, 1979)

Production Design and Illustrations by: Ken Adam

Set Decoration by: Peter Howitt

Art Direction by: Charles Bishop, Max Douy, and Harry Lange

Associate Art Direction by: Ernest Archer, Jacques Douy, Serge Douy, John Fenner, and Marc Frederix

Set Design by: Frank Walsh

Dr. Strangelove: Or How I Learned to Stop Worrying and Love the Bomb (Hawk Films/Columbia Pictures, 1964)

Production Design and Illustrations by: Ken Adam

Art Direction by: Peter Murton

Matte Painting by: Bob Cuff

Goldfinger (Eon Productions/United Artists, 1964)

Production Design and Illustrations by: Ken Adam

Set Decoration by: Freda Pearson

Art Direction by: Peter Murton

Associate Art Direction by: Maurice Pelling and Michael White

Set Design by: Peter Lamont

You Only Live Twice (Danjag/United Artists, 1967)

Production Design and Illustrations by: Ken Adam

Set Decoration by: David Ffolkes

Art Direction by: Harry Pottle

Associate Art Direction by: Peter Lamont

Set Design by: Roy Dorman

Matte Painting by: Cliff Culley

The Birds (Alfred Hitchcock Productions/Universal Pictures, 1963)
Production Design by: Robert Boyle
Set Decoration by: George Milo
Illustrations by: Harold Michelson
Matte Painting by: Albert Whitlock

Planet of the Apes (Twentieth Century Fox, 1968)
Art Direction by: William J. Creber
Supervising Art Direction by: Jack Martin Smith
Set Decoration by: Norman Rockett and Walter M. Scott
Illustrations by: Mentor Heubner, Bill Sully, and Fred Harpmen

The Graduate (Embassy Pictures, 1967)
Production Design by: Richard Sylbert
Set Decoration by: George R. Nelson
Art Direction by: Joel Schiller
Illustrations by: Harold Michelson

Rosemary's Baby (Paramount Pictures, 1968)
Production Design by: Richard Sylbert
Set Decoration by: Robert Nelson
Art Direction by: Joel Schiller
Illustrations by: William Majors

The Seventies
Star Wars (Lucasfilm/Twentieth Century Fox, 1977)
Production Design by: John Barry
Set Decoration by: Roger Christian
Art Direction by: Leslie Dilley and Norman Reynolds
Associate Art Direction by: Leon Ericksen and Al Locatelli
Illustrations by: Ralph McQuarrie, Joe Johnston, Alex Tavoularis, and Ron Cobb

Set Design by: Steve Cooper
Matte Painting by: Harrison Ellenshaw

The Godfather (Paramount Pictures, 1972)
Production Design by: Dean Tavoularis
Set Decoration by: Philip Smith
Art Direction by: Warren Clymer
Associate Art Direction by: Samuel Verts

The Godfather: Part II (Paramount Pictures, 1974)
Production Design by: Dean Tavoularis
Set Decoration by: George R. Nelson
Art Direction by: Angelo P. Graham

The Sting (Universal Pictures, 1973)
Production Design and Illustrations by: Henry Bumstead
Set Decoration by: James W. Payne
Matte Painting by: Albert Whitlock

The Towering Inferno (Irwin Allen Productions/ Twentieth Century Fox, 1974)
Production Design by: William J. Creber
Set Decoration by: Raphael Bretton
Art Direction by: Ward Preston
Associate Art Direction by: Steven P. Sardanis
Illustrations by: Tom Cranham, Dan Gooze, Nikita Knatz, and Joseph Musso
Set Design by: William Cruse
Matte Painting by: Matthew Yuricich
Scenic Painting by: Eward T. McAvoy and Benjamin Resella

Chinatown (Paramount Pictures, 1974)
Production Design by: Richard Sylbert

Set Decoration by: Ruby R. Levitt
Art Direction by: W. Stewart Campbell
Illustrations by: William Majors
Set Design by: Gabe Resh and Robert Resh

Barry Lyndon (Hawk Films/Warner Bros., 1975)
Production Design by: Ken Adam
Set Decoration by: Vernon Dixon
Art Direction by: Roy Walker
Associate Art Direction by: Bill Brodie and Jan
Schlubach

All the President's Men (Warner Bros., 1976)
Production Design by: George Jenkins
Set Decoration by: George Gaines
Associate Art Direction by: Robert I. Jillson
Set Design by: George Szeptycki
Scenic Painting by: Edward T. McAvoy

Jaws (Zanuck/Brown/Universal Pictures, 1975)
Production Design by: Joe Alves
Set Decoration by: John M. Dwyer
Illustrations by: Thomas J. Wright

Close Encounters of the Third Kind (Columbia Pictures,
1977)
Production Design by: Joe Alves
Set Decoration by: Phil Abramson
Art Direction by: Daniel A. Lomino
Illustrations by: George Jensen and Ralph McQuarrie
Matte Painting by: Matthew Yuricich and Rocco Gioffre

Star Wars (Lucasfilm/Twentieth Century Fox, 1977)
Production Design by: John Barry
Set Decoration by: Roger Christian

Art Direction by: Leslie Dilley and Norman Reynolds
Associate Art Direction by: Leon Ericksen and Al
Locatelli
Illustrations by: Ralph McQuarrie, Joe Johnston, Alex
Tavoularis, and Ron Cobb
Set Design by: Steve Cooper
Matte Painting by: Harrison Ellenshaw

All That Jazz (Columbia Pictures, 1979)
Production Design by: Philip Rosenberg and Tony
Walton
Set Decoration by: Gary J. Brink and Edward Stewart
Scenic Painting by: Eugene Powell

The Wiz (Universal Pictures, 1978)
Production Design and Illustrations by: Tony Walton
Set Decoration by: Robert Drumheller and Edward
Stewart
Art Direction by: Philip Rosenberg
Associate Art Direction by: John Jay Moore, John
Kasarda, and Lawrence Miller
Matte Painting by: Albert Whitlock and Syd Dutton
Scenic Painting by: Edward Garzero and Eugene Powell

Apocalypse Now (Zoetrope Studios/United Artists, 1979)
Production Design by: Dean Tavoularis
Set Decoration by: George R. Nelson
Art Direction by: Angelo P. Graham
Associate Art Direction by: James J. Murakami
Illustrations by: Alex Tavoularis and Thomas J. Wright
Scenic Painting by: Roger Dietz

Amadeus (Saul Zaentz Company/Orion Pictures, 1984)
Production Design by: Patrizia von Brandenstein
Set Decoration by: Karel Cerny
Associate Art Direction by: Francesco Chianese
Set Design by: Josef Hrabusicky, Boris Ondrusek, and Josef Svoboda

Blade Runner (The Ladd Company/Warner Bros., 1982)
Production Design by: Lawrence G. Paull
Set Decoration by: Linda DeScenna, Leslie Frankenheimer, Thomas L. Roysden, and Peg Cummings
Art Direction by: David L. Snyder
Associate Art Direction by: Stephen Dane and Peter J. Hampton
Set Design by: Charles Breen, Curtis A. Schnell, and William Ladd Skinner
Illustrations by: Syd Mead, Mentor Huebner, Sherman Labby, Tom Cranham, and Tom Southwell
Matte Painting by: Matthew Yuricich
Scenic Painting by: Edward T. McAvoy

Raiders of the Lost Ark (Lucasfilm/Paramount Pictures, 1981)
Production Design by: Norman Reynolds
Set Decoration by: Michael Ford
Art Direction by: Leslie Dilley
Associate Art Direction by: Ken Court, John Fenner, Fred Hole, Joe Johnston, Michael Lamont, and Hassen Soufi
Illustrations by: Roy Carnon, Ron Cobb, Michael Lloyd, Ralph McQuarrie, David J. Negron, Ed Verreaux, Dave Stevens, William Stout, and Jim Steranko
Set Design by: George Djurkovic

Matte Painting by: Alan Maley and Michael Pangrazio
Scenic Painting by: Andrew Garnet-Lawson and Eric Shirtcliffe

The Shining (Hawk Films/Warner Bros., 1980)
Production Design by: Roy Walker
Set Decoration by: Peter Hancock and Tessa Davies
Art Direction by: Leslie Tomkins
Associate Art Direction by: Norman Dorme
Set Design by: Michael Boone, John Fenner, and Michael Lamont
Scenic Painting by: Del Smith and Robert Walker

Out of Africa (Universal Pictures, 1985)
Production Design and Illustrations by: Stephen B. Grimes
Set Decoration by: Josie MacAvin
Art Direction by: Colin Grimes, Cliff Robinson, and Herbert Westbrook
Matte Painting by: Syd Dutton

Amadeus (Saul Zaentz Company/Orion Pictures, 1984)
Production Design by: Patrizia von Brandenstein
Set Decoration by: Karel Cerny
Associate Art Direction by: Francesco Chianese
Set Design by: Josef Hrabusicky, Boris Ondrusek, and Josef Svoboda

Dangerous Liaisons (Warner Bros., 1988)
Production Design by: Stuart Craig
Set Decoration by: Gérard James
Art Direction by: Gavin Bocquet and Gérard Viard
Associate Art Direction by: Jean-Michel Ducourty
Scenic Painting by: Claude Périnet

The Untouchables (Paramount Pictures, 1987)
Production design by: Patrizia Von Brandenstein
Set Decoration by: Hal Gausman
Art Direction by: William A. Elliott
Set Design by: E. C. Chen, R. Gilbert Clayton, Nicholas Laborczy, and Steven P. Sardanis
Scenic Painting by: Steven Kerlagon

Wall Street (Twentieth Century Fox, 1987)
Production Design by: Stephen Hendrickson
Set Decoration by: Leslie Bloom and Susan Bode
Art Direction by: John Jay Moore and Hilda Stark
Associate Art Direction by: Charles E. McCarry
Scenic Painting by: Elisa Nevel Demarest, Billy Puzo, James St. Clair, and Lohr Wilson

Arthur (Orion Pictures, 1981)
Production Design by: Stephen Hendrickson
Set Decoration by: Carol Joffe and Steven Jordan
Associate Art Direction by: Paul Eads and W. Steven Graham
Scenic Painting by: Cosmo Sorice and James Sorice

The War of the Roses (Twentieth Century Fox, 1989)
Production Design by: Ida Random
Set Decoration by: Anne D. McCulley
Art Direction by: Mark W. Mansbridge
Illustration by: Sherman Labby
Set Design by: Mark Fabus, Perry Gray, and Stan Tropp

Brazil (Embassy International Pictures/Universal Pictures, 1985)
Production Design by: Norman Garwood
Set Decoration by: Maggie Gray
Art Direction by: John Beard and Keith Pain

Associate Art Direction by: Françoise Benoît-Fresco and Dennis Bosher
Illustration by: Andrew Lawson and Ray Caple
Set Design by: Stephen Bream and Tony Rimmington
Matte Painting by: Ray Caple
Scenic Painting by: Andrew Garnet-Lawson
Graphic Design by: Bernard Allum and Dave Scutt

The Adventures of Baron Munchausen (Columbia Pictures, 1988)
Production Design and Illustration by: Dante Ferretti
Set Decoration by: Francesca Lo Schiavo
Art Direction by: Maria-Teresa Barbasso, Giorgio Giovannini, Nazzareno Piana, and Massimo Razzi
Illustrations by: Mauro Borrelli
Matte Painting by: Bob Cuff, Joy Cuff, Doug Ferris, and Leigh Took

The Nineties
Saving Private Ryan (Amblin Entertainment/Dreamworks SKG, 1998)
Production Design by: Thomas E. Sanders
Set Decoration by: Lisa Dean
Supervising Art Direction by: Daniel T. Dorrance
Art Direction by: Tom Brown, Ricky Eyres, Chris Seagers, Alan Tomkins, and Mark Tanner
Associate Art Direction by: Gary Freeman and Kevin Kavanaugh
Illustrations by: Matt Codd, Tim Flattery, and John Greaves
Set Designer: Stephen Bream, Robert Cowper, William Hawkins, Margaret Horspool, Paul Westcott, and Andy Thomson
Matte Painting by: Matthew Hendershot

Edward Scissorhands (Twentieth Century Fox, 1990)
Production Design by: Bo Welch
Set Decoration by: Cheryl Carasik
Art Direction by: Tom Duffield
Illustrations by: Jack Johnson
Set Design by: Ann Harris, Rick Heinrichs, and Paul Sonski

Dances with Wolves (Tig Productions/Orion Pictures, 1990)
Production Design and Illustration by: Jeffrey Beecroft
Set Decoration by: Lisa Dean
Art Direction by: William Ladd Skinner
Illustrations by: Steve Burg and Len Morganti
Matte Painting by: Matthew Yuricich, Robert D. Bailey, Paul Curley, and Rocco Gioffre
Scenic Painting by: Richard Puga, Jim Steere, Patrick Thoms, and Ward Welton

Sleeping with the Enemy (Twentieth Century Fox, 1991)
Production Design by: Doug Kraner
Set Direction by: Lee Poll
Art Direction by: Joseph P. Lucky
Illustrations by: Len Morganti
Set Design by: Stan Tropp

Unforgiven (Malpaso Productions/Warner Bros., 1992)
Production Design by: Henry Bumstead
Set Decoration by: Janice Blackie-Goodine
Art Direction by: Adrian Gorton and Rick Roberts
Set Design by: James J. Murakami
Scenic Painting by: Tim C. Campbell

The Age of Innocence (Cappa Production/Columbia Pictures, 1993)
Production Design and Illustration by: Dante Ferretti

Set Decoration by: Robert J. Franco and Amy Marshall
Art Direction by: Speed Hopkins
Associate Art Direction by: Dan Davis, Jean-Michel Hugon, Robert Perdziola, Carl Sprague, and Rick Butler
Scenic Painting by: James Sorice and Lauren Doner

L.A. Confidential (Regency Enterprises/Warner Bros., 1997)
Production Design by: Jeannine Claudia Oppewall
Set Decoration by: Jay Hart
Art Direction by: William Arnold
Illustrations by: Gary Thomas
Set Design by: Louisa Bonnie, Julia K. Levine, and Mark Poll
Scenic Painting by: Paul Stanwyck

Pleasantville (New Line Cinema, 1998)
Production Design by: Jeannine Claudia Oppewall
Set Decoration by: Jay Hart
Supervising Art Direction by: William Arnold
Art Direction by: Dianne Wager
Illustrations by: Carl Aldana, Jim Bandsuh, Jack Johnson, and Len Morganti
Set Design by: Julia K. Levine, Mark Poll, Dawn Snyder, Mindy R. Toback, and Randall D. Wilkins
Matte Painting by: Mark Sullivan
Scenic Painting by: Peter Allen, Stephanie Cooney, Antonio Santelli, and Paul J. Stanwyck

Howards End (Merchant Ivory Productions, 1992)
Production Design and Illustrations by: Luciana Arrighi
Set Decoration by: Ian Whittaker
Art Direction by: John Ralph

Oscar and Lucinda (Fox Searchlight Pictures, 1997)
Production Design and Illustrations by: Luciana Arrighi
Set Decoration by: Arthur Wicks and Sally Campbell
Art Direction by: Tom Nursery and John Wingrove
Associate Art Direction by: Paul Ghirardani, Jacinta Leong, and John Ralph
Illustrations by: Nikki DiFalco
Set Design by: Helen Baumann and Gary Tomkins
Scenic Painting by: Martin Bruveris and Michael O'Kane

The Remains of the Day (Merchant Ivory Productions/ Columbia Pictures, 1993)
Production Design and Illustrations by: Luciana Arrighi
Set Decoration by: Ian Whittaker
Art Direction by: John Ralph

Saving Private Ryan (Amblin Entertainment/Dreamworks SKG, 1998)
Production Design by: Thomas E. Sanders
Set Decoration by: Lisa Dean
Supervising Art Direction by: Daniel T. Dorrance
Art Direction by: Tom Brown, Ricky Eyres, Chris Seagers, Alan Tomkins, and Mark Tanner
Associate Art Direction by: Gary Freeman and Kevin Kavanaugh
Illustrations by: Matt Codd, Tim Flattery, and John Greaves
Set Designer: Stephen Bream, Robert Cowper, William Hawkins, Margaret Horspool, Paul Westcott, and Andy Thomson
Matte Painting by: Matthew Hendershot

Jurassic Park (Amblin Entertainment/Universal Pictures, 1993)
Production Design by: Rick Carter
Set Decoration by: Jackie Carr
Art Direction by: John Bell and William James Teegarden
Associate Art Direction by: Lauren Cory, Martin A. Kline, and Paul Sonski
Illustrations by: Tom Cranham, David Lowery, and Mark "Crash" McCreery
Set Design by: John Berger, Masako Masuda, and Lauren E. Polizzi
Matte Painting by: Christopher Evans and Yusei Uesugi

Forrest Gump (Paramount Pictures, 1994)
Production Design by: Rick Carter
Set Decoration by: Nancy Haigh
Art Direction by: Leslie McDonald and William James Teegarden
Associate Art Direction by: Steve Arnold, Linda Berger, Tony Fanning, and Doug Chiang
Illustrations by: Stephan Dechant, James Hegedus, Martin A. Kline, Erik Tiemens, David Dozoretz, and George Hull
Set Design by: James C. Feng, Erin Kemp, Elizabeth Lapp, and Lauren E. Polizzi
Matte Painting by: Eric Chauvin, Bill Mather, Craig Mullins, and Yusei Uesugi
Scenic Painting by: John W. Morgan

Titanic (Twentieth Century Fox & Paramount Pictures 1997)
Production Design by: Peter Lamont
Set Decoration by: Michael Ford

Supervising Art Direction by: Charles Dwight Lee

Art Direction by: Martin Laing

Associate Art Direction by: Robert W. Laing, Neil Lamont, Steven Lawrence, Bill Rea, Héctor Romero, Andrew Ackland-Snow, and Sandi Cook,

Illustrations by: Thomas W. Lay Jr., Christian Scheurer, Phillip Keller, Rick Newsome, and Eric Ramsey

Set Design by: Eugenio Casta, Peter Francis, Francisco García, Dominic Masters, Marco Niro, Carlos Benassini, Jon Billington, Doug J. Meerdink, and Martha Snow Mack

Matte Painting by: Peter Baustaedter, Charles Darby, Christopher Evans, Caroleen Green, Richard Kilroy, and Rick Rische

Scenic Painting by: Marienus Cetani Sr., Marcus Cetani, James N. Delaplane, Rodney Delaplane, Bernard Faye, Elizabeth K. Fisher, José González, Jose Jimenez, Lynn A. Johanson, Cheryl C. Johnson, Carl Keller, Genessa Goldsmith Proctor, Steven Sallybanks, Dave Westcott, and Aprile Lanza Boettcher

Graphic Design by: Doreen Austria and Eric Rosenberg

The Bonfire of the Vanities (Warner Bros., 1990)

Production Design by: Richard Sylbert

Set Decoration by: Joe D. Mitchell and Justin Scoppa Jr.

Art Direction by: Gregory Bolton and Peter Landsdown Smith

Set Design by: Richard Berger, Robert Maddy, and Nick Navarro

The Prince of Tides (Columbia Pictures, 1991)

Production Design by: Paul Sylbert

Set Decoration by: Caryl Heller, Leslie Pope, Arthur Howe, Jr.

Art Direction by: W. Steven Graham

Associate Art Direction by: Judeth Lowey

Illustrations by: Brick Mason

Set Design by: Chris Shriver

Scenic Painting by: Roland Brooks and Lewis Bowen

Six Degrees of Separation (Metro-Goldwyn-Mayer, 1993)

Production Design by: Patrizia von Brandenstein

Set Direction by: Gretchen Rau

Art Direction by: Dennis Bradford

Associate Art Direction by: Ed Check

Scenic Painting by: Jon Ringbom

Meet Joe Black (Universal Pictures, 1998)

Production Design and Illustrations by: Dante Ferretti

Set Decoration by: Leslie Bloom

Art Direction by: Robert Guerra

Associate Art Direction by: Ed Check, Darrell K. Keister, Nancy Winters, and Patricia Woodbridge

Illustrations by: John Davis

Scenic Painting by: William Armstrong, Karla J. Bailey, Meredith Barchat, Roland Brooks, James Donahue, Emily Gaunt, Jim Gilmartin, Philip Kennedy, Julius Kozlowski, Silvija L. Moess, Lyvan A. Munlyn, Susan Peterson, John Ralbovsky, Kevin Sciotto, Haven Storey, and Sylvia Trapanese

Graphic Design by: Joan Winters

A Perfect Murder (Kopelson Entertainment/Warner Bros., 1998)

Production Design by: Philip Rosenberg

Set Decoration by: Debra Schutt

Art Direction by: Patricia Woodbridge

Associate Art Direction by: Laura Brock, Darrell K. Keister, Charles E. McCarry, and Loren Weeks

Illustrations by: Brick Mason
Scenic Painting by: Joseph Garzero

The Thomas Crown Affair (Irish Dream Time/Metro-Goldwyn-Mayer, 1999)
Production Design by: Bruno Rubeo
Set Decoration by: Leslie E. Rollins
Art Direction by: Dennis Bradford
Associate Art Direction by: Teresa Carriker-Thayer, Jay Durrwachter, and Paul D. Kelly
Scenic Painting by: Joseph Garzero
Graphic Design by: Joan Winters

American Beauty (Dreamworks SKG, 1999)
Production Design by: Naomi Shohan
Set Decoration by: Jan K. Bergstrom
Art Direction by: David S. Lazen
Associate Art Direction by: Catherine Smith
Illustration by: Tony Chance and Robin Richesson
Set Design by: Andrea Dopaso and Suzan Wexler
Graphic Designer by: Ted Haigh

The Millennium
Harry Potter and the Half-Blood Prince (Warner Bros. Pictures, 2009)
Production Design by: Stuart Craig
Set Decoration by: Stephanie McMillan
Supervising Art Direction by: Andrew Ackland-Snow
Associate Art Direction by: Alastair Bullock, Martin Foley, Molly Hughes, Tino Schaedler, Hattie Storey, Gary Tomkins, Sloane U'Ren, Stephen Swain, and Ashley Swain
Illustrations by: Rob Bliss, Adam Brockbank, Jane Clark, Jim Cornish, Stephen Forest-Smith, Peter McKinstry, Miraphora Mina, and Andrew Williamson

Set Design by: Denise Bell, Ashley Lamont, Amanda Leggatt, Elizabeth Loach, Alex Smith, Emma Vane, and Ketan Waikar
Matte Painting by: Juan Jesus Garcia, David Gibbons, Sevendalino Khay, Damien Mace, Zoltan Pogonyi, Tania Richard, and Doug Winder
Scenic Painting by: Nicky Kaill, Steven Sallybanks
Graphic Design by: Eduardo Lima, Nicholas Saunders, Lauren Wakefield, Lydia Fry

Gladiator (Dreamworks SKG/Universal Pictures, 2000)
Production Design by: Arthur Max
Set Decoration by: Crispian Sallis, Jille Azis, and Sonja Klaus
Supervising Art Direction by: David Allday, Benjamín Fernández, and John King
Art Direction by: Keith Pain and Peter Russell
Associate Art Direction by: Carlos Bodelón, Jose Luis Del Barco, Adam O'Neill, and Clifford Robinson
Illustrations by: Denis Rich and Sylvain Despretz
Set Design by: Anthony Caron-Delion, Alejandro Fernández, Julie Philpott, Sarah "Toad" Tozer, Helen Xenopoulos, and Stuart Kearns
Matte Painting by: Dave Early and Simon Wicker
Scenic Painting by: Cynthia Sadler, Bob Walker, Brian Bishop, and Doug Bishop

Gosford Park (USA Films, 2001)
Production Design by: Stephen Altman
Set Decoration by: Anna Pinnock
Supervising Art Direction by: John Frakish
Art Direction by: Sarah Hauldren
Associate Art Direction by: James Foster and Matthew Gray

Set Design by: Helen Xenopoulos
Scenic Painting by: Adrian Start and Howard Weaver

Far From Heaven (Focus Features, 2002)
Production Design by: Mark Friedberg
Set Decoration by: Ellen Christiansen
Art Direction by: Peter Rogness
Associate Art Direction by: Miguel López-Castillo and Jeffrey D. McDonald
Scenic Painting by: Rob Landoll, Elizabeth Linn, Don Nace, and Paul Ramirez

Chicago (Miramax, 2002)
Production Design by: John Myhre
Set Decoration by: Gordon Sim
Art Direction by: Andrew M. Stearn
Associate Art Direction by: Brad Milburn, Nancey Pankiw, Grant Van Der Slagt, Abbie Weinberg, and Wayne Wightman
Illustrations by: Sean Breaugh and Ron Hobbs
Set Design by: Thomas Carnegie, David G. Fremlin, and Michael Shocrylas
Matte Painting by: Bojan Zoric
Scenic Painting by: John Bannister and Janet Cormack
Graphic Design by: Paul Greenberg and Jason Graham

Down with Love (Fox 2000, 2003)
Production Design by: Andrew Law
Set Decoration by: Don Diers
Art Direction by: Martin Whist
Associate Art Direction by: David Sandefur
Set Design by: Gregory S. Hooper, Mary Saisselin, Hugo Santiago, Catherine Smith, and Eric Sundahl
Matte Painting by: Glenn Cotter, Christopher Evans, Todd R. Smith, and Chris Stoski

Something's Gotta Give (Columbia Pictures, 2003)
Production Design by: Jon Hutman
Set Decoration by: Beth A. Rubino
Art Direction by: John Warnke
Associate Art Direction by: Franck Schwarz, Ashley Burnham, Jean-Michel Ducourty, W. Steven Graham, Jean-Michel Hugon, and Hinju Kim
Illustrations by: Nathan Schroeder
Set Design by: Gary Diamond, Anthony D. Parrillo, and Dianne Wager
Scenic Painting by: Jon Ringbom
Graphic Design by: Eric Rosenberg and Jason Sweers

The Holiday (Columbia Pictures, 2006)
Production Design by: Jon Hutman
Set Decoration by: David Martin Smith, Cindy Carr, and Al Hobbs
Art Direction by: Dan Webster
Associate Art Direction by: Ashley Burnham, James Foster, and Andy Nicholson
Illustrations by: Nathan Schroeder and Vladimir Spasojevic
Set Design by: Robert Fechtman, Al Hobbs, Julia K. Levine, Lauren E. Polizzi, John Warnke, and Tim Browning
Matte Painting by: Christopher Sage
Graphic Design by: Dan Burke, Edward A. Ioffreda,

It's Complicated (Universal Pictures, 2009)
Production Design by: Jon Hutman
Set Decoration by: Beth A. Rubino
Art Direction by: W. Steven Graham
Associate Art Direction by: Hinju Kim, Ray Kluga, David Stein, and Tom Warren

Illustrations by: Mark Lambert Bristol, Alex Hill, Brick Mason, and Karl Shefelman
Set Design by: Easton Michael Smith
Scenic Painting by: Adam Jones, Michael Lee Nirenberg, Diane Rich, Annie Simeone, Robert Topol, and M. Tony Trotta
Graphic Design by: Edward A. Ioffreda and Clint Schultz

The Aviator (Miramax, 2004)
Production Design and Illustrations by: Dante Ferretti
Set Decoration by: Francesca Lo Schiavo
Supervising Art Direction by: Robert Guerra and Claude Paré
Art Direction by: Luca Tranchino, Martin Gendron, and Réal Proulx
Associate Art Direction by: Michele Laliberte, Réal Proulx, Lori Rowbotham, and Christina Ann Wilson
Set Design by: William J. Law III, Frédéric Amblard, Vincent Gingras-Liberali, Julia K. Levine, Steven Schwartz, and Alex Touikan
Matte Painting by: Dylan Cole, Patrick Paul Mullane, and Tim Sassoon
Scenic Painting by: Jimmy Garcia, Alain Giguère, Jean-François Merlot, Michel Robichaud, Chris Klein, Mélanie Truchon, and Louis Trudeau
Graphic Design by: Isabelle Côté, Jean-Daniel Frenette, Karen Teneyck, and Trong-Kim Nguyen

Pride & Prejudice (Focus Features, 2005)
Production Design by: Sarah Greenwood
Set Decoration by: Katie Spencer
Supervising Art Direction by: Ian Bailie
Art Direction by: Nick Gottschalk and Mark Swain
Associate Art Direction by: Netty Chapman and Joanna Foley

Set Design by: Anna Bregman, Antonio Calvo-Dominguez, Alex Cameron, and Lotta Wolgers
Matte Painting by: Neil Miller
Scenic Painting by: Nigel Hughes

Good Night, and Good Luck. (Warner Bros., 2005)
Production Design by: James D. Bissell
Set Decoration by: Jan Pascale
Art Direction by: Christa Munro
Set Design by: Gae S. Buckley

Memoirs of a Geisha (Columbia Pictures, 2005)
Production Design by: John Mhyre
Set Decoration by: Gretchen Rau
Supervising Art Direction by: Tomas Voth
Art Direction by: Patrick M. Sullivan, Jr.
Associate Art Direction by: Kazuo Tashima, Greg Berry, and Michael E. Goldman
Illustrations by: Darek Gogol and Tracey Wilson
Set Design by: Jann K. Engel, Robert Fechtman, Luis G. Hoyos, Rich Romig, Maya Shimoguchi, Chad S. Frey, Jeff Markwith, Masako Masuda, and Patte Strong-Lord
Scenic Painting by: Gunnar Ahmer
Graphic Design by: J. C. Brown and Michael Marcus

The Last Samurai (Warner Independent Pictures, 2003)
Production Design by: Lilly Kilvert
Set Decoration by: Gretchen Rau
Art Direction by: Christopher Burian-Mohr, Jess Gonchor, and Kim Sinclair
Associate Art Direction by: John Berger, Elizabeth Flaherty, and Harry E. Otto
Illustrations by: P. K. McCarthy and Christopher Glass
Set Design by: Roy Barnes, James R. Baylis, Tristan Paris Bourne, John P. Goldsmith, Adrian Gorton, Ann Harris,

Anthony D. Parrillo, Michael Smale, Samuel J. Storey, Patte Strong-Lord, and Philip Thomas
Matte Painting by: Scott Brisbane, John Coats, Ron Crabb, Chris Stoski, and Patrick Paul Mullane
Scenic Painting by: Sourisak Chanpaseuth and Ray Massa
Graphic Design by: J. C. Brow and Ted Haigh

Under the Tuscan Sun (Touchstone Pictures, 2003)
Production Design by: Stephen McCabe
Set Decoration by: Nick Evans, Mauro Passi, and Cinzia Sleiter
Art Direction by: Gianfranco Fumagalli and Gianni Giovagnoni
Illustrations by: Cristiano Donzelli
Graphic Design by: Derrick Kardos

Ocean's Twelve (Warner Brothers, 2004)
Production Design by: Philip Messina
Set Decoration by: Kristen Toscano Messina
Supervising Art Direction by: Doug J. Meerdink
Art Direction by: Tony Fanning
Associate Art Direction by: Jean-Michel Hugon, Stefano Maria Ortolani, Easton Michael Smith, Eugenio Ulissi, Rudy van den Berg, Suzan Wexler, Gianpaolo Rifino, and Saverio Sammali
Illustrations by: Joanna Bush, James Clyne, Martin L. Mercer, and Christopher S. Ross
Set Design by: C. Scott Baker, Andrea Dopaso, Billy Hunter, Lauren E. Polizzi, and Lori Rowbotham
Graphic Design by: Mark Pollard and Karen Teneyck

Marie Antoinette (Columbia Pictures, 2006)
Production Design by: K. K. Barrett
Set Decoration by: Vérnonique Melery

Supervising Art Direction by: Anne Seibel
Art Direction by: Pierre Duboisberranger
Illustrations by: Lilith Bekmezian and Christiano Spadoni
Set Design by: Benoît Bechet, Matthieu Beutter, Jean-Yves Rabier, and Charles Schwacsina
Scenic Painting by: Valentina de la Rocca, Antoine Fontaine, Eric Gazille, Frederic Heurlier, Stéphane Le Lièvre, and Audrey Vuong

The Devil Wears Prada (Fox 2000, 2006)
Production Design by: Jess Gonchor
Set Decoration by: Lydia Marks
Art Direction by: Tom Warren
Associate Art Direction by: Jonathan Arkin, Gregory Hill, and Anne Seibel
Illustrations by: Thomas H. Tonkin
Scenic Painting by: Alex Gorodetsky, Jay Hendrickx, Nikolay Mikushkin, Quang Nguyen, Joel Ossenfort, Charles R. Suter, Marcia C. Suter, Christopher Weiser, and Steve Rosenzweig
Graphic Design by: Derrick Kardos

The Nanny Diaries (Weinstein Company, 2007)
Production Design by: Mark Ricker
Set Decoration by: Andrew Baseman
Art Direction by: Ben Barraud
Associate Art Direction by: Robert Pyzocha and Blythe R. D. Quinlan
Scenic Painting by: Alexander Garzero and Joseph Garzero
Matte Painting by: Chris R. Green, Kirstin Hall, Ali Kocar, Brendan Smith, and Sohee Sohn
Graphic Design by: Kelly Hemenway

Harry Potter and the Order of the Phoenix (Warner Bros. Pictures, 2007)
Production Design by: Stuart Craig
Set Decoration by: Stephanie McMillan
Supervising Art Direction by: Neil Lamont
Associate Art Direction by: Andrew Ackland-Snow, Mark Bartholomew, Alastair Bullock, Martin Foley, Martin Schaedler, Stephen Swain, Gary Tomkins, and Alexandra Walker
Illustrations by: Andreas Adamek, Rob Bliss, Adam Brockbank, Jane Clark, Jim Cornish, Miraphora Mina, Nick Pelham, Denis Rich, and Andrew Williamson
Set Design by: Andrew Bennett, Julia Dehoff, Molly Hughes, Gary Jopling, Hattie Storey, and Emma Vane
Matte Painting by: Joe Ceballos, Giles Hancock, Joshua Ong, Kristi Valk, and Patrick Zentis
Scenic Painting by: Nicky Kaill
Graphic Design by: Eduardo Lima, Miraphora Mina

Harry Potter and the Chamber of Secrets (Warner Bros. Pictures, 2002)
Production Design by: Stuart Craig
Set Decoration by: Stephanie McMillan
Supervising Art Direction by: Neil Lamont
Associate Art Direction by: Andrew Ackland-Snow, Mark Bartholomew, Peter Francis, John King, Steven Lawrence, Lucinda Thomson, Peter Dorme, Alan Gilmore, Dominic Masters, and Gary Tomkins
Illustrations by: Martin Asbury, Rob Bliss, Adam Brockbank, Julian Caldrow, Paul Catling, Temple Clark, Cyrille Nomberg, Nick Pelham, Dermont Power, and Ravi Bansal
Set Design by: Patricia Johnson, Alastair Bullock, Julia Dehoff, and Stephen Swain
Matte Painting by: Brett Northcutt, Susumo Yukhiro,

Wei Zheng, Juan Jesus Garcia, Rachel Haupt, and Gurel Mehmet
Scenic Painting by: Marcus Williams, Matt Williams, Robert J. Dugdale, and Howard Weaver
Graphic Design by: Miraphora Mina and Ruth Winick

The Lord of the Rings: The Fellowship of the Ring (New Line Cinema, 2001)
Production Design by: Grant Major
Set Decoration by: Dan Hennah and Alan Lee
Supervising Art Direction by: Dan Hennah
Art Direction by: Joe Bleakley, Philip Ivey, Rob Outterside, and Mark Robbins
Associate Art Direction by: Jacqui Allen, Jules Cook, Ross McGarva, and Christian Rivers
Illustrations by: John Howe and Alan Lee
Set Design by: Clarke Gregory, Gareth Jensen, Russell Murray, Tim Priest, Philip Thomas, and Kate Thurston
Matte Painting by: Laurent Ben-Mimoun, Max Dennison, Yannick "Botex" Dusseault, Wayne John Haag, Roger Kupelian, Richard Mahon, and Deak Ferrand
Scenic Painting by: Steve Mitchell and Troy Stephens

The Lord of the Rings: The Return of the King (New Line Cinema, 2003)
Production Design by: Grant Major
Set Decoration by: Dan Hennah and Alan Lee
Supervising Art Direction by: Dan Hennah
Art Direction by: Joe Bleakley, Simon Bright, and Philip Ivey
Associate Art Direction by: Mark Robbins, Jacqui Allen, Jules Cook, and Rosa McGarva
Illustrations by: John Howe, Alan Lee, Kyle Ashley, Gus

Hunter, Jacob Leaf, Kristoffer Lynch, Stephen Lynch, and Danielle Norgate
Set Design by: Clarke Gregory, Gareth Jensen, Russell Murray, Tim Priest, Helen Stevens, Philip Thomas, and Kate Thurston
Matte Painting by: Ronn Brown, Dylan Cole, Karen deJong, Max Dennison, Roger Kupelian, Mathieu Raynault, and Richard Mahon
Scenic Painting by: Troy Stephens

Lemony Snicket's A Series of Unfortunate Events (Paramount, 2004)
Production Design by: Rick Heinrichs
Set Decoration by: Cheryl Carasik
Supervising Art Direction by: John Dexter
Art Direction by: Tony Fanning, William Hawkins, and Martin Whist
Associate Art Direction by: Bill Boes, A. Todd Holland, Deborah Jensen, and Eric Sundahl
Illustrations by: Mauro Borrelli, James Carson, Peter Chan, Rodolfo Damaggio, John Davis, Tim Flattery, Giacomo G. Ghiazza, Gabriel Hardman, Michael Anthony Jackson, Jim Martin, Christopher S. Ross, and Nathan Schroeder
Set Design by: C. Scott Baker, Roy Barnes, Jackson Bishop, J. André Chaintreuil, Todd Cherniawsky, Kevin Cross, Nancy Deren, Jann K. Engel, Luke Freeborn, Sean Haworth, Scott Herbertson, Victor James Martinez, Lauren E. Polizzi, Marco Rubeo, Easton Michael Smith, Dawn Snyder, George Trimmer, and Donald B. Woodruff
Matte Painting by: Vanessa Cheung, Pamela Hobbs, Paul Huston, and Benoit Pelchat
Graphic Design by: Dianne Chadwick, Ted Haigh, and Karen Teneyck

Batman Begins (Warner Bros., 2005)
Production Design by: Nathan Crowley
Set Decoration by: Paki Smith and Simon Wakefield
Supervising Art Direction by: Simon Lamont and Steven Lawrence
Art Direction by: Alan Tomkins, Peter Francis, Paul Kirby, Dominic Masters, Su Whitaker, Eggert Ketilsson, David Lee, and Shane Valentino
Associate Art Direction by: Alastair Bullock, Peter Dorme, Stuart Kearns, Patrick Lumb, Stephen Morahan, and Sloane U'Ren
Illustrations by: Martin Asbury, James Cornish, Dan Walker, Ravi Bansal, Cyrille Nomberg, Simon McGuire, Dermont Power, Dan Walker, and Andrew Williamson
Set Design by: Guy Bradley, Toby Britton, Claudio Campana, Oliver Goodier, Charles Leatherland, Alex Smith, Remo Tozzi, Anna Bregman, Jordan Crockett, Kate Grimble, and Lotta Wolgers
Matte Painting by: Diccon Alexander
Scenic Painting by: David Packard, Mike Sotheran, Julian Walker, and Greg Winter
Graphic Design by: Mary Ann Mackenzie

The Dark Knight (Warner Bros. Pictures, 2008)
Production Design by: Nathan Crowley
Set Decoration by: Peter Lando
Supervising Art Direction by: Kevin Kavanaugh and Simon Lamont
Associate Art Direction by: Mark Batholomew, James Hambidge, Craig Jackson, Steven Lawrence, Naaman Marshall, Toby Britton, Neal Callow, Peter Dorme, and Ashley Winter
Illustrations by: Rob Bliss, Jim Cornish, Stephanie Olivieri, Jamie Rama, Matthew Savage, Dan Walker, Michelle Blok, Faraz Hameed, and Jason Horley

Set Design by: J. Andre Chaintreuil, Mary Mackenzie, and Robert Woodruff
Matte Painting by: Diccon Alexander and Lizzie Bentley
Graphic Design by: David Hicks, Phillis Lehmer, and Joanna Pratt

Avatar (Twentieth Century Fox, 2009)
Production Design by: Rick Carter and Robert Stromberg
Set Decoration by: Kim Sinclair
Supervising Art Direction by: Todd Cherniawsky, Kevin Ishioka, and Kim Sinclair
Art Direction by: Nick Bassett, Robert Bavin, Simon Bright, Jill Cormack, Stefan Dechant, Seth Engstrom, Sean Haworth, Andrew L. Jones, Andy McLaren, Andrew Menzies, Norman Newberry, and Ben Procter
Supervising Virtual Art Direction by: Yuri Bartoli and Robert C. Powers
Virtual Art Direction by: Jose Astacio, Wayne D. Barlowe, Anthony Jacob, and Brian Pace
Associate Art Direction by: Jacqui Allen, Vanessa Cole, Patrick Peterson, Robert C. Powers, Mike Stassi, April Warren, and Jeff Wisniewski

Illustrations by: Francois Audouy, Wayne D. Barlowe, Jim Charmatz, Ryan Church, James Clyne, Dylan Cole, TyRuben Ellingson, Seth Engstrom, Karsa Farahani, Gus Hunter, Phillip Keller, James Lima, Victor James Martinez, Steven Messing, Phillip Norwood, Paul Ozzimo, Neville Page, Scott Patton, Jordu Schell, Craig Shoji, Richard Taylor, Stephan Yap, and Simon Webber
Set Design by: C. Scott Baker, Luke Caska, Andrew Chan, David Chow, Scott Herbertson, Joseph Hiura, Robert Andrew Johnson, Tex Kadonaga, Tammy S. Lee, Darryl Longstaffe, Karl J. Martin, Richard F. Mays, Sam Page, Andrew Reeder, Richard Reynolds, Michael Smale, and Mark Stephen
Matte Painting by: Heather Abels, Lyse Beck, Mannix Bennett, Rene Borst, Scott Brisbane, Brenton Cottman, Adam J. Ely, Elias Gonzalez, Jaime Jasso, Sun Lee, Damien Macé, Joseph McLamb, Kenneth Nakada, and Edward Quintero
Scenic Painting by: W. Therese Eberhard, Alastair Maher, and Eddie Yang
Graphic Design by: Zachary Fannin and Ben Myers

PHOTOGRAPHY CREDITS

Part Two

The Silent Era and the Twenties: 40: Douglas Fairbanks Pictures/United Artists/Photofest; 42: D. W. Griffiths/Courtesy of Marc Wanamaker/Bison Archives; 43: D. W. Griffiths Corp/Photofest; 44–45: Triangle Film/Photofest; 46: Douglas Fairbanks Pictures/United Artists/Photofest; 47: Douglas Fairbanks Pictures/United Artists/Photofest; 48: Douglas Fairbanks Pictures/United Artists/Courtesy of Marc Wanamaker/Bison Archives; 49: Metro-Goldwyn-Mayer/Courtesy of AMPAS; 50–51: Metro-Goldwyn-Mayer/Photofest; 52: United Artists/Courtesy of Marc Wanamaker/Bison Archives; 53: Decla-Bioscop AG/Photofest; 54–55: Universum Film (UFA)/Photofest; 56: Cosmopolitan Productions/Paramount Pictures/Photofest; 57–59: Metro-Goldwyn-Mayer/Photofest; 60: Metro-Goldwyn-Mayer/Photofest; 61: Fox Film Corp./Photofest.

The Thirties: 62: Paramount Pictures/Photofest; 64–66: RKO/Photofest; 67: Metro-Goldwyn-Mayer/Photofest; 68–71: Metro-Goldwyn-Mayer/Photofest; 72: Samuel Goldwyn Company/Photofest; 73: Columbia Pictures/Courtesy of the Art Directors Guild; 74: Columbia Pictures/Photofest; 75: London Film Productions/United Artists/Photofest; 76–79: Metro-Goldwyn-Mayer/Photofest; 80–83: Universal Pictures/Photofest; 84: Paramount Pictures/Photofest; 85: Charles Chaplin Productions/United Artists/Photofest; 86: Paramount Pictures/Photofest; 87: Paramount Pictures/Courtesy of the Art Directors Guild; 88–93: Selznick International Pictures/Metro-Goldwyn-Mayer/Photofest

The Forties: 94: Twentieth Century Fox/Courtesy of AMPAS; 96–98: Selznick International Pictures/Photofest; 99–101: RKO/Photofest; 102: Twentieth Century Fox/Photofest; 103: Warner Bros./Photofest; 104–5: Warner Bros./Photofest; 106: Warner Bros./Courtesy of AMPAS; 107: Twentieth Century Fox/Photofest; 108: Twentieth Century Fox/Courtesy of AMPAS; 109: Warner Bros./Photofest; 110, top and bottom left: Warner Bros./Photofest; 110, right: Warner Bros./Courtesy of AMPAS; 111: Warner Bros./Photofest; 112–13: RKO/Photofest; 114–16: Warner Bros./Photofest; 117: Paramount Pictures/Photofest; 118: RKO/Photofest.

The Fifties: 120, 122–23: Paramount Pictures/Photofest; 124: Paramount Pictures/Photofest; 125: Alfred Hitchcock Productions/Paramount Pictures/Courtesy of the estate of Henry Bumstead; 126: Alfred Hitchcock Productions/Paramount Pictures/Photofest; 127, top and bottom: Courtesy of the estate of Henry Bumstead; 128: Metro-Goldwyn-Mayer/Courtesy of AMPAS; 129: Metro-Goldwyn Mayer/Courtesy of the Art Directors Guild; 130: Metro-Goldwyn-Mayer/Courtesy of AMPAS; 131: Metro-Goldwyn-Mayer/Photofest; 132: Courtesy of Robert Boyle; 133: Stanley Kramer/United Artists/Photofest; 134: Paramount Pictures/Photofest; 135: Paramount Pictures/Courtesy of AMPAS; 136–38: Warner Bros./Photofest; 139–41: Metro-Goldwyn-Mayer/Photofest; 142–43: Metro-Goldwyn-Mayer/Courtesy of AMPAS; 144–45: Metro-Goldwyn-Mayer/Photofest; 146: Metro-Goldwyn-Mayer/Courtesy of AMPAS; 147, top and bottom: Twentieth Century Fox/Courtesy of AMPAS; 148: Twentieth Century Fox/Photofest; 149: Twentieth Century Fox/Courtesy of John DeCuir Jr.; 150: Courtesy of John DeCuir Jr.; 151: Universal International Pictures/Photofest.

The Sixties: 152: Metro-Goldwyn Mayer/Photofest; 154: Horizon Pictures/Filmbild Fundus Robert Fischer; 155: Horizon Pictures/Courtesy of Art Directors Guild; 156–57: Horizon Pictures/Photofest; 158–59: Twentieth Century Fox/Photofest; 160: Twentieth Century Fox/Courtesy of John DeCuir, Jr.; 161: Twentieth Century Fox/Filmbild Fundus Robert Fischer; 162: Metro-Goldwyn-Mayer/Photofest; 163, top: Metro-Goldwyn-Mayer/Courtesy of AMPAS; 163, bottom: Metro-Goldwyn-Mayer/Courtesy of the Art Directors Guild; 164: Metro-Goldwyn-Mayer/Photofest; 165–67: Metro-Goldwyn-Mayer/Photofest; 168-69: Warner Bros./Photofest; 170: Danjag/United Artists/Photofest; 171: Hawk Films/Columbia Pictures/Photofest; 172: Eon Productions/United Artists/Courtesy of AMPAS; 173: Eon Productions/United Artists/Courtesy of Marc Wanamaker/Bison Archives; 174:Eon Productions/United Artists/Photofest; 175–76: Danjag/United Artists/Photofest; 177: Eon Productions/United Artists/Photofest; 178: Universal Pictures/Photofest; 179: Universal Pictures/Courtesy of AMPAS; 180: Universal Pictures/Courtesy of Craig Barron; 181: Universal Pictures/Courtesy of AMPAS; 182–83:Twentieth Century Fox/Photofest; 184: Embassy Pictures/Photofest; 185: Paramount/Courtesy of the estate of Richard Sylbert; 186: Paramount/Filmbild Fundus Robert Fischer.

The Seventies: 188: Lucasfilm/Twentieth Century Fox/Photofest; 190: Paramount Pictures/Courtesy of AMPAS; 191: Paramount Pictures/Photofest; 192: Paramount/Courtesy of AMPAS; 193: Paramount Pictures/Photofest; 194: Courtesy of Dean Tavoularis; 195, top: Universal Pictures/Photofest; 195, bottom: Courtesy of Henry Bumstead Estate; 196: Irwin Allen Productions/Twentieth Century Fox/Courtesy of Art Directors Guild; 197: Irwin Allen Productions/Twentieth Century Fox/Photofest; 198: Courtesy of Richard Sylbert Estate; 199: Hawk Films/Warner Bros./Photofest; 200–201: Hawk Films/Warner Bros./Filmbild Fundus Robert Fischer; 202: Warner Bros./Photofest; 203: Warner Bros./Courtesy of AMPAS; 204: Universal Pictures/Courtesy of Joe Alves; 205: Universal Pictures/Photofest; 206: Columbia Pictures/Photofest; 207, top left: Columbia Pictures/Photofest; 207, right top to bottom: Columbia Pictures/Courtesy of Joe Alves; 208-9: Lucasfilm/Twentieth Century Fox/Photofest; 210–11: Columbia Pictures/Photofest; 212: Universal Pictures/Courtesy of Tony Walton; 213, top: Universal Pictures/Courtesy of Tony Walton; 213, bottom: Universal Pictures/Courtesy of AMPAS; 214: Zoetrope Studios/United Artists/Courtesy of Dean Tavoularis; 215: Zoetrope Studios/United Artists/Photofest; 216: Zoetrope Studios/United Artists/Courtesy of Dean Tavoularis; 217, left: Zoetrope Studios/United Artists/Photofest; 217, right: Zoetrope Studios/United Artists/Filmbild Fundus Robert Fischer.

The Eighties: 218: Saul Zaentz Company/Orion Pictures/Photofest; 220–22: The Ladd Company/Warner Bros./Courtesy of Lawrence G. Paull; 223: Lucasfilm/Paramount/Photofest; 224–25: Hawk Films/Warner Bros./Photofest; 226-27: Universal Pictures/Photofest; 228: Saul Zaentz Company/Orion Pictures/Photofest; 229: Warner Bros./Photofest; 230–31: Paramount Pictures/Photofest; 232-33: Twentieth Century Fox/Photofest; 234: Twentieth Century Fox/Courtesy of Stephen Hendrickson; 235: Twentieth Century Fox/Photofest; 236: Orion Pictures/Photofest; 237: Embassy International Pictures/Photofest; 238: Columbia Pictures/

Courtesy of Dante Ferretti; 239, top: Columbia Pictures/ Photofest; 238, bottom: Columbia Pictures/Courtesy of Dante Ferretti.

The Nineties: 240: Amblin Entertainment/Dreamworks SKG/Photofest; 242–43: Twentieth Century Fox/ Photofest; 244–45: Tig Productions/Orion Pictures/ Courtesy of Jeffrey Beecroft; 246–47: Twentieth Century Fox/Courtesy of Doug Kraner; 248: Malpaso Productions/Warner Bros./Courtesy of the estate of Henry Bumstead; 249: Malpaso Productions/Warner Bros./Photofest; 250: Cappa Production/Columbia Pictures/Photofest; 251: Cappa Production/Columbia Pictures/Courtesy of Dante Ferretti; 252: Regency Enterprises/Warner Bros./Courtesy of Jay Hart; 253: Regency Enterprises/Warner Bros./Courtesy of Jeannine Oppewall; 254–55: New Line Cinema/ Photofest; 256: Courtesy of Jeannine Oppewall; 257–58: Merchant Ivory Productions/Courtesy of Luciana Arrighi; 259: Fox Searchlight Pictures/Courtesy of Luciana Arrighi; 260: Merchant Ivory/Columbia Pictures/ Photofest; 261: Merchant Ivory Productions/Columbia Pictures/Courtesy of Luciana Arrighi; 262–63: Amblin Entertainment/Dreamworks SKG/Photofest; 264–65: Amblin Entertainment/Universal Pictures/ Courtesy of Rick Carter; 266: Amblin Entertainment/ Universal Pictures/Photofest; 267: Paramount Pictures/ Courtesy of Rick Carter; 268: Courtesy of Rick Carter; 269–70: Twentieth Century Fox/Photofest; 271–72: Twentieth Century Fox/Courtesy of AMPAS; 273: Courtesy of the estate of Richard Sylbert; 274: Columbia Pictures/Courtesy of Paul Sylbert; 275: Metro-Goldwyn-Mayer/Photofest; 276–77, top: Courtesy of Universal Pictures; 277, bottom: Universal Pictures/Photofest; 278: Warner Bros./Courtesy of Kopelson Entertainment; 279: Irish Dream Time/Metro-Goldwyn-Mayer/ Courtesy of AMPAS; 280–81; Dreamworks SKG/ Photofest.

The Millennium: 282: Warner Bros./Photofest; 284: Dreamworks SKG/Universal Pictures/Filmbild Fundus Robert Fischer; 285: Dreamworks SKG/Universal Pictures/Photofest; 286: USA Films/Photofest; 288–90: Focus Features/Courtesy of Mark Friedberg; 291–92: Miramax/Courtesy of Gordon Sim; 293–94: Fox 2000/ Photofest; 295–96, top: Courtesy of Columbia Pictures; 296, bottom: Columbia Pictures/Photofest; 297–98: Courtesy of Columbia Pictures; 299–300: Courtesy of Universal Pictures; 301–2: Miramax/Photofest; 303; Miramax/Courtesy of Dante Ferretti; 304–6: Focus Features/Courtesy of Sarah Greenwood; 307–9: Warner Bros./Courtesy of James Bissell; 310: Courtesy of Columbia Pictures; 311: Warner Independent Pictures/ Photofest; 312: Courtesy of Columbia Pictures; 313: Touchstone Pictures/Photofest; 314: Warner Bros./ Courtesy of Kristin Messina; 315–16: Columbia Pictures/ Photofest; 317: Weinstein Company/Photofest; 318–19: Courtesy of Weinstein Company; 320–22: Warner Bros./ Photofest; 323: New Line Cinema/Courtesy of Grant Major; 324: New Line Cinema/Photofest; 325: New Line Cinema/Courtesy of Grant Major; 326–27: Paramount/ Photofest; 328: Warner Bros./Courtesy of Nathan Crowley; 329: Warner Bros./Photofest; 330:Warner Bros./ Courtesy of Nathan Crowley; 331–33: Courtesy of Twentieth Century Fox; 334: Twentieth Century Fox/ Photofest.

INDEX

Note: Page numbers in *italics* refer to illustrations.